ONE WEEK LOAN

10 JAN 2003

20/3/03

18 MAY 1999

14 MAY 2001

21 SEP 2001

25 MAY 1999

4/6/99

24 JAN 2002

- 6 DEC 1999

- 5 MAR 2002

18 MAR 2002

- 3 FEB 2000

- 1 MAR 2000

12 APR 2002

16 NOV 2000

22 APR 2002

26 NOV 2002

TOURISM COMMUNITY RELATIONSHIPS

TOURISM SOCIAL SCIENCE SERIES

Series Editor: Jafar Jafari
Department of Hospitality and Tourism, University of Wisconsin-Stout,
Menomonie, WI 54751, USA.
Tel: (715) 232-2339; Fax: (715) 232-3200; E-mail: jafari@uwstout.edu
Associate Editor (this volume): Peter Murphy
La Trobe University, Australia

The books in this Tourism Social Science Series (TSSSeries) are intended to systematically and cumulatively contribute to the formation, embodiment, and advancement of knowledge in the field of tourism.

The TSSSeries' multidisciplinary framework and treatment of tourism includes application of theoretical, methodological, and substantive contributions from such fields as anthropology, business administration, ecology, economics, geography, history, hospitality, leisure, planning, political science, psychology, recreation, religion, sociology, transportation, etc., but it significantly favors state-of-the-art presentations, works featuring new directions, and especially the cross-fertilization of perspectives beyond each of these singular fields. While the development and production of this book series is fashioned after the successful model of *Annals of Tourism Research*, the TSSSeries further aspires to assure each theme a comprehensiveness possible only in book-length academic treatment. Each volume in the series is intended to deal with a particular aspect of this increasingly important subject, thus to play a definitive role in the enlarging and strengthening of the foundation of knowledge in the field of tourism, and consequently to expand its frontiers into the new research and scholarship horizons ahead.

New and forthcoming TSSSeries titles include:

DENNISON NASH (University of Connecticut, USA)
Anthropology of Tourism

JÓZSEF BÖRÖCZ (Rutgers University, Institute for Political Studies of the
Hungarian Academy of Science)
Leisure Migration: A Sociological Study on Tourism

BORIS VUKONIČ (University of Zagreb, Croatia)
Tourism and Religion

Related Elsevier Journals
Annals of Tourism Research
Cornell Hotel and Restaurant Administration Quarterly
International Journal of Hospitality Management
International Journal of Intercultural Relations
Tourism Management
World Development

TOURISM COMMUNITY RELATIONSHIPS

Philip L. Pearce, Gianna Moscardo
and Glenn F. Ross

*James Cook University of North
Queensland, Australia*

Pergamon

U.K.	Elsevier Science Ltd, The Boulevard, Langford Lane, Kidlington, Oxford OX5 1GB, U.K.
U.S.A.	Elsevier Science Inc., 660 White Plains Road, Tarrytown, New York 10591-5153, U.S.A.
JAPAN	Elsevier Science Japan, Higashi Azabu 1-chome Building 4F, 1-9-15, Higashi Azabu, Minato-ku, Tokyo 106, Japan

First edition 1996

Library of Congress Cataloging in Publication Data

Pearce, Philip L.
Tourism community relationships/Philip L. Pearce, Gianna Moscardo, Glenn F. Ross. – 1st ed.
p. cm. – (Tourism social science series)
Includes bibliographical references and index.
1. Tourist trade. I. Moscardo, Gianna. II. Ross, Glenn F. III. Title.
IV. Series
G155.A1P362 1997
338.4'791-dc20 96-41663
 CIP

British Library Cataloguing in Publication Data
A catalogue record for this book is available from the British Library.

ISBN 0-08-042395-7

Typeset by Gray Publishing, Tunbridge Wells, Kent
Printed and bound in Great Britain by Redwood Books, Trowbridge, Wilts

We dedicate this book to Tom and Jack Pearce. Without them we might still have written this book. With them we probably wrote it more slowly but we will remember our experiences of doing so more clearly.

1996

Contents

Acknowledgments

The authors would like to thank Dr Peter Murphy, University of Victoria, Canada, for his considered comments on the first draft of this book. Since the present volume is in part an extension and reconsideration of issues raised by his own, it was particularly valuable to receive his feedback. Importantly, Professor Jafar Jafari has shown patience and faith in the progress of this volume and we would like to thank him for this confidence in our work.

A large part of this volume was constructed while two of the authors (Pearce and Moscardo) were undertaking a sabbatical leave at Kangaroo Island, South Australia. It is a part of the personal history of this book that their stay on Kangaroo Island afforded both a living example of communities and tourism and a very memorable period outside a university environment. John and Shirley Andersen and the community of this spectacular island were important hosts while this book was prepared.

Some of the driving ideas in this research were derived from the work of Professor Rob Farr, London School of Economics, and his contribution is acknowledged. Mrs Anne Sharp, Senior Secretary, Department of Tourism, James Cook University, assisted us with the drafts and final manuscript with her customary skilled and sustained typing efforts. Thanks are also extended to Joanna Phelps and Barbara Woods who acted as valued research assistants in the development stages. Carmel Ross also deserves sincere acknowledgments not only for her continued academic support for tourism studies but also for her hospitality and calming influence on the research team.

The present volume builds on and reconceptualizes the endeavors of many tourism researchers. The authors acknowledge their efforts and the responses and concerns of the residents whom they have studied.

Chapter 1

Why Do We Need To Understand and Manage the Tourism–Community Relationship?

What is the Problem?

In a monograph there are obviously many related issues to be addressed. For clarity, however, it is useful to follow the example of Lord Florey, the Nobel Prize-winning chemist who pioneered the development of penicillin. Florey, by most accounts a demanding and stimulating supervisor and teacher, was reputedly fond of wandering around his Oxford laboratories and assailing his research workers with penetrating questions. Florey's central question was usually of the style, "Tell me, as simply as you can—what is the question you are asking?" (Bickel 1983:19). This emphasis on keeping researchers focused on the big question driving the research is valuable to avoid being sidetracked by many fascinating and related issues. What is the question or problem that informs this particular book? What answer would the authors give to Lord Florey? The question of central importance is precisely that defined by Hawkins (1993) in his review of research questions for key issues in global tourism policy. The question Hawkins poses and the question driving this monograph is:

> How can we improve our understanding of resident perceptions, values and priorities regarding tourism's role in their community?

This monograph seeks to understand how communities respond to and live with tourism. In the present authors' view, better long-term planning for tourism must be guided by a more sophisticated understanding of how communities react to the burgeoning phenomenon of

1

tourism. It is therefore not a book about tourism planning itself, although one consequence of understanding community reactions to tourism will be to assist planning. Instead it is the aim of this book to develop an understanding of community reactions to tourism which can be the basis for future applied documents on tourism planning, tourism project development and regional economic growth embracing tourism. It is argued here that before innovative and practical advances can be made in the tourism–community planning arena, effort needs to be made to advance our understanding of how communities develop their knowledge of, and attitudes towards, tourism.

Further, this is not a book about how communities should develop or generate tourism. Instead it will consider community reactions to tourism for both entrepreneur-led tourism and community-generated tourism projects. It is also not a book which focuses solely on the impacts of tourism. So far, terms have been used, and will continue to be used, such as community attitudes towards, knowledge of, and reactions to tourism, and phrases such as the community–tourism relationship because a broader phenomenon than the impacts of tourism is explicitly under investigation. This monograph seeks to understand what communities know about and think about tourism, which includes perceptions of impacts, but also embraces its future development, who should be responsible for its control and development, why it has the impacts it has and how it relates to other aspects of social and community life.

Finally, and perhaps most importantly, it is hoped that this monograph will be generative; a source of ideas for researchers, practitioners and students. The authors believe that the theory of social representations, which it will be argued provides a new and valuable perspective for understanding the tourism–community relationship, has many potential applications across a broad range of tourism topics. Thus it is hoped that this monograph will be a catalyst both for further discussion about understanding tourism and communities, and for generating some new approaches to a variety of tourism research areas.

The theory of social representations is at the core of this monograph. This theory, which is explored extensively in *chapter 2*, is specifically concerned with understanding everyday knowledge and how people use this knowledge and common sense to understand the world in which they live and to guide their actions and decisions. Moscovici, the French social psychologist responsible for developing this new theory, describes its focus most clearly when he says,

> People on the street, in cafes, at their places of work, in hospitals, laboratories, etc., are always making critical remarks, commenting and concocting spontaneous, non-official "philosophies" which have a decisive influence on their relations, their choices, their way of educating their children, making plans and so on (Moscovici 1981:183).

His argument is a simple one. These ordinary world views or social representations have a very powerful influence on people's perceptions, beliefs, decisions and actions. If social scientists want to understand things such as social change and conflict they must understand the world of everyday knowledge and common sense (Moscovici 1981). The goal here has two complementary parts. In the first the theory of social representations as it applies to tourism is used to develop new insights into the community–tourism relationship. In the second it is hoped that the use of social representations to understand the social explanations and dynamics of the introduction of tourism into a community will provide an applied example of the theory which will stimulate the interest of social scientists beyond tourism.

In summary then, who should benefit from reading this book? Firstly and primarily, tourism researchers and graduate students concerned with understanding the impacts of tourism on communities and how planning for tourism may be improved will be a core group of readers. It is hoped that the monograph will be both useful in generating research programs and in guiding their own teaching. Secondly, tourism researchers and graduate students in general who may be seeking new theories or approaches to any number of tourism questions should find value in the conceptual approaches and methods described in this book. Tourism planners and practitioners seeking some greater insight into the world in which they work may find the approaches, reviews and case studies to be of particular interest, while undergraduate students pursuing specific interests in the area of tourism–community relationships could be guided by the critical appraisal of existing work offered in this monograph. For these last two groups it must be stressed that this is not a textbook or handbook that will easily provide principles or answers. Rather, it will hopefully challenge them to question their own social representations of tourism and its impacts, how they can be measured and how tourism can be better managed and developed to ensure its long-term sustainability.

How to Use This Book: A Brief Reader's Guide

As a consequence of having multiple and different audiences the design and structure of this book is multilayered. As a monograph in a social science series it deals with detailed material requiring careful logical and empirical attention. Accordingly, all readers will benefit from a close sequential reading of the text as the argument builds from chapter to chapter. Nevertheless it is recognized that in a world of exponentially expanding information, many readers will want to access key issues and component parts of the book or at least to gain an overview of the work

before launching into the details of each chapter. This use of a layered approach to the argument will hopefully assist readers in identifying material of personal interest and will both guide and consolidate their appreciation of the core text.

The first and core layer is the central argument set out in detail in the main body of the text. In a second layer, short case studies, or examples, which demonstrate or clarify the main arguments, will be included in separate boxed sections. A third layer will present, again in separate boxes, key issues, questions or implications that arise from the main argument. It is not possible, even in a lengthy monograph, to discuss in detail every issue or implication that arises. Thus the goal with these boxes is to identify briefly some interesting issues and hope that these boxes encourage others to take up and explore these options.

In keeping with the approach outlined above, the following section will outline the contents of this first chapter and then present an overview of the rest of the book. The material presented in the remainder of this first chapter will focus on the need for new approaches to tourism planning. This need will be seen as coming both from various recommendations for ecologically sustainable development, and from core issues predicted to be influential in the future of tourism. Existing theories or models for understanding community responses to tourism will be reviewed and the strengths and limitations of these approaches will be noted. Included in this review of existing theoretical approaches to understanding community responses will be an overview of the methods used to understand what communities think and feel about tourism. By combining the results of the theoretical and methodological reviews of existing studies, the need for new approaches and the opportunities for answering critical questions will be introduced.

At the beginning of *chapter 2* a section will identify the kind of new approach, in brief a more social and emic paradigm, required to understand community reactions to tourism. The term emic requires clarification."Emic studies draw upon the actors' interpretations and local inside knowledge of the meaning of the behaviour under study" (Pearce 1983:91). Emic approaches can be contrasted with etic approaches where the researchers generate their own constructs to describe the observed behavior or cultural pattern. In this second chapter of the volume the literature on social representations as a system for understanding communities and their responses to change will be described. This material, which is richly embedded in the history of twentieth-century social science research, will consider the strengths and key features of a social representational approach. The links between the concept of social representation and other concepts such as image, opinion, attitude and group identity will be outlined and illustrated with various research examples.

Chapter 3 will merge the present interest in tourism and communities with the general approach of social representations. This chapter will provide guidelines for research, taking a social representational perspective. In addition to outlining the features of this model, *chapter 3* will examine the social representations of tourism and its impacts, which can be seen in the literature generated by tourism researchers.

The value of the social representational approach will be considered in two chapters based on a series of case studies. In *chapter 4* various international examples of community responses will be examined. A detailed set of empirical studies will provide the fundamental focus for *chapter 5*. These studies, conducted over a five-year period, include community surveys of established tourism locations, emerging tourism destinations and communities with little current tourism. By comparing destinations that are at different stages of tourism development, the review will explore how a social representations approach explains and describes changing resident enthusiasm for tourism. Importantly, this review of one substantial region containing different communities will also consider what the communities share or have in common when responding to tourism. It will be argued that the commonality inherent in community responses provides an equally valid focus to that derived from an emphasis on differences in community reactions.

While it has been previously stated that the present monograph is not in itself a treatment of tourism planning, it is important to assess the value and consequences of the social representational approach to this significant area of tourism. In particular, the value of this new theoretical approach for public participation exercises will be discussed in *chapter 6*. Finally, *chapter 7* will look to the future of community–tourism relationships. In this concluding set of statements an emphasis will be placed on the need to define research agendas in tourism studies which can respond to, guide and shape the actions of the tourism industry and government bodies. The establishment of an effective symbiosis between tourism researchers and government and industry operators will be canvassed using the topic of this book, community reactions to tourism, as an illustration.

Why are Tourism–Community Relationships Important?

The constancy of social change is one of the paradoxes of human existence. For individuals there can be stimulation and excitement involved in shaping and responding to a changing social environment, yet there are also emotional rewards in dealing with familiar places and predictable events. At the community level Toffler (1970) was one of the first authors to highlight that an inability to respond to change could be

socially destructive, while Langer (1989a) convincingly outlined the need for individuals to be mindful in order to avoid the psychological costs of relying only on familiar and established ways of thinking and acting. In this work Langer also presents substantial evidence of the difficulty that we have stepping outside familiar and established routines. Change and flexibility do not come easily to us. The issue of how communities shape and respond to social and environmental changes is a driving factor in assessing community response to tourism. The tension between embracing the future and the change it contains, and valuing the past and the stability and predictability it represents, will be studied in the social representations of tourism in this monograph.

Communities, Tourism and Ecologically Sustainable Development

One broadly based conceptual scheme for considering the implications of change and development pressures in human endeavour is the ecologically sustainable development (ESD) framework (Brundtland 1987). A number of countries have used this world-wide framework for highlighting key issues in managing economic growth and change and applied it to tourism development. In Australia, Canada, and Britain the principles set out in the Brundtland report have been translated into national goals, policies and more detailed principles (ESD Working Group—Tourism 1991; Lane 1991; Pigram 1990). The ideas of ESD have also permeated into the planning and policy documents of many countries (Pigram 1990; Sofield 1991).

Ecologically sustainable tourism is best defined through an understanding of its goals and a description of its characteristics. Table 1.1 sets out the key goals and characteristics of EST as described in the Australian Government's ESD Working Group Report for Tourism (1991). Lane (1991), drawing upon various British planning documents, expands upon several of the characteristics listed in Table 1.1, in particular those concerned with social equity and community involvement, regional planning and the nature and quality of the experience for visitors. He defines sustainable tourism as providing

> satisfying jobs without dominating the local economy. It must not abuse the natural environment, and should be architecturally respectable. ... The benefits of tourism should be diffused through many communities, not concentrated on a narrow coastal strip or scenic valley (1991:2).

An important feature of these derivations from the global ESD debate to specific tourism issues is the role of community well-being as a priority consideration. While the community is given much attention in the goals of ecologically sustainable tourism, it has been noted before that much

Table 1.1. Goals and Characteristics of Ecologically Sustainable Tourism

Goals

To improve the material and non-material well-being of communities.
To preserve intergenerational and intragenerational equity.
To protect biological diversity and maintain ecological systems.
To ensure the cultural integrity and social cohesion of communities.

Characteristics

Tourism which is concerned with the quality of experiences.
Tourism which has social equity and community involvement.
Tourism which operates within the limits of the resource—this includes minimization of impacts and use of energy and the use of effective waste management and recycling techniques.
Tourism which maintains the full range of recreational, educational and cultural opportunities within and across generations.
Tourism which is based upon activities or designs that reflect the character of a region.
Tourism which allows the guest to gain an understanding of the region visited and which encourages guests to be concerned about, and protective of, the host community and environment.
Tourism which does not compromise the capacity of other industries or activities to be sustainable.
Tourism which is integrated into local, regional and national plans.

of the language of the ecologically sustainable development literature emphasizes biological and biophysical considerations, an emphasis which has marginalized the importance of social and community impacts and considerations in the total ESD debate (Pearce 1993; Pigram 1990). If the ESD emphasis in tourism focuses only on biophysical processes and does not consider positive and negative community impacts then it will gradually lose power as an organizing system for tourism thinking and become synonymous with environmental impact assessment.

An important part of the later sections of this book will be to argue that the social representations approach can assist in defining how to, and what to, study in assessing community reactions to tourism. Indeed, it could be argued that the trend noted above to marginalize community perspectives in the ESD analysis may stem from a current research inability to measure and assess the community perspective, a difficulty which places the issue in the "too hard" and "subjective" basket. The importance of understanding community–tourism relations is thus central to the goals of ESD.

Looking to the Future of Tourism

A second background issue providing a context for the study of tourism and community change can be identified in the work on the future of tourism. These studies, reports and analyses begin with the concern of identifying the forces shaping tourism and changing its direction. Hawkins (1993) reports 19 major issues identified by international tourism policy makers. These key factors were identified in an iterative research process at the First International Assembly of Tourism Policy Experts in Washington, DC. This work was seen as extending and building on both the policy statements and conference reports of the World Tourism Organization and the World Travel and Tourism Council. Five of the 19 issues are of particular interest to this monograph. Issues 1, 5, 8, 13, and 18 (highlighted in Table 1.2) are all related to and reinforce the importance of the present monograph.

This international and global identification of community-based concerns as high-profile items in the total set of tourism future issues is a challenge to researchers and analysts, particularly in the development of approaches to understanding and developing practice for enhanced management of these concerns.

Ritchie (1993), following on from Hawkins, has itemized key research issues to facilitate "resident-responsive tourism". Ritchie's analysis divides research into strategic policy research, evaluation research, management research, action research and operational research. While the distinctions among these research types are subtle, the list of research needs he generates for resident-responsive tourism overlaps substantially with the basic concerns of this monograph. Ritchie suggests that academics "may wish to focus their efforts on such topics" and that they can most usefully "have an interest in more fundamental or basic research addressing major issues with medium to long term implications" (Ritchie 1993:206). Ritchie's list of research needs for resident-responsive tourism is given in Table 1.3.

Additionally, several other items of concern to an analysis of community reactions to tourism are included in the research agendas which Ritchie provides for other issues identified by the tourism policy group in Washington. These items are described in Table 1.4.

While both Hawkins (1993) and Ritchie (1993) argue that resident-responsive tourism will become increasingly important in future tourism policies and planning, it is not the case that these issues have not been previously considered. The often-quoted works of both Murphy (1985) and Krippendorf (1987) directly argue for and describe new approaches to planning for tourism. Both these authors review the range of potential negative impacts of tourism on both host communities and their environment. Krippendorf goes on to propose various changes to

Table 1.2. Major Issues Shaping Global Tourism Policy

Issue 1: There is a recognition that there are finite limitations to tourism development, in terms of both the physical and social carrying capacity of destinations.

Issue 2: The physical environment is taking center stage in tourism development and management.

Issue 3: The growing demands of the high cost of capital for development of the tourism infrastructure and rising taxation/fees will maintain and increase financial pressure in the tourism industry.

Issue 4: Technological advances are giving rise to both opportunities and pressures for improved productivity, human resource development and restructuring of the tourism industry.

Issue 5: Tourism must strive to develop as a socially responsible industry; more specifically, it must move proactively rather than simply responding to various pressures as they arise.

Issue 6: Continued regional conflicts and terrorist activities are impediments to the development and prosperity of tourism.

Issue 7: The political shift to market-driven economies is bringing about a global restructuring in which market forces rather than ideology are used to guide decisions and develop policy.

Issue 8: Resident-responsive tourism is the watchword for tomorrow: community demands for active participation in the setting of the tourism agenda and its priorities for tourism development and management cannot be ignored.

Issue 9: Despite recent progress, recognition by governments of the tourism industry and its importance to the social and economic development and well-being of regions is still far from satisfactory; one part of the reason for this is a lack of credibility of tourism data.

Issue 10: Demographic shifts are occurring which will dramatically influence the level and nature of tourism.

Issue 11: Patterns of tourism are being transformed by increasingly diverse lifestyles.

Issue 12: The human resource problem. There is a continuing and growing need to increase the supply of personnel and to enhance their professionalism.

Issue 13: Cultural diversity should be recognized within the context of a global society.

Issue 14: The trend to market economies and shrinking government budgets is creating strong pressures for privatization and deregulation of tourism facilities and services.

Issue 15: Health and security concerns could become a major deterrent to travel.

Issue 16: Regional political and economic integration and cooperation will predominate.

Issue 17: The rise in influence of the global/transnational firm will accelerate.

Issue 18: The widening gap between the North/South (developed/developing) nations continues to cause frictions and to be a constant source of concern for harmonious tourism development.

Issue 19: Growing dissatisfaction with current governing systems and processes may lead to a new framework (paradigm) for tourism.

(After Hawkins 1993:185–198)

Note: Issues were derived from discussion groups with 90 senior tourism personnel from 26 countries representing 23 disciplines and a variety of industry and government organizations.

**Table 1.3. A Research Agenda to Encourage and Facilitate
Resident-Responsive Tourism**

Research needs

- To identify methodologies for improving public participation/input into tourism development priorities and directions.
- To establish the role, impact and acceptability of non-resident ownership of tourism facilities/services.
- Formulation of a local vision for tourism development.
- To assess the impact of a program to enhance public participation in tourism planning and development.
- To determine the impacts of foreign ownership on resident support for tourism.
- Design of a cost-effective program to provide information to the community concerning tourism impacts and issues.
- Assessment of the ongoing implementation of a program to enhance resident reception of visitors.
- To determine where to locate city-related information so as to benefit both residents and visitors.

(After Ritchie 1993:208)

**Table 1.4. Additional Research Agenda Items Relevant to Community
Reactions to Tourism**

Issue 1: Tourism and the environment on center stage

- Value research—identifying and measuring the values that drive/should drive tourism development.
- Assessment of alternative planning methods for reaching workable/acceptable consensus concerning directions for tourism development.
- Measuring and managing cultural and social "pollution".

Issue 18: Tourism, the north–south gap and resulting frictions

- Identification of the major sources of tourism friction between developed and developing countries with a view to establishing their seriousness, generalizability and possibility of resolution.
- Identifying the appropriate travel experiences which can/should be offered by a developing country.
- Determining how best to facilitate tourist entry/exit without compromising national integrity.
- Assessment of the effectiveness of alternative approaches which have been tried for enhancing tourism development in Third World countries.

(After Ritchie 1993:207–213)

tourism as a social phenomenon. In a much more pragmatic fashion Murphy (1985 and 1988) outlines a new "community-driven tourism planning" approach. Central to this community-driven tourism planning is an explicit recognition that experts cannot judge the perceptions, preferences or priorities of host communities. Murphy argues instead

for the direct participation of local communities in tourism planning and development. "It is crucial to the tourism industry's long-term survival, therefore, to develop a better understanding of its local image" (Murphy 1985:18). The authors hope that the present volume will provide a fresh theoretical and methodological approach to the needs described by Murphy (1985).

This discussion of new planning and policy approaches to tourism is reinforced in a substantial account by Poon (1992) of what she terms "new tourism". This concept, which should be distinguished from such terms as alternative or green tourism, is a description of the kind of tourism that Poon sees as reflecting new forces in global tourism demand and supply. In particular, Poon sees new tourism existing when:

1. the holiday is flexible and can be purchased at prices that are competitive with mass-produced holidays;
2. production of travel and tourism-related services are not dominated by scale economies alone. Tailor-made services will be produced while still taking advantage of scale economies where they apply;
3. production is increasingly driven by the requirements of consumers;
4. the holiday is marketed to individuals with different needs, incomes, time constraints and travel interests. Mass marketing is no longer the dominant paradigm;
5. the holiday is consumed on a large scale by tourists who are more experienced travellers, more educated, more destination oriented, more independent, more flexible and more "green";
6. consumers look at the environment and culture of the destinations they visit as a key part of the holiday experience (Poon 1992:85).

In emphasizing the spread of new tourism Poon argues that there are a number of forces producing or determining these new features of tourism. Her analysis focuses on new consumers, new technologies, new production practices, new management techniques, and changes in the industry's frame or background conditions. In the last-mentioned category Poon includes the emphasis placed by host cultures on the tourism in their community and argues for a shift from host communities being passive recipients of the social impacts of tourism to host cultures generating new initiatives which better manage the guests themselves and infrastructure for their visitors. Poon's analysis is therefore optimistic and challenging. Her arguments and analysis suggest that the core topic of tourism-induced community change can be positively dealt with by community innovation, including environmental audits and more creative managerial approaches to environmentally based tourism. While these suggestions are broadly consistent with the aims of the present volume, it can be suggested that there is an important step missing in Poon's analysis, a missing step which is shared by many of those advocates

Case Studies and Specific Examples 1.1
Tourism and the Community: Two Nineteenth-Century Examples

1. The *Success*
In the late 1880s, Australia was still divided into a number of growing colonial settlements without unity or national focus. In the southern-most part of the country, known then as Van Dieman's land and now called Tasmania, several entrepreneurs bought an old disused convict ship with the interesting name, the *Success*. The new owners fitted the old ship with the artefacts of prison life, complete with convict mannequins, and exhibited their tourist attraction to the public. The *Success* lived up to its name and the eager public of the fledgling colony proved to be a most receptive market. Greatly encouraged by their efforts the owners sailed the vessel to Sydney, an older and more substantial colonial settlement. In one of the monumental failures of nineteenth-century Australian tourism, the new attraction lasted less than a week and was sunk one night by indignant citizens who did not want to be reminded of the convict past of their community. The early Van Dieman's Land entrepreneurs were clearly poor market researchers as well as being insensitive to the potential community backlash which tourism can engender.

(After Hughes 1987)

2. Weston-Super-Mare
The resort destination of Weston-Super-Mare in the county of Avon in south-west England is an unlikely site for a tourism destination. The tidal range is one of the highest in the world, causing the sea to retreat up to one mile from the shore at each tide. Additionally, the waters are turgid and muddy, an extensive area of soft mud is exposed at every low tide and the early town settlement was of a basic shanty type. It was far from being an attractive fishing hamlet. Yet from being one of the poorest and smallest villages on the coast in 1801, Weston-Super-Mare became a major nineteenth-century seaside resort, and continues to prosper in this role in the twentieth century. The genesis of this successful resort from such unpromising beginnings lies in a number of forces including improved transport, changes to land tenure in the area permitting individual ownership, and, significantly, substantial community participation fostering and nurturing early development. Much of the early development capital was raised within the local farming community and even those without capital were willing to lease single plots to individuals or speculative builders. The enthusiasm for the new industry went beyond financial speculation with a willingness to inform visitors of where to stay and what to do. Thus the industry, based on taking the waters to cure medical problems and nurtured by the local community enthusiasm, survived until more grandiose efforts such as the construction of a promenade and larger resort houses were able to assume a significant role. In this case study community involvement, financing and effort were able to overcome some limited physical resources to create one of south-west England's major tourist resorts.

(After Brown 1985)

of improved management for tourism to offset socioenvironmental costs. The gap in this kind of thinking lies in not having a substantial and reliable research base from which planners and industry operators can formulate new approaches. Without such a resource, it is likely to be an unproductive exercise merely to state that community-based innovations will solve the socioeconomic impacts of a changing tourism industry.

In summary, this consideration of ecologically sustainable development issues in tourism and community-responsive planning for tourism, supported by research agendas related to the future of tourism, provide a direct and quite specific argument for the present monograph.

What is Already Known About Community Reactions to Tourism?

The aim of this section is to review the tourism literature about community reactions to tourism in order to understand both what is already known and, more importantly, what is not known about this topic. In any review of existing literature the articles, books and reports that are used can be seen as types of data. As with all areas in social science, data can be analyzed qualitatively and/or quantitatively. Traditional literature reviews can be seen as fundamentally qualitative analyses providing their readers with information on dominant themes, ongoing conflicts and debates, major emphases, and omissions. This qualitative tradition will be used in the present chapter to provide readers with an overview of the area of community reactions to tourism and its major directions.

The issues of sample representativeness and bias are equally important to both quantitative and qualitative approaches and so it is necessary to provide the reader with a description of the procedure used to generate the sample of relevant literature to be reviewed here. Four main methods were used in this review process and details are given in Table 1.5. In the first instance the entire volumes of two key tourism journals (as identified by Sheldon 1990), the *Annals of Tourism Research* and the *Journal of Travel Research*, were searched for any articles which discussed tourism's social or cultural impacts, or community attitudes towards tourism. This search provided the core of the material used.

Secondly, the last six years (that is, from the first available issue in 1989 to the first available issue of 1994) of volumes from a larger set of tourism, leisure, and environmental management journals were searched for articles relevant to the themes of tourism impacts and community attitudes towards tourism. A preliminary examination of the contents of earlier volumes indicated only a limited number of relevant articles available prior to 1989 in these more broadly based journals. Thirdly,

Table 1.5. Literature Review Procedures

1. Search *Annals of Tourism Research* and *Journal of Travel Research* from the first issue published to first issue available in 1994.
2. Search *Tourism Management, Journal of Tourism Studies, Journal of Leisure Research, Leisure Sciences, Environment and Behavior, Environmental Conservation, Journal of Environmental Management, Progress in Tourism, Recreation and Hospitality Management, Leisure Studies, Tourism Recreation Research,* from first issue available in 1989, or first issue published, to first issue available in 1994.
3. Search Current Contents for 1989–93 Social and Behavioral Sciences.
4. Check reference lists of literature already compiled.

the key words of community attitudes to tourism and tourism impacts were searched in the Current Contents Social and Behavioral Sciences Index for the years 1989 to 1993 inclusive. Finally, the reference lists of the articles and books already selected were searched for further articles and books on the topic of interest. Literature solely concerned with actual (that is, not as perceived by hosts) economic and environmental impacts and reports from public organizations that were not readily accessible were excluded from the literature search. One major limitation of this review is that is does not include material published in languages other than English. An examination of research reported in translated references such as that by Krippendorf (1987) and research reported for non-English-speaking countries (e.g., Husbands 1989; Haukeland 1984; Kariel and Kariel 1982) did not, however, indicate any major differences in methodology or conceptual approaches. It should be remembered that throughout this chapter the literature referred to is best described as the English literature.

In total, this sampling procedure produced 262 references.A smaller set of 110 publications was then further identified which described research on or theories about either tourism's social and cultural impacts or community attitudes towards tourism. Commentaries, reviews and planning literature make up the rest of the total sample. It is these research and theoretical discussions that will be reviewed here, seeking an answer to the question: what is already known about community reactions to tourism?

Jafari (1990) provides an interesting historical overview of tourism "as a subject of research and scholarly treatment" (p. 33). He proposes that there exist four traditions in the tourism research literature which he refers to as platforms, each distinguished by a different perspective on tourism's impacts. The first, or advocacy platform, appeared in the era of post World War II economic reconstruction and expansion and strongly emphasized the positive economic (and other) impacts of tourism. This platform was, and still is, dominated by reports and docu-

ments generated by private and public organizations. The second was a cautionary platform, and he traces its beginnings to the early 1970s, coinciding with a major increase in academic research interest in tourism. This platform challenged the position of the advocacy platform, documenting a variety of negative consequences for the hosts of tourism. The description of various alternative forms of tourism identifies the third or adaptancy platform. This platform has focused its attention on various new, soft, green, responsible, and indigenous forms of tourism, which it is argued will have fewer negative impacts. While these new forms of tourism have been very optimistically described there is a growing body of literature suggesting that the evidence to support these supposedly less negative forms of tourism is not very strong (Butler 1992; Eadington and Smith 1992; Wheeler 1992). Jafari (1990) describes a fourth approach labeled the knowledge-based platform. This "new platform aims at positioning itself on scientific foundations" (p. 35). It is important to note that while these four platforms have developed or emerged in a historical sequence, no one platform has replaced another and so all can be currently found in the tourism literature (Jafari 1990).

For the present purpose of reviewing academic research concerning communities and tourism, Jafari's history suggests that this review should begin in the 1970s and that academic research in this area began with a cautionary perspective highlighting the negative impacts of tourism on host communities. The texts identified by Jafari as part of this cautionary platform include Young's (1973) Tourism: Blessing or Blight, Turner and Ash's (1975) The Golden Hordes, Smith's (1978b) work, Hosts and Guests, and de Kadt's (1979) Tourism: Passport to Development. The present authors would add to these key texts Finney and Watson's (1975) A New Kind of Sugar: Tourism in the Pacific, and Farrell's (1977) The Social and Economic Impact of Tourism on Pacific Communities. In these early, and still often-quoted, tourism texts there was a strong tradition of ethnographic case studies of tourism impacts on developing countries, particularly in the South Pacific, the Caribbean, and Asia.

In this literature on tourism impacts and community responses to tourism, stage or step models were and still are popular. For example, Smith (1978b) saw the development of tourism in terms of waves of tourist types; the seven categories in order of expanding community impacts are shown in Table 1.6. Smith's model was directed at cross-cultural contact issues, and her book Hosts and Guests contained several studies where social impacts on local communities were directly related to the expansion of tourism (Greenwood 1978; Pi-Sunyer 1978; Smith 1978a; Urbanowicz 1978).

At about the same time as Smith's work was gaining attention from anthropologists encountering tourists in the cultures that the researchers had come to study, Doxey (1975) proposed an irritation index or

Table 1.6. Smith's Typology of Tourist Types Linked to Community Impact

Type of tourist	Number of tourists	Community impacts
1. Explorer	Very limited	
2. Elite	Rarely seen	Very few
3. Off-beat	Uncommon but seen	
4. Unusual	Occasional	Gradually
5. Incipient mass	Steady flow	increasing
6. Mass	Continuous flow	Substantial
7. Charter	Massive arrival	

"irridex" to assess host–guest interactions and relationships. Doxey's scale has four steps; (a) euphoria (delight in contact); (b) apathy (increasing indifference with larger numbers); (c) irritation (concern and annoyance over price rises, crime, rudeness, cultural rules being broken); and (d) antagonism (covert and overt aggression to visitors). Another stage development model relating to tourism was proposed by Butler (1980) (see Figure 1.1). In this model the impacts of tourism are not the direct focus of attention; instead the model is concerned with the more general issue of the evolution of tourist areas (marketing issues, organization and ownership of the tourist services and attractions), although the attitudes of residents and community support for tourism are discussed as a part of the larger process. Butler sees tourist areas as evolving through the stages of exploration, involvement, development, consolidation, stagnation, and then either decline or rejuvenation. In the consolidation stage he sees the emergence of social impacts. "The large numbers of visitors and the facilities provided for them can be expected to arouse some opposition and discontent among permanent residents" (Butler 1980:8). The stagnation phase, where peak numbers of visitors have been reached, is seen as follows: "capacity levels for many variables will have been reached or exceeded with attendant environmental, social and economic problems" (Butler 1980:8).

Stage-based models of individual and social processes in general evoke a number of concerns, many of which can be directed at these tourism-related models. All three models have poor demarcation between the stages or steps. It is also unclear whether shifting from one stage to another precludes the continued existence of the previous stage. For example, just as children who have moved from crawling to walking may also still crawl, is it the case that tourism communities that have moved from development to consolidation will retain and exhibit many of the features of the development phase, or are they necessarily superseded?

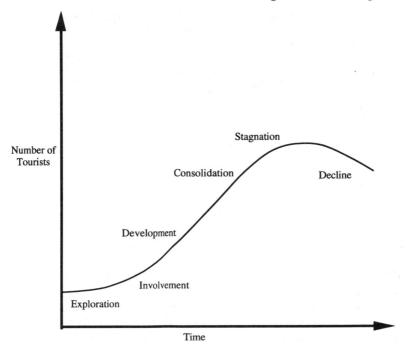

Figure 1.1 Butler's Destination Life Cycle Model (Source: Butler 1980)

Additionally, stage models prompt the question of whether or not the order of the stages is invariant. The Doxey (1975) and Smith (1978b) models appear to assume this point, but Butler (1980) notes that some tourism destinations (he cites the major Mexican resort of Cancun) may move directly into a higher level stage without the preceding steps. A related question concerns the speed of development through the resort development or tourism growth stages. Does it matter, in terms of community impact, how quickly the environment has been developed for tourism, or is it simply a matter of which stage of development has been reached?

Further, in the final stages of the Doxey (1975) and Butler (1980) models, is it the whole community that becomes hostile to tourism or are there only sections of the population who suffer and complain about the social impacts? In another article Butler (Brougham and Butler 1981) himself questions the assumption of a homogeneous community. In general, these models are seen as too simplistic in many ways. Johnson and Snepenger (1993) point out that tourism growth often coincides with growth in general and certainly often accompanies other changes (cf. Johnson et al 1994; Perdue et al 1987, 1990). Ap and Crompton (1993) suggest that hosts have the capacity to develop various strategies to deal

with tourism and that these strategies mediate their perceptions of tourism, adding another dimension to be considered.

One must also query whether the whole process of social impacts and tourism evolution as outlined is inevitable, leaving individuals and local groups powerless to confront the forces of economic change and gain. There is evidence that this is not the case. Dowling (1993), for example, reports on a survey of residents of a remote coastal community, Shark Bay in Western Australia. The resident population is a little over 1,000. Visitation levels to Shark Bay, now famous for its opportunity to touch and interact with the Monkey Mia dolphins, have grown from 10,000 in 1984 to 150,000 in 1990. This represents a change in resident:visitor ratios from 1:10 to 1:150 in six years. The size and rate of growth of tourism and the existence of serious environmental impact problems would clearly place the destination in an advanced stage of development. Yet residents are very positive about tourism and strongly supportive of its continued growth. King, Pizam and Milman (1993) present similar evidence for residents of Nadi, Fiji. Again, despite very high levels of tourism development and contact with tourists, hosts remain very positive in their reactions and attitudes.

At a more specific methodological level several authors have noted the difficulties in operationalizing the stages in these models. That is, what is it that can be measured about tourism that will indicate what stage a destination is in? (Allen et al 1988; Johnson and Snepenger 1993). Some authors have fallen into the trap of circular definitions. Belisle and Hoy (1980), for example, conclude that the residents surveyed were generally positive about tourism and therefore that the destination must be in an early stage of development. But they give no description of the level or nature of tourism development, thus providing no evidence that the level or stage of tourism development is linked to community or host reactions.

In part, the limits of these models are those of the research from which they were originally derived. These models are best described as *post hoc* descriptive accounts based on a tradition of ethnographic case studies. Dann et al (1988) argue that it is difficult to derive theory from such research as each individual case brings with it so many idiosyncratic features. Van Doorn (1989) is even more critical of this ethnographic work, suggesting that the existing research could be described as "quasi-intellectual findings pretending worldwide validity, but which in fact do not go beyond small-talk at a social gathering" (p. 89).

It was criticisms such as these that generated a second tradition of research into how communities perceive tourism and its impacts. This research moved away from ethnographic methods and took up social survey methods to generate data on how hosts perceived tourism and tourists. These researchers aimed to move this research area from a

cautionary to a knowledge-based perspective (cf. Jafari 1990). Pizam (1978) makes this clear when he says in his introduction,

> Recently, however, several studies of tourism have indicated the existence of some real negative impacts on the local resident population. These theoretical studies assume that tourism might have some serious social, psychological, and economic effects on the resident population.... The following study is among the first attempts to examine empirically the existence of such negative impacts and their correlates and results (p. 8).

These host community surveys usually examine one or both of the following questions. Firstly, they attempt to explore a stage model, most commonly Butler's (1980) approach, by comparing the responses of samples drawn from two or more destinations which are believed to differ in terms of level of tourism development. Secondly, and often concurrently, the research examines differences in the attitudes or perceptions of different subsections of the sample. In these studies the researchers are trying to determine which variables influence host perceptions of tourism in their region. Table 1.7 contains summaries of the key findings and conclusions of a selection of survey studies that investigated these two questions, organized according to the variables examined.

One striking conclusion that can be drawn from Table 1.7 is that there are few consistent relationships or patterns observed, a point of view reinforced in several other reviews of this material (Ap 1990; King et al 1993; Lankford and Howard 1994; Milman and Pizam 1988). For example, in some places, residents living closer to areas of higher or heavy tourism concentration are more positive about tourism, while in other cases such residents are more negative than those living farther away. Sometimes attachment to a place or community is related to greater support for tourism, and sometimes it is related to lesser support for tourism. Some of these inconsistencies are the result of the use of different measures. In the case of community attachment, for instance, some researchers have used place of birth and length of residency as indicators of likely attachment to a community. McCool and Martin (1994) and Lankford (1994) provide evidence that these may be poor measures of attachment.

Despite these problems, there are four important areas in which patterns of relationships appear in the conclusions presented in Table 1.7. The first and most researched is that of economic dependency or personal benefits gained from tourism. It has been argued that these results suggest that attitudes towards tourism follow some kind of equity or social exchange function (Lankford and Howard 1994; Perdue et al 1990). This reflects the influence of an emerging conceptual approach derived from social exchange theory. Madrigal (1993) describes social

ge theory as providing

> an economic like analysis of interaction that focuses on the exchange and mutual dispensation of rewards and costs between actors. ... The underlying assumption of exchange is that actors behave in a way that maximizes the rewards and minimizes the costs they experience (p. 338).

Ap (1992) provides a longer discussion of social exchange processes and proposes how they might be used to explain resident perceptions of tourism. His basic assumptions are, however, the same as those outlined by Madrigal above.

While a selective view of the research evidence supports an exchange or equity system in the case of evaluating tourism, a more detailed investigation of the results suggests a more complex relationship. All studies in section 2 of Table 1.7 report that residents who are likely to benefit from tourism (either because they or family members are employed in tourism or because they believe that tourism's benefits outweigh its costs to them personally) are more likely to support tourism and report more positive impacts from tourism. Several studies, however, report that these people are also more likely than other residents to report negative impacts (King et al 1993), or that personal benefits are significantly related to perceptions of positive benefits but explain very little in the case of perception of negative impacts. Murphy's 1983 study of the perceptions of tourism of business people, residents and administrators found significant differences between these groups. These differences, however, were not large and were not consistent across all attitudes towards tourism. Both Madrigal (1993) and Lankford and Howard (1994) report a positive relationship between perceived personal benefits and beliefs about personal influence on tourism decision making. The nature of this relationship is yet to be investigated in detail but it could be an alternative to perceived equity in the explanation of perceptions of tourism.

Knowledge of tourism also seems to be positively related to support for tourism. The possibility exists that this is not a simple relationship. For example, it seems reasonable to suggest that people with greater involvement in tourism might also have greater knowledge of tourism. Alternatively, it could be argued that greater knowledge of tourism might allow for the more detailed assessments of impacts that people with positive exchange or equity outcomes seem to express.

An additional variable to consider is that of the extent to which people consider community as opposed to personal benefits or costs in any exchange or equity deliberations. Ap (1992) argues that social exchange processes can operate at both individual and collective levels but he offers no mechanisms to describe how an individual balances personal against community costs and benefits. Certainly, the bulk of the existing research

Table 1.7. Major Conclusions of Selected Survey Studies of Community Perceptions of Tourism

Variable examined	Study	Key conclusions
1. Level of tourism development	1. Liu et al (1987)	Residents of places with a longer history of tourism development are more aware of both positive and negative impacts.
	2. Allen et al (1988)	There was a curvilinear relationship between perceptions of negative impacts and development of tourism, but this was not as strong a relationship as between perceptions of negative impacts and population growth.
	3. Long et al (1990)	There was a curvilinear relationship between support for tourism and level of development, but as level of tourism development increases so do perceptions of both negative and positive impacts.
	4. Perdue et al (1990)	Perceptions of impacts are related to level of tourism development.
	5. Madrigal (1993)	Level of tourism development is the best predictor of perceptions of negative but not positive impacts of tourism.
2. Economic dependency on tourism A. Comparisons of residents, business owners and government officials	1. Pizam (1978)	Entrepreneurs were more positive about tourism than other groups.
	2. Thomason et al (1979)	Entrepreneurs were more positive about tourism than other groups.
	3. Keogh (1990)	There were no significant differences in the perceptions of business owners and residents.
	4. Lankford (1994)	Residents were more cautious than business owners and public officials.
	5. Murphy (1983)	There were significant differences between residents, administrators and the business sector.
B. Job in tourism or perceived positive balance of personal costs and benefits of tourism	1. Pizam (1978)	There was a positive relationship between employment in and support for tourism.
	2. Rothman (1978)	Economic dependency on tourism was related to more positive perceptions of tourism.
	3. Husbands (1989)	Residents employed in tourism were more positive about tourism.
	4. Perdue et al (1990)	Personal benefits from tourism were important in explaining perceptions of positive but not of negative impacts of tourism.
	5. Mansfeld (1992)	Residents employed in tourism were more positive about tourism.
	6. Madrigal (1993)	Personal benefits from tourism were the best predictors of perceptions of positive impacts.
	7. Prentice (1993)	There was a positive relationship between perceived benefits of tourism and positive perceptions of tourism.
	8. Glasson (1994)	Positive relationship between working in tourism and support for tourism.
	9. Lankford and Howard (1994)	Those who were more dependent on tourism were more positive about tourism.

Table 1.7. (continued)

Variable examined	Study	Key conclusions
3. Distance from place of residence to tourist areas	1. Belisle and Hoy (1980)	As distance from place of residence to tourist areas increased residents were less positive about tourism.
	2. Brougham and Butler (1981)	Some relationships were found between residence in zones of high tourist pressure, but the nature of the relationship differed for different types of tourist.
	3. Sheldon and Var (1984)	Residents in higher tourist density areas were more positive about tourism.
	4. Keogh (1990)	People living closer to a proposed tourist development perceived more negative impacts.
	5. Mansfeld (1992)	People living further from tourist areas saw more negative impacts from tourism.
4. Level of contact with tourists	1. Pizam (1978)	Residents with more contact with tourists were negative about tourism.
	2. Rothman (1978)	High contact with tourists was associated with positive perceptions of tourism.
5. Respondent demographics	1. Belisle and Hoy (1980)	No relationships between perceptions of tourism and age, gender or level of education.
	2. Brougham and Butler (1981)	Older residents were less positive about tourism.
	3. Davis et al (1988)	No relationships between demographics and attitudes towards tourism.
	4. Ritchie (1988)	Older residents were less positive about tourism.
	5. Husbands (1989)	Education and age were related to perceptions of tourism.
	6. Perdue et al (1990)	There were no relationships between perceptions of tourism and demographics when personal benefits from tourism were controlled for.
	7. Caneday and Zeiger (1991)	Level of education was related to more positive perceptions of tourism for residents, but it was related to more negative perceptions for entrepreneurs who were not in tourism.
	8. King et al (1993)	Only limited differences in perceptions of tourism between different demographic groups.
	9. Lankford (1994)	No significant relationships between perceptions of tourism and demographics.
6. Community attachment	1. Brougham and Butler (1981)	People who had lived longer in a community were more positive about some types of tourists.
	2. Davis et al (1988)	People born in a place were more positive about tourism than newcomers to a place.
	3. Lankford and Howard (1994)	No significant relationship between community attachment and perceptions of tourism.
	4. McCool and Martin (1994)	Greater attachment to a community was associated with higher ratings of both positive and negative impacts of tourism.

Table 1.7. (continued)

Variable examined	Study	Key conclusions
7. Use of outdoor recreation facilities	1. Perdue et al (1987)	No significant differences in perception of tourism between groups with different levels of outdoor recreation.
	2. Keogh (1990)	Residents who used an area proposed for tourism development saw both more positive and negative impacts from the development.
8. General economic conditions of a community	1. Perdue et al (1990)	If residents believe the future of their town is bright they are less supportive of tourism development.
	2. Johnson et al (1994)	Lower support for tourism was related to low levels of general economic activity.
9. Perceived ability to influence tourism decisions	1. Madrigal (1993)	Perceived ability to influence decisions was significantly related to positive perceptions of tourism.
	2. Lankford and Howard (1994)	There was a significant positive relationship between perceived ability to influence tourism decisions and perception of positive and negative impacts of tourism.
10. Knowledge of tourism	1. Davis et al (1988)	Knowledge of tourism was positively related to positive perceptions of tourism.
	2. Keogh (1990)	Greater knowledge of a proposed tourism development was associated with more detailed and more positive perceptions of tourism impacts.
	3. Lankford and Howard (1994)	Greater knowledge of tourism was related to greater support for tourism.
11. Political self-identification	1. Snepenger and Johnson (1991)	Residents with conservative political views were more negative about tourism than those with moderate or liberal views.
12. Influence of a tourism public relations campaign	1. Robertson and Crotts (1992)	Residents of a community with a public relations campaign were more positive about tourism than those not exposed to a public relations campaign.

Several survey studies were not included in this table because they did not examine the relationships between any variables and perceptions of tourism. Rather, these studies provide descriptions of community responses; e.g., Cooke (1982), Andressen and Murphy (1986), Murphy (1981), Pizam and Pokela (1985) and Milman and Pizam (1988).

focuses on a personal level of equity. Prentice (1993) provides what seems to be a rare analysis of the relationship between perceived personal and community benefits. His conclusion was,

> despite the general perception [of the respondents] that tourism was of little personal benefit; tourism (or strictly, tourism and day trip making) was generally perceived as beneficial in keeping Dales residents in employment and in supporting local services (p. 223).

It must also be noted that many of the studies that report a positive relationship between personal benefits and support for tourism also report that overall the majority of the sample are positive about tourism and it is often the case that people with no apparent benefits are also supportive of tourism (Caneday and Zieger 1991; Davis et al 1988; Keogh 1990; Liu et al 1987; Madrigal 1993; Prentice 1993; Thomason et al 1979). Perdue et al (1990) raise the question: how do we explain the reactions of hosts for whom equity considerations result in an even balance or are irrelevant? Johnson, Snepenger and Akis (1994) provide one possible answer when they suggest that self-image and group identity may provide an individual with some ready-made attitudes towards tourism. In their study of attitudes towards tourism in the Shoshone County, Idaho (USA), they conclude that the "local population still see themselves as primarily mine and timber workers" (p. 938) who find it difficult to adapt to change because their self-image is so strongly based on their traditional "occupational community" (p. 638). Their argument is consistent with an earlier study (Snepenger and Johnson 1991) in which perceptions of tourism were found to be related to political self-identification.

One notable omission in the literature reviewed thus far in this chapter has been the lack of reference to current attitude theory and research. A research area has been reviewed that is ostensibly concerned with understanding attitudes towards tourism and yet that has made virtually no use of a large and sophisticated body of knowledge about a core concept in social psychology. Ap (1992) provides one exception when he refers to the work of Fishbein and Ajzen (1975) and discusses the problem of consistency between expressed attitudes and actual behavior. A common problem in attitude research has been that expressed attitudes often do not appear to influence actual behavior. The work quoted by Ap (1992) is, however, somewhat dated, and more recent social psychological approaches to understanding attitudes provide some interesting insights into the results summarized in Table 1.7. Specifically, current attitude theories suggest that when an individual is highly involved with a topic or object (for example, if it forms part of their work or daily life), then they are more likely to hold more detailed attitudes

towards it (Chaiken and Stangor 1987; Petty and Cacioppo 1986). This provides an alternative explanation to that of social exchange or equity for why individuals with jobs in tourism have more detailed perceptions of its impacts (see Key Issues 1.1).

In the same way that the stage models were criticized for treating hosts as a single homogeneous group, the social survey studies can be criticized for treating tourism as a homogeneous phenomenon and tourists as a single homogeneous group. Even those studies which explicitly examine different levels of tourist development do not take into account differences in the types of tourism or tourists associated with different levels of tourism [even though both Smith (1978a) and Butler (1980) noted such changes]. There is evidence that hosts respond differently to different types of both tourism and tourists. Ross (1992), for example, found that older residents of an Australian community were more accepting of American and Australian visitors than of other visitors, although younger residents were less positive about American than Japanese visitors. Liu and Var (1986) and Var et al (1985) also provide evidence of tourist stereotyping. In the case of different types of tourism, Ritchie (1988) found that levels of support for tourism development varied according to the type of development proposed, with casinos the least favoured and festivals the most acceptable. Simmons (1994) found greatest support for tourism which was locally owned and small to medium in scale.

It is timely to summarize the main points made thus far in this review of the existing research literature into community perceptions of tourism. There have been two major methodological traditions and two major conceptual approaches identified in the research literature concerned with community reactions to tourism. The first methodological tradition was one of ethnographic case studies conducted mostly in developing countries, and took a cautionary perspective which emphasized the negative consequences of tourism. Several stage models formed the major conceptual background to this research. These stage models suggested that as tourism development increases in a destination, host communities suffer from a variety of negative impacts and almost inevitably become hostile to tourism.

The ethnographic tradition was supplemented by a second methodological tradition, social survey research. The survey work typically attempted to detail and examine host community attitudes towards tourism and its impacts. Many different variables were studied in various locations but few consistent patterns or relationships were uncovered. In general there was limited support for a relationship between increased tourism development and greater awareness of tourism impacts. Some evidence was also found for the existence of equity or social exchange processes which constituted the second major conceptual approach to

Key Issues 1.1
Social Psychological Approaches to Attitudes:
Some Important Lessons

1. What is an Attitude?
Like all questions of definition much has been written about what an attitude is or is not. Most psychologists, however, would agree that attitudes are cognitive structures for organizing our experience of the world with three major components: (1) knowledge of, or beliefs about, an object or topic, (2) a positive or negative evaluation of that object or topic, and (3) a direction on how to behave when the object or topic is encountered.

2. Attitude Change and Structure
Much of the research conducted in the last 70 years by social psychologists has concentrated on understanding how to change attitudes. While the focus may have been on changing attitudes much has also been learnt about the structure of attitudes. Current attitude change theories propose that there are two different ways in which people can process information to create or change attitudes; either through a central route (or systematic processing) or through a peripheral route (or heuristic processing). This idea of two types of information processing is not a new one to psychology. In one type (heuristic processing or peripheral routes) people process very little of the available information, using shortcuts to make decisions and familiar routines to guide behavior. In the case of attitudes towards tourism an individual taking a peripheral route might borrow a stereotype of tourism presented in the media and make do with that information and evaluation. In the other type (systematic processing or central routes) people carefully process, examine, and analyze much of the available information. Attitudes developed through such systematic processing are likely to be more detailed, more consistently related to behavior and harder to change than those adopted through a peripheral route. People are more likely to engage in systematic processing when the topic or object is of importance or relevance to them. Thus we would expect people with businesses or jobs in tourism to have more detailed and strongly held attitudes towards tourism.
[See Chaiken and Stangor (1987) for a discussion of systematic versus heuristic processing, and Petty and Cacioppo (1986) for a description of central and peripheral routes to attitude change.]

3. Connecting Attitudes and Behavior
As early as 1934 (La Piere) it was found that behavior is not always consistent with attitudes. In a study of the attitudes held by North American hotel owners and restauranteurs, La Piere found that more than 90 per cent of those surveyed expressed a negative attitude towards potential Chinese guests. Yet when he traveled to many of these hotels and restaurants with a Chinese couple he found virtually no evidence in the behavior of the respondents to indicate that they held such negative attitudes.
There are several reasons why such inconsistencies might exist. It might be that the questions asked to elicit attitudes were not specific enough. Thus answers to a question about support for "increased tourism in the future" may be poor predictors of subsequent support for very specific tourism development proposals. Poor links between attitudes and behavior may also reflect the relevance or importance of a topic to individuals. People for whom tourism is distant or unimportant may be able to express an attitude to a tourism researcher which is only a simple one with few detailed directions for behavior.
[See Nisbett and Wilson (1977) for a discussion of "telling more than we can know"].

4. Positive versus Negative Attitudes
Another important point to note about attitudes is that positive and negative attitudes are organized differently. Specifically, negative attitudes are often more detailed and more strongly held (Moscovici 1963).

the study of tourism–community relationships. These approaches propose that individuals balance the costs and benefits of tourism and their support for tourism depends on the outcome of this cost–benefit equation. Unfortunately, this is too simple a notion to explain the complex pattern of results that have been reported, and equity or exchange-based explanations appear occasionally rather than consistently in the survey-based literature.

Overall, three major problems exist in this area of research, and in combination they provide an explanation for the considerable confusion that appears to exist. Firstly, there are definitional and measurement problems with the concepts of tourists, tourism, and community. In particular, there has been no attempt to investigate systematically the nature of the tourism phenomenon. The available work has mostly targeted differences in hosts and only a handful of studies has examined differences in tourists or tourism. In the latter case there has been some attention paid to the level of tourism development but little given to types of development. It would be a useful exercise to examine the critical dimensions along which types of tourist and tourism differ.

Burr (1991) also observes that the concept of what constitutes a community has not been considered carefully by researchers. In a review of 25 empirical studies on tourism impacts and communities, Burr attempted to classify the views and approaches to the community concept used by the researchers. He found a good deal of variation in the clarity of the researchers' views of community. Occasionally, researchers appeared to use a simple human ecological model focusing only on the term community as a synonym for place, while a further small set of articles adopted critical elements, such as an emphasis on power, decision making, or dependency, as a part of their analysis. Burr concludes that the empirical research literature "gives far too much credence to a conceptualization of community as a social system in which travel and tourism fit nicely" (p. 551) (see Key Issues 1.2).

The second major problem is that of describing and profiling the perceived impacts of tourism. While not all of the survey studies have this as an aim, most studies ask respondents to rate in some way a list of tourism impacts. Unfortunately very few studies develop this list from respondents themselves or give their respondents an opportunity to add to or comment on these lists. In addition, only a few studies have asked respondents to rate or assess the importance of the various impacts. Thus it could be argued that currently we have a very limited view of the nature and content of host perceptions of tourism. This issue will be pursued in greater detail in *chapter 3* when the attitudes and perceptions of tourism held by tourism researchers are examined.

The final and most important problem is the lack of theory. Dann et al (1988), in a review of tourism research in general, have concluded that

Key Issues 1.2
Approaches to Community

Burr (1991) has argued that there are four theoretical approaches to community germane to the literature on tourism impacts. These approaches are labeled the human ecological approach, the social systems approach, the interactional approach and the critical approach. In the human ecological approach, the emphasis is on the community living together and adapting to the setting, a process that produces distinctive community characteristics. The second or social systems approach stresses the roles and institutions that govern society. The focus in the social systems approach is on the ordering of social relations and the primacy of group membership. The third approach, termed the interactional approach, has its origins in the work of Mead (1934) and can be seen as the sum of the regular social interactions of individuals. Warren (1978), consistent with this interactional perspective, views the community as the sum of the clustered interactions of people and organizations occupying a restricted geographic area. The fourth and final approach, referred to as the critical approach, emphasizes the opposing forces in groups of people, including communities, and pays particular attention to the power of key groups in the decision-making process.

Burr goes on to argue that social systems approaches and human ecological theories both emphasize order, organization and structure, an emphasis he sees as disparate with the dynamic and sometimes difficult and troubled introduction of tourism into existing economies. Burr expresses a preference for the interactional approach, combined with certain elements of critical theory, noting that interaction theory focusses attention on the dynamic processes that create and alter community structure. Additionally, elements from the critical perspective focusing on who benefits and who suffers from tourism development would probably enhance researchers' understanding of how communities operate.

Burr's analysis is challenging and in some ways consistent with the aims of this monograph. The views and definitions of communities held by observers will direct researcher and analytical attention to certain groups, individuals or processes. It is also instructive to appreciate that the selection of one perspective may also deflect the research and empirical attention away from other topics. It is the expressed aim of this monograph to understand community reactions to tourism with a social representation approach. The core issue for understanding the community–tourism relationship centers on how community members communicate and interact, how they are influenced in their opinions and how this dynamic process of influence might be successfully managed for sustainable tourism enterprises. It is therefore consistent to advocate an interactional perspective and definition of community within this monograph. That is, the term community will be used in this exposition to refer to an interacting and communicating aggregate of individuals, sometimes at large and sometimes at small scale in terms of population and location. It is not inconsistent with this interaction paradigm and definition to include critical theory concerns, such as the role of power elites, in understanding community reactions. It is argued here that a pluralism of theoretical approaches is appropriate to suit a diversity of tourism study purposes, but the emphasis in this monograph will be on the interacting, communicating, dynamic community.

the atheoretical nature of much tourism research is a major limiting factor in its development. Ap (1990) goes so far as to say that,

> Unless researchers launch out of the elementary descriptive stage of current research and into an explanatory stage, where research is developed within some theoretical framework, they may find themselves none the wiser in another ten years time (p. 615).

This review of existing work, published in English, on tourism and communities, provides several clear imperatives for a monograph on this topic. Kurt Lewin, an eminent social scientist, was fond of saying "there is nothing so practical as a good theory". Lewin's comment could be paraphrased for this topic area as "there is nothing so needed as a good theory". Such a theory needs to consider carefully what kinds of tourists, tourism and communities are being studied. Additionally, any emerging theory in this area needs to have the power to explain and integrate some of the existing research findings and to have substantial credibility in the broader realm of social science. The second chapter of this book will canvas the theory of social representations as a candidate for this theoretical role on the tourism–community stage.

Chapter 2

What are Social Representations?

> Here is a concrete example: unemployment at the moment is widespread and each of us has at least one unemployed man or woman among his acquaintances. Why doesn't this man or woman have a job? The answer to this question will vary according to the speaker. For some, the unemployed just don't bother to find a job, are too choosy or, at best, unlucky. For others they are the victims of an economic recession, of unjustified redundancies or, more commonly, of the inherent injustice of a capitalist economy. Thus the former ascribe the cause of the unemployment to the individual, to his social attitude, while the latter ascribe it to the economic and political situation, to his social status, to an environment that makes such a situation inevitable. The two explanations are utterly opposed to each other and obviously stem from distinct social representations. The first representation stresses the individual's responsibility and personal energy—social problems can only be solved by each individual. The second representation stresses social responsibility, denounces social injustice and advocates collective solutions for individual problems
>
> (Moscovici 1984:49).

In this quote Moscovici (1984) provides a specific example of social representations shaping everyday social knowledge and thinking. Social representations can be described as the "concepts, statements and explanations originating in daily life in the course of inter-individual communications" (Moscovici 1981:181). The theory of social representations focuses on both the content of this social knowledge and the way that this knowledge is created and shared by people in various groups, societies or communities (Moscovici 1981). Such a theory can be very applicable to studies of tourism and host communities. What communities think tourism is, what they expect it will bring and how they respond to tourism are all aspects of a social representation of tourism.

The adoption of a new theory or explanation, such as social representations, implies that previous or existing explanations are inadequate in some way (Emler 1987). The best way to demonstrate the power of

31

the new theory is to first examine in more detail the limitations of the old ones. This chapter thus begins with a brief review and critical discussion of the key elements or assumptions of those theories adopted by researchers in the area of community reactions to tourism. Social representations theory will then be described. Definitions and characteristics of social representations will be set out and the processes by which social representations are created, communicated and changed will be outlined. The history and connections of this new theory of social knowledge and thinking will then be explored. It will be argued that one of the major strengths of social representations theory is its explicit combination of concepts from social psychology, sociology and anthropology (Farr 1993a). The methodological implications for research into social knowledge will also be explored. Throughout the chapter, examples of previous research into social representations are presented, with the aim of enriching the definitions and processes described. The goals of this chapter are therefore to introduce and describe the theory of social representations and to demonstrate its potential in understanding how communities react to tourism.

Concepts and Assumptions Borrowed from Psychology

In the previous chapter an increasing use of social exchange theory in tourism–community research was noted. Additionally, many researchers use the term attitudes, although usually without definition. Both of these concepts come from psychology. It is valuable in the present discussion to consider the sort of psychology from which these tourism researchers are borrowing. In particular, an understanding is required of the assumptions inherent in the use of these concepts and consequently their problems and limitations.

Let us begin with the concept of social exchange. Most obviously, the concept assumes a model of humans as computer-like information processors, a model which came into dominance in Anglo-American psychology in the 1960s (Gardner 1987; Taylor 1981). Less obvious, but no less important, social exchange is borrowed from a psychology which is focused on individuals, on the reality of the researcher and on behavior rather than experience. These assumptions also underlie the version of attitudes that has been adopted by tourism researchers. Although few researchers explicitly refer to any particular approach to, or definition of, attitudes, it can be argued that most subscribe to a view of attitudes as having three components; a cognitive or information component, an evaluative component, and a behavioral or action component. Ap is explicit in his definition of an attitude as "a person's enduring predisposition or action tendencies to some object" (1992:671), and in his

references to Fishbein and Ajzen's (1975) theory of reasoned action. Both this definition and this theory adopt a model of humans as isolated, computer-like information processors (Jaspars and Fraser 1984; McGuire 1986). Such assumptions are made, although less obviously, by many other researchers examining the reactions of host communities to tourism. Perdue et al (1990), for example, test a model in which beliefs about tourism impacts are related directly to evaluations of tourism and then to support for tourism. This model, which includes an exchange component, assumes systematic information processing and a connection between information, evaluation and action very similar to the Fishbein and Ajzen (1975) version of attitudes.

A brief account of the history of psychology provides an important background to the understanding of these concepts. Throughout its history, particularly in Britain and the USA, psychology has been plagued by a concern to be taken seriously as a science. Farr refers to this tension as a "rivalry between our conceptions of man and our conceptions of science" (1987:352). Koch argued that from the pioneers to the present the stipulation that psychology be adequate to science outweighed the commitment that it be adequate to humanity (Koch 1959). This scientific emphasis is clear in the dominance of behaviorism in Anglo-American psychology. Behaviorists insisted that psychology should be a natural science and exclusively study behavior (Farr 1987; Farr and Moscovici 1984). The behaviorist model of humans presented them as without minds and without culture, reacting endlessly to the stimuli around them. The only acceptable psychology was to be conducted in laboratories, observation of behavior was the only reliable method for data collection, and the only reality that could be trusted was that of the researcher (Farr 1987). All phenomena, including language, social institutions such as the family and religion, and culture, could be ultimately be explained as the cumulative result of stimulus-responses chains located in individuals.

The cognitive information processing theorists, who replaced behaviorists as leaders in Anglo-American psychology during the 1950s, criticized behaviorism in terms of its adequacy in explaining human achievements such as language and concept formation. A core element of their argument was that experimental evidence indicated that the human nervous system had limited processing capacity and that it was improbable that humans could process all the stimulus–response connections necessary for even relatively simple behaviors (Cherry 1953; Broadbent 1954; Gardner 1987). Such criticism paved the way for a variety of new theoretical approaches to be considered in psychology and significantly broadened the phenomena that could be studied by psychologists. Nevertheless, it did not challenge the predominance of the laboratory, the focus on individuals in isolation or the single reality of

the researcher (Forgas 1981a). Social exchange theory and an individual approach to attitude analysis, as used in community reactions to tourism research, are products of this version of psychology and as such share the many limitations that have been identified.

There are three fundamental, and interrelated, problems associated with these approaches. The first problem is that the model of humans as systematic information processors is inadequate to explain much behavior and is not supported by the empirical evidence (Chaiken and Stangor 1987; Eiser 1986; Emler and Ohana 1993; Emler 1987; Halfacree 1993; Lewis 1990; Langer 1989a, b; Markova and Wilkie 1987; Moscovici 1972, 1981, 1984; Petty and Cacioppo 1986; Taylor 1981; Tversky and Kahneman 1983). McGuire, referring specifically to models of attitudes such as those of Fishbein and Ajzen (1975), makes the following observation.

> The attribution x evaluation utility-maximizing analysis has superficial plausibility but raises worrisome questions about the costs of forming attitudes and making decisions by this tedious procedure which requires the person to estimate each object's or behavior's conduciveness to each of her/his multiple goals, evaluating each goal, integrating these products by some additive and/or averaging cognitive algebra to arrive at a bottom-line evaluation for a given alternative and then repeating this procedure for each of the other choice options until at last the person can arrive at a choice by determining which of the alternatives has the highest subjective utility or expected value. One wonders if so onerous a procedure is ever used except perhaps by a peculiarly deliberative person in an unusually important yet leisurely choice situation (1986:111).

This critical view is supported empirically by the work of Petty and Cacioppo (1986); Chaiken and Stangor (1987) and Palmerino et al (1984) into the way in which individuals deal with information in situations of persuasive communication (where someone is trying to change an individual's attitude). In some instances individuals do engage in systematic or mindful processing of the available information, but in many situations they use a cue, such as the prestige or attractiveness of the communicator, or a label that allows them to use existing knowledge to deal with the situation with very little processing of the information available.

It is important to point out that the research that gave us humans as systematic information processors was conducted almost exclusively in laboratories, was not about real-world decisions, issues, or objects (Forgas 1981a), and rarely considered the relevance of the material being studied for the experimental subjects (Moscovici 1981). When research has moved beyond these constrained boundaries the evidence reveals a very different model of humans as cognitive misers (Taylor 1981), and the term heuristics, which refers to the use of various shortcuts in thinking and decision making, is now a common one in psychology. It seems that

Case Studies and Specific Examples 2.1
Mindfulness/Mindlessness

A central argument in the work of Ellen Langer on mindfulness and mindlessness is that people can and often do engage in complex social behavior with minimal processing of the available information. She further believes that many social scientists erroneously assume that other people are thinking in the same way as themselves, and she has presented a large body of evidence showing that even when people are engaged in behaviors which should involve detailed information processing, they are not always engaged in such processing. For example, in one study Langer and Abelson (1974) presented two groups of clinical psychologists with a film of an interview between two people. One group was told that the situation was a job interview and the other was told that it was a psychiatric assessment. Thus for one group the target individual whom they were asked to assess was presented as a job applicant, while for the other the target individual was presented as a potential psychiatric patient. If the model of humans as systematic information processors was accurate then there should have been no differences between the two groups of clinical psychologists in their assessments of the target individual. Yet Langer and Abelson (1974) found that the group that was given a definition of the situation as a psychiatric interview were significantly more likely than the other group to describe the target individual's behavior as disturbed and to give negative assessments of the target individual. In other words, their thinking was significantly influenced by the definition of the situation that was given to them. Our thinking is very much influenced and constrained by the definitions and knowledge that we bring with us to a situation.

Readers are directed to Langer (1989a, b) for further descriptions of this work.

when faced with a problem, people first generate a conclusion, often based on previous experience, and then seek information to support that conclusion (Moscovici 1984; Wason and Johnson-Laird 1972). Several studies conducted by Ellen Langer and her associates (Bandura et al 1984; Langer 1978; Langer and Abelson 1974; Langer and Newman 1979) demonstrate the extensive use of labels and pre-existing categories in decision making and thinking (see Case Studies 2.1). Further, numerous studies in attitude change have shown that a single vivid example is much more likely to influence thinking and attitudes than a substantial but remote body of evidence (McGuire 1985; Sherer and Rogers 1984).

In addition to this empirical evidence that people do not think like computers, there are several authors who point out the improbability that people can generate all the knowledge that they have through systematic information processing and direct experience (Emler and Ohana 1993; Emler 1987; Markova and Wilkie 1987). As Himmelweit

(1990) points out, we often have knowledge about events and issues which are beyond our personal experience. Much of the knowledge that we have comes to us from other people and through paths other than direct experience. It is also not the case that we are constantly presented with problems to solve. Emler (1987) describes analyses of communications between adults and children which reveal that children are usually presented with, or taught, solutions rather than problems. Further, the models which portray individuals as computers and processors assume that "there are optimal solutions to such problems, solutions that are optimally logical or objective, rational or correct" (Emler 1987:373). Emler asks whether there are single, optimal, objective answers to questions of social justice, economic theories and many other topics and issues about which there are debates and conflict. Emler's conclusion is that "we cannot assume that individual's preference for one interpretation over another is driven by considerations of logic or objectivity alone" (Emler 1987:379).

Moscovici (1972, 1981, 1984, 1987, 1988) argues that this erroneous view of ordinary thinking as information processing is the result of scientists assuming that all people are like themselves or, as noted previously, stems from giving pre-eminence to the reality of the researcher. This is the second problem that tourism researchers have inherited with their use of concepts based on information-processing models. Behaviorists explicitly refused to consider any reality other than that of the laboratory as organized and controlled by the researcher. The pressure to be seen as serious scientists means that it is "a dangerous heresy to pretend that what is real and worthy of study is what members of society define as real, since that is what they act upon" (Deutscher 1984a:xvi). This theme of differences between the thinking and reality of researchers and the thinking and reality of people being researched is an important one. It is present in the work of Moscovici (see Key Issues 2.1), in several streams of psychology, for example, the Gestaltists (Farr and Moscovici 1984), and in anthropology and sociology where researchers recognize explicitly the importance of determining what is real, important, and meaningful to the people they study (Markova and Wilkie 1987).

Lewis (1990), in a critical discussion of exchange theories, notes that these theories assume that individuals are motivated by self-interest, an assumption for which there is little evidence, and that self-interest is defined by the researchers who cannot presume to know what is important to the individual being studied without, at least, asking them. He concludes that "self-interest assumptions imply a kind of cynicism, which diminishes people, stripping them of moral judgements, religious and other beliefs and values" (Lewis 1990:203). In the second half of this quote Lewis reflects the earlier arguments of Emler (1987) and Markova and Wilkie (1987), that much of our knowledge is socially

derived and that much of our thinking is influenced by various social factors that exist outside the individual (Harré 1981). This is of course a central proposition of sociology (Berger and Luckmann 1967; Deutscher 1984b; Landis 1986) and much psychology (Bruner 1960; Harré and Secord 1972; Parker 1987).

There is a third problem with viewing humans as information processors. Such models attempt to understand the thinking of the individual in a vacuum, without any context or history. In studying individuals as separate, isolated units these models do not recognize

Key Issues 2.1
The Consensual and the Reified Universes

Moscovici (1981, 1987) has described two fundamentally different approaches to thinking and knowledge; a scientific approach which reigns supreme in the reified universe and an approach known variously as common sense, everyday knowledge, or popular thought, which exists in the consensual universe. The consensual universe "speaks with a human voice, is part and parcel of our lives" and sees itself as a group of individuals each of whom "is free to behave as an 'amateur' and 'curious observer'"(Moscovici 1981:186). The reified universe is a very different one in which individuals can only participate if qualified and "there is a proper behaviour for each circumstance; a proper style for making statements for each occasion, and of course, information suitable to given contexts" (Moscovici 1981: 187).

Unfortunately, many scientists fail to appreciate this difference in thinking (Farr 1993b; Roiser 1987; Wolpert 1992). Wandersman and Hallman (1993) describe vividly what happens when scientists and public officials fail to recognize the very real division between their reality and that of non-scientists.

> We have attended public meetings in towns facing environmental threats. Often a local official will rise to the podium and explain, "Look, if you people would just listen to the facts, you would understand that there is nothing to worry about." Not surprisingly, this incantation holds little magic. Yet, some public officials continue to be astonished by the "irrationality" of their constituencies (p. 681).

This theme of the public as irrational is a common but misleading feature of scientific attempts to influence public action (Wandersman and Hallman 1993; Roiser 1987). Farr (1993b) argues that the beliefs of the public are usually internally logical and consistent with the assumptions they have made. An example of this can be found in Farr's (1993b) discussion of the issue of adding fluoride to water supplies to improve community dental health. He refers to research into common-sense approaches to understanding illness which revealed a strong theme of illness as the result of the toxic products of modern life and notes that many American communities voted against the addition of fluoride to water supplies despite the support of medical scientists. If people believe that illness is often the result of toxic elements and that fluoride can be harmful in high concentrations [a scientific fact which "often emerged in public meetings when scientists were cross-questioned by the public" (p. 200)], then it is reasonable not to want to add something so "hazardous to health to something so 'pure' and 'natural' as water" (p. 200).

the power of such factors as the mass media, cultural norms, and group influences. Such reductionist approaches cannot recognize the importance of conflict and power in social lives (Billig 1993; Moscovici 1987).

Conflict and power, it can be argued, should be of particular significance to researchers investigating the tourism–community relationship. Prentice (1993) notes that most researchers in this area believe in community involvement in tourism planning and have as one of their study objectives the desire to improve tourism policy and planning. To date, the concepts that they have chosen to assist them in this task are inappropriate. Concepts such as social exchange are not consistent with a large and growing body of empirical evidence about the way people think; such approaches fail to recognize the reality of the people being studied and promote methods which focus on individuals as isolated units. Importantly, social exchange concepts assume that each individual has an equal influence on policy and planning; an inappropriate assumption. To understand the complex, often conflict-ridden and social nature of a community's response to tourism, a different approach or theory is needed. As Cohen argued in 1979, what is needed is a theory which is emic, contextual, processual, and longitudinal.

What are Social Representations?

Moscovici (1984, 1985, 1988) presents social representations both as a theory for explaining various aspects of social life and as phenomena that can be studied in their own right. The definition of social representations most commonly referred to is one given by Moscovici in 1973. In his foreword to a study of social representations of health and illness he defines them as

> cognitive systems with a logic and language of their own and a pattern of implication, relevant to both values and concepts, and with a characteristic kind of discourse. They do not represent simply "opinions about", "images of" or "attitudes towards", but "theories" or "branches of knowledge" in their own right, for the discovery and organization of reality (1973:xiii).

He goes on to argue that these systems, which include values, ideas, and practices, have two key functions.

> First, to establish an order which will enable individuals to orientate themselves in their material and social world and to master it; and secondly to enable communication to take place among the members of a community by providing them with a code for social exchange and a code for naming and classifying unambiguously the various aspects of their world and their individual and group history (1973:xiii).

These two quotes provide some insight into the key features of social representations and how they function. They are theories or branches of knowledge and they are systems for understanding and communicating about social reality. Social representations theory is concerned with describing and understanding how and what people think in their ongoing everyday experiences and how a wider social reality influences these thoughts (Billig 1993; Moscovici 1981). They can be seen as meta-systems which include values, beliefs and common-sense explanations of how the world operates (Doise 1993; Farr 1993a). Social representations can also be seen as incorporating the stock of common knowledge (Augoustinos and Innes 1990; Flick 1992; Kruse and Schwarz 1992). Our social world and our everyday knowledge are defined, organized and understood through social representations (Halfacree 1993).

Several authors propose that social representations are particularly valuable for explaining social conflict or reactions to salient issues (Billig 1993; Carugati 1990; Emler 1987). There are two reasons given for this proposal. The first is that conflict brings social representations out into the open. If we argue that social representations define the world then

Case Studies and Specific Examples 2.2
Social Representations of AIDS

While medical science puzzled over the "new disease" the public responded to AIDS immediately by applying available social representations that have existed in western culture for centuries. AIDS was identified as a sexually transmitted disease, so it was the existing social representations of sex, pollution, immorality, the punishment of sinners, and of public danger by outcasts that were immediately applied. ... AIDS was publicly labelled a "gay plague"

(Markova 1992:180).

Markova and Wilkie (1987) present a detailed analysis of social reactions to, and understanding of, AIDS using social representations. In the above quote they demonstrate how the unfamiliar, and threatening, is described and classified using existing social knowledge and beliefs. The resulting social representation presents this new disease as widespread ("now two die each day"), as highly contagious ("catching AIDS at the barber") and as a disease confined to homosexuals and deviants ("spread of AIDS blamed on degenerate conduct"). Markova and Wilkie point out the power of this social representation in influencing people's behavior. In particular, the social stigma suffered by AIDS patients, including those who did not contract the virus through homosexual behavior, and the failure of public education campaigns to encourage safe sex practices, are seen as important consequences of this social representation. The authors also note the influence of the mass media in constructing and communicating these social representations. The quotes given earlier in parentheses are newspaper headlines (Markova and Wilkie 1987:393).

when we communicate with people sharing the same social representation of a topic we can assume a great deal of shared understanding and thus very little of the representation needs to be presented in public. When we find ourselves in an argument then we are more likely to use our social representations to support our judgments and thus they emerge clearly (Billig 1993). In turn, the now explicit representations can be used to explain why the parties in conflict are unable to agree even over simple facts, since the evidence is being interpreted differently by different theories or branches of everyday knowledge. The second reason why social representations can be seen as especially useful in the study of social conflict is related to the proposition that a core function of social representations is to make the unfamiliar familiar (Moscovici 1981, 1984, 1988). Many contemporary social conflicts present people with the problem of dealing with something new or unfamiliar.

The need to understand the unfamiliar is presented by Moscovici (1981, 1984, 1987, 1988) as the major force driving the development and use of social representations. This drive to understand the unfamiliar and make sense of the world around us is seen by many psychologists as a powerful one (Berlyne 1967; Jahoda 1988; Mugny and Carugati 1989; Piaget 1928). Moscovici (1984, 1988) proposes the existence of two processes central to the construction and operation of social representations and central to the familiarization of novel topics, issues or events. These are referred to as anchoring and objectification.

These two processes, anchoring and objectification, are directly related to the naming, classifying and defining functions of social representations. Moscovici (1981) defines anchoring as process which allows us to take a new and unfamiliar object and, by comparing it to what we know already, classify it, name it, and put it in a category. It is a process of fitting new elements into existing frameworks (Doise et al 1993) and proceeds through the use of analogies (Mugny and Carugati 1989). Thus mental patients housed in French villages become identified as like half-wits and tramps. These new residents can be placed into this category and named with the existing label "bredins" (Moscovici 1981). This classifying and naming involves comparisons with prototypes of existing categories and so draws upon the existing social and cultural knowledge and experiences possessed by an individual (Augoustinos and Innes 1990; De Paolis 1990). De Paolis (1990) provides a definition of a prototype:

> The prototype is the best exemplar of a category; it is an image which combines the characteristics defining a category in such a way as to maximise its distinctiveness from other categories (pp. 145–146).

Moscovici (1990) suggests that there are two types of prototypes. The first is the most commonly occurring instance of a category, while the second and more powerful is a dominant version. Here Moscovici is argu-

ing that we do not always use the most commonly occurring example of category. For example, if asked to think about theme parks in the USA, Disneyland and Disney World could be seen as dominant exemplars or prototypes, even though there are many more Six Flags theme parks. Moscovici (1984) also notes that in this classification process we often alter or adjust our perception of the unfamiliar object so that it can be fitted into the categories that we already have. Objectification is about taking abstract concepts or ideas and making them ordinary and concrete, and is concerned with building up images of the concept or idea (Moscovici 1981, 1984; Wells 1987). Moscovici (1981) presents this process as having two phases. The first phase involves the matching of a concept to an image. It has been argued that this makes objectification a logical extension of anchoring. The process of comparing something to a prototype can generate an image (Duveen and Lloyd 1990). Thus comparing God to a father (Moscovici 1981) is an act of both anchoring (classifying and naming) and objectification in that the mind now has "a visible person" (Moscovici 1981:199) or a concrete image. The second and most important phase of objectification is when the image becomes reality or "when the perceived replaces the conceived" (Moscovici 1981:200). As Doise (1993) notes, this process of objectification isolates concepts from their original networks.

Hughes (1987) provides an example of this process of objectification in his description of the reactions of British sailors to the Australian landscape in 1788. In this discussion he quotes from the diaries of Captain John Hunter, who described the area around what is now Sydney as resembling a deer park. Hughes continues:

> The comparison of the harbor landscape with an English park is one of the more common, if startling, descriptive resources of First Fleet diarists. Partly it came from their habit of resorting to familiar European stereotypes to deal with the unfamiliar appearance of things Australian; thus it took at least two decades for colonial water colorists to get the gum trees right, so that they did not look like English oaks or elms (p. 3).

When confronted with a completely unfamiliar world, these Europeans began to describe the landscape by firstly comparing and classifying (anchoring) it to what they already knew, in this instance, an English deer park. This gave them access to an image which then so dominated their perceptions of the physical reality that their drawings and paintings presented Australian gum trees as English oaks or elms. This dominance of an image is objectification.

The power of objectification and its relevance to tourism can be appreciated by analogies between the spread of tourism and its objectification as a disease or plague. Once the term has been used the imagery attaching to this social representation process can interpret and classify many tourist activities and tourism developments as the manifestation of unhealthy forces which are difficult to control.

In the preceding discussion images were given a central role in social representations. Indeed, in many definitions of social representations, images are seen as distinguishing features. Moscovici (1984) refers to a "figurative nucleus, a complex of images that visibly reproduces a complex of ideas" (p. 38) and in 1988 he defines social representations as networks "of concepts and images" (p. 222). Thus social representations can be seen as semiotic systems providing the meaning for symbols and the relationship between a signifier and what is signified (Carugati 1990; Duveen and Lloyd 1993; Molinari and Emiliani 1990; Moscovici 1990). Images are commonly used in everyday conversation and the mass media (Himmelweit 1990; Molinari and Emiliani 1990) and it is important to recognize that the use of images to give access to abstract concepts involves necessarily a simplification of the concept and a reduction of information (Moscovici 1990).

Social Versus Collective Representations

The choice of the word social by Moscovici is an important one and the reasons for, and implications of, this choice are worthy of attention. Moscovici (1981) has drawn upon the work of Durkheim in developing his theory of social representations. Durkheim proposed two levels of analysis for the study of social life and experience, the person and society. This dichotomy was important in establishing sociology as a different discipline from psychology. According to Durkheim, psychology was the study of individuals and their representations and sociology was the study of society and collective representations. For Durkheim these collective representations were entities such as myths and religion. They were powerful forces which persisted and influenced all individuals within a society. These collective representations assume a homogeneous society and do not allow for any study of their origins or how they change (Moscovici 1981, 1988). The emphasis on collective representations also assumes that individuals are passive receivers of socialization and that individual behavior is culturally determined (Emler 1987). These assumptions are not supported by either intuition or experience (Moscovici 1981). Thus while Moscovici agrees with Durkheim that there is more to understanding social experience than can be learnt from the exclusive study of isolated individuals, he proposes a new concept of social representations which recognizes plurality and diversity in society and which gives individuals a much more active role in the construction and experience of their social reality (Doise 1993; Emler 1987).

McGuire (1986) proposes six ways in which the term social can be used. It can be used when referring to social objects or content; it can be used to describe things which people share; it can refer to the results

of interaction between people; it can be something which can be communicated between people; it can describe something which maintains social systems; and it can be used for phenomena which can exist outside individuals. Social representations are social in all of these ways. It is obvious from all our discussions to this point that social representations deal with social content or social objects. It must be stressed that the content of social representations is important. Individual information-processing models assume that the process of acquiring, and the structure of, information is the same across all types of content. Social representations theory makes no such assumptions and has as a core research imperative the study of the content of a particular social representation (Emler and Ohana 1993; Emler 1987; Moscovici 1988).

Moscovici's representations are also social in that they are produced through social interaction. It is through conversation and participation in social activity that individuals develop, contribute to, and change social representations (Emler and Ohana 1993; Moscovici 1981, 1984, 1988). As previously noted, the use of images to represent concepts necessarily involves a simplification and reduction of information. Emler and Ohana (1993) extended this argument and proposed that the process of communication in general requires simplification of information. They note, however, that the process of communication can also place demands on individuals to justify their decisions or beliefs and so can result in the elaboration of social representations.

Once created, however, social representations have an existence independent of individuals, the sixth criterion for "social" listed by McGuire (Augoustinos and Innes 1990). It is this independent or social existence that allows them to be shared by people and communicated. Once created, social representations become part of the culture that is presented to individuals through socialization and interaction (Emler 1987; Emler and Ohana 1993; Moscovici 1981, 1984, 1988). This independent existence of social representations can be seen most clearly in the images and information presented in the mass media (Himmelweit 1990; Kruse and Schwarz 1992; Moscovici 1981, 1988).

The final way in which social representations are social lies in their role as important contributors to both group and individual social identity (Moscovici 1981). Duveen and Lloyd (1993) emphasize the function that social representations have in establishing social order (see Case study 2.2 for an example of this process) and stress that social representations can be regarded as important properties of groups.

> Indeed, what makes a group is the existence of a shared set of beliefs among its members, beliefs which will be expressed in the practices of the group, whether these are linguistic practices, preferences, activities (Duveen and Lloyd 1993:91).

Several authors suggest that an individual's social identity may be substantially defined by the social representations that they hold. This argument has two components. The first is that an individual's social identity is strongly influenced by the groups that they join, while the second is that joining a group usually involves adoption of the group's social representations, and thus social identity is closely connected to social representations (Breakwell 1993; Lloyd and Duveen 1993; Hewstone et al 1982; Dougherty et al 1992).

Moscovici (1972, 1981) recognizes that there are varying levels of cohesiveness in groups and therefore proposes varying levels of group consensus with regard to social representations. In 1988 Moscovici proposed three types of social representations which vary according to the nature of the group involved. The first is labeled hegemonic, and is seen as most like Durkheim's collective representations. They are defined as uniform, coercive, and stable, and apply to homogeneous groups. The second type of social representations is called emancipated, defined as an "outgrowth of the circulation of knowledge and ideas belonging to subgroups that are in more or less close contact" (Moscovici 1988:221). The third type is referred to as polemical, and arises in the context of group or social conflict.

Moscovici (1992) also proposes three ways in which social representations can be created and communicated: diffusion, propagation, and propaganda. Diffusion is concerned with creating common knowledge with little group differentiation and can be seen in operation in "the daily exchange of conversation, rumour, a television programme or a newspaper article" (Moscovici 1992:6). It seems reasonable to propose a connection between diffusion and emancipated representations, and between hegemonic representations and propagation. Propagation is communication within a relatively cohesive and homogeneous group and involves the accommodation of new information into existing social representations. Finally, propaganda can be described as "a form of communication that is embedded in conflicting social relations" (Doise 1993: 159), and this is clearly the form of communication for polemical social representations. Additionally, it has also been argued that social representations will vary according to the level of involvement that a group has with a topic, event or object. When the topic, event or object is beyond the direct experience of the group or is of little relevance to the group, the group is most likely to borrow a social representation from elsewhere (Dougherty et al 1992; Echabe et al 1992; Markova and Wilkie 1987).

Taking the preceding two points, that social and group identity are substantially defined by social representations and that the nature, origin, and communication of social representations vary for different types of group, then a number of forces for both stability and change in

social representations can be seen, and their role in social conflict and change can be investigated (Breakwell 1993).

Thus it could be proposed that when social representations are borrowed and the group has little direct experience of the topic these social representations will be highly resistant to change (Dougherty et al 1992). Direct experience with a phenomenon may provide a force for change. The word "may" is used here because Moscovici and other authors note several features of social representations and social interaction that can work against change in the face of direct experience. One important feature of social interaction that must be recognized is that individuals differ according to the influence that they have over other group members (Himmelweit 1990; Moscovici 1981). If it is argued that direct experience is most likely to occur in individuals who report their experiences to the group, then the extent to which a social representation is changed or modified will depend on the power and influence of the various individuals.

A further force for stability in social representations is their prescriptive power (Moscovici 1981; Wells 1987). Social representations are prescriptive in two main ways. The first is their capacity to prescribe actions. That is, social representations can tell us how to act in certain situations (Campbell and Muncer 1987; Hewstone et al 1982). Social representations are, however, more than prescriptions on how to act. More important is their power over our perception. Social representations define reality and so greatly influence the way that we perceive and interpret the actions of others. Our direct experiences are very much shaped by the social representations that we hold (Emler and Ohana 1993; Farr 1987; Moscovici 1981).

Echabe and Rovira (1989) have demonstrated the power of social representations to influence our perceptions and definitions. These researchers asked 365 people questions about AIDS, including the causes of the disease, who was most likely to be affected, and its modes of transmission. A cluster analysis of the responses indicated the existence of two social representations of AIDS which were labeled conservative: blaming and liberal. All the interviewees were given a brochure and a presentation on AIDS, and two weeks later were given recall and recognition tests on this information. The results clearly indicated that people were more likely to remember information consistent with their social representation and to distort contradictory information.

Another factor to consider in this discussion of stability and change in social representations is that individuals are virtually always members of several groups (Breakwell 1993; Hewstone et al 1982) and thus may be presented with several social representations for any given topic, some of which may be mutually contradictory (Mugny and Carugati 1989).

This interplay of different groups offers both a path for the transmission of social representations and an opportunity for change.

Change in social representations can also be directly linked to social conflict and power. Moscovici (1972) suggests that conflict is often the result of groups holding different social representations. In this situation the groups have no common framework or understanding, and resistance to change, the development of polemical representations, and polarization can be expected. That is, the groups will become more extreme in their views (see Galam and Moscovici 1991 for a more detailed discussion of these processes). In this situation of group conflict it is important to understand the differences in the power of certain

Case Studies and Specific Examples 2.3
Intergroup Alliances and Political Protest

In 1978 the Belgian government decided to double annual university enrolment fees. In response to this decision, several student organizations with close connections to the political left created both a national committee and committees at each university with the aim of generating protest actions against the government. Di Giacomo (1980) studied the development of this protest at the Catholic University of Louvain. Initial surveys indicated high levels of knowledge about the issues, and support for the goals of the protest movement, yet the committee failed to get the students to act. Di Giacomo asked the question, "why wasn't the committee able to incite the student population to action on issues with which it agreed and for which it said it was ready to act?" (1980:336). He sought the answers in the social identities of the students and their social representations of the committee. He investigated these social representations by presenting a sample of students with the words **committee**, **extreme left** (the political position taken by the committee), **strike** (an action proposed by the committee), **workers** (a word used by the committee in appealing for solidarity), **students**, **executives** (in opposition to workers and a likely future label for students), **power** (a key issue), **extreme right** (in opposition to extreme left) and **AGL** (the mainstream political body which eventually took over the protest movement and chose negotiation rather than direct action) and asking them to give all the adjectives that they associated with the target word. This allowed Di Giacomo to construct a dictionary for each word and, through cluster and multidimensional scaling analyses, to investigate the relationships between the words. The results indicated that the students were seen as most like executives, as non-political (distant from both the extreme left and the extreme right), not like workers and not like the committee. Di Giacomo (1980) concluded that the students had a social representation of the committee and politics as being quite different from them, and although they agreed on the issues the students did not follow the committee into political protest as the proposed actions were not consistent with their self-identity. The standard attitude or opinion survey alone could not explain the actions, or lack thereof, of the students. Social representations and group identity proved to be more useful in this instance.

groups to influence both decision making and the media. Moscovici (1972) suggests that groups initiating change will often use persuasive communications to present and support their social representation.

Connecting Individuals to Their Social Worlds

In the previous section it was proposed that individuals can influence groups and social representations, although a number of forces for the reverse influence were noted. It is important to stress again that while social representations can and do influence individual thinking they are not completely deterministic. Individuals have a role in the construction and development of social representations and can choose between alternative social representations. Emler and Ohana present this most eloquently when they state that,

> each of us is confronted with the imperfect, though far from arbitrary solutions embodied in our culture—but we are not the blind prisoners of these solutions. We will argue about their merits and disadvantages as every previous generation has done, and so contribute to the process that created them (1993:77).

This interaction between individuals and their social or cultural world is central to social representations theory, and arguably it is this feature that gives this theory its greatest advantage over both the individualistic concepts and models that dominate Anglo-American psychology and the strongly deterministic nature of some sociological traditions (Billig 1993; Dann 1992; Di Giacomo 1980; Farr 1987; Forgas 1981b; von Cranach 1992).

This interaction between individuals and social groups is worth exploring in more detail. Both Dann (1992) and von Cranach (1992) provide models that describe the interconnections between individuals, groups and social representations. Each model takes a different level of analysis and so it is valuable to present and describe both. Von Cranach's (1992) model is given in Figure 2.1 and places the individual, represented by the smaller shaded circle, within the broader circle of a group. Individuals have their own individual social representations (ISR) which are embedded within the social representation of the group. Von Cranach (1992) also placed the actions of the individual within the actions of the group, and through communication the individual and the group exert mutual influence on both social representations and actions. On the right side of the model the group exerts an influence on the individual through socialization and social control, while on the left social change provides a mechanism for individuals to exert an influence on the group. This possibility highlights the point that social representations are not totally deterministic. Von Cranach (1992) further argues that there is a

hierarchical structure linking groups together. Therefore, the model in Figure 2.1 might be envisaged as contained within the circle of another larger group and so on.

Dann (1992) presents a model which focuses more specifically than von Cranach (1992) on the processes of influence between individuals and groups. In terms of Figure 2.1, Dann provides a more detailed investigation of the links drawn between the individual and the group. Dann uses the term subjective theory to refer to individual social representations. For the sake of clarity "subjective theories" has been replaced with "individual social representations" in the model presented in Figure 2.2. In this model it can be seen that cultures, subcultures, groups and institutions can exert both direct control over actions, through such mechanisms as rules and regulations, and indirect control, through socialization and the sharing of social representations. These group influences are shown by the solid lines in Figure 2.2. Individual actions can also influence social representations through both a direct path (where groups must deal with the consequences of the actions of its individual members) and an indirect path through changes to individual social representations and personal influence. These individual

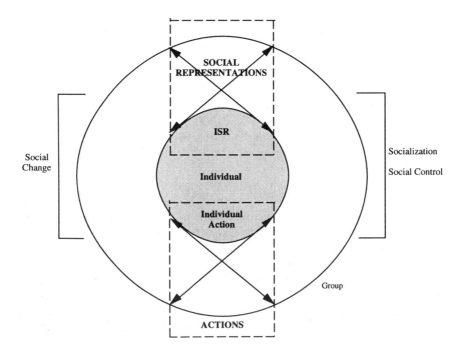

Figure 2.1 An Adaptation of von Cranach's (1992:19) Model Linking Individual and Social Representations and Actions

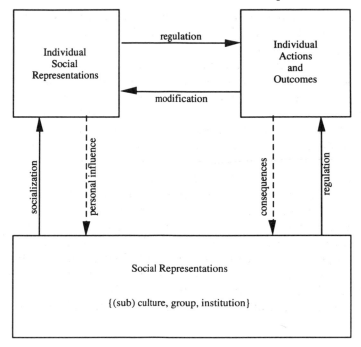

Figure 2.2 An Adaptation of Dann's (1992) Model Linking Individual and Social Representations

influences are depicted by dashed lines in Figure 2.2 to indicate that these influences are more indirect.

Connecting Social Representations to Attitudes Theory and Sociology

It is important to emphasize that these models do not attempt to set out all the key elements of social representations and how they operate. They have been included as a way of demonstrating relationships between individuals and their social groups, especially for readers with little previous experience of psychology or sociology.

In the same vein it is useful to highlight the connections between social representations and other theories or concepts which may be familiar to readers. Specifically, connections will be made to the study of attitudes, symbolic interactionism, and Berger and Luckman's social construction of reality.

The connection between attitudes and social representations has been noted and discussed by many authors (Billig 1993; Farr 1987, 1993a;

Gaskell and Fraser 1990; Moscovici 1963, 1973, 1981, 1988). There are two main themes in these discussions of social representations and attitudes. The first theme notes the similarity between social representations and early definitions of attitudes (i.e., before the rise of behaviorism; Billig 1993; Farr 1987, 1993a; Forgas 1981b; Jaspars and Fraser 1984). Forgas (1981b) points out that early conceptions of attitudes drew very explicit links between attitudes and values and saw attitudes as cultural or social products. Farr (1987) also argues that early attitude theorists saw attitudes as the product of social value or belief systems and that Thurstone's procedures for developing attitude scales, a technique widely referred to today, logically implied the existence of social representations. Specifically, Thurstone developed his items by content analyzing the mass media and used panels of judges to order responses (Farr 1993a). Both Farr (1993a) and Jasper and Fraser (1984) provide historical accounts of the development of attitude theory and measurement and, as with psychology in general, this history is one of moving away from external validity and social levels of explanation towards individual levels of explanation and internal reliability.

This loss of the social or cultural element in attitude theory and measurement has been seen as responsible for the limited explanatory power of current attitude theories. Specifically, current approaches to attitudes do not address the questions of where attitudes come from and how they are interrelated, two important issues in explaining attitudes and actions (Himmelweit 1990; Lewis 1990; Scarbrough 1990). It is these problems that Moscovici (1963, 1973) hopes to address through the development of social representations theory. He proposes that individual attitudes reflect broader social representations. That is, attitudes are a part of social representations (Moscovici 1981, 1988; Duveen and Lloyd 1990; Gaskell and Fraser 1990). However, social representations theory directs the researcher to look for more than a measure of an individual's position on an attitude scale. It directs us to ask how this position relates to positions on other scales, to relationships with values, and to the origin of the knowledge and beliefs on which the attitudes are based (Billig 1993; Moscovici 1988).

Moscovici, in his arguments for social representations, refers to Durkheim as a significant influence, points out the limits of Durkheim's demarcation of academic territory between sociologists and psychologists, and calls for a more sociological social psychology (Moscovici 1981, 1988). Not surprisingly then, it is possible to see many similarities between social representations and sociological approaches to understanding knowledge. Specifically, links with symbolic interactionism (Deutscher 1984b; Farr 1993a, 1987; Forgas 1981b) and Berger and Luckman's (1967) treatise on the sociology of everyday knowledge have been made (Augoustinos and Innes 1990; Carugati 1990; D'Alessio 1990;

Farr 1987; Flick 1992). Both of these sociological theories emphasize the importance of social interaction and socialization in the development of an individual's identity and in providing the individual with the social or cultural knowledge necessary to function in everyday settings and to communicate and interact with others (Landis 1986). These ideas are consistent with social representations theory. The core difference is that social representations give greater power to individuals both to influence their own socialization and to create and change social representations. Social representations theory also incorporates psychological research which examines how individuals deal with information (Moscovici 1972). Berger and Luckmann recognize the importance of these psychological factors in explaining everyday knowledge. They point to the importance of developing

> what might be called a sociological psychology, that is a psychology that derives its fundamental perspectives from a sociological understanding of the human condition (1967:186).

Social Representations and Science

One final aspect of social representations which must be discussed is the role of science in providing some of the content or information that is incorporated into social representations. Although Moscovici emphasizes that thinking is a very different phenomenon for scientists (in Moscovici's reified universe) than for people in everyday situations (Moscovici's consensual universe), he does not propose that these two worlds never connect. Instead he argues that in contemporary western societies science often provides content for social representations (Moscovici 1981, 1987, 1988). One of Moscovici's earliest discussions of social representations was in a study of how concepts from psychoanalysis were adapted and incorporated into everyday knowledge. He observed that through the processes of anchoring and objectification, concepts such as "neurotic" and "complexes" were incorporated into everyday thinking and conversation (Moscovici 1981, 1984, 1987, 1988). The reader is directed to these references for more details. What is important to note is that scientific concepts and research findings are not directly and/or immediately taken up by the general public. Instead they are selectively attended to, simplified, adapted, and often extended beyond the scientists' original intentions. Case Studies 2.4 provides an example of the process in relation to the results of public opinion polls.

In addition to the influence of science on social representations, several authors have argued that social representations can influence science (Doise 1993; Farr 1987, 1993a; Halfacree 1993; Moscovici 1984). Thus Farr (1993a) argues that Watson's development of behaviorism was very

Case Studies and Specific Examples 2.4
Roiser's (1987) Study of Common Sense, Science and Public Opinion

Roiser's aim was to examine "public opinion as a social representation" (1987:411). He provides both a history of the development of scientific approaches to studying public opinion and an examination of the presentation of public opinion results in the media. While it is this analysis of the media that is of most interest to the present discussion, there is one point which arises from Boiser's historical research that is worthy of mention. Specifically, he notes that early public opinion researchers, including Gallup, explicitly recognized that the presentation of opinion poll results could change public opinion. This concern for the impact of opinion polls has virtually disappeared from current scientific discussions, but is of increasing concern for politicians and political commentators. An important component of this concern is the accuracy of media presentations.

Roiser's analysis of media presentations notes that "frequently difference or changes within the margins of error are reported as meaningful" (1987:425). Thus a reported difference of 4%, well within survey error margins, is presented as "Tories leap into 4% lead" (1987:425). Results are presented without any regard for the statistical complexities on which they are based, but are seen as powerful because they are presented as scientific.

Roiser also provides evidence that opinion polls are often depicted graphically in cartoons. As predicted by social representations theory, these images both simplify the abstract results and use analogies to give them a concrete image. Public opinion polls are thus depicted as roller-coasters and yo-yos rising and falling and are often personified or presented as an individual, for example, as a baby or as Rodin's thinker.

In summary, Roiser's study demonstrates how scientific information is simplified and adapted by the media for presentation to the public. He also argues that this process has important social and political impacts which are usually ignored by the social scientists responsible for generating the results in the first place.

much guided by his representation of what constituted natural science. Farr suggests that "his particular representation of science was an out-of-date version of physics" (1993a:18). Farr and Moscovici (1984) also present a history of social psychology and in this describe how the focus of American social psychology on individuals reflects a more widespread American ideology or social representation of individuals in control of and shaping their own lives.

Social Representations: Some Methodological Comments

Emler and Ohana (1993) provide a cautionary tale of seeking a method which will provide access to a theory. After traveling to France "to learn this new alchemy, to sit at the feet of the masters and acquire powerful new tools with which he could go forth and extract social representa-

tions" (p. 63) and finding no such tools, the first author describes his travels "deeper into Europe" (p. 64). However

> his puzzlement only deepened. Evidently a large number of different methods had been used—rating scales, observation, account gathering, children's drawings, content analysis of published texts, questionnaire semi-structured interviews, unstructured interviews (p. 64).

Our traveling scholar finally realizes the folly of his quest and recognizes that his mistake was "to suppose the only thing that lies between the scholar and the discovery of new truths is the absence of a method" (p. 64). Emler's story provides an important insight into the methodological implications of social representations theory—there is no single method or model which can be used to discover social representations: eclecticism is the order of the day.

Despite this recognition that there are many research techniques which can be used to study social representations (Breakwell and Canter 1993; Farr 1993a), a number of methodological points arises from social representations theory. The first is the need to be emic. Regardless of the method used, the researcher needs to access the reality of the social actor and to use the language of the actor. A logical extension of both taking an emic perspective and taking from the theory directly is the need to study the content and structure of social representations in detail (Breakwell and Canter 1993). Such detail includes understanding connections between social representations (Breakwell 1993; Good 1993), the history and development of social representations (Breakwell and Canter 1993; Breakwell 1993), and the sources of the actor's information (Moscovici 1988).

Additionally, social representation theory directs us to look for commonalities in responses rather than just individual differences (Billig 1993; Dann 1992; Good 1993). Further, when differences are examined, connections to group and individual social identity should be explored. Doise (1993) cautions us that in examining differences between groups we should be careful to ensure that we identify significant social groups and "not just contrasting social categories" (p. 165). Both Breakwell and Canter (1993) and Forgas (1981b) call for the use of multidimensional, multivariate and non-linear analysis techniques in order to deal with the complex nature of social representations.

Understanding social representations may also require an understanding of group interactions and distributions of power (Breakwell 1993). As social representations have an independent existence we can also search for them in the media, in literature, and in other cultural artifacts (Breakwell and Canter 1993). Finally, several authors argue that we need to understand or recognize the social representations that affect researchers (Doise 1993; Emler 1987; Farr 1993b, 1987; Moscovici 1984).

Social Representations: Some Critical Comments and Conclusions

From the previous two sections summarizing the key features and some methodological implications of social representations theory, it can be concluded that social representations theory offers an emic, contextual, process-oriented, and longitudinal approach, which Cohen (1979) proposed was necessary to understand the complex social phenomenon of tourism. Before moving on to the next chapter, which includes an examination of how social representations theory can be used better to understand tourism–community relationships, it is necessary to contemplate the limits of this theory. Moscovici's work has been the subject of much debate, and social psychologists seem to react with either great enthusiasm or equally great antagonism to his social representations theory. Farr (1993a) believes that these debates reflect a clash of different approaches to social science (see Key Issues 2.2). Certainly, the most common criticism, that Moscovici's definitions are vague or too broad, seems to reflect a concern for research style rather than a serious attack on the logic of his argument or the consistency of evidence. In reply to this criticism of vagueness (which can be found

Key Issues 2.2
Styles of Explanation

Galtung (1981) identified four culturally different approaches to social science which he referred to as saxonic (which had two versions, a British and US version), teutonic (German), gallic (French) and nipponic (Japanese). The saxonic (British) social scientist is characterized by a love of documentation, while the saxonic (US) social scientist is impressed by statistics. Neither is seen as "very strong on theory formation" (1981:828). By way of contrast, both the teutonic and gallic scientists are very concerned with theory, although in different ways. The teutonic seek purely deductive theory, while the gallic are more concerned with grand perspectives. Galtung's view of the future provides an illuminating, if depressing, view of social science. He argues that both the teutons and gauls

> will be grasping for perspectives ... that will put some order into the untidy saxonic landscape of stubborn facts, and the saxons will continue to get restless when teutons and gauls speed off into outer space, leaving a thin trail of data behind (p. 849).

Zajonc (1989) suggests that

> while Galtung's characterisation may be questioned for assuming that the style differences are rooted in national and cultural disposition, it is certainly a keen classification of social scientists within any one of those cultures (p. 351).

He goes on to propose that much debate in social science is about style and "no style is all perfect or all wrong" (1989:351).

in Jahoda 1988; McKinlay et al 1993), Moscovici points out that he has been specific and clear enough to generate a considerable body of research, and that "clarity and definition will be an outcome of research instead of being its prerequisite" (1985:91). This latter sentiment is supported by Farr (1987) and Doise (1993). Additionally, Doise (1993), Augoustinos and Innes (1990), Markova and Wilkie (1987), and Farr (1987) argue that this criticism arises from a misunderstanding about levels of analysis. According to this argument, the critics are attempting to reduce social representations to an individual level of analysis, when the point of the theory is to seek a different, more social level of analysis.

A second common criticism is that the theory of social representations is nothing new (see Parker 1987; Jahoda 1988). While it is clear to many authors that social representations is indeed something new, Farr (1987) replies that even if it is not, even if all it does is to make social and cultural dimensions more salient and explicit, then it has provided a major advance over existing theories. Another criticism is that of reflexivity, or the extent to which researchers are themselves constrained by social representations (Jahoda 1988; McKinley and Potter 1987). There are two replies to this criticism. The first and most direct is that it treats social representations as completely deterministic and this is not an accurate description of the theory. A core element of the theory is the power of the individual to construct and change social representations and to choose between them. It is not unreasonable to propose that humans have the capacity to recognize the existence of different interpretations and realities. The second can be phrased in questions to the critics. Is social representations theory the only theory that is subject to this criticism? Is there some other approach that gives researchers freedom from their own existence? The authors think not.

It may be best to close this discussion with the replies of Moscovici to his critics. In 1988 Moscovici suggested that there are two types of theory.

> Some are conceptual frameworks which enable us to discover a new, fruitful aspect of the facts, interpret them and discuss them, which is not a negligible contribution. Other theories are a system of hypotheses that are derived from the facts and can be verified or falsified (1988:239).

Moscovici argues that social representations is currently an example of the first type of theory which can be very useful in science. He notes that in social science we do not have enough facts for coherence to emerge and that the collection of facts without a theory is likely to miss important features. His conclusion is that social representations theory will be refined as more research is conducted. "The essential requirement is to have new ideas which can be outlined and developed" (Moscovici 1972:47).

Social Representations: A Summary

Table 2.1 provides a summary of the key features of social representations theory. In addition to these key features, social representations theory is based upon several assumptions which are also valuable to list. It is important firstly to recognize that social representations theory is opposed to either a completely individual or constructivist approach or a completely interactionist or social deterministic approach to understanding social knowledge (de Rosa 1992). Social representations theory explicitly takes an emic perspective and seeks to understand the reality of the social actor. Many authors refer to Thomas's statement, "if men define situations as real, they are real in their consequences" (1928:57). Social representations also assume that in any society there will be many and diverse social realities. Social representations theory is based on a

Table 2.1. Key Features of Social Representations Theory

1. Social representations are complex meta-systems of everyday knowledge and include values, beliefs, attitudes, and explanations.
2. The content and structure of social representations are important.
3. Social representations help to define and organize reality.
4. Social representations allow for communication and interaction.
5. Social representations make the unfamiliar familiar.
6. Through the use of metaphors, analogies and comparisons with prototypes, social representations fit new and abstract concepts/events into existing frameworks.
7. Images are central components of social representations.
8. Abstract concepts are both simplified (through the use of images and analogies) and elaborated (through connections to existing knowledge).
9. Social representations have an independent existence once created and so can be found in social or cultural artefacts.
10. Social representations are critical components of group and individual identity.
11. Social representations are important features of group interaction and so social representations theory explicitly recognizes social conflict and the importance of power in social dynamics.
12. Social representations are prescriptive. They can direct both action and thought (especially perception).
13. Social representations are not deterministic or static. They vary along many dimensions including the level of consensus about them, their level of detail and how they are communicated. Individuals can and do influence, create and change social representations. They can be changed through individual influence, direct experience, persuasive communication, and/or group interaction.
14. Social representations connect individuals to their social/cultural worlds.
15. Social representations are both influenced by and influence science.

conception of society as organized into groups and subgroups, not as a collection of individual social atoms (de Rosa 1992). The next chapter of this volume will apply this very social approach to understanding community knowledge and experience to the tourism context.

Chapter 3

Social Representations and the Tourism–Community Relationship

Tourism is a highly social business. Tourist behavior itself is often very public behavior which is carried out in the presence of other people. The social nature of tourism is also inherent in the great diversity of actors involved in host–guest relations. There are immigration officers and information officers, travel executives and executive travelers, ship's captains, and shop assistants all interacting with visitors in diverse social roles. Additionally, the industry planners and promoters, as well as government officials, have a detailed socioeconomic interest in tourist behavior and the impacts of tourism. The very social process of communication and promotion is also at the heart of the tourism phenomenon. The budgets of many national and regional tourism associations are largely dedicated to the process of promoting and communicating the attractions of their home areas, usually creating appealing images of the local natural and social environment. The social nature of tourism is also special in that hosts and guests may change roles; visited community members today may be travelers tomorrow and this reciprocity of experience provides individuals with specific, personal, direct information on the social nature of tourism.

As discussed in the previous chapter, a social representations framework is a broad organizing approach which helps to explain how groups of people understand and react to phenomena. Social representations are particularly appropriate when the topic of study involves multiple social perspectives, provides challenges, difficulties and conflicts due to change and features the communication of ideas in the public arena. The study of tourism and host community reactions to it is therefore well suited to the social representations framework.

The social representations framework is an organizing theory. It directs attention to whole systems of benefits, values, attitudes and explanations which individuals and groups hold about tourism. It is a theory which operates specifically on a community level. It places a priority on understanding the emic or participant's point of view on any topic and is tolerant of diverse methods to collect information describing how individuals feel and react. It emphasizes the commonalities in individual and group views on tourism and argues that for social representations to exist one should be able to identify clusters of images which serve as simplifying mechanisms aiding people's understanding of the topic. Social representations serve the purpose of making the novel, the new, and the unfamiliar less strange, and in order to understand how people react to tourism it will be valuable to understand the sources contributing to social representations. Communities in which there is conflict over tourism development can be understood with a social representations framework by identifying the different types and content of the social representations which groups hold.

It will be argued in this chapter that identifying social representations is a prime requirement in applying the approach. Certainly, there may be situations where there is so little consensus on a topic or indeed that a topic is so novel or irrelevant to a community that little evidence of social representations can be found. Additionally, a distinct possibility exists that social representations may not have been identified or are difficult to identify in a particular case, thus weakening the value of the general social representations framework. The topic of identifying social representations of tourism will therefore be the first concern of this chapter. Subsequent discussion will concentrate on how social representations, if present, serve community members in perceiving and reacting to tourism, with an additional section detailing the sources that contribute to the content and formation of these holistic organizing clusters of images, attitudes, and explanations.

In presenting the value of the social representations framework to tourism–community relationships two further steps will be taken in this chapter. First, a consideration of the value of the social representations framework in illuminating tourism–community conflicts will be outlined. It will be argued that competing and polemical social representations linked to key group identity issues provide a systematic way of understanding such conflicts. A second and less controversial but equally potent application of the social representations framework will also be presented. Tourism researchers, it will be argued, also have social representations of tourism conflicts. The social representations framework will be applied to existing tourism impact studies to highlight the power of the approach to generate new insights into what we know and how we think about the tourism–community relationship.

Identifying Social Representations

The quest to identify social representations of tourism has much in common with the tale of the befuddled party-goers who lose their car keys. It is late at night, the street is dark and our unfortunate colleagues have no torch or moonlight to guide their endeavours. A passing pedestrian is puzzled by their behavior; our party-goers are seen diligently inspecting the ground quite distant from their vehicle, where the one streetlight is illuminating a small section of footpath. For a successful outcome our party-goers would do better to re-examine the logic of their behavior and search in a wider context, as success will not be achieved by ever more subtle methods of searching in the same limited but illuminated area.

In this attempt to identify social representations of tourism there is also a need to search in different ways, to seek consensus and commonality in community response where others have attempted principally to find group differences. Additionally, there is a need to be wary of the fallacy that more sophisticated multivariate testing procedures—ever brighter lights—focused on the problem area will adequately guide this search.

The groundwork for this search is provided by the emic approach, the view that researchers should consistently take the actor's point of view in trying to understand how they think, feel and speak about tourism phenomena. The emic approach usefully explores the range of attitudes and breadth of the residents' opinions but perhaps more importantly directs attention to the relevance and importance of certain impacts in constructing the total attitude to tourism. Additionally, the conceived relationship between perceived tourism impacts and a community's overall attitude to tourism also bears re-examination. It has been a common assumption that the overall attitude to tourism is created from perceptions of its various impacts. This is a fundamental assumption in all research based on Doxey's Irridex and Butler's destination life cycle model. Some researchers have carried this to the point of actually summing perceptions of impacts to create a score to indicate a total attitude towards tourism. This logic could, however, be reversed. Perhaps it is the overall image of tourism and tourists and associated beliefs which structure the way that impacts are perceived and felt. This important issue will be explored further in subsequent sections of this chapter and monograph.

In addition to the lack of evidence to support the common assumption that an individual's overall attitudes to tourism are the result of their perceptions of various tourism impacts, there are some serious methodological flaws in the practice of summarizing perceptions of tourism by creating a single mean score from a series of impact rating scales (Belisle and Hoy 1980; Caneday and Zeiger 1991; King et al 1993; Pizam 1978

provide examples of this approach). Specifically, such an approach assumes that all impacts are of equal importance or relevance to the respondents. This assumption has rarely been subjected to empirical investigation and it seems likely that residents give differing weights to impacts. It is also likely that these weightings are not uniform across community members. Additionally, the reduction of many items into a single score often disguises important and meaningful patterns in the data. For example, a study may ask residents to rate various impacts of tourism on a scale ranging from –5, indicating a strong negative effect from tourism, to +5, indicating a strong positive effect. The study reports a mean score for its sample of +4 for job creation and –4 for disruption of lifestyle. The summing approach would provide a result of 0 and the assumption that job creation is of equal importance to residents as lifestyle and indicating that the sample is neutral towards tourism. This is clearly misleading. To understand community responses to tourism it is apparent that we must do more than provide a simple algebraic approach to this complex topic.

Three key criteria help to establish and identify social representations. The three criteria are the commonality or consensus which exists among members of a community or subgroup, the connection or network of links between the tourism impacts and related ideas, and the notion that there is a central cluster or core of images serving to portray the social representation. These criteria are helpful aids in identifying social representations, not necessary conditions or definitive benchmarks. They may not all be present at once and they may co-exist with other defining elements, such as evidence describing the communication of representations, but they do serve as tangible landmarks in exploring the terrain described in a social representation framework.

The first enabling criterion, that of shared commonality or consensus, suggests that within a group or community subgroup there is a uniformity in the way that people react to tourism impacts. Characteristically, researchers have focused on what kinds of individual differences exist in the perceived impacts of tourism. The social representations framework argues that the similarity of group responses should be searched for. In particular, the search for similarities can provide a basis for consensus appraisal and community problem solving in tourism-related conflicts. Clearly, in a large community survey of residents' opinions one would not expect total uniformity of responses. There may well be several social representations of tourism co-existing in the study location. What should be looked for, however, are not differences on such variables as age or length of residence on single impact items but rather a number of response patterns which are similar across the full range of items. If these response patterns can be identified and clearly differentiated, it is then of interest to ask what the psychodemographic

profiles are of the groups providing these response patterns. In schematic terms, if all community responses to an extensive participant derived list of tourism impact items were uniformly bimodal, two social representations of tourism would be a likely explanation and it would be of interest to identify the individual characteristics that described each pattern of responding.

Davis et al (1988) followed this logic of seeking patterns in the responses to items measuring attitudes towards tourism. The authors cluster analyzed the responses of 415 Florida residents to 31 questions rating various attitudes towards the tourist industry in Florida. The analysis revealed five clusters or patterns of responses which were labeled Haters, Cautious Romantics, In-Betweeners, Love 'Em for a Reason, and Lovers. Table 3.1 summarizes the patterns of attitude responses for each cluster. The study also examined differences between the clusters in terms of gender, age, length of time living in Florida, education, occupation, whether any family members worked in the tourism industry, whether respondents were born in Florida, and respondent knowledge of tourism in Florida. Statistically significant differences between the clusters were only found for the latter two variables and results for these are also presented in Table 3.1. The Davis et al study provides some evidence that community subgroups share holistic ways of thinking about tourism.

In an extension of this work, Madrigal (1995) initially identified three patterns of responses to tourism impact statements in samples drawn from York (UK) and Sedona (USA). He then examined the differences between these clusters of respondents in terms of their attitudes towards the role of local government in developing and regulating tourism. Table 3.2 contains a summary of Madrigal's results. These results bear strong similarities to those of Davis et al (1988). What is of particular interest about Madrigal's study is that he based his approach to understanding resident perceptions to tourism on an earlier sociological account of conflict and power (Molotch 1976) in which communities are seen as comprised of a number of groups "each competing with the others to maximize their particular vision of land-use potential" (Madrigal 1995:87). These groups may vary according to cohesiveness and whether or not they are formal entities. In this vision of communities,

> An individual's identification with a particular group's view usually occurs in reaction to policy and land-use decisions made by local officials; ... residents are forced to take some kind of a position on development. Residents who share perceptions may be considered part of the same nested community, whereas residents with competing views of development belong to different nested communities (Madrigal 1995:87–88).

This view of conflict and groups is entirely consistent with a social representations approach.

Table 3.1 Key Features of Tourism Attitude Clusters Amongst Florida Residents

Cluster	Key Attitudes to Tourism	High Knowledge (%)	Born in Florida (%)
Haters (16%)	Extremely negative. Very low support for further tourism development. High agreement with negative impact statements.	12	40
Cautious Romantics (21%)	Somewhat negative. Recognize benefits. Low support for further tourism development.	20	21
In-Betweeners (18%)	Middle-of-road. Recognize benefits. Moderate support for further tourism development.	30	22
Love 'Em for a Reason (26%)	Positive. Support further tourism development. Recognize negative impacts.	31	23
Lovers (20%)	Very positive. High support for further tourism development. Low recognition of negative impacts.	34	16

Source: Davis et al (1988).

An examination of some landmark studies in the tourism impacts literature provides further evidence that consensus exists and the argument that there are patterns of linked responses appears to be highly plausible. For example, Murphy (1983), in a discriminant analysis appraisal of tourism attitude among community groups, observed:

> although the groups are in different quadrants and have been statistically separated by the analysis, the graph shows the group centroids are relatively close. Furthermore when all the group members are plotted the peripheral members create considerable overlap. Such proximity and overlap indicate group positions are not inviolable and bodes well for future trade off deliberations (p.12).

On occasion, researchers who have searched for individual differences indirectly provide evidence for a widespread consensus and communality of response to tourism. Allen et al (1993), for example, examined ten rural towns in Colorado which could be classified as high or low in tourism development and high or low in total economic activity. The researchers analyzed their data using a 2×2 analysis of covariance

Table 3.2. Key Features of Tourism Attitude Clusters Amongst York (UK) and Sedona (USA) Residents

Cluster	Key Attitudes to Tourism	Key Attitudes to Local Government
Haters (31%)	Strong disagreement with positive aspects.	Support for greater regulation.
	Strong agreement with negative aspects.	Opposed to development.
Realists (56%)	Agreed with positive aspects. Agreed with negative aspects.	Between the other two groups.
Lovers (13%)	Strong agreement with positive aspects. Strong disagreement with negative aspects.	Most in favour of more development.

Source: Madrigal (1995).

design with length of residence as the covariate, and identified only seven significant results out of a possible 72 tests. Additionally, three of the significant results pertained to just one item—how happy residents were with tourism planning—thus adding further weight to the view that a high degree of consensus existed in the rural Colorado data.

A close examination of these kinds of data frequently reveals the important distinction between effect size and significance. While there may be some significant differences on individual variables, very often the actual size or magnitude of the difference is small, albeit reliably different. For example, in their pioneering and frequently quoted study of winter visitors to the Texas Gulf, Thomason et al (1979) found that there were significant differences on six impact items. When the mean values on the items providing the differences are examined, the actual size of the effects involved is small (less than or equal to 0.5 on a seven-point scale) and the differences are never between positive and negative scale points, instead reflecting subtly different values on the positive or negative pole of the scale.

Even in data sets where considerable individual differences can be shown to exist, the search for consensus remains valuable. Pizam (1978), in his formative study of residents' and entrepreneurs' responses to tourism on Cape Cod, Massachusetts (USA), examined 44 tourism effects. In this highly developed tourism destination there were 29 significant differences distinguishing entrepreneur and resident attitudes. In accord with existing practices in the literature the author concentrates on these differences but the close consensus on the non-significant items also warrants examination. For example, there is commonality by both residents and entrepreneurs on impacts such as traffic conditions, road conditions, availability and accessibility of recreational facilities, noise,

litter, vandalism, cultural identity, and a number of other minor items. Of the 29 significant differences, 27 have the same polarity, that is both groups agreed that the effect was a positive or negative one but there was a difference in the perceived magnitude of the effect. Additionally, only four items generated a difference greater than one on an 11-point scale.

These findings indicate that one social representation of tourism probably summarizes Pizam's data, with his two study groups holding the same kinds of views as to how tourism works, with slightly differing intensities. Evidence for two distinct social representations of tourism would come from data with more significant differences in select item categories and with more contrasting negative and positive scale scores.

The second enabling or identifying criterion in the search for social representations lies in the connection or network of tourism impact items with other beliefs, attitudes, values and explanations. One of the defining attributes of social representations is that they are conceptualized as systems of related attitudes, values, and attributions. In studying tourism impacts and social representations it should therefore be possible to identify linked networks of ideas which form any one single social representation of tourism. Additionally, a more external and global view of the network concept may be presented in which links between the social representation of tourism and other social representations may be demonstrated. The first or internal sense of the network concept is demonstrated in studies focusing on how residents define tourism. For example, Lea, et al (1994) note, with good emic sensitivity, that before residents are asked what they think or feel about tourism it is necessary to know what they mean by tourism and tourists. The researchers argue that technical definitions used in the tourism statistics world such as "generally tourism is taken to include at least a one-night stay away from the place of permanent residence or origin" may have limited meaning and not be a part of the residents' subjective definition (cf. Pearce D. 1989).

Lea et al provided New Zealand university students and residents with eight descriptions of travelers, each of the descriptions varying according to the requirements of a $2 \times 2 \times 2$ design in which the manipulated variables were overnight stay (or not), leisure travel (or business travel), and foreign (Australian versus New Zealand) origin. All three factors had significant main effects. The New Zealand subjects placed most emphasis on the importance of overnight stays and a leisure trip purpose in characterizing the descriptions as "tourists" but the foreign origin also contributed positively and significantly to the tourist label. These findings highlight some differences in the way that residents conceive of tourists—business travelers and local New Zealanders are less likely to be included in the subjective definition—as compared to the broader

government and industry approach to defining a tourist. Further, since the work carried out by Lea et al raises the connection between tourists and tourism, one can suggest that if asked to comment on tourism's effects on their local area the respondents in their study will be influenced disproportionately by the section of the industry catering to the international leisure-oriented holidaymakers.

Similarly, the importance of networks of information and the meaning of tourists and tourism to respondents is illustrated in several studies which were referred to briefly in *chapter 1*. In Cairns, North Queensland (Australia), Ross (1992) reported that there were differences in responses to the term tourist according to the nationality of the visitor. Nor were these differences uniform in the community. For example, younger residents described Japanese visitors as pleasant and considerate people, while residents who had lived in the city during the World War II, when the town was an important link in the Battle of the Coral Sea, were not so positive in their judgments of Japanese tourists but quite positive in their assessment of American tourists. Ross speculated that these attitudes may be explained by a "residue of fear or hostility" towards the Japanese lingering after the conflict and a contrasting pro-American attitude deriving from the solidarity of the two nations in wartime. In the Australian context other researchers have identified the Japanese tourist and Japanese investment in Australian tourism and development projects as provoking a strong set of reactions in some groups (cf. Forsyth and Dwyer 1993; Pigram 1980).

Mok et al (1991), in a survey of Hong Kong residents' perceptions of tourism, reported that some respondents did not want growth in tourists from the People's Republic of China. The authors conclude that such negative attitudes were partly the result of the political situation in Hong Kong at the time of the survey and partly a consequence of a belief that tourists from the People's Republic of China would have less money to spend than other tourists. Liu et al (1987) report evidence of tourist stereotyping in resident surveys conducted in Hawaii, Wales, and Turkey. Their total discussion of this evidence was as follows:

> Stereotyping dimensions appear prominently in factor structures of all three destinations. This indicates that stereotyping might play an important role in resident perception and hence has a place in the planning process. Clearly, there is a need for further research in this area (p. 31).

Unfortunately such research has not been forthcoming.

In addition to residents responding differently to different tourists, there is evidence that residents differentiate between different types and/or aspects of tourism. In 1988, Ritchie surveyed 1,004 residents of Alberta and British Columbia (Canada) and asked respondents to indicate their support for various areas of tourism development. Table 3.3

summarizes the results for these questions and demonstrates considerable variation in resident support.

In another Canadian study Simmons (1994) reports on both a resident survey and a series of focus groups which considered a range of future development options. Three combinations of options were found to be supported: lakeshore development, medium scale, with local ownership; development throughout the county, medium scale, with local ownership; and development throughout the county, at a mix of scales, with local development. It is clear that the specification of the type of tourist or tourism development brings different community reactions, thus confirming the need for researchers to consider carefully how they present tourism to residents and the consequences of residents thinking about tourists and tourism of particular types.

The view that connections and networks of beliefs, attitudes and values provide a valuable focus for exploring tourism impacts and portraying social representations is further demonstrated in the Gulf of Texas study conducted by Thomason et al (1979). This study is distinguished in its methodology by its concerted attempt to maintain the breadth, context and language of the residents in the final questionnaire. The concern to preserve the structure and relatedness of resident concerns does not see the frequently neat but arid division of researcher or etic-derived categories in the research results. Thus, in a figure detailing the results of the study (see Figure 3.1), information is provided on visitor characteristics, visitor beliefs about locals, visitor impacts and visitor needs in a rich network of results. As with other studies discussed in this chapter there are some differences between the three study

Table 3.3 Percentage of Residents Supporting Types of Tourism Development

Type of Development	Percentage of Residents Supporting
Winter/summer festivals	94.5
Historic sites and museums	94.4
Camping and hiking facilities	92.6
Cultural events	92.4
Major events (Olympics/World Fairs)	90.1
Ski areas	89.0
Fishing facilities	88.7
Adventure activities	87.4
Mountain resorts	86.8
Theme parks	75.4
Hunting facilities	48.4
Casinos	34.3

Source: Ritchie (1988).

groups (residents, entrepreneurs, public sector providers) in their ratings of these diverse visitor components but a broad commonality is apparent behind the minor differences.

This early Texas study may be contrasted with a more recent and highly structured attempt to develop a tourism impact attitudes scale. Such an approach is in marked contrast to the network considerations inherent in a social representations approach as it focuses solely on tourism impacts and undertakes the task with the belief that a uniform pan-regional scale can be constructed. Lankford and Howard (1994) diligently pursue the methodologically rigorous work of perfecting and "purifying" their scale items, complete with split-half reliability (not validity as they claim) assessment. At the end of the process they produce a 27-item, two-dimensional scale (labeled the TIAS, Tourism Impact Attitude Scale) to measure resident attitudes towards tourism. This approach deserves comment in the context of the present concern for the interconnected, emically based network of ideas on resident responses. The emphasis on scale construction focuses on reliability rather than validity and the original items are extracted from previous literature rather than any local concern or priority issues. Similar concerns have been expressed by Preglav (1994) and Dann (1984). Dann describes the problem succinctly when he says

> respondents are being asked to react to an *a priori* theoretical framework which has been devised by researchers. Consequently findings are valid only in so far as the *a posteriori* experience of the subjects coincides with the mental constructs of the analyst (1984:295–296).

Further, in the Lankford and Howard (1994) study impacts alone are addressed and there is little concern with the potential interaction between the type of tourism and tourists to be assessed and the kinds of impacts that they generate. In common with a number of other simplistic quantitative approaches, items on the scale are summed to give two tourism impact scores, the summing of items being justified by the finding that they load on an impact factor. Regrettably, similar kinds of items are then used as independent variables in a multiple regression model and the researchers report a successful prediction in their regression equation. The earlier remarks on our befuddled party goers searching for their lost keys are again appropriate. Even if the streetlight is brighter, searching in the wrong place in the wrong way will still not advance the cause. Dann et al (1988) describe this kind of tourism study as high on methodological sophistication and low on theoretical awareness.

A social representational approach also emphasizes the need to understand how various beliefs and attitudes are interconnected. In the case of tourism–community relationships many authors (including Lankford

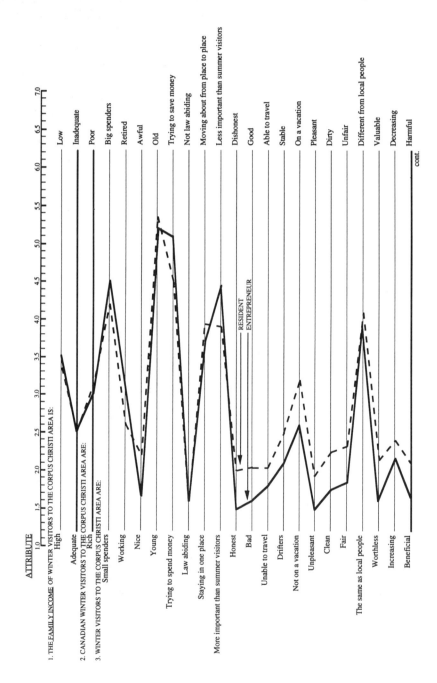

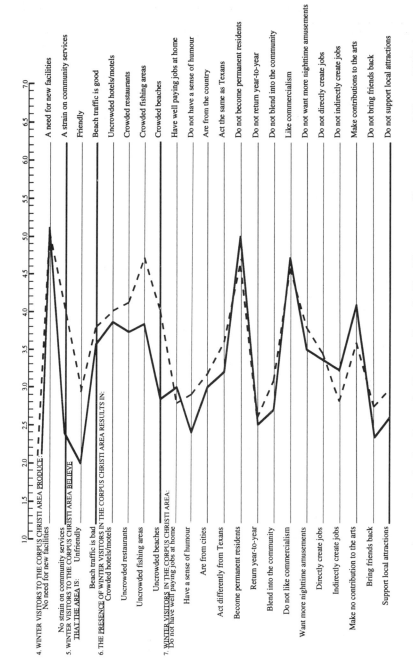

Figure 3.1 The Range of Attitudes Towards Tourists Revealed by Thomason, Crompton, and Kamp 1979:4

Key Issues 3.1
What Residents Really Think About Tourism: In Their Own Words

Few published studies of resident perceptions of tourism have used open-ended questions to elicit perceived impacts. It is valuable to consider some of the published studies that have attempted to get at the core of resident responses to tourism. The following table lists both the benefits and costs of tourism as expressed by respondents in five published studies:

I. Andressen and Murphy (1986) report on two surveys of residents in Canada. In both surveys residents were asked about tourism's present impact in their region.

II. Brown and Nolan (1989) surveyed Western Indian Tribal managers or councils and asked what they perceived would be the benefits of tourism development in their reservations.

III. Glasson (1994) asked residents of Oxford (UK) to list the advantages and disadvantages of tourism in Oxford.

IV. Keogh (1990) surveyed Canadian residents about a specific tourism development and asked for their perceptions of potential positive and negative impacts of the development.

V. Mok et al (1991) studied Hong Kong residents' attitudes towards tourism and asked for their reasons for supporting or opposing an increase in tourists to the city.

Responses to Open-ended Questions about the Benefits and Costs of Tourism

Benefits	Andressen and Murphy	Brown and Nolan	Glasson	Keogh	Mok et al
General economic	67%/95%	69%	56%	—	Yes
Employment	47%/60%	—	14%	39%	Yes
Increased income	—	—	—	26%	Yes
Increased trade	—	—	6%	—	—
Increased social opportunities	28%/6%	—	—	11%	—
Opportunities for cultural exchange	—	19%	9%	2%	Yes
Educational for residents	—	9%	—	—	—
Perpetuates cultural traditions	—	3%	—	—	—
Better facilities and services	26%/27%	—	8%	18%	—
Environmental protection/ maintenance	—	—	4%	20%	—
Improves images of town/region	—	—	1.5%	—	Yes
More activities	—	—	1.5%	—	—
Increased prices	—		3%	6%	—
Increased taxes	—		—	11%	—
Congestion/ overcrowding	32%/27%		59%	8%	Yes

Key Issues 3.1 (Contd)

Benefit/Cost	Andressen and Murphy	Brown and Nolan	Glasson	Keogh	Mok et al
General environmental	11%/11%		—	2%	—
noise	—		12%	9%	—
litter	—		11%	—	—
traffic	—		6%	17%	—
pollution	—		2%	—	—
Change in character of town	—		—	9%	—
General social	13%/54%		—	—	—
crime	—		—	4%	—
bad service	—		—	1%	—
decline in morality	—		—	—	Yes
community disputes	—		—	9%	—
Restrictions of residents' rights	—		—	19%	—

Mok et al listed impacts only, with no data on numbers or percentages of respondents giving the response.

There is one key point worthy of note about the pattern of results presented in the table above, and that is the variety in both impacts listed and the levels of response. General economic benefits are the only consistently common responses. Such a pattern provides support for the argument that residents respond differently to different types of tourism. These differences are not just in terms of the perceived magnitude of impacts but also in terms of what impacts are actually perceived.

Keogh's (1990) Canadian study also provides a comparison of responses to open-ended questions about, and lists of, potential positive and negative impacts of a tourism development. A summary of this comparison is given below and indicates the substantial difference that a prompting from a list can make to respondent perceptions, particularly of negative impacts.

Another influence on responses may derive from whether the study uses a mail questionnaire or an interview approach.

Comparison of Percentage of Respondents Recording Positive and Negative Impacts of Tourism in Open and Closed Questions
(Keogh 1990:454–455)

Impacts	Open Questions	Closed Questions
Increased traffic	17	63
Increased noise	9	37
Price inflation	3	28
Change in character of village	9	24
Congestion of services and stores	6	21
Congestion of beach facilities	2	4
Creation of jobs	39	83
Increased incomes	26	61
Increased opportunities for social encounters	11	26
Increased opportunities for cultural exchanges	2	9

and Howard) have argued that an understanding of perceptions of impact is important for the future planning of tourism. In practice, an approach like that pursued by Lankford and Howard (1994) provides very little information about the attitudes of residents towards specific types or aspects of tourism development or their beliefs about the processes of tourism planning. By way of contrast, Murphy's (1988) work on involving communities in tourism planning indicates the existence of complex networks of beliefs about tourism impacts, specific development proposals, who should be responsible for tourism planning, and management and marketing themes. It is thus appropriate to view the social representations framework and its emphasis on the emic, network-based connection of types of tourism to types of impact not as denying the value of methodologically sophisticated work but as emphasizing the need to place this powerful research in a theoretically meaningful context.

Figure 3.2 Adapted from illustration in Contours Journal Vol. 3, No. 4, Dec. 1987 (Credit: Victoria Francis)

The value of social representations as a concept where networks and connections of values, beliefs, attitudes and explanations are emphasized is apparent when possible links between tourism social representations and other social representations are pursued. In one of the first studies to link tourism concerns to political self-identification, Snepenger and Johnson (1991), researching tourism attitudes in Montana, found a number of consistent relationships. They reported that conservatives sometimes agreed with moderates and at other times moderates agreed with liberals. Conservatives, however, seldom agreed with liberals. The content of these reactions included conservatives being less supportive

**Figure 3.3 A Representation of Tourism Impacts on Hawaiian Residents.
(Source: Lynn 1992:371)**

Case Studies and Specific Examples 3.1
Visual Images of Tourism

The four images of tourism presented on the opposite page were selected from a group of images drawn by students as a practical exercise conducted by one of the authors. The class was comprised of two main groups of students, third-year undergraduates and postgraduate students studying tourism. Both groups included Australian and international students. This exercise was not meant specifically to examine visual or figurative components of social representations of tourism; rather it was part of a series of exercises designed to encourage creative thinking skills. The results, however, were most interesting in terms of the symbolism involved and the degree of similarity in the symbols used. Virtually all of the drawings included substantial numbers of tourists and levels of development (Drawing A provides a typical example here) and a predominance of beach activities and scenes (Drawings A, B, and C include this element). Coconut and/or palm trees were often used as symbols, as were symbols of economic exchange (Drawing D uses both these symbols). High-rise hotel blocks, cruise boats, and aircraft were also dominant features. The inclusion of cruise boats is interesting given the generally low levels of such tourism in the region. Two other features of the drawings are worthy of mention. Drawing B provides us with a visual parallel to the metaphor of "tourists as invaders", with tourists dropping like paratroopers from a helicopter. Drawing C shows us where the tourists are coming from, a rainy place dominated by the office. This home place, however, appears to be much less crowded than the holiday place depicted. The social representations of tourism held by these students appear to involve images of tourism as involving high-density high rises, beach activities with large numbers of group tourists seeking photographs, and sunny beaches.

of tourism development and placing less importance on the value of tourism's cultural exchanges. The liberal and, at times, the moderate position favored more commercial activity and positive cultural exchange, and viewed recreational possibilities and public facilities as benefitting from tourism. Snepenger and Johnson effectively advocate building bridges between the social representations relating to political beliefs and those pertaining to tourism when they observe

> A range of political behaviors and attitudes, beside political self-identi-
> fication, may prove useful in building causal models. For example, voting
> patterns in tourism areas, political activity (i.e. voter registration, active
> participation in political races, party membership) in tourism dependent
> regions, the nature of residency turnover and activity, and political culture
> are all promising areas of research (1991:514).

It is one of the strengths of the social representations framework that it is consistent with and promotes this wider ambit of research concerns in tourism–community studies.

Another indicator of the existence of social representations in the tourism field lies in identifying a central cluster or core of images which communicates or portrays social representations. It was noted in *chapter 2* that Moscovici described social representations as "not simply opinions about, images of or attitudes towards a phenomenon but branches of knowledge in their own right for the discovery and organization of reality" (1973:xiii). While social representations are clearly much more than images, in subsequent writing Moscovici presents social representations as having:

> a figurative nucleus, a complex of images that visibly reproduce a complex of ideas (1984:38).

Since the study of the impact of tourism has not proceeded within a social representations framework it would be premature to look for these figurative nuclei in existing research or resident reaction to tourism. Nevertheless a broader focusing on the work of tourism commentators produces a set of images which conveys some of the power of the social representations approach. It is possible that communities or community subgroups share these clusters of images. In tracing the history of tourism studies, McIntosh (1992) observes that the early 1970s represent a flowering of texts, commentaries, and analyses of tourism. One of the most widely distributed popular commentaries of this period was the book entitled "Tourism; Blessing or Blight" written by George Young and published by the Penguin group (Young 1973). It is notable in the present context because of its front cover, a darkly humorous cartoon outlining a forested, mountain valley with the stick figure characters commenting that "pretty soon, we'll pull all this down and have some decent hotels built". The social representation of tourism as the agent of environmental destruction, an essentially modern force which would improve upon nature, was to be echoed by other writers in the same decade. Turner and Ash (1975) describe tourists as the golden horde, the barbarians of our age of leisure colliding with cultures far removed from their own and swamping apparently less dynamic societies. In the same tradition of portraying tourism with unflattering images, Rosenow and Pulsipher (1978) portray tourism as comparable to human growth. For a time increasing size ensures survival and connotes strength, vitality, and maturity. There is, however, a point at which size becomes unhealthy, and the result is a dysfunctional organism.

Other powerful evocative images of tourism abound in the category of tourism literature which Jafari (1990) has referred to as the cautionary platform. This material includes such expressions as tourism is a paved paradise, covering up a rotten core of vice, drugs, and crime; a ruined Garden of Eden where the forbidden fruit of ready promiscuity masks destructive exploitative host–guest relations; and tourism as

"whorism", a system where the locals are prostituting themselves and their culture to wealthy yet inadequate strangers (Kent 1975; Turner and Ash 1975). It is not of course established by these authors that the host communities conceptualize tourism and tourists with these images, beliefs and linked ideas. The social representations approach would benefit from a wave of creative studies outlining how tourism is imaged in different locations and by different community groups.

Making the Unfamiliar Familiar

Cohen (1979) suggested that new theoretical approaches in tourism studies should be emic, contextual, processual, and longitudinal. The emic qualities of social representations theory have already been amply portrayed while the need for tourism studies to consider contextual issues were also revealed as a part of the social representations framework when examining the network of ideas within and between peoples' knowledge systems. Cohen's requirement that new theoretical approaches in tourism should also pay attention to processes and to the history of the phenomenon are also well served by social representations. Two processes, anchoring and objectification, are seen by social representation theorists as central in shaping social representations. These linked processes, where anchoring may be thought of as preceding objectification, serve the purpose of taking unfamiliar social events or experiences and, by comparing them with well-known phenomena, classifying and categorizing the unfamiliar material. Anchoring specifically proceeds by analogy whereas objectification acts in the capacity of a metaphor. In objectification the once unfamiliar object is seen as having an independent existence, producing its own effects and consequences as a result of the labeling process. Syme (1980), writing about the impacts of tourism in the South Pacific, demonstrates in sequence the process of anchoring and then objectification:

> Mass tourism to Rarotonga is like a plague ... (like) Hawaii for example, where Hawaiians no longer speak Hawaiian and masses of concrete buildings have been built to accommodate tourists ... Let us cast our mind into the future—say twenty years—and see how much of our island will have been converted to cater for this religion ... already (tourists) solemnly pray and worship in the various temples ... There are so many holy spots erected to cater for the influx of pilgrims seeking spiritual fulfilment at these recently constructed shrines ... Rarotonga would be better off without the pilgrims and temples of the religion (1980:57–58).

In Syme's comments the very common process can be seen of comparing one location with a well-known tourism setting with this (usually) unfavorable anchor representing a point from which further analysis and

understanding can proceed. The anchoring can be local (the beach, resort, or town just a few miles away) or it may be national or international in scale with such tourism concentrations as Las Vegas, Orlando (Disney World), Bali, Hawaii, and the Costa Brava being common referents. The objectification proceeds when the image and comparison (tourism as religion, as a plague, as prostitution, as a town savior) is treated as having a life of its own; in objectification the metaphor structures and controls how people treat tourism and creates new images which may not be reflected in the actual tourism setting. For example, once the objectification that tourism is a religion has been made Syme treats the visitors as seeking spiritual fulfilment; one can question whether the motivation of many of the visitors to Rarotonga is indeed spiritual but rather is much more likely to be prosaic and mundane.

Anchoring and objectification can also be understood by examining the roles assigned to contemporary tourists by various communities. Crick has proposed that resident reactions to tourism are often mediated by the categories in which tourists are placed (anchoring). He notes that in the Trobriand Islands the only available category for tourists was soldiers (sodiya), while in the Seychelles tourists are seen as "tous riches", which translates as all wealthy. In the West Indies "tourism is associated strongly with servility; it reawakens memories of the colonial past" (1989: 330). Each of these anchors provides its community with a set of attitudes which can be readily applied to tourism. In a similar fashion Andronicou (1979) argues that Greek Cypriots appear to have suffered from few, if any, adverse cultural impacts from tourism because they do not perceive the tourist as an invader. "The Greek word xenaro, 'foreigner', means guest-friend who is looked upon as a sacred person" (p. 246). Similarly, Boissevain (1979) reports positive resident reactions to foreign tourists on the island of Gozo. His investigations revealed that foreign tourists were favorably compared to the neighboring Maltese who are disliked intensely by Gozitans. Here is an example of a negative anchoring process where the tourists are classified as **not** being like the Maltese and therefore likeable. This ingroup–outgroup distinction is an important feature of the operation of social representations which can be a consequence of the anchoring process.

There are also examples of the anchoring process placing tourists into categories which contain negative stereotypes. Fukunaga (1977), in a discussion of tourism's impacts in Hawaii, suggests that residents associate tourism with a colonial past. He further describes the negative consequences for the self-esteem of tourism workers who see direct parallels between tourism jobs and the work done in the past for plantations. Pi-Sunyer (1978) provides a similar analysis for a Catalan coastal community. In this case study residents classify tourists not as guests but as foreigners and strangers. These categories are described by Pi-Sunyer

as devoid of "individuality and human qualities". Such classifications encourage residents to use rigid and largely negative stereotypes of international tourists. Brewer (1984) provides evidence that the resident stereotypes of tourists can act as self-fulfilling prophecies. His examples demonstrate how resident behavior, which is guided by the stereotype, can produce stereotyped tourist behavior.

In accordance with social representations theory it appears that communities that have had little contact with others have greater difficulty dealing with tourism than those with a longer history of dealing with other cultures. Thus Manning (1979) and Loukissas (1982) suggest that residents in Bermuda and the larger Greek Islands, respectively, have few difficulties dealing with tourism because of long histories of contact with other cultures. Cohen (1982b), however, notes the difficulties that some southern Thailand residents have with tourists because of their limited prior experience with outsiders. For a few indigenous communities, the early arrival of Western visitors was too bizarre for any form of anchoring or objectification to take place. Thus some Australian aborigines, observing Cook's ship the *Endeavour* in 1770, paid absolutely no attention to this unclassifiable phenomenon (Hughes 1987).

Anchoring and objectification are very much in evidence in contemporary Western tourism settings. For example, one consistent puzzle in a number of studies researching residents' attitudes to possible tourism developments is the relatively low level of support for casino development (cf. New Zealand Ministry of Tourism 1992; Pizam and Pokela 1985; Ritchie 1988). This reduced level of support for casino growth or innovation usually exists independently of and in contrast to strong levels of support for other tourism developments. The study by Pizam and Pokela (1985) in particular illustrates why these attitudes to casino development might occur. It can be proposed that casino development is not a part of many residents' social representation of tourism; instead the anchoring of casino growth and building is to big business linked to potential organized criminal activity. Pizam and Pokela exploring attitudes towards legalizing casinos in two Massachusetts communities found that two-thirds of their respondents thought that the presence of organized crime in their towns would increase with a hotel–casino, while 26.2% thought that there would be no change and only 1.2% thought that organized crime would decrease if casinos were to be built. More than any other factor respondents linked casino development to organized crime but there were also strong negative reactions to the casinos' impact on the character of the town, the prevalence of drugs and prostitution, the occurrence of theft and violent crimes and the belief that outsiders (large commercial interests) would control local government. Eadington (1986), commenting on Pizam and Pokela's findings,

effectively paraphrases the case for the existence of a strong social representation at work here:

> [The authors] find that there are strong positive correlations between the attitudes toward casino legalization and its effect on the town character, its effect on the town's standard of living, the state's ability to regulate casinos, and the number of jobs that will be created and a significant negative correlation between the overall attitude and legalization's effect on drugs and prostitution in the community. As a matter of realistic assessment, it is quite possible that a person's attitude towards casino legalization is initially shaped by one specific perception [effectively an anchoring process], such as how a casino would affect his income or lifestyle and then attitudes toward other possible effects are chosen that are consistent with that opinion. Thus the factors which the authors claim explain variations in attitude among residents may in fact be rationalizations that are a result, rather than a cause, of the residents' overall attitudes (1986:281).

Eadington also notes that casinos attract a certain amount of sensational publicity and this popular attention, together with images from the cinema and novels, may contribute to the total public representation of the casino.

The anchoring process for some tourism-related developments may also work in a more favorable direction. In the last decade special events, festivals and mega events have rapidly emerged as key development initiatives supporting tourism growth (Getz 1989). In particular, very large international events such as the World Cup Soccer, Grand Prix motor races, or the Olympic Games might be thought of as producing high levels of impact on host communities and a resident backlash towards the event, event organizers, and visitors. The evidence is quite to the contrary. From both studies of the Grand Prix events and detailed longitudinal research on the Calgary Winter Olympics, researchers have established that residents have an initial enthusiasm for the event, retain the enthusiasm up to and during the event, and remain positive even after the event has been completed (Haxton 1993; Ritchie and Aitken 1984, 1985; Ritchie and Lyons 1987). Again, an explanation for the positive resident reaction is tied to a social representations framework. The Olympic Games, despite the large number of visitors involved, are anchored to sport and city self-esteem rather than to tourism. By referring to this kind of anchoring—that the special event and the impacts are sport and city image related not tourism serving—the residents appear ready to redefine and accept the impacts of the event, notwithstanding the fact that such impacts would normally evoke a more concerted negative host reaction.

One further illustration of the processes of anchoring and objectification lies in the emergence of different versions of tourism itself. In the last decade, and particularly the last five years, various descriptions of tourism such as ecotourism, alternative tourism and green tourism have

been widely discussed (see Case Studies 3.2). For the expression ecotourism in particular, there has been an international industry identification with the term, so that it is not uncommon to see ecotourism discussed as being separate and different from tourism itself. Yet, many of the same businesses are involved and many of the visitor experiences, routes and host–guest relations are virtually indistinguishable from earlier tourism practices. In brief, ecotourism has been objectified—it has become an entity in its own right shaping how we see and describe tourism operations which, in earlier years, we were content to describe as a part of the range of tourism, the larger entity. Arguably, some of the practices of ecotourism operators have evolved and become more environmentally sensitive, which in itself is a good illustration of how objectification changes the way we behave and perceive the world. Indeed, the possibility exists that there may now be more uniformity in the total range of tourism experience because the very objectification of ecotourism has given rise to pressures towards standardization and conformity to pro-environment principles. Having the social representation of ecotourism thus becomes a powerful rallying point for planners and self-regulation by the tourism industry because, albeit slowly, individuals can work towards a nucleus of ideas and a system of knowledge as to how this part of the tourism world should operate.

The Sources of Social Representations

Three factors working together help to shape our social representations. The integrated effects of the mass media in their multiple forms, conversation and social interaction in its different levels of intensity, and direct experiences in diverse tourism locations provide the sources of knowledge about tourism. Few direct empirical studies exist which link these sources of information and their impact on the public image of tourism. Nevertheless there are some indications that the media do pursue some consistent themes in treating tourism topics and that social interaction and direct experience are powerful forces in influencing how people think about and react to tourism.

1. The Print and Electronic Media

The present monograph adopts a view of the mass media similar to that outlined by Snow (1983), who argues that communities are not powerless, passive recipients of the print and electronic world. Instead, people use the media as sources of information on which to enact or play out their personal identities. Snow comments:

Case Studies and Specific Examples 3.2
Alternative Versus Mass Tourism: Examples of Mutually Opposed Social Representations

"Alternative tourism" has become a very common phrase in both the popular and academic literature in recent times. In most cases it is enthusiastically described as providing solutions to the negative impacts of tourism on various host communities. Several authors, however, have argued for a critical analysis of the term and the phenomenon it is meant to represent (Cazes 1989; Cohen 1989; Butler 1990; Wheeller 1992). In these critical discussions we can find clear examples of the processes of developing and using social representations.

Let us begin with anchoring or classifying. Originally, alternative tourism described the use of accommodation other than hotels, motels and resorts and was thus associated with independent travelers and was used mostly by tourism academics as a simple way of categorizing types of tourism (Jones 1992; Cazes 1989). Its rise to popularity coincides with increasing concern over tourism's adverse impacts. As predicted by social representations theory this once unfamiliar concept has been transformed through anchoring and objectification and in Cazes' words "has been robbed of its originality and made commonplace" (1989:118).

All authors agree that alternative tourism as it is currently used is an ambiguous concept and that it is difficult to define it by inclusion. It is, however, very easy to define by exclusion or what it is not. In the words of Cazes (1989), "the different meanings of the concept 'alternative tourism' ... derive principally from the constant preoccupation with being considered different from the also mythical concept of **'mass tourism'** which functions in this context as a repulsive point of reference" (p. 123). Of course, mass tourism is itself an ambiguous term as there is no single dominant market for the product.

Thus alternative tourism can be made a familiar concept by anchoring it in opposition to mainstream mass tourism. The positive and desirable features of this new form of tourism can then be easily derived; they are the opposite of the negative and undesirable features of mass tourism.

Of course, to be successfully incorporated into one's system of social representations it is important that one has the appropriate social representation of mass tourism. Butler (1990) provides a summary table of the opposing features which are part of the social representations of mass and alternative tourism. Mass tourism is rapid, aggressive, unplanned, uncontrolled, and unstable, with remote control. Alternative tourism is slow, considerate, planned, controlled, and stable, with local control. Mass tourists are nosey, loud, and passive, and travel in large groups with little time, no mental preparation, and no language skills. Alternative tourists are tactful, quiet, and active, and travel independently with much time, mental preparation, and language learning.

Cazes (1989), Butler (1990), and Wheeller (1992) all note that these social representations belong to certain groups. Butler argues that the alternative tourist is "highly educated, affluent, mature and probably white" (1990:43) and bears a striking similarity to those authors who have so enthusiastically embraced it. According to Cazes,

> One thing is certain, those who speak of the mass rarely recognize themselves as belonging to it. The mass is the other, the anti-Other, the seat of all sorts of harmful potentialities (1989:124).

Case Studies and Specific Examples 3.2 (Contd)

Thus the social representation of alternative tourism is firmly anchored, as opposed to the social representations of mass tourism. Additionally, holding these social representations is clearly an important feature of the social identities of those who embrace alternative tourism.

The greatest fear of authors like Cazes (1989), Butler (1990), and Wheeller (1992) is that for those who support and promote alternative tourism the social representation has become reality without any questioning. In terms of social representations theory, objectification has taken place. At this point the proponents of alternative tourism see tourism as composed solely of two polar opposites, with mass tourism as inevitably bad and alternative tourism as automatically good. All three authors describe at length the problems with such a perspective, noting the many actual and potential negative impacts of alternative tourism and that tourism as a whole cannot be so simply portrayed. Their fear is that the prevailing social representation of alternative tourism may be sufficiently promoted that it becomes a major force which may generate substantial adverse impacts on host communities and, further, is unlikely to address the real problems that tourism is capable of creating.

The media world can become an environment for total immersion, a world tempered by critical evaluations or an aspect of culture almost totally rejected by the individual (1983:219).

People are neither neutral nor passive audiences for either print or electronic media. Their consumption of media information is "frequently interactive, taking place in conversation with other readers who may see different meaning" (Gamson et al 1992:373). People bring with them to the media their existing social representations and experiential knowledge which both assists them to understand the information or images presented and guides their attention (Gamson et al 1992). Despite these qualifications there is clear evidence that the media do provide information which is used in the social construction of reality and which influences public opinion. There are at least three main ways in which the mass media can influence people's understandings of public affairs or issues. Firstly, the media can influence, through their selection of stories, what are considered to be salient issues (Neuman 1990). In the case of tourism this agenda-setting, as it is referred to, could determine the extent to which tourism is seen by a community as a topic worthy of discussion or thought. Secondly, and most obviously, the media can provide individuals with content for their social representations, including analogies, metaphors and visual images. In the case of public affairs or social issues the media can and often do present opposing interpretations of an issue, thus providing audiences with a range of social representations (Gamson et al 1992). Thirdly, it is common to present issues as conflict between different groups. Such a presentation can make salient group identity and through social identification influence an

individual's attitudes or opinions. Price (1989) describes this as a social identification model of media influence which can be seen as having three stages.

> A news report emphasizing group conflict over an issue (1) cues its recipients to think about the issue through their particular group perspective, which (2) leads to polarized or exaggerated perceptions of group opinions, and finally (3) leads to expressions of personal opinion consistent with these exaggerated perceptions of group norms (p. 197).

There is a clear imperative to study and understand what kinds of messages about tourism are being presented by the media.

Robertson and Crotts (1992) provide a rare study of the impact of a tourism public relations campaign on resident attitudes toward tourism development. The research, conducted in Florida, investigated the impact of media releases and other public information stressing the benefits of tourism to residents, on support for existing and future tourism development. Their results indicated that residents who recalled seeing or hearing the campaign in the mass media were generally more positive about tourism. Although the sample sizes in this study were small, it provides some initial evidence that the media can influence resident perceptions of tourism.

In another study of the tourism–media relationship Timmerman (1992) undertook an archival analysis of two newspapers, one regional and one national, and examined the content of tourism stories over a full year for each paper. Timmerman's study, conducted in Australia, focused on the news and editorial sections of the papers and excluded advertising material. His two papers, the *Australian* and the *Townsville Bulletin*, were the two most commonly read newspapers in the regional city of Townsville, which has an active but not dominant local tourism industry. The study used a number of reliability and coding checks to ensure that the data were free from personal interpretive bias, both in the selection of tourism-related stories and in the allocation of the tourism articles to categories in a 20-item coding scheme. How then did the print media depict tourism over a full year? Was it largely a reporting of the environmental impacts of tourism or was it a concern with the future job prospects of the community which dominated the stories? Did the regional newspaper provide the same kind of picture as the national daily or did more small-scale, personal-interest stories occur in the regional pages?

Key results from the study were that the regional newspaper, with 331 stories for the year, featured a tourism story on an almost daily basis, whereas the national paper had only 137 tourism articles. While the two media outlets were, overall, equally positive about tourism (61.7% for the regional paper and 60.9% for the national paper), the national paper placed a greater emphasis on mass tourism stories and economic impacts.

Table 3.4. Content of Tourism Articles in a Regional and National Newspaper for One Calendar Year, 1991

1. Total number of tourism stories

	Regional Paper	National Paper
Mass tourism theme	230 (69.5%)	115 (83.9%)
Special-interest tourism theme	101 (30.5%)	22 (16.1%)
Total	331 (100%)	137 (100%)

Chi-square = 10.4, df = 1, $P < 0.05$.

2. Tourism stories concerned wholly or in part with the impacts of tourism

		Regional Paper	National Paper
Economic	positive	69 (27.3%)	44 (40.0%)
	neutral	27 (10.7%)	18 (16.4%)
	negative	22 (8.7%)	4 (3.6%)
Sociocultural	positive	56 (22.1%	13 (11.8%)
	neutral	6 (2.4%)	5 (4.5%)
	negative	17 (6.7%)	7 (6.4%)
Physical	positive	31 (12.2%)	10 (9.1%)
	neutral	6 (2.4%)	0 (0.0%)
	negative	19 (7.5%)	9 (8.2%)

Chi-square = 5.8, df = 2, $P < 0.10$.
(For major categories only.)
After Timmerman (1992).

The regional paper provided more articles on sociocultural and physical impacts and substantially more special-interest tourism stories. Table 3.4 presents the category-by-category breakdown of these differences.

Several points can be made to summarize this study. It demonstrates at least in one location that tourism stories can be a recurring and frequent topic in the print media. If one were to be entirely influenced by the national newspaper, the community would have a broadly positive view of tourism justified by the positive economic impacts of mass tourism. This broadly positive view would be tempered a little with some minor concerns about tourism's effects on the physical environment and, to a lesser extent, sociocultural impacts. If one were to be influenced entirely by the local print media, the community would still have a positive view of tourism but here the very phenomenon of tourism would be seen as a richer mix of special interest and mass tourism activities. The positive view of tourism based on the regional newspaper would be

buttressed by a positive view of its economic *and* sociocultural impacts but with some concerns that at times negative economic, physical, and sociocultural consequences can follow tourism.

While the print media are likely to provide regular information on tourism, other media forms are more likely to supply the visual core of social representations with single powerful images or short influential scenarios. A single photograph may serve as a powerful summary of a major public debate while brief footage on the television news or in a documentary may crystallize the perceptions and impacts of an occasion. For major international events such as the Vietnam War a few select images may form the central core of the social representation of millions of people. The photograph of terrified naked children fleeing from the menace of a napalm attack, and the television footage of hopelessly overloaded American helicopters struggling to lift off as hundreds of people clamber to get on board undoubtedly form core reference points for many international citizens in recalling this event. For tourism there are fewer universal images but many personally relevant illustrations of the effects of crowding, growth, and host–guest relations. Special films and short documentaries on tourism also provide rich sources of tourism scenes and images. Thus the character of tourism on small South Pacific islands is crystallized in a film on Tuvalu featuring the rapid postponement of the local soccer game so the field can be cleared for international aircraft to land (Sofield 1994). Images as well as text are central to the amplification of social representations, and further research on the relationship between images and the meaning of tourism would enhance our understanding of how the visual record helps to define what we think and know about tourism (cf. Milgram 1984; Urry 1990).

In addition to the photographic and documentary record on tourism, the effects of tourism marketing on how communities perceive tourism both in general and locally are substantial. Of course it is not the direct aim of tourism marketers to convey generic images of tourism, tourism–community relationships, and tourism impacts, but such communication occurs as a substantial side-effect of the marketing of tourism products and places. There are several levels at which this process operates. In tourism marketing it has become increasingly fashionable and cost effective to emphasize target marketing as essentially the process of trying to influence the travel behavior of select community groups by conveying images of potential tourism experiences which this group is known to favor (Morrison 1989). Such target marketing is not yet exact, resulting in sometimes large numbers of people also receiving promotional material on tourism in which they are unlikely to parti-cipate. This side-effect of marketing communication has received little research attention, with most researchers and practitioners being

concerned with how the marketing process elevates locations from initial to choice to selected destinations (Crompton and Ankomah 1993). It can be suggested, however, that broadly based ineffective marketing still provides information, but it is likely to be perceived by the disinterested traveler to be of interest in terms of the nature of tourism in that location rather than influencing purchasing behavior. The social representations of tourism which community members have may owe much to the impacts of destination marketing, even if this was not an intended goal of that communication.

The power of this indirect marketing is sometimes highlighted when individuals who are traveling out of their own state or internationally, see the tourism marketing of their own home community. The selectivity and the emphasis placed by tourism marketers on familiar physical and cultural landscapes can sometimes raise doubts about the validity of promotional efforts generally. Such cynicism is buttressed by the occasional exposé of tourism marketing efforts, such as when Qantas rapidly withdrew a promotional piece for Australia when its marketing agents were justly accused of having filmed the beach scenes in Hawaii, not Australia.

One emphasis which has recently emerged in the business world in general and tourism in particular is that of ethics and working to ethical principles (D'Amore 1992; Hall 1992). The establishment of business school courses in ethics is a recent international trend and the need for tourism marketers to be ethical, and in some senses responsible to the community they are promoting, has led to the development of societal marketing: effectively the vetting of promotional material by the community to ensure that an acceptable image has been crafted (Morrison 1989). The adoption of societal marketing as a style of working with multicultural and/or indigenous communities is particularly appropriate, and used skilfully can convey information that the destination has a well-integrated, welcoming host population.

2. Social Interaction

There are two other important sources of information for the content of social representations about tourism. One of these information sources is social interaction. Moscovici's work with its powerful European intellectual heritage frequently refers to the role of everyday conversation in shaping and constructing a whole variety of social representations. This social interaction emphasis should be interpreted very broadly. It is not limited to detailed intense debates in a café-style society, but is instead meant to embrace all sorts of conversations with workmates, family, friends, and strangers. Information for our social representations of

tourism may come from a taxi driver or a hairdresser, or may be worked out with a long-time friend, and it is in both the opinions received and the opinions given that we evolve our thinking on tourism and communities.

Moscovici's emphasis on the importance of conversation and interpersonal influence for the development and maintenance of social representations is supported by recent research into the concept of opinion leaders (Weimann 1991). This concept emerged in studies of mass communication conducted in the 1940s and 1950s (Katz and Lazarsfeld 1955; Merton 1949). At this time it was proposed that there existed in social networks individuals who exerted considerable influence over the opinions held by other members of the network or group. These individuals or opinion leaders were seen as passing on and using information from the mass media to influence the opinions of others. The concept suffered, however, from empirical problems. These opinion leaders were difficult to identify and this limited investigations of their influence and characteristics. Weimann (1991), however, has called for a return to the concept, arguing for new methods of identification. As part of this call Weimann presents evidence from a sociometric analysis that there do exist individuals who exert considerable influence over the opinions of others in their social networks and that they do use the media as a source of their own personal information. Such studies would be valuable in understanding community reactions to tourism.

In one study linking social interaction to tourism topics, Pearce (1991) reported that there were consistent differences in communicating negative and positive tourism experiences, with reduced communication for the less favorable instances. Additionally, the same study reported that tourism topics which reflected badly on the self-esteem of the speaker were restricted to a very close circle of friends, whereas simply dangerous or physically challenging experiences were widely broadcast. It can be suggested that discussions of tourism impacts and communities may have a similar structure in that negative impacts which relate to one's self-esteem may not be widely discussed, whereas the less personal environment or even economic impacts can be readily shared. It is clear from the limited studies in the field that how we speak about tourism and the nature of tourism talk are of interest to the theory of social representations and should repay close research attention.

3. Direct Experience

A further source of our social representations is our direct experience as tourists. If there is some cynicism adhering to our tourism images and tourism information from the promotional arena then by way of contrast

there is a strong commitment in the beliefs and perceptions formed by visiting a destination. In an early study of tourism in Europe, British travelers to Greece and Morocco returned home substantially more confident in their beliefs about the character of the host nation than they were prior to departure (Pearce 1982). Clearly, direct experience provides more information and more information under the individual's control than any other tourism reference sources. The very high levels of confidence that we place in personal and direct experience in the consensual universe may well be at odds with information available in the reified universe. For example, will travelers to Russia be more influenced by their own week-long experience or by a detailed ten-year sociological account of the country's changes? It is clear that in the consensual universe it is the traveler's experience not the sociological treatise which will be the organizer of information, although a few scholarly travelers will undoubtedly use the reference work to shape their own perceptions. The belief in the value of direct experience is, of course, misplaced in some areas; locations are different from one time of the year to another, they are different from year to year, and only certain windows on the visited society are available to the short-term holiday maker. Direct experience will also persist over time as an organizer of people's social representations, despite the fact that the visited destinations may have changed drastically since the individual last visited that destination five, ten, or more years ago. The experience of having "been there, seen it and done it" is, however, a prime information source contributing to how individuals construct their social representations of tourism.

Tourism Conflict and Group Interaction

It is one of the larger aims and justifications of the present monograph that a social representations approach might assist in the understanding of tourism–community conflicts. Such an understanding lies partly in using the organizing language of social representations to describe and portray typical sequences of tourism–community conflict. Additionally, the value of the social representations framework lies in bringing new insights and perspectives to the analysis of the conflict. The material in this section will pursue these joint aims; this description of tourism–community conflicts in the language of social representations and the contributions of new observations on these conflicts from this theoretical perspective.

Moscovici (1988) argued that a misunderstanding of other people's thinking, rather than a lack of information, was at the core of many group and social difficulties:

Many problems come up in the relations between different groups such as physicians and patients, parents and children, the media and the public [tourism and the community]. They are caused neither by a lack of information—on the contrary information is plentiful—nor by a lack of logical skill. But they do reflect a lack of [understanding] social representations or a flaw in the representations that are exchanged and communicated in daily life (1988:243).

In terms of the different types of representations which Moscovici has described (hegemonic, prevailing in tightly knit groups; emancipated, shared by groups with some contact; and polemical, reflected in group struggle), it is the polemical representations which are centrally engaged in situations of group conflict. When a community is confronted by a major decision, change, or crisis, there is a rapid modification in the process of communicating ideas. In regular and ordinary situations, diffusion—television, news, daily conversation—is the normal method of exchange creating common knowledge with little group differentiation and leading to emancipated representations.

Of course, some special-interest groups, for example a tourism association or a strong environmental preservation lobby, will have tighter hegemonic representations which have greater uniformity and are more prescriptive in the way that they encourage group members to view the world. Such hegemonic representations are normally fueled by specific types of communication such as newsletters, seminars, and conferences. The method of communication that best describes the information sources of this group is propagation—effectively preaching to the converted—and within the structured nature of the group new information is effectively integrated into the existing social representations. Hegemonic representations are also served by the broad community process of diffusion, although such sources of information are selectively incorporated into the group view.

At a time of rapid change, crisis, or new opportunity, hegemonic representations may give way to polemical representations, world views constructed and defended with a particular opposition group or force in mind. As Moscovici observes, polemical representations are often expressed in terms of a dialog with an imaginary interlocutor, and distinctions between believers and non-believers are quickly made. For polemical representations the mode of communication becomes one which Moscovici has labeled propaganda, an avowedly emotive label, but one which recognizes that conflicts are about power struggles and involve attempts to persuade others with unabashed advocacy.

In a recent theoretical article Galam and Moscovici (1991) provide a series of postulates based on existing data on studies of groups in conflict and groups undergoing attitude change. This work will be used here to serve as an analysis of the processes at work when a tourism–community

conflict has begun and polemical representations are formed as groups struggle for broader support. Galam and Moscovici argue that any defined, finite group will tend to polarize under such situations, that is groups with clear boundaries and in close contact will adopt and construct polemical social representations. By way of contrast, any unlimited open group will tend to moderate consensus, a kind of average level of support consistent with their existing emancipated social representation.

Galam and Moscovici describe the unlimited open group members as equivalent to "swinging" or variable voters whose commitment is being sought by advocates from the parties now holding polemical social representations. The likely winner of such controversies, in the theoreticians' view, is the side which is closest to the pre-existing views on tourism in the community. Nevertheless, they offer some advice for conflicting parties, which has much of the character of the archpolitical schemer, Machiavelli, when they comment:

> The best tactic is to actually strengthen one's own side, to increase the vigour of the exchange between the participants … . This finding is at the opposite pole of the customary tactic which consists of trying to win over and modify the point of view of the undecided voters so as to reconcile them with one's own point of view. This tactic results in reducing the pressure exerted on one's own partisans and in diminishing the solidarity of their choice … by acting more strongly on one's own group one has the greatest impact on others (1991:68–69).

The concept of group identity should be linked closely to this process of trying to influence the open group members. Individuals are powerfully influenced in their choices and decisions by whether or not they see themselves as similar to the group members advocating the polemical social representation. An important feature of this group identity lies also in recognizing that a few powerful individuals may be effective in galvanizing support for a particular perspective since inexperience or unfamiliarity with a topic can lead uncommitted voters to "borrow" the social representations of people to whom they they feel similar or whom they would like to be like. There are, of course, many similarities between the process just described and the conventional selling of products through advertising, the chief differences involved here being that it is a view of the world and a choice of community future that are on offer, rather than consumer goods.

Canter and Monteiro (1993) provide an example of these group processes in an exploration of the lattices of overlapping social representations in Brazilian culture, particularly as it applies to a crisis in housing development. Their study, with many parallels to situations involving tourism development, explored the world views of shanty-town dwellers, residents of public housing estates, and middle-class Brazilians.

The essence of the problem involved the construction of new housing developments which had been rejected, underused, and eventually occupied by groups other than the intended shanty-town residents. Canter and Monteiro make a number of telling observations in their creative study of Brazilian social representations. The researchers initially demonstrate the generative power of social representations perspectives by articulating a hypothesis that the groups being studied do not share the same conceptions and world views of how society works. It is a matter of the shanty-town dwellers not simply rejecting the facilities on offer, but instead holding views on how to live and of a society not understood by planners and not incorporated into the housing design. Additionally, Canter and Monteiro demonstrate in their work that a multiple sorting procedure, effectively asking people to identify social groups and characters and placing them in neighborhoods, can access social representations. Consequently, researchers do not have to rely on an articulate population or a heavily verbal response to study important social issues. Further, the study employs an advanced statistical approach, partial order scalogram analysis, which permits individuals' perspectives on key topics to be profiled in n-dimensional space, each individual being located in the space according to their categorization of groups and people. This visual technique then allows researchers to identify clusters of individuals holding similar views and thus helps to determine which groups in society are sharing emancipated representations, following hegemonic representations, or potentially constructing deeply divided polemical positions. The three groups, shanty-town dwellers, residents of public housing estates, and middle-class citizens, did conceive differently of occupations, social class, and social mobility. These differences are not just the expected and predictable differences between these groups on socioeconomic success factors, but profound differences in the way that they perceive the world to work, what life chances people have, and how communities are structured.

The message from Canter and Monteiro's study is clear. The Brazilian groups that they studied had polarized over the issue of housing choices in Brazil. One group was designing houses for another which held quite a different world view, and it is little wonder therefore that the project had failed. It is productive here to think of this situation in the terms familiar to anthropologists: there are truly different cultures with different belief systems co-existing in contemporary society.

The issue of intergroup conflict has also been addressed by Murphy (1978). In this study he investigated the differences in belief structures of five groups involved in urban decision making: property developers, local politicians, citizen pressure groups, architects, and professional planners. Although Murphy did not explicitly use a social representa-

tions approach, his use of the concepts of constructs and belief systems is compatible with Moscovici's ideas. Murphy asked individuals from each of the five groups to locate high-rise apartment buildings in a model town, to explain their locational choice, and to complete a test which assessed the constructs that they used to deal with environmental issues. The results indicated two major patterns: "a professional–business ideology, shared by the architects, planners and developers", and "a more reticent group of citizen activists and local politicians, with a more cautious outlook" (p. 755). Despite these differences there were areas of overlap, and Murphy concluded that "if areas of conflict, compromise and agreement can be identified at an earlier stage it may be possible to develop real trade-offs and speed up the decision-making process" (p. 759).

Clearly, planning for different groups cannot be done by forcing one world view on to another, but requires the incorporation of the user's design ideas, social values, and way of living to modify the planned environment. This approach lies beyond the rhetoric of consultation; it is a mutual design process facilitated by research laying out for all participants the basis of similarity and differences in the world views of the groups concerned. Power, of course, does not disappear in such a process of facilitated design, but the effectiveness of the communication between the groups is enhanced and positions of compromise breaking the defensive propaganda deriving from polemical social representations are made possible. The power of leading individuals to initiate this process of understanding other world views is paralleled by the power to convert others to their position.

Some of these processes may be represented schematically (see Figure 3.4). Initially, the social representations of tourism in a community may be largely emancipated and a large proportion of the population holds a variety of such representations. These broad representations may include tourism as an economic force, tourism as an activity of local environmental concern, and tourism as a positive mix of people in an area. A few tightly knit groups in a community with an enduring interest in tourism might hold rich, detailed hegemonic social representations such as: tourism, an economic savior complete with statistical details; tourism, environment wrecker, again with evidence of impact; or tourism, advanced agent of overdevelopment of all sorts supported by examples anchoring local tourism to tourism elsewhere. It will take a particular instance or crisis for these world views to be defended at all costs with attendant disparaging remarks about the opposing polemical social representations. Once the crisis has engaged the community and the propaganda form of communication is in force, individuals holding emancipated social representations are drawn towards the polemical positions as much through group identity forces as by the arguments and

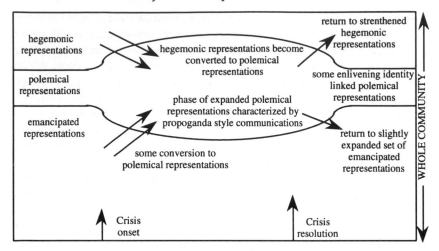

Figure 3.4 Tourism Social Representations and the Advent of a Crisis

logic of the proponents. The intervention of political processes, final development or entrepreneurial decisions will result in a reduction of the polemical views, but how much they abate will depend on the adequacy of the compromises achieved and the lingering power of the opposition forces to pursue polemical social representations. Such polemical positions may, as Galam and Moscovici (1991) noted, fade because of the inability of the group to maintain its members as well as a lack of effectiveness in influencing outside members.

There are several elements of the preceding discussion which will be examined further in later chapters of this book. In particular, attention will be given to the planning process and dispute resolution with an attempt made to see such activities through the expansive lens of social representations. Additionally, further commentary on the issue of group identity and identification will be pursued in the detailed presentation of empirical data collected in the tourism–community case studies to be described in *chapter 5*.

Social Representations of Tourism Researchers

A traditional social science perspective embraced the view that research was value-free and researchers seeking after knowledge somehow avoid-
...les and debates of people involved in managing human ...gnition that the value-free approach was idealistic has been ...me time, with philosophy of science commentators noting ...of any type is embedded in larger social forces and

researchers should at least be aware of the social values in which they operate (Sampson 1978). The recognition of values and social forces shaping research does not imply that individuals are knowingly seeking to influence their data or are misinterpreting their findings. Such biases may indeed occur, although such work would be unlikely to pass the test of being methodologically sound. Instead, rather more subtle processes of influence are at work. For example, the broad social acceptability of certain topics may make researchers avoid critical issues, while the immediate acceptance of colleagues can provide a powerful day-to-day dynamic limiting the breadth of the researcher's view. Topics such as the impact of tourism on prostitution, crime, sexual diseases, and drug use fall within the ambit of these forces. Additionally, findings with unexpected and perhaps unpopular results have been shown to be less likely to be recorded and published (Gergen 1983; Harré and Secord 1972). All of these forces should not daunt researchers but should instead be seen as strengthening their understanding of what there is to be studied and help them to anticipate the difficulties of presenting less than popular findings and topics to the broader community. In essence, a value-aware approach should be liberating rather than constraining to researchers, making them less likely to fall into what Murphy has described as "limited and subjective interpretations" of tourism impacts (Murphy 1983:8).

In a similar spirit, Cohen (1979), discussing community change, notes that broad value perspectives and interpretations by agents external to a given community may be flawed and in effect set a dangerous hidden value precedent for researchers. If a researcher demonstrates, for example, that it is population growth due to the expansion of a range of industries, including tourism, which is placing pressure on the environmental resources of a region, this finding may contradict more widespread popular interpretations that it is the visible force of tourism alone that is responsible for the impacts. Tourism researchers should not be encumbered with a social representation of tourism which portrays a necessarily negative view of the impacts of the phenomenon.

The importance of these value-based shortcomings in tourism–community studies has been noted by a number of researchers and some important consequences have flowed from this attention. In dealing with the sociocultural effects of tourism in Third World countries van Doorn (1989) warns that researchers should not be blinded by their own ideology and observes, quoting Rentes de Carsalho (1982), that we should be on guard against "elaborate and pseudo-intellectual analysis from our 'correspondent in …' who has been in Colombia for two weeks and writes twice the number of articles about it and who takes into the bargain the problems of Brazil and Argentina, with the certainty and serenity of an ayatollah" (1989:71–72). For van Doorn the implications

Case Studies and Specific Examples 3.3
Collective Representations of International Tourism in the Social Sciences

In 1989 Crick took an anthropological perspective on the state of tourism research and offered an analysis of the collective representations of international tourism in the social sciences. His use of a collective representations approach (see *chapter 2* for a discussion of collective versus social representations) was particularly concerned with

> the issue of whether we yet have a respectable scholarly analysis of tourism, or whether the social science literature on the subject substantially blends with the emotionally charged cultural images relating to travel and tourists expressed in the literary views (p. 308).

In his examination of the literature on tourism and sociocultural change, Crick notes that much of the anthropological and sociological work begins from a negative stance. He also describes three types of bias in the research which derive from and support a negative representation of tourism. The first bias is compounding the consequences of tourism with those of other forces such as urbanization, population growth, and the mass media. The second bias is referred to as the noble savage syndrome. Crick here notes the concerns with commoditization and loss of authenticity. His thesis is best put in his own words.

> Moral and behavioral changes are certainly occurring, but we must be careful not to indulge in romanticism and ethnocentrism by setting our descriptions against some Rousseauesque idyll of traditional life (p. 336).

He supports this statement by citing numerous cases of positive sociocultural impacts of tourism. The final bias referred to is the lack of local voices in the literature. Crick notes that even in anthropology the voice of residents is rarely heard. Although there has been an increase in survey research designed to access these local voices, its success is usually undermined by methodologies which use other researchers or tourism experts as the source of survey items (see Key Issues 3.1). Crick's overall view is not an encouraging one. He says "ambivalence, sweeping generalizations, and stereotypes abound" (p. 309), thus setting in place a serious challenge to tourism researchers.

are that researchers should at least exercise caution in generalizing their results from one developing community to another and should particularly admit that they have difficulty in establishing the size of tourism's sociocultural effects and the causal mechanisms underlying change, particularly for different community groups, and further difficulty in identifying the leading agents of change. It should be noted that while the focus of van Doorn's critique lies in addressing sociocultural studies of tourism's impacts, economic and ecological studies are subject to similar weaknesses (Cleverdon 1979; Mathieson and Wall 1982; OECD 1980).

One importance consequence of van Doorn's concern that tourism researchers do not limit their research by adhering to a conventional

social representation of tourism's ill effects has been his explicit construction of a model which itemizes the sources of sociocultural change in developing countries. Significantly, this work is not the contribution of a single scholar but rather one of the outputs of the Vienna Centre Tourproject (van Doorn, 1985). It is redrawn here to highlight the multitude of factors that can be considered in such research and as a source of advice for researchers who want to undertake comprehensive case studies of tourism's impacts.

Above all, the details in the accompanying model alert researchers to the multitude of specific factors likely to structure the effects of tourism in each individual situation, thus reinforcing the view that a social representation with simple global generalizations of tourism's impacts is likely to be locally misleading.

Two other consequences of this concern with the social representation of tourism researchers can be outlined. The concern has also been expressed in other terms, particularly in Jafari's (1990) four platforms of tourism research and Urry's (1990) concept of the tourist gaze. As discussed in *chapter 1*, Jafari has distinguished four platforms: the advocacy, cautionary, adaptancy, and knowledge-based positions. The cautionary platform is of chief interest here since it is structured around the impacts of tourism and has many characteristics of a polemical social representation, cast against the more pro-tourism advocacy position. The contrasting claims of these two positions are revealed in Table 3.5.

Jafari's own advocacy for a knowledge-based platform is consistent with the emancipated social representation of tourism's impacts which

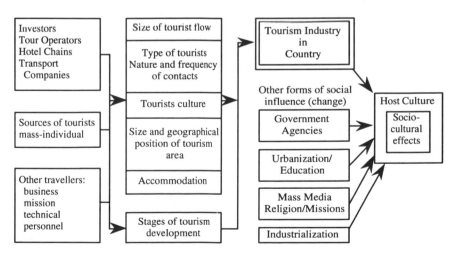

Figure 3.5 Model of Sources of Sociocultural Change in Developing Countries with Particular Emphasis on Tourism (based on van Doorn 1989)

Table 3.5. Positions of Advocacy and Cautionary Platforms on Tourism's Impacts

Advocacy Platform		Cautionary Platform	
Economic	Sociocultural	Economic	Sociocultural
Examples:	**Examples:**	**Examples:**	**Examples:**
• Tourism is labor intensive — full time — seasonal — unskilled • Generates foreign exchange • Can be built on existing infrastructure • Can be developed with local products and resources • Spreads development • Complements production of other economic activities • Has high multiplier effect	• Tourism broadens education • Promotes international peace and understanding • Breaks down — language barriers — sociocultural barriers — class barriers — racial barriers — political barriers — religious barriers — sex barriers • Reinforces preservation of heritage and tradition • Promotes worldview/membership in the global community • Enhances appreciation of one's culture	• Tourism causes inflation • Results in high leakage • Has seasonality and contributes to unemployment • Is susceptible to change, rumor, and spread of disease, economic fluctuation • Results in unbalanced economic development • Leads to extraneous dependency • Increases demonstration effects • Destroys resources and creates visual pollution	• Tourism contributes to misunderstanding • Generates stereotypes of the host and guest • Leads to xenophobia • Results in social pollution • Commercializes culture, religion, and the arts • Threatens family structure • Contributes to prostitution • Increases instances of crime • Induces conflicts in the host society

Source: Jafari (1990).

researchers should adopt. He argues that a knowledge-based platform would

> position itself on a scientific foundation, at the same time maintaining bridges with other platforms. For a balanced view the foundation would assure objectivity and the bridges accesses (but not attachment) (1990:35).

This perspective may be usefully connected to another treatment of tourism, the view that there are different gazes which structure the nature of the tourism experience (Urry 1990). The core argument in Urry's analysis is that there are really two types of tourism: the first based on the romantic gaze which sees places as objects of beauty to be enjoyed in relative solitude and giving pleasure because of their scenic and spiritual qualities; and the second an alternative way of viewing places which is much more hedonistic, communal, and social. Urry terms this the collective gaze and notes that tourism in cities, theme parks, and seaside resorts actually requires large numbers of people to provide the sense of excitement, festive spirit, and fun germane to these locations. For the present analysis it can be suggested that these two gazes have strong social class or at least social identity overtones, with the romantic gaze and the desire for quiet enjoyment of places being a middle-class, educated, and fundamentally invented pleasure. The collective gaze, in contrast, with its emphasis on conviviality and sociability, is often looked down upon by those concerned to conserve the environment (Walter 1982). The personal values, education, and social characteristics of researchers are likely to make them sympathetic to the romantic gaze, a social representation which effectively defines crowds as synonymous with congestion, overcrowding, and undesirable impacts. The alternative collective gaze will be predisposed to see the presence of others as adding value and creating a sense of shared excitement. The romantic gaze can be linked to the cautionary platform, thus providing another useful reminder that researchers can be bound by deeply personal views of the world when they could be exploring all of the available gazes.

A further consequence of being aware of the range of tourism's effects, and the need to research rather than prejudge tourism's consequences, has led to the development of the quantitative research tradition in impact studies (c.f. Pizam 1978). This survey-based approach was initially conceived as a thorough alternative to the potentially biased cultural interpretations of more qualitatively minded researchers. While the 1970s had been marked by some leading anthropological accounts of the sociocultural impacts of tourism (e.g., Smith 1978b), the next decade of research witnessed the growth of the survey work.

Thirty-one articles from leading tourism journals published between 1978 and 1995 were identified which presented quantitative data from surveys of community responses towards tourism impacts. It is of interest

to ask what kinds of tourism impacts receive priority in these 31 articles, and are there any notable trends in this data set of data-based articles that can highlight how researchers are viewing the tourism–community relationship? Table 3.6 summarizes the types of impacts assessed in these articles. While not all of the studies were attempting to provide a comprehensive account of tourism impacts, the relative emphasis on various kinds of impacts is interesting.

Two main approaches were used in the surveys to measure resident perceptions of tourism impacts. Approximately one-third of the studies gave their respondents a list of aspects of community and personal life and asked them to rate the degree of tourism impact on these items; usually on a positive–neutral–negative scale. The second and most common approach was to provide a list of statements about tourism and ask respondents to rate their agreement with the statements. The lists usually included both negative and positive statements about tourism. Table 3.6 shows both the numbers of different types of impacts assessed and whether or not they were presented to subjects in a neutral, positive, or negative fashion. Inspection of the table indicates that socioeconomic impacts as a group are most commonly presented to respondents and are most likely to be presented in a positive fashion. Sociocultural impacts are the next most commonly presented group, but in this instance these impacts are more likely to be presented in a negative fashion. This is also the case for environmental impacts. A Chi-square analysis of the totals for the neutral, positive, and negative categories for the three types of impact indicated that the presentation of impacts differed significantly across the types of impacts ($\chi^2 = 222.5$, df $= 4$, $P < 0.001$). In other words, socioeconomic impacts are significantly more likely to be presented as positive or neutral, than either environmental or sociocultural impacts. An examination of the individual impact items is consistent with the previously reported patterns. Of the ten most commonly used items, five are socioeconomic, two environmental, and three sociocultural.

Considering that only three out of the 30 studies appeared to derive their impact items from procedures such as focus groups, with the rest generated either by the researcher or from previous research, it could be argued that Table 3.6 presents a picture of the social representations of tourism impacts held by researchers. It would seem these researchers see tourism as generally good for the host economy (except for prices), bad for the environment (particularly for crowding and traffic), and bad for crime and the residents' quality of life.

Table 3.7 provides another interesting comparison as it summarizes the impacts described in various case studies and ethnographic accounts of tourism impacts. Clearly, the transition from the qualitative to more quantitative accounts of tourism has resulted in a much more restricted view of tourism impacts. Many proposed sociocultural impacts and

Table 3.6. Summary of Tourism Impacts Listed in Surveys[a]

Impacts	Neutral Wording	Positive Wording	Negative Wording	Total
1. Socioeconomic				
Employment	8	12	—	20
Facilities for recreation and entertainment	5	10	4	19
Prices/cost of living	4	—	8	12
General economy	2	9	—	11
Standard of living	7	4	—	11
Infrastructure	3	7	—	10
Public services	4	2	4	10
Taxes	4	4	—	8
Investment	—	5	—	5
Income	4	—	—	4
Other industries/economic activities	2	1	—	3
Availability of goods/services	1	—	1	2
Housing conditions	2	—	—	2
Total	**46**	**54**	**17**	**117**
2. Environmental				
General environment	3	9	5	17
Traffic	7	—	10	17
Pollution/litter	2	—	5	7
Crowding/congestion	—	—	7	7
Character of town	3	3	—	6
Noise	1	—	4	5
Historic sites	—	2	1	3
Total	**16**	**14**	**32**	**62**
3. Sociocultural				
Crime	6	—	10	16
Quality of life	3	6	7	16
Traditional culture/cultural activities	4	6	4	14
Social interaction	3	2	6	11
Drugs/alcohol	7	—	2	9
Cultural exchange	3	4	1	8
Social justice/equity	1	—	6	7
Morality	4	—	3	7
Prostitution	4	—	2	6
Stereotyping	3	—	—	3
Family life	1	—	1	2
Outside political control	1	—	1	2
People become more commercial	—	—	2	2
Education	1	1	—	2
Language	—	—	1	1
Total	**41**	**19**	**46**	**106**
Overall total	**103**	**87**	**95**	**285**

[a]Appendix A contains the list of references used for this table.

Table 3.7. Summary of Tourism Impacts From Case Studies, Ethnographics and Reviews[a]

1. **Socioeconomic**
 More and more varied employment
 Unskilled, menial employment
 Seasonal income and seasonal unemployment
 Increased unemployment as people migrate for work
 Increased standard of living
 Inflation and increased costs
 Dispersion of development
 Increased dependency on a single industry
 Dominance by multinational companies
 Improved infrastructure/services
 Increased taxes to build infrastructure
 Infrastructure/services strained
 Leakage of income to external sources
 Displacement

2. **Environmental**
 Crowding and congestion
 Degradation and damage to the environment in general
 Traffic problems
 Pollution/litter
 Damage to sites of historical and cultural significance
 Preservation of sites of historical and cultural significance
 Preservation and restoration of the environment

3. **Sociocultural**
 Changes to family structure and gender roles: often creates new opportunities for women and younger people, but also tension and loss of self-esteem for men and older generations
 Demonstration effect: copying of tourists and loss of traditional values and activities
 Support for a revival of traditional culture
 Support for demonstration of ethnic identity
 Changes to arts, craft, dress, festivals, etc. as a part of production for tourists
 Crime
 Drugs and alcoholism
 Loss of privacy
 Changes in morals, values, and attitudes
 Introduction of commercialism
 Begging
 Invasion of traditional/sacred sites
 Breaking of cultural taboos
 Recreational conflicts
 Community conflicts
 Creation and maintenance of stereotypes
 Breaking down of stereotypes
 Increased social inequity
 Loss of language
 Support for language
 Increased recreational opportunities
 External political control
 Better education
 Loss of artifacts
 Cultural exchange
 Introduction of disease
 Prostitution
 Loss of access to various places
 Interference with/disruption to traditional practices

[a]Appendix A contains the list of references used for this table.

negative socioeconomic impacts have been given little or no attention in the quantitative work. This brief analysis indicates that the world view of tourism researchers needs constant critical attention so that truly comprehensive, well-structured studies can be performed. Social representation perspectives can therefore be seen as working in a reflexive and critical fashion, as such a perspective not only gives a researcher an approach to thinking about tourism–community relationships, but also has the power to reflect on existing paradigms in which researchers may be rather too firmly rooted.

Summary and Conclusions

The clearest and most important conclusion that can be drawn from the literature examined is the need for researchers in the field of tourism–community relationships to understand the reality of tourism for host communities. A social representations approach is an emic, contextual, processual theory. In order to achieve this goal of understanding tourism in the words and images of hosts, social representations provides eight core ideas or points to pursue.

1. A focus on the types of tourism, tourists and communities

In its emphasis on context and the larger issues troubling any society and its members, the social representations framework requires documentation, however schematic, of some of the features and defining characteristics of the variants of tourism, types of tourist, and community character being studied. Such an emphasis tends to caution against overly simplistic positivistic generalizations from one study setting to another.

2. An emphasis on the content of responses

A social representation approach to tourism and communities requires attention to what is being said, recorded, and analyzed about tourism. This emphasis makes researchers pay attention to who is providing the content of the community responses, the breadth of that content, and exactly how respondents' perspectives are being sought.

3. The structure and organization of responses

In addition to the content of the responses, attention should be directed towards how much variability there is in the community response,

whether there are extreme negative or positive responses, and whether there is consistency or variability when questions are asked or information is sought in different ways. The relative importance of statements or responses should also be considered, as this factor strongly defines the structure of the social representation. Breakwell and Canter (1993), in a call for the use of multidimensional analyses to understand social representations, state that

> Rather than seeing the social and psychological processes under examination as made up of a few variables which can be measured by unidimensional instruments and which have their effect in simple and direct ways, the use of multivariate statistics takes as its starting-point the assumption that important psychological processes will be revealed only through the interplay of many variables in a reasonably complex system (p. 3).

4. The commonality of opinions within the community

The social representations approach directs attention to what people jointly believe, that is the extent to which their opinions overlap. It will be argued in this chapter and in subsequent chapters that many individual tourism communities are much more united in their view of tourism than has previously been described. Social representation perspectives, by exploring the commonality of existing community attitudes, partly reverse the trends noted in many previous studies where researchers have determinedly set out to describe community differences and produced relatively few consistent findings (refer to Table 1.7: *chapter 1*).

5. The role of familiarity and unfamiliarity

A touchstone for understanding social representations is to understand that people and communities need to deal with the unfamiliar and manage change. Social representations provide a mechanism for people and communities to process unfamiliar and changing worlds, and some of the case studies in the following chapters will focus particularly on community reactions when changes and new developments are being planned.

6. The processes which shape social representations

Researchers need to seek and document the processes of anchoring and objectification. What are the analogies and metaphors used by hosts to describe tourism? What prototypes do they use to understand tourism

and its impacts? What visual images do they have when they talk about tourism either to researchers or to others in their communities? All these are important questions to investigate.

7. The sources of our information about tourism

Social representations approaches are cognizant of the fact that not all of our ideas and information are obtained from personal experience. Instead, we glean material from the electronic media, from magazines and books, and from others. Attention to the sources of our information is an important part of extending our understanding of community reactions to tourism, since any process of social influence demands that we know not just what people know but how they developed and consolidated those understandings.

8. Social representations may define community groups

One of the confusing questions about community reactions to tourism has long been who holds what opinions. An important possibility inherent in the social representation approach is to define the commonality of opinions first and then explore the psychodemographics of the groups holding these opinions. Currently, much work proceeds with limited and *a priori* sociodemographic segmentation. The possibility of providing a much more integrated and emic view of how communities react to tourism is an attractive feature of the social representations approach. These features will be particularly valuable when planners and researchers are faced with the complex data sets currently being generated in empirical studies of tourism–community responses.

Chapter 4

Social Representations in Action: International Examples

This chapter will consider two major case studies, one from Hawaii and one from New Zealand. The intention underlying the selection of these examples is to showcase the applicability of a social representations approach to different types of tourist setting. Systematic community survey work exists for both of the case studies, thus enabling an empirical rather than a purely descriptive appraisal of the social representation approach to be pursued.

Of course it would be preferable to be able to report whole studies informed at the outset by a social representations framework, but in the early days of a new approach this is not possible, and interpreting existing evidence is a valid alternative. While there is a particular concern with the empirical work conducted in each setting, the methodological pluralism which is admissible in a social representations approach will be illustrated in the chapter as material ranging from journalistic style commentary to survey research is considered.

A First Case Study: Hawaii

Why study Hawaii?

The choice of Hawaii as an exemplar of tourism–community relationships is based on a number of considerations. It is an internationally significant tourism destination, sharing perhaps with the Spanish islands and coastline an almost icon-like stature as an archetypal tourism destination. The choice was also influenced by the fact that several previous holistic tourism studies exist which help to describe the nature

of Hawaiian tourism. There is, furthermore, an important and linked set of studies documenting socioeconomic impact and community reactions to tourism in Hawaii. Interestingly, these studies, when published, were frequently at the forefront of the international literature on tourism and communities, thus often providing a role model for other studies assessing tourism and community issues. Accordingly, if the social representation approach can be seen as improving understanding of the community–tourism relationship in the well-studied, significant destination of Hawaii, then the adoption of the approach in other settings may be enhanced.

As a mid-Pacific tropical outpost of the USA, Hawaii will be familiar to many readers of this volume. From the main island of Oahu, Australia lies 5,000 miles to the south west, Japan 4,000 miles to the north west, Vancouver nearly 3,000 miles to the north east and Los Angeles a little over 2,000 miles to the east. For research and analytical purposes Hawaii is usually considered under four island or county groups, these being Oahu, where Honolulu and Waikiki are located; Kauai County; Maui County, which includes Lanai and Molokai islands and where substantial resort building is on-going; and the so called big island of Hawaii, famous for its volcanic activity and increasingly a site for coastal tourism development (see Map 4.1).

It is difficult for the tourism researcher to describe the ambience of Hawaii succinctly without employing the clichés of tourism marketing. Farrell, who has analyzed Hawaiian tourism intensively since the 1950s, describes the resource base of the industry in terms of climate, landscape, people, and stimulating built environments. He argues that Hawaii's resources are

> that special combination of elements such as a warm, sensuous, and non debilitating climate; exciting coastal and mountain scenery; warm, clear ocean water; uncluttered open spaces of cropland, forest, and park; and one of the most interesting cosmopolitan populations in the world (1982:29).

He further observes that Waikiki, occupying in total a mere 360 acres, has seen a rapid and brutal transformation from a few elegant hotels into a jagged forest of architectural canyons; an environment which nevertheless is a fascinating tourist resource in its own right, worthy of nurturing and improvement.

One particular feature of Hawaiian tourism and community life needs definition for researchers, readers and students. The spirit of "Aloha" is frequently mentioned in characterizing Hawaiian hosts and community life. Farrell sees it as a spirit of tranquillity with accompanying personal warmth and hospitality and describes it as embedded in open space, ruralness and cultural tolerance. It is a matter of considerable debate as to whether "Aloha" is in decline in Hawaii.

Map 4.1

The major studies of Hawaiian community responses to tourism span a period from the early 1970s to the early 1990s. The resident population has in this time expanded, owing to the dual and equally matched forces of natural increases and immigration, from 600,000 to over 1 million Hawaiian residents. In broad terms the annual number of tourists visiting Hawaii rose from 46,000 in 1951 to 1 million in 1967, up further to 2 million in 1972, 3 million in 1976 and 4 million in 1980. The figure of 6 million was reached in the mid-1980s, with a slowing of the growth in the later part of that decade. By the mid-1990s visitor numbers had stabilized at approximately 7 million annually.

What has been said about tourism and the community in Hawaii?

With the rapidly escalating visitor numbers to Hawaii in the 1970s, it is not surprising that government, industry, and academic concern with the effect of tourism has been manifested in a number of studies. Liu and Var (1986) report that in 1972 the Hawaii Visitors Bureau examined economic impacts, that in 1975 the Hawaii State Department of Planning and Economic Development looked at tourism employment, while in 1974 the Visitor Industry Education Council (effectively an industry lobby group) looked at visitor attitudes and pro-tourism television

advertising. A report identifying key parameters for a visitor attitude study was released by Knox in 1978 but undoubtedly the most wide-ranging and influential document was a joint publication by the East–West Center based in Honolulu and the Center for South Pacific Studies at the University of California (Santa Cruz). Titled "A New Kind of Sugar" and edited by Finney and Watson, the monograph had been produced in a limited run in 1975 following a series of workshops, and was reprinted by the joint sponsors in 1977 as demand for the material was widespread. While the articles cover a range of Pacific tourism destinations the core article by Kent, "A New Kind of Sugar" and an intensive case study by Fukunaga on the impacts of hotel building will be the focus of this initial analysis. In tracing the path of tourism–community studies in Hawaii additional landmark publications will be considered. The work of Knox (1978) in identifying a range of tourism impacts in Hawaii will be outlined. In 1982 Bryan Farrell's book "Hawaii: The Legend that Sells" was published; this wide-ranging volume includes two substantial chapters commenting on community–tourism reactions. Farrell's work will provide an important resource in studying Hawaii and resident reactions to tourism. In 1986 Liu and Var produced a study which in their own view was "far more comprehensive in scope than previous surveys". The Liu and Var study lies in the mainstream of academic tourism analyses using survey work and will also be reviewed.

The final key study to be considered was produced for the Department of Business and Economic Development (DBED) in 1989 and was a massive effort in conception, surveying and reporting on the State-wide impact of tourism. Perhaps more than any other international study of tourism and communities it provides enormous scope for exploring a social representations approach.

The initial analysis of tourism's social impact on Hawaii by Kent is colorful, controversial and somewhat confused. At core he argues that one form of plantation mentality has replaced another. It is a view which sees clear divisions between the power holders and developers and the workers, and pinpoints both exploitation and poor working conditions as the basis for Hawaiian tourism success (Kent 1975). Kent concludes his somewhat lengthy article by reporting an incident which would undoubtedly alarm most academic researchers and administrators as well as the wider community. In March 1971 the relatively newly formed School of Travel Industry Management at the University of Hawaii (Honolulu campus) was severely damaged by a gasoline-ignited blaze. The then Dean of the School was reputed to have attributed the motives behind the attack as a protest against the ecological impacts and pollution caused by hotels. Kent sees a much more deeply rooted and social alienation underlying the incident, a genuine act of rage expressing

pent-up anger from the many disadvantaged locals which should not be dismissed as the work of an ecologically conscious minority.

Kent's argument emphasizes the very rapid advancement of Hawaii as a tourism destination, particularly the Waikiki area, and he observes that there is

> something to remember ... Hawaii's people were never once consulted as to their ideas about what kind of place Hawaii should become. 800,000 people forced to abide by the judgment of a few score corporate executives (1975:173).

Kent's view that tourism is a new kind of sugar, a monoculture with plantation mentality overtones, is augmented by his further discussion of the ills of tourism as an employing industry. For Kent tourism is also whorism, and he argues that "the things that characterize the brothel—inhabitants who are obedient, docile and prostituting themselves" also characterize tourism. According to this logic the attack on the School of Travel Industry Management is more understandable: it is an attack on the pimps of the tourism prostitution system who are merely providing their industry masters with technically competent workers, not thinking, critical, and independent human beings.

Kent is not alone in drawing attention to the lot of the tourism worker. Fukunaga (1977) describes tourism as a fire raging throughout Hawaii and argues that while hotel work was attractive to employees many locals felt "a deep sense of shame in their encounters", a feeling which added to insecurities deriving from their plantation heritage. In short, the crash technical and educational courses designed to groom new workers for the hotel industry had overlooked the kind of pidgin English in which locals habitually communicated, and many newly employed staff found themselves unable to speak freely to guests without misunderstanding and embarrassment.

Kent's arguments, supported by Fukunaga's accounts, provide some clear social representations of tourism; tourism as a new kind of sugar, tourism as whorism, tourism as a raging fire. However, only a limited number of social representation issues can be pursued from such work. A clear question which remains in doubt is how many community members and hotel employees share these social representations. While it is possible to guess at some of the origins of these social representations, the extent to which they were or remain current in the media cannot be appraised. Kent's analysis is clearly an industry-hostile piece, so it is fair to ask what other prevailing social representations exist. Further, the analysis lends only to a pessimistic negative outcome: might there not be a number of ways of rectifying the supposed social costs both in action and in social representations recasting the lot of tourism workers and the tourism-driven community of Hawaii?

A singular and distinctive contribution to the study of tourism impacts in Hawaii is that of Knox (1978). This study, avowedly emic in design, drafted several comprehensive lists of attitudinal items regarding resident attitudes towards tourists and tourism in Hawaii. The principal aims of the study were to foster an appreciation of the diverse nature of resident attitudes and to guide future research into residents' attitudes towards impacts both in Hawaii and elsewhere. The emic emphasis of Knox's study is particularly powerful, with the expressed intention of providing a basis for later questionnaires which use the same range, nature, and phraseology of beliefs that the community had expressed earlier. Knox's analysis is therefore a study of the questions to be asked, the impacts to be assessed rather than questions answered and impacts investigated.

Knox provides two critical lists concerning residents' beliefs about the impact of tourism: one documents 100 perceived impacts and the other provides 31 causal themes or issues which appear to be behind these 100 concerns. The largest number of impact items is generated in an area that Knox labels economic, while substantial numbers of items occur in categories that he describes as physical changes, land and environment, population and crowding, crime, human relations, and lifestyle. Knox draws attention to three questions regarding residents' beliefs. (1) Do they believe the statements are essentially true? (2) If so, do they think these changes were caused by the growth of Hawaii's visitor industry? (3) Do they think these changes were personally important? While skilled social science questionnaire design may be able to combine the first two questions when presenting this kind of material to residents, Knox's third question, which assesses the relative importance of impact items, is a crucial independent requirement for effective interpretation of residents' responses. A summary of Knox's list of impacts and causal theories is presented in Table 4.1.

In addition to the thorough listing of impact items and causal theories, Knox's work contains some information which foreshadows and is consistent with a social representations approach. He observes that residents appear to have four ways of dividing tourists into types: one which emphasizes demographic descriptors, another which concentrates on behavioral elements, a third which attends to visitor reaction to Hawaiian people, and a final approach which is dominated by how visitors react to Hawaii and its tourism industry. Knox comments that the "type of typing" may be an important dimension of attitudes, thus foreshadowing the present social representations emphasis that it is shared, large-scale images of tourists/tourism which structure residents' attitudes and community reactions. In a further preliminary study Knox provides some more initial evidence which is highly congruent with the social representations perspective. Knox proposes that the

Table 4.1. Categories of Underlying Themes and Community Needs Identified in Knox's List of Tourism Impacts, Hawaii 1978

Economic
Education, social/cultural exchange
Available land, housing
Good educational opportunities
Convenient shopping, service areas, transportation
Travel opportunities
Good economy: lots of jobs, good salaries
High standard of living, ample tax revenues for government service projects
Good long-term economic prospects in confidence in the future
Most people feeling they have good equal chance for personal and economic betterment of their lives. Things like ethnic prejudice or current lack of training no great obstacles
Everybody having equal opportunity to carve out their own lives: no gender, age, ethnic, or other role restrictions
Strong labor unions

Land, Environment, Physical Changes
Protection against danger to the ecosystem
Pleasant surroundings, attractive buildings, quiet, green, cleanliness, natural areas
Continual access to old familiar enjoyable places and activities
Space to breathe and avoid being overcrowded by people, cars, buildings

Social Cultural Heritage
Pride in our homes, our people, our way of doing things. Knowing we are as good as or better than any other place or culture
A society in which as many people as possible share our values, beliefs and moral standards
Making sure no one ethnic group dominates, keeping a mix of people
People staying in touch with their true ethnic heritage, getting pride and value from it: feeling equal to all other peoples

Education, Social/Cultural Exchange
Good educational opportunities
Confidence in ability to cope in society, now and in the future
Exchange of ideas with outside world: a cosmopolitan society, avoiding insularity and being "behind the times"
Personal contact with old and new friends from outside world

Lifestyle
Self-respect and interest in work, all social activities
Friendly, sincere, trusting relations among all peoples. No tensions or prejudices
Peace, relaxation, privacy, freedom from lots of demands
A sense of responsibility to family, community, other people

Entertainment
A variety of convenient, not too expensive, good entertainment opportunities
Lots of opportunity for swimming sports, outdoor activities
Excitement, activity, stimulation
Preserving and adding to "culture" challenge (crafts, arts, music)

Crime Control
Keeping crime as low as possible
A safe and decent society for our children to grow up in

After Knox (1978:14–15).

impact of tourist imagery or attitudes is worthy of investigation, and hypothesizes that

> Residents who tend to think of tourists as "groups" or "group animals" are much more likely to have negative attitudes than those who think of tourists as "singles" or individual human beings (1978:28).

In order to evaluate the hypothesis Knox employed a questionnaire with three slightly different forms: one form instructed the respondent to complete the questionnaire while thinking of tourists as a group, a second form instructed respondents to keep in mind the imagery of a single tourist or tourist couple, while the third form carried no explicit instructions. The results and the study revealed that people who followed the "single" imagery instructions were more likely to express pro-tourist attitudes on a variety of items and indices. People in the "no instructions" condition tended to have positive or negative attitudes towards tourists in about the same proportions as those who were instructed to keep a group image in mind. Importantly, Knox noted, but without amplification, that the instructions were effectively followed by only about half the respondents in each group. This inability to follow the instructions suggests that while images and social representations of tourists appear to exist and are important in shaping resident responses, they are not simply and easily changed by one or two minor instructions. Nevertheless, Knox observes that for the purpose of a pro-visitor public relations campaign in Hawaii it would be effective if the individual "instruction" or focus were to be adopted, rather than dwelling only on the more impersonal economic contribution of groups of visitors.

The scholarly work of Farrell (1982) approaches the topic of tourism–community relationships using historical data, some survey work, and extensive personal observation. Farrell describes four resident reactions to tourism: habituation, aggression, self-justifying commercial rip-offs, and establishing equality and credibility through achievement. Farrell suggests that there is a well-defined reaction of island communities to any outsider and one part of the resident reaction to tourists is that due to any outsider. This argument is analogous to that developed by Simmel (1950) in portraying the fears, anxieties, and sometime intimacy displayed by an ingroup to any stranger.

Farrell's historical analysis describes the transition of Hawaii from an agriculturally based economy to a tourism one. In 1960 the economic contributions of sugar, pineapples, and tourism were almost equal and were all less important than defense spending. By 1970 tourism was approaching defense spending as the leading economic contributor and had, in a decade, become three times more important than sugar and four times more important than pineapples. By 1980 the income from

tourism was double that of defense spending, six times more important than sugar and thirteen times more important than pineapples. This significant restructuring of the Hawaiian economy has not, according to Farrell, changed many of the attitudes and values engendered in earlier times.

In attempting to isolate the cause of community alienation, and Farrell believes that there is genuine resident disquiet, five factors are considered as priming agents. He argues that as island dwellers Hawaiian residents experience a sense of invasion and territorial awareness more readily than inhabitants of mainland communities. Further, the cultural heterogeneity of Hawaii sensitizes the community to cultural threats and imbalances so that some community subcultures are quick to feel culturally threatened. Additionally, visitor behavior is sometimes offensive and many Hawaiians raised in a morally conservative environment with a strong work ethic view the permissiveness and relative affluence of visitors as irritating. Farrell pays particular attention, however, to what he labels a "situation neocolonialism", a force that he feels is the most telling source of alienation in Hawaii's history. He argues that, in contemporary tourism, only the role players have changed and the new colonizers are the tourist, the developer, and the entrepreneur. At times, each of these groups is likely to be patronizing, paternalistic, and exploitative. Farrell thus advances a social representation of tourism as an echo of colonial power and argues that

> tourism may trigger what is really fundamental and deep seated disquiet. For the time being at least most hostility is directed towards the industry in the abstract and the tourists who symbolise it (1982:224),

and further,

> The real object of some or much hostility, for which the tourist is blamed, may be influential land companies, associated old establishment kamaaina families or the ever increasing streams of new mainland migrants (1982:236–237).

Farrell's analysis thus views the community disquiet as less pervasive than did Kent, but a recognizable similarity exists in the colonial exploitation social representation with Kent's whorism argument.

Additionally, Farrell's historical analysis produces a similar new kind of sugar representation to that explicit in Kent's work. Farrell argues that the relationship between tourism and agriculture in Hawaii is special and that they have a mutual need to support one another (cf. Bowen et al 1991; Cox and Fox 1991). Nevertheless, many agricultural companies see tourism business as a good commercial alternative, a new form of sugar in fact. For example, the Maui Land and Pineapple Company sees tourism as "the money tree", a new crop which is "a promising growth area" and "light at the end of the tunnel" (Farrell 1982:180).

The second methodological approach to the tourism–community relationship pursued by Farrell lies in reporting the results of some of the first quantitative surveys of resident reaction to tourism. Drawing on the work of Knox (1978), Farrell notes the strong negative feelings of respondents concerning crime, vice, morals, human relations, and crowding and environment. He further notes that of the 20 impact items labeled economic by Knox only six were seen as favorable. In considering this information Farrell makes a number of observations consistent with a social representations approach. He suggests that the structure of the social representations might well be different for anti-tourism forces and tourism supporters, noting that the former find many ways of expressing dissatisfaction while the latter stress a limited number of well-documented benefits. Farrell also observes that the importance of the impact items was not assessed in Knox's survey, thus the minor issues are juxtaposed with the crucial issues, which invalidates any simple count of the effects.

One particular finding which Farrell (1982) highlights from the Knox study is that

> our tourism research project survey found little or no difference between emotional attitudes and behavioural inclinations of those who had a tourism job in their family and those who did not (1982:231).

Farrell's reaction to this finding is fascinating and illustrates how researchers are subject to the power of social representations and biases in the genesis of their individual representations. Farrell writes:

> After a long period of working in Hawaii, I am convinced that in general those who stand to gain markedly from tourism have developed a different consciousness from those have not ... these persons (are) tourism advocates ... the greater the return from tourism, monetary or otherwise, the greater the recipient's positive response (1982:232).

Thus Farrell expresses the view that business interests and tourism beneficiaries have social representations unlike those prevailing in the broader community, despite Knox's evidence that this is not valid. Farrell's commitment to this position is a good example of the power of sustained personal experience to define representation, in this case the perspective that tourism business people view the tourism–community relationship differently to others. Perhaps Knox's data are flawed, and other studies may reveal that Farrell's (1982) view, consistent with a social exchange approach, is supported by other more subtle survey data. The subtlety in this argument may be the difference between working in tourism at a low level and benefitting from tourism in an entrepreneurial or executive capacity. Tourism workers may be less inclined to operate according to an exchange model since they consider

other community costs to a greater extent than the executive and entrepreneur group who focus on their own significant and larger economic returns.

A second survey-based analysis of Hawaiian tourism was also conducted in 1982 but not published until 4 years later (Liu and Var, 1986). In Fall 1982, Liu and Var mailed 3,000 questionnaires to residents of Oahu, Hawaii, Maui, and Kauai. Respondents were asked to answer 115 questions, 51 of which were specified items on tourism impacts. Over 600 questionnaires were returned, representing a 20% response rate which the authors felt was "excellent and has ensured a more than sufficient number of responses for statistical validity of the results". The authors also report confidence in their findings despite the sample being skewed towards older age categories, Caucasians, higher education levels, higher family income groups, and residents who were not born in Hawaii. Arguably these sample trends might, in Liu and Var's phrase, affect the results by "not more than a few percentage points in either direction".

The Liu and Var study is remarkable in a number of ways. Clearly the researchers had some strong views on what to include as tourism impacts and how to organize and present the data on their resident perception of impacts. The study risks, however, being described as data rich and information poor. The researchers do not acknowledge any particular source for their 51 items despite, as has already been discussed, the emic and varied work on this topic in the work of Kent (1975), Farrell (1982), and Knox (1978). Despite the recommendations of Knox, they fail to consider the structure of residents' responses and there is no importance ratings for the 51 impacts. Even more curious is the attempt by the authors to structure three areas of impact: economic, sociocultural and ecological. As an initial organizing device this might be appealing, but the lists of impacts provided under these headings contain several items which could easily be transferred to another list. As argued in *chapter 3*, this kind of work fails to do justice to the content and organization of community reactions to tourism. It does not consider any emic, spontaneously generated information, it fails to consider the importance of different tourism impacts, and it does not provide any grasp of how the residents connect the tourism impacts.

Understandably, the authors struggle to write a sensible conclusion to their article. Armed with a mass of data they attempt to provide a broad construction of the results with the claim that in terms of importance:

a high standard > environmental > economic > social > cultural
 of living protection benefits costs benefits

This curious juxtaposition somehow separates economic benefits and a high standard of living and is based on the ordering of the respondents' agreement (in percentages) to select items from the economic and ecological impacts tables. The structure and organization of resident responses into meaningful emically generated groupings are sorely needed to organize the findings of this study. The strong possibility exists that the authors are merely reporting percentage differences in item agreement which are due to the form of the question and its context rather than meaningful patterns of community attitudes. In the platform of findings relating demographic variables to the individual impact items, Liu and Var state:

> it is surprising that respondents who work in the industry did not respond differently from those who hold nontourism-related jobs (1986:201).

Judging by Liu and Var's comment juxtaposed with Farrell's earlier view, it appears that this lack of evidence contradicts the expectations of tourism researchers.

The importance of considering the social representation issue relating to the consensus or commonality of respondents' opinions is particularly well illustrated in the Liu and Var study. The abstract of the article rather blandly asserts,

> residents regard environmental protection as being a more important priority than the economic benefits of tourism, but are not willing to lower their standard of living in order to achieve this goal (1986:193).

In interpreting this summary it should be recalled that Liu and Var obtained a 20% response rate to their questionnaire and affluent, executive Caucasian residents were over-represented in their sample. Even amongst this group it was actually 41% of respondents who still agreed with the item:

> A lower standard of living is worth the cost of a protected environment.

By focusing attention on the content, structure, and commonality of responses, social representations theory would suggest that Liu and Var's study should be taken as indicating a much greater concern for industry and government alarm than do the authors.

Perhaps as a measure of the sophistication of the tourism industry in Hawaii, perhaps as a result of previous research and media attention, a Statewide Tourism Impact Core Survey was conducted throughout Hawaii in 1988. This substantial study of over 3,900 adult residents was designed on a population-weighted basis to cover 23 sampling areas of Hawaii with very low error rates (e.g., plus or minus 2.5%) for the dominant population area of Oahu. For the purposes of

referring to their study it will be labeled the DBED study (in detail The Tourism Branch of the Hawaii State Department of Business and Economic Development study conducted in 1988 but published in 1989). The historical context of the 1988 survey is presented in Table 4.2.

The initial and startling conclusion of the DBED study was that despite believing that tourism has been good for them and good for the state, majorities opposed further hotel development and majorities or near majorities did not even favor more tourism jobs. As with all puzzling or ambiguous results, the search for an explanation of the findings can proceed in several directions. The excellent sampling frame of the study and the use of multiple cross-referenced questions in the DBED study

Table 4.2. Historical Context of 1988 Survey

Statewide: Hawaii's economy had been growing since 1983. Unemployment was down to 3.1% at mid-year; a tight labor market. Visitor arrivals had not increased greatly since 1986 but visitor spending was substantially up. More Japanese visitors with higher average per capita spending and fewer Mainland/Canadian tourists. Relatively few visitors from other countries.

Oahu. Occupancy rates in Waikiki, which had been down in the early 1980s, were now very healthy. The "facelift" of the area, reflecting substantial private and public funds, had worked and the surge in Japanese tourism had benefitted Waikiki. Few major hotels were yet located outside Waikiki; with three notable exceptions. Earlier in 1988 the need for and location of a convention center had been hotly debated. Throughout the year there was substantial press coverage of large-scale Japanese investment in real estate including hotels and golf courses. (The debate had occurred statewide but was particularly intense on Oahu.)

Maui County. With the August 1987 opening of the 762 unit Westin Maui the labor shortage on Maui was acute. Press coverage on Maui focused on recurrent complaints about West Maui traffic and island-wide housing shortages. Four other new hotels under construction as of mid-1988 raised fears of increasing conditions. There was some discussion of a possible hotel-building moratorium.

Kauai County. The new Westin Kauai had opened in late 1987, attracting workers from other hotels. Also, hotel occupancy rates fell during 1987 and early 1988. Traffic congestion was a reported problem (a new by-pass opened after the survey was completed). The Fall elections following this survey resulted in the replacement of the pro-growth administration with a new controlled growth administration.

Hawaii County. The 1250 room Hyatt Regency, Waikoloa, was under construction, opening a few months after survey completion. There was substantial publicity about thousands of other planned or proposed resort units. One initiative involving changing land zoning from a state park to hotel development was also newsworthy. Unemployment remained higher than on other islands and the future of sugar operations in the area looked increasingly uncertain.

Source: Department of Business and Economic Development study (1989:2–3).

ensured that methodological flaws were an unlikely source of the contradictory findings. The researchers examined other findings in the study in order to identify possible reasons which they felt would be rooted in the everyday experiences of the residents.

Effectively, one dominant social representation of tourism with two major features was identified by considering the structure and linkages between survey questions. The first feature is identified by a cluster of responses which can be labeled as Tourism—the socioeconomic growth generator, the engine of Hawaii's development. Many residents saw tourism as having some very positive impacts for the community as a whole; for example, 82% thought tourism had improved the availability of jobs, 63% thought the overall standard of living was higher, and 60% thought tourism had brought better shopping, entertainment, and restaurants for residents.

Questions about the impacts of tourism were asked at a personal level as well as at a community or "your part of the island" level. Data in Table 4.3 consist of percentages of residents who, having answered the question as to whether tourism was good or bad for them personally, were then asked to explain how it was good or bad.

Table 4.3. Residents' Explanations as to Why Tourism has been Personally Good or Bad for Them

A. Explanations pertaining to the **good** effects of tourism

	State of Hawaii	County			
		Oahu	Hawaii	Maui	Kauai
Job/Economic Issues	78[a]	76	77	87	86
Positive Personal Interactions	11	11	12	10	13
Social Cultural Factors	5	5	4	3	2
Services/Amenities	3	3	3	3	2
Environmental Benefits	1	1	2	1	1

B. Explanations pertaining to the **bad** effects of tourism

	State of Hawaii	County			
		Oahu	Hawaii	Maui	Kauai
Job/Economic Issues	31[a]	33	19	28	23
Traffic/Driving Problems	23	21	16	35	31
Compete for Resources	18	17	22	18	24
Tourist Behavior	17	13	18	13	16
Non-Traffic Congestion	16	16	13	18	33

[a]Numbers refer to column percentages. Percentage may exceed 100 owing to multiple responses. Column percentages less than 100 are due to minor categories not listed here.

There is a dual and dynamic quality inherent in the social representation of tourism. At an individual level residents may be divided about the personal benefits or costs of tourism but in either case economic concerns dominate. When asked to evaluate tourism at the island or community level the positive effects of tourism are largely economic (jobs, overall standard of living) but so are the reported negative effects (the cost of housing, food and clothing costs, traffic and population growth). The DBED study points to the dynamic nature of the "engine of growth" tourism representations with the comments:

> Jobs are a top priority for individual and community survival. Tourism has played a major role in meeting that need for many communities. When the basic need is met attention turns to other needs, or to the negative tourism side effects which once seemed less important.

Further, the DBED study argues that it might be useful to view the survey findings as suggesting a "hierarchy of community needs" or, expressed a little differently, as containing a well-structured, organized dynamic social representation. Viewed in this way, the problem of tourism impacts, at least in Hawaii, are partly the problem of raised community expectations caused by the prosperity generated by tourism. For the managers of Hawaiian tourism the DBED study points out that identifying and ameliorating these second-order problems, the problems caused by prosperity, remains an important goal since resident irritation could reduce support for existing tourism. Such reduced support could expose the industry to a period of decline from internal social factors irrespective of the pressures of external economic and market forces.

Resident concerns about the quality of tourism jobs are also identified as an organized cluster of responses in the DBED study. These concerns, echoing earlier social representations of the characteristics of employment in tourism in Hawaii, are presented in Table 4.4.

When answers from people who described themselves as "in the visitor industry" were compared with other Hawaiian residents, highly similar attitudes towards tourism jobs were reported. Additionally, few "don't know" responses were given by the visitor industry employees.

The detailed demographic analyses available in the DBED study, including material available in a special advice for "demographic and social researchers" enables a holistic view of which community subgroups hold key perceptions to be constructed. Five ethnic categories are used in these analyses—Caucasian, Filipino, Hawaiian, Japanese, Other/Mixed—together with five income levels, as well as the four counties of Hawaii; age, and length of time resident in Hawaii. In order to appreciate the linked nature of these individual variables it should be observed that there are more Caucasian and Japanese occupants in

Table 4.4. Statewide Perceptions of Visitor Industry Jobs in Hawaii

	Agree	Disagree	Don't Know
People wanting to be tourism managers can get good training in Hawaii	67	12	20
There is a wide variety of jobs in Hawaii's visitor industry	73	17	11
Tourism jobs have poor work hours and a good chance of being laid off part of the year	55	27	18
Most tourism jobs don't have much chance of advancement	45	30	24
Most visitor industry jobs pay pretty well	38	38	24
Most visitor industry managers are people from Hawaii these days	37	37	26
People from Hawaii have a hard time competing with outsiders for the best tourism jobs	40	42	18
Visitors usually treat tourism workers like servants	33	47	21
If I had a bright child going into college I'd encourage the child to study visitor industry management	35	57	7

Derived from DBED study (1989).

Oahu, and that Japanese and Caucasian residents generally have higher incomes and lower employment in tourism. By using the percentage agreement with the statement "Visitors usually treat tourism workers like servants" as a central emotive item from the survey responses, akin to the social representations of tourism as whorism (Kent, 1975) and "situational neocolonialism" (Farrell, 1982), and juxtaposing this item with other employment questions, some clear patterns of how tourism jobs are seen in Hawaii can be outlined (refer to Table 4.5).

By exploring the data in Table 4.5, it is apparent that there is a grouping of attitudes among ethnic Hawaiian and Filipino residents. These residents, who together comprise over a quarter of the total Hawaiian population, value the pay from tourism jobs but see them as difficult to get, requiring education, and having some undesirable social characteristics. Filipino residents and ethnic Hawaiians were slightly more likely to have had or currently hold a tourism job than other residents, thus their views are based (in at least 50% of cases) on personal tourism job experiences. In integrating and making sense of the tourism employ-

Table 4.5. Perceptions of Visitor Industry Jobs by Ethnicity and Household Income

Statement	Ethnic background	Percent agreement by			
		Income		County	
Visitors treat tourism	Caucasian	31	$40k+	27	Not available
workers as servants	Japanese	25	$30–40k	34	
	Other/Mixed	36	$20–30k	36	
	Hawaiian	39	$10–20k	39	
	Filipino	39	Under $10k	33	
		Overall agreement 33%			
People from Hawaii	Caucasian	36	$40k+	33	Oahu 39
have a hard time	Japanese	30	$30–40k	45	Hawaii 40
competing with	Other/Mixed	41	$20–30k	42	Maui 43
outsiders for the best	Hawaiian	52	$10–20k	39	Kauai 47
tourism jobs	Filipino	48	Under $10k	51	
		Overall agreement 40%			
Most visitor industry	Caucasian	27	$40k+	33	Oahu 35
jobs pay pretty well	Japanese	42	$30–40k	38	Hawaii 40
	Other/Mixed	38	$20–30k	38	Maui 52
	Hawaiian	46	$10–20k	35	Kauai 55
	Filipino	52	Under $10k	46	
		Overall agreement 42%			
If I had a bright child	Caucasian	28	$40k+	32	Oahu 35
going into college I'd	Japanese	30	$30–40k	31	Hawaii 36
encourage that child to	Other/Mixed	39	$20–30k	33	Maui 40
study visitor industry	Hawaiian	43	$10–20k	41	Kauai 39
management	Filipino	51	Under $10k	44	
		Overall agreement 37%			

Derived from DBED study (1989), Volume 3: Results for Demographers and Social Researchers. Tables IV–B13, B15, B21, B22, B25, B26 and (Summary Report) Figures 9 and 10.
The statewide sample of 3904 yielded a sample error of plus or minus 1.6%. For three or four-way breakdowns, such as at the County level, the error rises to a high of plus or minus 3.5%. The data in the above table can be interpreted as indicating reliable differences where there are 4% point differences in the scores.

ment-related attitudes it would appear to be worthwhile to see a select group of less privileged residents, particularly Kauai and Maui inhabitants, as sharing the social representation that tourism jobs, while desirable, have some demeaning servant-like qualities, a representation which may in part explain the hesitancy of the respondents to embrace tourism and further tourism employment in Hawaii.

The evidence for other competing or alternative social representations of tourism in the DBED survey data is less compelling. Most residents do not perceive tourism as intruding too much on their daily lives (except for the single issue of traffic congestion) and, indeed, people make significant use of amenities provided by the tourist industry. One secondary area of intrusion which was reported was the loss of or diminished amenity in some outdoor recreation areas but conversely these areas were also noted as the most frequent sites for pleasant interaction with visitors. In brief, there is not adequate evidence in the survey data to support the construction of a social representation relating to an invading horde of tourists violating island territorial imperatives. Similarly, the debate about the continued existence of the Aloha spirit and the reporting of friction between hosts and guests is only a minor consideration in the survey findings. Residents appear equally divided as to whether or not Aloha is diminishing or is about the same, and there is no clear agreement that tourism, rather than other factors, is particularly responsible for this situation.

The DBED study thus provides evidence for one strong social representation of tourism: tourism as the engine of Hawaii's overall economic growth, a job provider with some dubious qualities. These representations, documented by the interconnected attitudinal responses of over 3,000 residents, thus reinforce some of the earlier representations of Kent and Farrell and help to clarify the duality and confusion in the Liu and Var study by providing information on the relative importance of the impacts and noting the distinction between individual and community levels of response. Little evidence exists in the DBED study for Farrell's analysis of territorial invasion or offensive visitor behavior. Arguably, most elements of Kent's appraisal of tourism as a new kind of sugar are subsumed in the tourism as the engine of Hawaii's growth representation as both emphasize the two-sided, dynamic nature of tourism's contribution to Hawaii's development.

It is appropriate to reflect, albeit briefly, on the achievements of the social representations approach to the Hawaiian studies. The approach has been able to make sense of the existing individual findings, it has provided a degree of integration by examining the continuity of representations across the historically linked studies, and it has provided some methodological insights on the content and structure of residents' responses which heighten the interpretation of the existing material. It should be clearly acknowledged, however, that the extent to which residents continuously use the social representations that have been identified has not been established, although by inference and from the consistency of their responses it appears that such usage is a genuine possibility. Further, despite providing some broad contextual information on the state of Hawaiian tourism it was not possible to identify

the role of the media in promulgating these representations, nor was there enough open-ended data to investigate the processes of anchoring and objectification which are central to the formation of social representations. By way of contrast, all of the Hawaiian data based studies failed to find any evidence that an equity or social-exchange approach explained resident reactions. The lack of social evidence has already been outlined for the Knox and Liu and Var data and finds further expression in the DBED study from the following linked comments:

> ... simply having a tourism job (or even perceiving that family income depends on tourists) was less related to basic attitudes about tourism than was household income ... people who had prospered in the current economy were more likely to feel tourism has been good for Hawaii (1989:4).

and

> Popular opinion about tourism impact should not be confused with objective truth. "Conventional wisdom" about tourism impact can simply be mistaken in some instances (1989:15).

The insights and interpretations offered in the DBED study are buttressed by a powerful case study of tourism and resort development on the island of Moloka'i. Canan and Hennessy (1989), working within a tradition of rural and community sociology and largely ignoring the parallel tourism literature, discuss the tension among groups of island residents. Basing their analysis on the work of Molotch (1976) and his colleagues (Molotch and Logan 1984; Logan and Molotch 1987), the authors argue that communities may be subdivided according to their interests in the management of land. Following Molotch, Canan and Hennessy identify a "growth machine" which is a coalition of two groups who are likely to benefit from land development: the first consists of direct beneficiaries such as land owners, speculators and investors, while the second aligned group is "statesmen"—the bankers, owners of secondary industries and persons benefitting from overall rather than specific growth. Other local residents are likely to have different interests in the use of the land and may oppose or support development according to their values and related social identities.

It is readily apparent that Canan and Hennesy's application of Molotch's growth machine notion is consistent with the DBED study. The social representation of tourism as an engine of growth was constructed quite independently of Molotch's approach or Canan and Hennesy's work and the different levels of support for this representation were foreshadowed in the original study. Canan and Hennessy's case study provides data to support their own conceptual analysis. By focusing on the organization of residents' values Canan and Hennessy provide an empirical demonstration of a social representations approach.

The central question asked in their empirical study was: will three groups of residents (locals opposed to development, locals supporting development, and decision makers) really have three different value structures? In the language of social representations the question becomes one of: is the organization of the values and attitudes of the three groups clearly distinct and likely to be reflecting a different organization of knowledge about tourism and communities? The researchers employed what they describe as a Galileo approach to the task. This methodological style involved three steps, starting with a sound emic approach of defining the important value concepts for the population in question. Taped interviews lasting from 1 to 2.5 h were content analyzed and 13 common and representative concepts (such as slow pace, family togetherness, jobs, and preferred way of life) were used as the basis for further analysis. In the second step a simple random sample of Molokai residents and 29 key decision makers was then asked to rank the similarity of pairs of concepts including the label "me" to reflect individual identification with the 13 cultural and economic values. Finally, spatial plots of the organization and similarity of the values were prepared which indicated that the three groups of residents did indeed see the world from different value perspectives. The plots confirm the existence of linked systems of knowledge and personal identification with certain values. In effect, three social representations of tourism exist in the Molokai community, with the business community closely identifying with the jobs and development values. Importantly, however, this group actually divides and reorganizes the cultural values differently from the other groups, not viewing such values as slow pace and rural as opposed to development but rather incorporating such values into the core development push. By way of contrast, supporters of limited types of development see the maintenance of Hawaiian culture, family togetherness and jobs as linked items but not as a part of the tourism development grouping of values. For this group economic prosperity and one's way of life are not tourism linked or dependent, effectively a different social representation from that evident in the shared thinking of the developer community. The second group, supporters of diverse types of development, generally show less differentiation in the total organization of the 13 value statements and place themselves in a moderate position located between all-out involvement in tourism growth and substantial orientation to preserving existing land and cultural lifestyle. Nevertheless, the fact that this group's value structure is not strongly polarized enables them to adapt their views to specific developments on a case-by-case basis; thus their social representation plays a flexible and utilitarian role.

Canan and Hennessy conclude their work with the observation that there are internal contradictions in the growth machine social repre-

sentation of tourism since it links tourism, development, and high prices, but does not differentiate these values from an enduring belief in the community togetherness, family connections, Hawaiian culture, and pace of life. Arguably, the growth machine social representation is naively accepting that all values can be maintained in the future as tourism grows rather than holding a linked system of beliefs and knowledge which highlights the need for management and careful nurturing of the traditional values while the economic progress is in full swing. As with the Brazilian case study of housing development described in *chapter 3* it is again valuable to note how a detailed exposition of the social representation of community subgroups promises to be an advantage for constructing strategies to facilitate the design and development process. Further discussion of these kinds of planning implications of the present work and the use of social representation as a pre-planning tool to describe community views of tourism will be pursued in *chapter 6* of this book.

A Second Case Study: New Zealand

The growth in international visitor numbers to New Zealand, in common with many other Pacific destinations, was quite spectacular in the 1980s (Hall, 1994; D. Pearce, 1990). In 1980 almost 450,000 visitors came to New Zealand whereas by 1992 almost 1.3 million visitors were recorded. In New Zealand, with a domestic population of just over 3 million and a largely rural economic base, this growing industry presently accounts for 14% of total exports. The high growth rates are dispersed unevenly. In the North Island substantial growth (over 40% in the 1980s) has occurred in the thermal springs resort town of Rotorua, in Auckland, the country's main gateway and largest city, in the east coast yachting and fishing villages of Paihia/Russell and Whitanga, and in the Central lake resort region of Taupo. On the South Island dramatic growth has occurred predominantly in the mountain and lake-based scenic resorts of Queenstown and Te Anau, with the gateway city of Christchurch also benefitting from the increased tourism flows (see Map 4.2).

The pattern of international arrivals to New Zealand has also changed. While Australians remain the most numerous (34.5%), stay the longest and in total spend the most (27%), the number of short-stay, high-spending Japanese tourists has increased to 13% of the market in numbers and 15% in expenditure. Visitors from the USA and Canada together account for 16% of the market and 19% of expenditure, while European and other Asian visitors have also been increasing both in

Map 4.2

numbers and as a share of total expenditure (Hall, 1994). D. Pearce reports that the

> marked concentration of the Japanese demand stands in sharp contrast to the more dispersed patterns of the Australians, British and Germans The Americans constitute something of an intermediate group (1990:36).

Japanese and to a lesser extent North American holidaymakers are concentrated in Auckland, Christchurch, Rotorua, and Queenstown. Secondary destinations such as Wellington, Dunedin, Gisborne, and Hokitika are more likely to be visited by Australians, British, and other European visitors.

In an early study of the public support for international tourism in New Zealand, Mings (1980) analyzed government reports, academic papers, and industry material. He found a distinct lack of any critical or hostile reactions to tourism in any of these sources and noted, effectively, a hegemonic social representation which was broadly based and consistent in its support for tourism. Criticism of the industry was limited and there was no organized opposition to the growth and development of New Zealand tourism. The growth of tourism in New Zealand in the 1980s and the government's plans to support further growth of international tourism—a target of 3 million visits by the year 2000 has been advanced—have jointly prompted the need to re-assess the comforting and supportive community reactions of earlier times.

In 1991 the Ministry of Tourism, as a part of its brief to ensure sustainable long-term development, commissioned research into residents' attitudes to tourism which included three objectives: providing information on resident attitudes which could be linked to earlier surveys, obtaining resident perspectives on issues such as tourism, growth, investment, and the capacity of visitor facilities, and finally exposing any myths or misunderstandings on tourism issues held by New Zealanders. In August 1992 a 62 page report summarizing the findings from 1485 residents was released under the title "Residents' Perceptions and Acceptance of Tourism in Selected New Zealand Communities" (hereafter called the Ministry of Tourism 1992 report).

For the purposes of this monograph and this particular chapter the central issues here are how might a social representations approach advance or improve understanding of this completed project and how might further work in New Zealand benefit from the insights of social representation perspectives. Regrettably, the Ministry of Tourism report did not collect the kind of data which would allow the nature and extent of New Zealanders' social representations of tourism to be demonstrated fully. There are some possibilities, hints and approximations to this goal but they are partial rather than complete answers. In the absence of being able to provide a complete documentation of the New Zealanders' social representation of tourism, three important contributions from the general social representations perspective still remain for this reported material. First, the value of exploring the consensus or commonality of New Zealanders' reactions to tourism can be highlighted. Additionally, by attending to the content and structure of the responses in the questionnaire, including the methodological details of how the

respondents were sampled, some of the existing interpretations of the data can be questioned and alternative explanations outlined. Finally, some suggestions on how to advance the study of resident responses can be derived from the social representations framework of this monograph.

The Ministry of Tourism report examined 15 locations in New Zealand, 13 of which had been studied in two previous Ministry surveys. There were 404 residents sampled in Auckland, 201 in Christchurch, 200 in Wellington and 72 in Dunedin, while between 54 and 57 residents responded in each of the other locations. With small sample sizes in the regional locations considerable care must be exercised in interpreting the data. Fourteen statements about tourism (refer to Table 4.6) form the core of the report, with residents being asked to agree or disagree with a mix of impact style items such as "Tourism has created jobs in your area" and "Tourism creates traffic congestion and parking problems in your area", as well as items containing a more managerial, future scenarios style including "Your area should be promoted to attract many more overseas visitors" and "Your area should have a casino to attract more overseas visitors". The Ministry of Tourism Report provides a nation-wide view of New Zealanders' responses to the 14 items, constructing a Tourism Acceptance Index (the extent of agreement with each of the statements) as an integrating label for these items. The findings of the report are couched in terms of an overall view that tourism has a positive impact, particularly in relation to job creation, widely distributed benefits and cultural benefits. The authors favor a seasonality and dependence on tourism account to explain regional differences, arguing that:

> dependence on tourism leads to positive attitudes towards tourism but these may be prejudiced in localities in which seasonality is high where the negative consequences of the influx of annual holiday makers influences the view of local residents (1992:3).

The Ministry report presents data from each of the regions independently and contrasts changes over the three surveys, as well as noting and explaining the differences among regions.

The social representations framework directs attention to the consensus of residents' responses. The data in the Ministry report are presented in percentages and the report frequently focuses on changes in these percentages for regions across select impact or tourism initiatives. With sample sizes of 54–57 for the smaller communities, these percentages tend to inflate the difference being recorded. Statistically, with sample sizes in the mid 50s, it requires a 20% difference in the cells for between-region or between-attribute ratings to be reliably different. Treating each row of Table 4.6 as an extended 13×2 cross-tabulation table, the missing data being the percentage not agreeing with the

Table 4.6. Percentage Agreement with Tourism Statements by Residents of 13 New Zealanders Communities

Tourism statement	Auckland	Wellington	Christchurch	Dunedin	Rotorua	Gisborne	Hokitika	Te Anua	Taupo	Paiha/Russell	Wanaka	Whitianga	Queenstown	Mean Score \bar{X}
Tourism has created jobs in your area	71	71	77	70	81	67	84	88	82	83	83	76	88	76
Tourism creates opportunities to meet people from different cultures in your city or town	81	79	81	78	78	86	79	85	82	81	77	84	76	81
Your area should be promoted to attract many more overseas visitors	78	81	81	85	86	85	85	83	78	83	75	76	74	80
The benefits of tourism get distributed widely through your city or town's economy	67	66	70	69	69	71	77	81	75	71	76	71	71	70
Shopping hours should be extended in your area to cater for visitors	61	64	56	62	67	64	64	61	56	66	59	71	50	61
Your area should have a casino to attract more overseas visitors	57	53	58	50	53	46	37	48	51	47	37	34	51	51
Your area should offer more nightlife to attract overseas visitors	68	67	66	71	74	75	66	73	67	71	57	57	48	67
Ratepayers have to pay too much towards facilities used by tourists in your area	30	28	27	24	30	25	27	32	33	41	31	32	36	29
Tourism has increased the cost of living in your area	25	23	25	20	29	21	22	40	37	47	45	39	49	28
The development of tourist facilities and attractions is a threat to your local environment	26	23	26	23	22	23	20	28	26	33	32	30	36	26
Tourism creates traffic congestion and parking problems in your area	24	21	21	19	28	23	24	40	53	47	35	45	48	28
Tourism makes you feel like a stranger in your own town	19	16	19	14	17	15	18	22	25	24	23	24	25	19
Overseas visitors have made your area too expensive for New Zealanders to holiday in	30	25	30	25	26	20	28	26	29	32	23	25	36	27
New Zealanders on holiday in your area are a real nuisance at certain times of the year	20	18	19	19	21	21	19	20	39	31	34	35	30	23

attribute, the required significant differences in the table can be computed. Two possibilities emerge from this recalculation. For a significant difference to exist in any row of Table 4.6 there must be a 20% variation in the range of the scores in the row. Or, alternatively, if there are two or three items which are 10–15% different to other items in the row (effectively a bimodal distribution or an outlying cluster of scores), then a significant difference may also be obtained. The focus on consensus, the desire to see which constructs really contain differences, leads to a more stringent and cautious interpretation of the New Zealand data than that advanced in the Ministry report. In Table 4.6 only the shaded cells are reliably different from other cells in that row. Table 4.7 presents a summary of those constructs which are uniform, show slight variation or considerable variation in New Zealanders' perception of tourism.

The material presented in Table 4.7 provides a slightly sharper focus on how New Zealanders agree and disagree on tourism topics. There is a national consensus that favors more nightlife and promotion as initiatives, and sees the tourism benefits as spreading money through the community and meeting people, while agreeing that environmental and social alienation pressures are low and tourism destinations are not yet

Table 4.7. The Amount of Consensus in New Zealanders' Perceptions of Tourism Impacts and Initiatives

No Significant Variation

- Tourism creates opportunities to meet people from different cultures in your city or town.
- Your area should be promoted to attract many more overseas visitors.
- The benefits of tourism get distributed widely through your city or town's economy.
- Your area should offer more nightlife to attract overseas visitors.
- The development of tourism facilities and attractions is a threat to your local environment (low uniform agreement).
- Tourism makes you feel like a stranger in your own town (low uniform agreement).
- Overseas visitors have made your area too expensive for New Zealanders to holiday in (low uniform agreement).

Single Cases Of Significant Variation

- Shopping hours should be extended in your area to cater for visitors.
- Ratepayers have to pay too much towards facilities used by tourists in your area.

Repeated Significant Variation

- Tourism has created jobs in your area.
- Your area should have a casino to attract more overseas visitors.
- Tourism creates traffic congestion and parking problems in your area.
- New Zealanders on holiday in your area are a real nuisance at certain times of the year.

too expensive for New Zealanders. Overall, the consensus responses offer a kind of warm, yet differentiated and positive feeling towards tourism. When the lack of consensus responses are considered more personal, immediate and hard-hitting issues emerge. There is a lack of national consensus that tourism creates jobs, disagreement as to whether the cost of living has risen or that traffic congestion is worse, and diversity as to whether fellow New Zealanders are a nuisance at times and whether or not a casino should be built in the local area.

In Table 4.6 an interesting block of data can be distinguished within the total matrix. Residents in the cities of Auckland, Wellington, Christchurch, Dunedin, and Rotorua do not provide responses which are significantly different at the stringent levels of statistical significance discussed earlier. By way of contrast, the residents of the smaller communities which comprise the rest of the table do hold views on at least one variable and sometimes on several variables which are distinctive and which vary significantly from the national average. By adopting a social representations perspective and a consensus orientation to the Ministry data it can be suggested that it is not, as the report itself suggests, a matter of dependence and seasonality of tourism which relates to resident responses but the issue of small community size and consequently the visibility of tourism effects.

As a second tactic for providing insights into the New Zealand data the emphasis in the social representations approach on the structure and context of residents responses can be pursued. In this framework, researchers should pay attention to the interconnected network of ideas and images about tourism which residents hold, and attempt to connect these images to studies of impacts. It has already been noted that the structure and composition of international visitors to New Zealand has changed in the last decade. Additional exploration of these data enables further insights into the New Zealanders' social representations of tourism.

In the Ministry survey respondents were asked how much they would approve or disapprove if twice as many visitors of particular nationalities were to come to New Zealand over the next few years. While there was majority approval for expansion of visitors from all nationalities, a clearly expressed preference for certain groups can be extracted from these data. Again, the original data in the Ministry report were reconsidered. By establishing cut-off points for significant differences New Zealanders' perceptions of the national groups, a hierarchy of preferred visitors to New Zealand was established.

These preferences for the country of origin of future New Zealand tourists were also mirrored in New Zealanders' attitudes toward encouraging tourism investment from various countries, as portrayed in Table 4.8.

Table 4.8. Resident Views of Preferred Nationalities in the Future of New Zealand Tourism

Most preferred	Canadian, British
Preferred	Australian
Less preferred	German, American (USA)
Least preferred	Japanese

Significant differences lie between responses to Canadian and British visitors, and German, US, and Japanese visitors.
Additional significant differences lie between the preference for Australian visitors and Japanese visitors.
Further significant differences lie between the German and US visitors, and Japanese visitors.

Table 4.9. Resident Views of Preferred Investment in the Future of New Zealand Tourism

Most preferred	Australian, British
Preferred	US, European
Least preferred	Japanese, other Asian

Significant differences lie between responses to Australians and Britons, and all other nationalities.
Significant differences lie between responses to US and European visitors, and Japanese and other Asian visitors.

While it would be rather speculative to go too far beyond the existing data, it is clear that New Zealanders are expressing a preference for a future tourism industry which, if possible, has visitors who share New Zealanders' heritage supported by investment from these same countries (Table 4.9). One could further suggest that two social representations of tourism may be driving this set of responses: tourism which is traditional, dispersed, somewhat invisible, and Commonwealth country connected, versus tourism which is concentrated, short stay, ethnically diverse, and more conspicuous. One further point of evidence to reinforce this possible interpretation lies in residents' responses to the question of what types of new facilities are needed for visitors, with one set of responses favoring the development of low-key recreation-based amenities and a smaller proportion of respondents listing multilingual services, upmarket hotels/motels/restaurants, and better quality service.

The preceding examination of the Ministry report on resident reaction in New Zealand has revealed that a social representations framework provides some novel insights into the information collected by focusing on resident consensus and the structure and context of residents' responses. While it was not possible to make explicit the social representations of residents from the available data, some evidence was examined which suggested at least two perspectives. While other chapters in this book will explicitly examine how to improve studies of resident reactions to tourism of the type described here, it would at least be apposite to suggest that future work on this topic in New Zealand examine a wider range of impacts and more diverse future tourism scenarios which effectively distinguish the types of tourists and tourism involved. The low power of the 1992 Ministry study, resulting from the small sample sizes in the rural locations, should also be reconsidered. It might be more insightful, for example, to improve the understanding of what residents think and what they want in fewer sites, explored in more detail, rather than providing the present nation-wide coverage with a limited capacity to provide compelling statistical explanations within and across regions.

Summary

This journey through two tourist locations and a variety of tourism studies has done much to illustrate the value and generality of the social representations approach when confronted with existing analyses. The examples selected were judged to be particularly valuable because of the range of methodological styles they contain and the different kinds of points that can be made about the social representations approach from these case studies. In this chapter, social representations can be seen as a valuable integrating theoretical approach, able to deal with material ranging from a journalistic and impressionistic style to highly quantitative material. Importantly, the social representations approach has been shown at times to reinforce existing interpretations of the data, but on other occasions it has helped to clarify and sharpen the interpretation of findings. For example, in appraising the New Zealand data on resident response to tourism it was argued that small community size and the visibility of tourism effects provide better explanations of the data than seasonality and dependence on tourism variables. This reinterpretation of the results was reached by paying attention to the commonality of the social representations inherent in all the small towns.

Both of the case studies reported in this chapter confirm the potential of using a social representation framework as a predevelopment or planning tool in order that a rich array of community values towards tourism may be amply described. Additionally, the studies reviewed confirm the

value of the social representations framework in seeing tourism impacts as a part of a network of tourism-related ideas. In effect, the present approach elevates studies of the impact of tourism from simply recording tourism problems to the more challenging role of exploring the network of ideas associated with tourism impacts, thus fostering problem analysis and potentially problem resolution. Importantly, the social representation approach identifies differences in community groups which were not readily obvious (such as among tourism entrepreneurs and tourism employees, among Hawaiian ethnic groups, and among residents of large and small New Zealand towns). Thus the present framework can identify important groups of people holding different views of how tourism works, thus opening the way for effectively targetting persuasive communication efforts and negotiation in the tourism planning process. It is the core argument of this volume that it is highly desirable to know the different views held about tourism and work with these views in the planning process rather than simply working with predefined groups of people who are erroneously assumed to hold different views. The results from the present chapter suggest that different social representations are likely to be held by tourism developers and beneficiaries, tourism workers, the broad community and specific community groups with strongly identified moral and ethnic traditions. It is necessary, however, to re-establish the relevance of these groupings in each tourism planning study, otherwise the flexibility and power of the social representations approach will be lost if a formula-style approach to defining important community groups is pursued too mechanically.

Chapter 5

Social Representations in Action: Australian Examples

This chapter will consider four case studies which are drawn from the North Queensland region of Australia. Unlike the previous chapter where the case studies were conducted in very different locations, by different researchers using different methods, the material presented in this chapter is conducted by the same research team and covers a single region in some depth. Nevertheless, there is considerable diversity in the four tourism–community relationships to be explored. Additionally, the data collected in the four studies were informed to some extent by ideas from the social representations framework, thus providing a more focused opportunity to review the value of this approach.

It is important to note that the four studies were not limited to a consideration of tourism's impacts. Rather, the four studies are much more akin to the kinds of tourism planning and consensus policy work advocated by Murphy (1983, 1985) and Ritchie (1985, 1988). The first of these four studies, which was based in Cairns, was conducted as a trial of a number of conceptual and methodological innovations in tourism–community analyses. One facet of this study was published in a special journal issue applying psychology concepts to tourism (Pearce et al 1991). The remaining three studies were contributions to overall tourism planning and development reports for state and local government development bodies.

As with the Canadian work of Ritchie and Murphy, these planning studies share an explicit philosophical position when considering the tourism–community relationship. This position is summarized by Ritchie (1988), who observes that "achieving a reasonable degree of consensus on desired directions for tourism development is an important ingredient for long-term success". Similarly, Murphy's ecological

model views destination areas as having to maintain four components in mutual interdependence for tourism to succeed: the natural tourist attractions of the community, local resident reaction to tourism development, the industry's investment and return from developing the tourist resources, and visitor reactions to the total destination package (Murphy 1983). Again, there is an explicit view present here that resident reactions matter in the total context of tourism planning, tourism development, and tourism services.

The studies to be presented in this chapter seek to establish how the communities feel and think about tourism in general; the studies evaluate tourism compared to other industries; they explore resident reaction to specific tourism developments and to certain categories of visitors and they consider tourism in the context of the overall future of the region. This kind of work is, therefore, rich in its social representation components because it specifically seeks to identify networks of ideas and attitudes concerning tourism.

Initially, a context for the four community–tourism studies will be portrayed. This information should encourage the reader to predict, anticipate and compare the likely reactions to tourism in these four community studies as well as establishing basic information for generalizing the findings. The second emphasis in this chapter will be on the abstract and transferable issues resulting from this research. Thus there will tend to be an emphasis on the methods used to elicit and analyze the community reactions and on the application of social representation concepts such as the network of ideas and anchoring to understand the material. Once the four contrasting communities have been described many international readers might like to think of a set of familiar personal examples, parallel to the four Australian settings, in order to act as a local touchstone for their understanding and possible research endeavours in this field.

The Context: Presenting Four Communities

The general region in which these studies were conducted is that of North Queensland, Australia. This area of Australia, which is geographically remote from the main population centers of the country (Sydney, for example, is 2,800 km to the south of the study area), is a subtropical and tropical region. The region is defined in part by two key tourism resources, both of which are World Heritage areas—the Great Barrier Reef and the rainforests of the Wet Tropics. International tourism has been growing rapidly to this part of Australia since the mid-1980s, with approximately 2.5 million visitors annually, but the whole region has traditionally been a focus of holiday travel, with the southern hemisphere

winter months (May–August) being the peak of the domestic tourism season as southern Australians seek to escape the cold and enjoy the tropical north. The international parallel here is with Florida, although the levels of development are much lower and the significance of the reef and rainforest environments as attractions in addition to the climate should be emphasized.

Within this study area four separate communities were studied (see Map 5.1). In the chronological order in which the studies were conducted they were as follows. The first community was Cairns, a tropical city

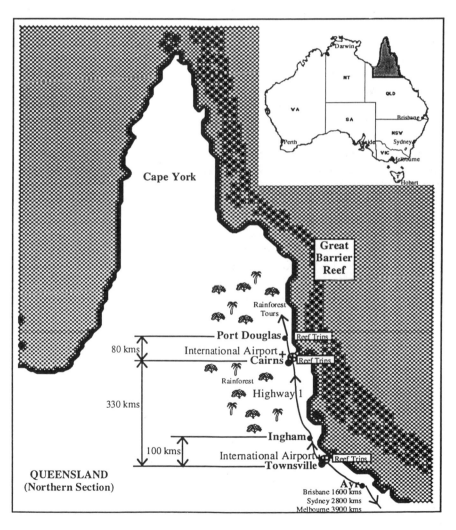

Map 5.1

of 70,000 people (at the time of study) with a major tourism profile and the effective tourism gateway to the region. The second study site was Port Douglas, a small once rural and now tourism-dependent community which is located 80 km north of Cairns and, like Cairns, is host to a number of reef and rainforest tourism operations. The third community to be considered was Townsville, the largest tropical city in Australia with over 100,000 people. Townsville has some tourism enterprises and a diversified public sector, but is also home to small manufacturing and mining-based enterprises. Townsville lies 330 km south of Cairns. Finally, the shire of Hinchinbrook, with its principal rural town of Ingham lying 100 km to the north of Townsville, was also studied. Here the dominant economic activity has been and remains sugar production. In the Hinchinbrook shire tourism has been a minor activity. Some of the major points of contrast among the four communities are presented in Table 5.1.

For the reader unfamiliar with these destinations, the style of tourism in the region has some distinctive characteristics. Both Cairns and Port Douglas function as transport and accommodation hubs for the tourism

Table 5.1. Four North Queensland Study Sites

Cairns (1989)	• Population 70,000[a]; tourism 2 million visits
	• Tourism a main economic activity
	• Considerable international and domestic tourism with reef and rainforest tours and substantial accommodation variety
	• A traditional center for Australian tourism
Port Douglas (1989)	• Population of Shire 11,000; town 4,000; tourism 300,000 visits
	• Tourism a main economic activity
	• International and domestic tourism with dominance of reef and rainforest tours and varied accommodation options
	• A recent center for tourism in Australia
Townsville (1991)	• Population 110,000; tourism 1 million visits
	• Tourism an emerging economic activity
	• Reef tours, some variety in accommodation, domestic tourism, some international tourism
	• Low profile traditionally in Australian tourism
Hinchinbrook Shire (1992)	• Population of Shire 13,000; town 7,000; tourism 20,000 (estimate) visits
	• Tourism a minor economic activity
	• Limited accommodation, little organized tourism industry, almost no international tourism
	• No existing tourism profile

[a]Figures cited throughout this chapter refer to those applicable at the time of the studies.

industry, with numerous rainforest and reef day trips available from these centers. The two communities, which are linked by an attractive coastal road, have developed significant amounts of tourist shopping and diversity in accommodation styles ranging from luxurious resorts and hotels to backpacker (budget-travel) hostels as well as older style motels and caravan or trailer parks. Much of the development has occurred since the mid-1980s and international visitors from Japan, Europe, North America, and other Asian destinations are the dominant inbound groups. The host communities have grown rapidly through both the extra employment created by tourism and an Australia-wide population drift to the warmer northern part of the country.

For Townsville, a dry tropical rather than wet tropical city and for Hinchinbrook, a tropical rural shire, the presence of tourism is less marked. Townsville has one major successful day cruise operation to the Barrier Reef but no rainforest tours, the distance to these areas limiting the operators' schedules and profitability. Townsville tourism is more focused on purpose-built attractions such as an aquarium, a native fauna sanctuary, a casino, and the beach and national park resources of the region, particularly the adjacent Magnetic Island. Hinchinbrook shire, a physically spectacular rural area with ample rainforest resources, has been dominated by agricultural enterprises, particularly sugar with some cattle and forestry industries. In recent years, all of the international traffic has flown into Cairns airport, with the facility at Townsville being underused, thus limiting easy access to the Hinchinbrook attractions. Tourism in the Hinchinbrook shire at the time of the study was limited to self-driving motorists independently exploring the scenery at rainforest sites, with a very small international group of budget travelers moving through the region.

Research Methodology

For each of the communities, a simple random sample of residents was obtained by selecting individuals from the listings of the Government electoral rolls. Corrections for bias in enrollment and size of household were made by interviewing in the adjacent houses to the listed address and by interviewing all adults in these households. Interviews were conducted by personnel who had spent time in training sessions with the researchers to sharpen interviewing skills, to reduce reactivity in the questioning and to clarify any ambiguities which the respondents might have in answering the questions. For Cairns, 507 interviews were conducted in early 1989, for Port Douglas, 300 interviews were completed in the same year, while for Townsville, 412 interviews were conducted in 1991 and for Hinchinbrook shire a further 329 cases were sampled in

1992. The refusal rate for the interviews was low, ranging between 9% (Port Douglas) and 15% (Hinchinbrook shire).

The content areas of the questionnaires are depicted in Table 5.2. As can be seen, a perfectly standardized interview protocol was not used in all studies but instead adapted according to the level of tourism and the character and number of current tourism developments/ proposals in the region. Additionally, the mix between open-ended and structured questions varied slightly from study to study, with residents from the more tourism-dependent communities being seen as having more to say about some topics owing to greater familiarity with tourism. It was an important feature of all questionnaires that open-ended material concerning the impacts of tourism was collected prior to presenting residents with structured lists of tourism's impacts drawn from other studies and regions and from focus group research. By adopting this research tactic, researchers are able to check whether or not the spontaneously generated resident concerns are matched with the concerns expressed in the structured items. Without the open-ended material, there is a potential bias in the research which lies in suggesting impacts to residents. Further, and in harmony with the social representations approach to tourism–community studies, the importance of the impacts was assessed in each study, and tourism and its future were evaluated in the context of other economic opportunities for the community.

These methodological checks and balances were boosted by the use of some specially created scenarios describing tourism futures in the Cairns study. These future tourism possibilities were deliberately structured so as to vary the scale and style of tourism futures to the residents. Additionally, in the Townsville and Hinchinbrook studies, where tourism is a less obvious component of community life, residents were presented with potential types of visitors, styles of development and even regional signatures or labels for their consideration. The presentation of this kind of material is consistent with the societal evaluation of tourism futures embodied in the work of Murphy (1985) and Ritchie (1988) cited earlier.

In presenting the findings of these four studies within the social representations framework, a number of key comparisons is possible. The present community studies did not conform fully to the field experimental paradigms favored in some areas of social science, but the choice of communities allowed for a contrast of moderate versus small-scale communities, and tourism-dependent versus minor tourism communities, and for an examination of the interactions between size and tourism dependence (Campbell and Stanley 1963). Additionally, from the social representations framework these four study sites will assist in understanding the role of familiarity in influencing the social

Table 5.2. Major Content Areas of Interview Protocols for the Four North Queensland Tourism–Community Studies

Clusters of Information Sought	Cairns	Community Port Douglas	Townsville	Hinchinbrook
Benefits of living in area	—	✓	✓	—
Survey respondent demographics	✓	✓	✓	✓
Contact with tourists	✓	✓	✓	—
Self, relatives, friends work in tourism	✓	✓	✓	(Desire to work in industry if it grows)
Overall community benefits of tourism	✓	✓	—	✓
Overall community cost of tourism	✓	✓	—	—
Overall personal benefits of tourism	✓ (plus specific extra question on economic benefits)	✓ (plus specific extra question on economic benefits)	✓ (plus one specific extra question on economic benefits)	✓
Overall personal cost of tourism	✓	✓	✓	✓
Responses to detailed list of tourism impacts	✓	—	—	—
Responses to specific developments in region	—	List of five specific developments	Emphasis on two special areas	List of 13 specific developments
Preferences for general styles/types of development	List of five scenarios	✓	List of ten types of development	—
Preferences for general styles/types of visitor	—	—	List of six types of visitors	Open-ended question
Changes like to see in future tourism	—	✓	✓	✓
Importance of tourism rated in context of other industries	—	—	✓ (specified for years in future)	✓
Preferred role for tourism in future	—	✓	✓	✓
Other comments on future of community	—	✓	✓	✓
Resources in area to be developed for tourism	—	✓	✓	✓
Resources in area to be protected	—	—	✓	✓
Suggestions on how to market/present the area	—	—	✓	✓
Who should control tourism?	✓	—	—	—

representations which residents hold and the influence of the anchoring process for communities which are entering tourism growth and are able to view nearby areas with existing and much larger tourism industries.

Cairns

As noted in the previous section (particularly in Table 5.2) a number of variables concerned with perceptions of, and attitudes towards, tourism was examined. These included perceptions of tourism impacts (using both open-ended and structured questions), attitudes towards tourism's future development, and who should control tourism development, experience with, and knowledge of tourism and judgments of specific tourism development proposals. To investigate the structure and content of the respondents' social representations of tourism it was decided to begin with perceptions of tourism's impacts. This choice was based on the approaches taken in previous research and on methodological considerations. Social representations theory does not suggest any simple or linear development of attitudes or beliefs. Rather it proposes a progressive elaboration of complex networks. Investigation of such networks can begin at any point. The authors chose to begin with respondents' ratings of tourism impacts because these data were the most amenable to multivariate pattern recognition techniques such as cluster analysis. Table 5.3 contains the mean ratings of tourism's impacts on 30 features derived from previous research. This study included an assessment of the importance of the features, and the percentage of the sample stating that the feature was important to them is also given in Table 5.3. An examination of the importance data emphasizes a critical issue. Only seven out of the 30 features rated (see Table 5.4) were considered important by at least one quarter of the sample and only one of these (cost of living) was seen as important by a majority of the sample. This has important implications for the way that researchers interpret the perceived impacts of tourism. It is clear that researchers who naively assume that all impacts are equally important or who believe that residents will conceive of impacts in the same way as the researchers themselves are very likely to be in error. The emic approach adopted here, where the views of the residents are explicitly obtained, suggests that sometimes only a limited number of impacts truly matters to the local community.

An examination of the seven most important features that tourism can influence (see Table 5.4) indicates that on some items there is considerable consensus about tourism's effect. In the case of Cost of Living, 83% of the sample believe that tourism has had a negative effect. For

Table 5.3. Mean Ratings of Tourism Impacts and Importance of these Impacts (Cairns)

Feature	Mean	(SD)	Importance
Native fauna and flora	3.6	(0.9)	29.4%
Fire-fighting services	3.0	(0.7)	3.5%
Scenic beauty of the area	3.3	(1.1)	28.3%
Prostitution	3.3	(0.9)	3.2%
General appearance of your street	3.0	(0.8)	5.1%
Recreation facilities	2.5	(0.8)	5.4%
Cost of living	4.3	(0.8)	53.5%
Cost of buying a house	4.6	(0.7)	35.1%
Cost of buying land	4.6	(0.7)	26.8%
Job opportunities	2.4	(1.1)	29.4%
Medical services	2.7	(0.8)	17.3%
Traffic congestion	4.0	(0.9)	13.7%
Entertainment facilities	2.5	(0.9)	8.0%
Bush/natural environment	3.5	(1.0)	26.1%
Business opportunities	2.2	(0.9)	7.2%
Privacy of residents	3.4	(0.7)	14.1%
Police services	3.2	(0.9)	9.9%
Roads and highways	3.2	(1.2)	16.0%
Higher education facilities	2.7	(0.7)	16.0%
Environmental cleanliness	3.5	(0.9)	22.1%
General appearance of town	2.7	(1.1)	11.3%
Local parks and gardens	2.3	(0.8)	6.4%
Shopping facilities	2.2	(0.9)	13.3%
Cost of renting a house	4.5	(0.7)	19.8%
Crime levels	4.1	(0.8)	23.6%
Emergency health services	2.8	(0.8)	7.5%
Hotels/restuarants	2.1	(0.9)	5.1%
Sporting facilities	2.5	(0.7)	6.2%
Friendliness of local residents	3.0	(1.0)	13.1%
Opportunities for social contact	2.4	(0.9)	3.9%

Scale: 1, very good effect; 2, good effect; 3, no effect; 4, bad effect; 5, very bad effect.

Table 5.4. Frequency Distribution of Responses for Tourism's Impacts on Features Seen as Important by at Least 25% of the Sample (Cairns)

	Tourism's Effect				
Feature	Very Good	Good	No Effect	Bad	Very Bad
Cost of living	0.4	1.0	15.7	34.9	48.0
Cost of buying a house	0.4	0.8	5.4	24.4	69.0
Job opportunities[a]	19.0	43.8	18.0	12.6	6.5
Native fauna and flora[a]	2.8	7.4	30.6	42.8	16.3
Cost of buying land	0.3	1.3	5.4	23.3	69.8
Bush/natural environment[a]	2.3	11.1	35.7	34.8	16.2
Scenic beauty of the area[a]	4.4	21.1	30.3	32.3	11.9

[a]Features with variation in responses.

other features, however, there is considerable variation in responses. In the case of Scenic Beauty of the Area, for example, 21% believe tourism has had a positive effect, 30% believe it has had no effect and 44% see tourism as having had a negative effect. These patterns suggest that more than one social representation of tourism may exist. A cluster analysis was conducted on the four features on which there was low consensus. The use of cluster analysis as a sorting technique in this chapter deserves careful consideration. While the technique is widely used in biomedical sciences, there are sometimes misgivings about the approach and an accusation that the technique permits researchers to identify as many groupings as they like. These concerns are sometimes expanded to include the view that researchers can somehow "manipulate" the cluster analysis data to have quite disparate cases coalesce into one cluster or grouping. Such misgivings and concerns misrepresent the mathematical procedure involved in cluster analysis. Clusters are formed on the basis of one of several clustering methods which are referred to as linkage methods, error sums of squares (variance based) methods, or centroid methods (Norusis 1990). In all procedures a quantitative systematic procedure for linking cases together is employed and no researcher judgment in assigning cases to clusters is involved. Like factor analysis, however, cluster analysis does require the researcher to make a judgment on the number of clusters which are deemed to be valuable. Here too, quantitative indices are available to guide the researchers' choices. In the research described in this chapter the guiding principle for choosing clusters was based on the criterion of maximizing distances among cluster centers so that variability within clusters was less than the variability among clusters. In choosing among 1, 2, 3, or more cluster solutions the principle of having clearly defined well-organized clusters was the guiding research rule. Further, the cluster solutions chosen were also required to identify statistically significant differences on the selected clustering variables.

This analysis suggested the existence of three groups, and Table 5.5 gives the mean responses of these groups to the seven important features. These responses were used to interpret and label the clusters. The largest group, making up approximately 44% of the sample, tended towards the center of the scale and saw tourism as having both positive and negative impacts but not to the extremes of the scales. This group was given the label Moderates. The other two groups shared an overall negative view of tourism but were different in two important ways. The first group in the table (20% of the sample) saw tourism as having a negative effect on all features but particularly on economic features and so was labeled Negative Economic Impacts. The final group (36% of the sample) also saw tourism as having generally negative effects except for Job Opportunities. This group also saw tourism as having a greater

Table 5.5. Mean Responses of the Three Clusters for Tourism's Effect on the Seven Features Seen as Important by at Least 25% of the Sample (Cairns)

	Clusters		
Feature	Negative Economic Impacts ($n = 138$)	Moderates ($n = 306$)	Negative Environmental Impacts ($n = 254$)
Cost of living	4.6 (0.7)	4.0 (0.8)	4.5 (0.6)
Cost of buying a house	4.8 (0.5)	4.4 (0.8)	4.8 (0.5
Job opportunities	4.2 (0.6)	2.1 (0.8)	1.9 (0.6)
Native fauna and flora	3.9 (0.9)	3.0 (0.8)	4.3 (0.5)
Cost of buying land	4.8 (0.5)	4.4 (0.8)	4.8 (0.4)
Bush/natural environment	3.7 (0.9)	2.9 (0.8)	4.2 (0.6)
Scenic beauty of the area	3.6 (0.9)	2.5 (0.7)	4.0 (0.7)

negative effect on environmental features and was given the label Negative Environmental Impacts.

It was decided to begin the investigation of these three proposed social representations by re-examining the perceived importance of the various features. A social representations approach would suggest that people might differ both in their perceptions of the impacts of tourism and in the relative importance of these impacts. Table 5.6 provides evidence relating to this hypothesis. This table lists the ten most important features for each group. As would be expected, the Negative Environmental Impacts group placed a much greater emphasis on environmental features, while the first five features for the Negative Economic Impacts group were all economic.

The next step in the analysis was to explore whether these representations could be reliably related to differences in community characteristics. The first set of variables analyzed was the demographic ones of age, length of residence in the community, and education. The first two variables differed significantly across the clusters. Table 5.7 summarizes these results. The Moderate group was more likely to be older, longer term residents, with the Negative Economic Group most likely to be in the youngest group, and the Negative Environmental Group the most recent arrivals. The next set of variables analyzed were those concerned with the respondent's experience with tourism. There were no significant differences found between the groups for contact with tourists, numbers of friends or relatives working in tourism and the distance of the respondent's residence from the major tourism area. There was, however, a significant relationship between the social representations clusters and their perceptions of personal economic benefits from tourism (see Table 5.8). As can be seen, the Negative Economic group was most likely to believe that tourism had not benefitted them at all.

Table 5.6. Ten Most Important Features for the Three Social Representation Groups (Cairns)

Negative Economic Impacts		Moderates		Negative Environmental Impacts	
Cost of living	(55%)	Cost of living	(51%)	Cost of living	(54%)
Cost of buying a house	(38%)	Job opportunities	(31%)	Native fauna and flora	(43%)
Job opportunities	(33%)	Cost of buying a house	(30%)	Cost of buying a house	(39%)
Cost of buying land	(29%)	Scenic beauty of the area	(29%)	Bush/natural environment	(35%)
Cost of renting a house	(28%)	Cost of buying land	(22%)	Environmental cleanliness	(29%)
Crime levels	(27%)	Native fauna and flora	(22%)	Scenic beauty of the area	(28%)
Scenic beauty of the area	(25%)	Crime levels	(22%)	Cost of buying a house	(26%)
Native fauna and flora	(22%)	Roads and highways	(21%)	Cost of buying land	(24%)
Bush/natural environment	(21%)	Bush/natural environment	(20%)	Crime levels	(24%)
Medical services	(20%)	Medical services	(20%)	Cost of renting a house	(17%)

Table 5.7. Age Distribution and Mean Length of Residence for the Three Social Representation Groups (Cairns)

		Group				
Age (yr)	Negative Economic		Moderates		Negative Environmental	
16–30	67	(49%)	87	(28%)	96	(38%)
30–50	45	(33%)	129	(42%)	114	(45%)
50+	25	(18%)	90	(29%)	44	(17%)
$\chi^2 = 25.1, P = 0.001$						
Mean Length of Residence (Months)	14	(14)	15	(16)	11	(14)

$F = 3.5$, df $= 2,506$, $P = 0.03$.

Standard deviations are in parentheses.

Table 5.8. Perceived Personal Economic Benefits of Tourism for the Three Social Representations Groups (Cairns)

Tourism Benefits Me Economically		Group				
	Negative Economic		Moderates		Negative Environmental	
Not at all	72	(52%)	112	(37%)	84	(33%)
A little	26	(19%)	66	(22%)	48	(19%)
Somewhat	17	(12%)	47	(15%)	43	(17%)
A great deal	23	(17%)	81	(26%)	77	(31%)

$\chi^2 = 17.3, P = 0.008$.

For the other two groups, however, there was a considerable spread of responses. It is interesting to note that nearly half of the Negative Environmental Impacts group reported some personal economic benefits from tourism.

The present study included two sets of variables which have been given little attention in previous research, knowledge of tourism to the region and personal travel experience. In the latter case, respondents were asked to give the number of overseas countries they had visited. While there was no significant difference between the three social representations groups, the data suggested that the Negative Economic group had the least overseas travel experience with a mean of 2.6 (SD $= 5.6$), while the other two groups had means of 4.2 (Moderates, SD $= 8.2$) and 4.5 (Negative Environmental, SD $= 9.1$). Knowledge of tourism to the region was assessed through two questions asking people to estimate the number of visitors to the region annually and the annual expenditure of visitors to the region. There was a significant difference in the estimates

of numbers of visitors to the region ($F = 4.6$, $P = 0.01$). The Negative Economic Impacts group had a mean of 1,815,000 visitors annually, the Moderates group had a mean of 194,000 visitors and the Negative Environmental Impacts group had a mean of 332,000. It is interesting to note that the Negative Economic group mean was the closest to the actual annual visitation rate (2.2 million at the time) and approximately six times greater than the estimate of the Negative Environmental group. These estimates of visitor numbers were not consistently related to estimates of visitor expenditure. The Negative Environmental group gave the lowest estimates ($\bar{x} = \$A173m$) while the other two groups gave similar estimates (Moderates, $\bar{x} = \$A238m$; Negative Economic Impacts, $\bar{x} = \$A249m$). One economic source suggested the figure of \$A300 million for the relevant time period (NCSTT 1991). The very large standard deviations accompanying these mean figures discouraged the use of further statistical analysis. There is clearly considerable variation in perceptions of how much visitors spend in the region.

These two items on resident knowledge of tourism reinforce the view expressed earlier that tourism statistics are not very meaningful to the majority of residents. The size and scale of tourism are probably assessed more by personal contact and physical parameters than a knowledge of these statistics.

The final set of variables considered was perceptions of tourism's future in the region. There were three sets of variables focused on the future of tourism in the region. The respondents were asked to rate directly the role they would like to see tourism play in their community in the future and to rank ten industries (including tourism) in terms of how desirable these industries would be for development in the region. Table 5.9 contains the responses of the three social representations groups to these questions. As expected, both Negative Impacts groups were significantly more likely than the Moderates to seek a decrease in tourism. It should be noted though that 27% of the Negative Economic group and 24% of the Negative Environmental group sought an increase in tourism. In the ranking of the various industries a consistent pattern of responses also appeared. The Moderates gave a significantly higher ranking for tourism than did either of the other groups and were less supportive of light industries. The Negative Environmental Impacts group also gave a significantly lower ranking to mining and rural industries. Since both of these significant regional industries have at times been criticized for their environmental practices, this finding provides a broad-scale link to the view that the environmental attitudes to tourism are not held in isolation but, for some citizens, are a part of a larger environmental ethic.

The second set of tourism futures variables was a set of questions which asked respondents to rate how much control or influence various groups

Table 5.9. Ratings of Tourism's Future Development in the Region by the Three Social Representations Groups (Cairns)

A. What kind of role should tourism play in your community in the future?

	Negative Economic	Moderates	Negative Environmental
A considerable increase	10 (7%)	62 (21%)	8 (4%)
A slight increase	28 (20%)	95 (31%)	51 (20%)
The same importance as now	44 (32%)	103 (34%)	95 (38%)
A slight decrease	25 (18%)	31 (10%)	56 (22%)
A considerable decrease	31 (23%)	11 (4%)	40 (16%)

$\chi^2 = 94.2, P = 0.0001.$

B. Mean ranking of industries from 1 (most desirable) to 10 (least desirable)

Industry	Negative Economic	Moderates	Negative Environmental	F	P
Education	2.5 (2.3)	2.6 (2.1)	2.3 (1.8)	1.9	0.15
Transport	4.1 (2.4)	4.4 (2.5)	4.1 (2.2)	1.6	0.20
Government services	4.8 (2.5)	4.9 (2.6)	4.7 (2.4)	0.5	0.61
Light industry[a]	5.2 (2.0)	5.7 (2.3)	5.3 (2.2)	3.7	0.03
Rural industries[a]	5.5 (2.2)	5.3 (2.5)	4.9 (2.3)	3.3	0.04
Tourism[a]	6.9 (2.8)	5.1 (2.9)	6.2 (2.8)	23.1	0.001
Forestry	6.2 (3.0)	6.2 (3.0)	6.5 (3.2)	0.8	0.47
High tech industry	4.9 (2.7)	6.4 (2.7)	6.0 (2.6)	2.7	0.07
Heavy industry	5.7 (2.2)	6.1 (2.2)	6.1 (2.2)	2.0	0.14
Mining[a]	8.0 (2.6)	8.0 (2.7)	8.9 (2.0)	6.9	0.001

[a]Significant differences.

should have over tourist developments. Table 5.10 gives the responses of the three social representation groups. Overall, all three groups were more likely to want an increase in the control of tourism developments by the state and federal governments and a decrease in the control of local government, lobby groups, and residents. The Moderates group in particular want more Federal and less State government influence and favor a greater or continuing role for lobby groups and residents compared to the other groups. The two negative impact groups were more strongly in favor of State government control and markedly less supportive of the power residing in the local government or residents.

The final set of variables analyzed was responses to five tourism development scenarios described in Table 5.11. For each scenario respondents were given three options: one which either opposed or restricted in a major way the development (labeled a Green response); one which supported the development with some restrictions (labeled

Table 5.10. Perceptions of Control Over Tourist Developments of the Three Social Representations Groups (Cairns)

How much control should there be by:	Negative Economic	Moderates	Negative Environmental
1. Federal Government			
More	58 (42%)	138 (46%)	105 (42%)
As is	41 (30%)	93 (31%)	63 (25%)
Less	38 (28%)	70 (23%)	80 (32%)
$\chi^2 = 6.0, P = 0.020$			
2. State Government			
More	66 (49%)	108 (36%)	127 (52%)
As is	36 (26%)	111 (37%)	57 (23%)
Less	34 (25%)	83 (27%)	63 (25%)
$\chi^2 = 17.9, P = 0.001$			
3. Local Government			
More	20 (15%)	30 (10%)	25 (10%)
As is	25 (18%)	70 (23%)	43 (17%)
Less	91 (67%)	201 (67%)	181 (73%)
$\chi^2 = 5.7, P = 0.22$			
4. Lobby Groups			
More	6 (4%)	28 (10%)	21 (8%)
As is	37 (27%)	87 (29%)	36 (15%)
Less	95 (69%)	184 (61%)	190 (77%)
$\chi^2 = 20.8, P = 0.001$			
5. General Residents			
More	4 (3%)	9 (3%)	3 (1%)
As is	14 (10%)	64 (21%)	20 (8%)
Less	120 (87%)	227 (76%)	228 (91%)

$\chi^2 = 25.4, P = 0.001$.

Green and Gold); and one which supported development (labeled Gold). The responses of the three social representations groups are given in Table 5.12. Two patterns of response can be quickly identified from a perusal of Table 5.12.

Firstly, the Negative Economic and the Negative Environmental groups respond to the future tourism possibilities in a very similar fashion. Across five scenarios and three classifications of responses the views of the two groups are repeatedly within two to four percentage points on each scenario and each scale item (\bar{x} = 2.9% difference, range 0–7%). This result demonstrates that the same responses to specific tourism developments may be driven by a different social representation. Indeed, the finding is supportive of the view that tourism conflict situa-

Table 5.11. The Five Tourism Development Scenarios and Response Options (Cairns)

Scenario 1: Wetlands Development

A number of major tourist complexes have been proposed on and immediately adjacent to a large mangrove/wetland area near the city. These mangrove/wetlands are environmentally sensitive and are the habitat of many animals, fish, and birds. However, the tourist developments may bring many tourists and a number of jobs to the area. What would you like to see happen?

A. Allow no development near the wetlands and encourage developers to build in less sensitive areas. (Green)

B. Permit only a few developments near the wetlands and monitor the extent of the impacts. (Green and Gold)

C. Allow tourist developments to proceed and encourage developers to set aside a portion of the wetlands and build an observatory/interpretation centre for tourists to see some of the wildlife. (Gold)

Scenario 2: Tourist Resort Variety

Suppose a large number of tourist resorts are currently springing up in this area, in a variety of styles, sizes, and architectural designs. What would you prefer to see happening in this area?

A. No more resort development in the area for a while. (Green)

B. Only permit resorts that are designed similar to the traditional architecture of the area and that blend in with the environment surrounding them. (Green and Gold)

C. Allow developers to build in the styles, sizes and designs they wish. (Gold)

Scenario 3: Integrated Specialist Resort

A new resort is scheduled to be constructed in your town that will cater for a maximum of 400 guests at any given time. The resort hopes to attract both domestic and international visitors, with package deals to encourage guests to stay several days at a time. The proposed resort will be situated within easy access of the city so that guests may enjoy the shopping facilities and sights of the city. The proposed resort is aiming at attracting approximately 12,000 visitors to the region annually. What would you like to see happen?

A. Like to see the development proceed. (Gold)

B. Like to see the development proceed—but on a smaller scale. (Green and Gold)

C. Do not want the development to proceed. (Green)

Scenario 4: Wildlife Sanctuary

A new landscaped wildlife sanctuary is being developed 3 km out of the city. The development will feature animal shows as well as the opportunity to view wildlife in their natural surroundings. Minibus tours around the 50 acre park will be conducted regularly and several bus companies will be offering day trips to the park. What would you prefer to see happen?

A. Like to see the development proceed. (Gold)

B. Like to see the development proceed but possibly on a smaller scale and with restrictions on the number of people the attraction will allow daily. (Green and Gold)

C. Do not want the development to proceed. (Green)

Scenario 5: Tourist Shopping Rezoning

The city council is proposing to rezone a street in your town that is currently residential but has several vacant sites suitable for development. This rezoning will make it possible for the development of several tourist souvenir and service shops in the street. What would you like to see happen?

A. Support the decision for rezoning. (Gold)

B. Support the decision for rezoning but only if the development of vacant sites is limited and strictly controlled. (Green and Gold)

C. Oppose the decision for rezoning. (Green)

Note: The scenarios were presented in different orders.

Table 5.12. Reactions to Proposed Tourism Developments by the Three Social Representations Groups (Cairns)

	Negative Economic		Moderates		Negative Environmental		χ^2	P
Wetlands Scenario								
Gold	14	(10%)	64	(21%)	22	(8%)		
Green and Gold	21	(15%)	68	(22%)	37	(15%)	32.0	0.001
Green	103	(75%)	172	(57%)	195	(77%)		
Tourist Resort Variety								
Gold	8	(6%)	39	(13%)	8	(3%)		
Green and Gold	76	(55%)	198	(66%)	152	(60%)	34.9	0.001
Green	54	(39%)	64	(21%)	94	(37%)		
Integrated Specialist Resort								
Gold	29	(21%)	147	(49%)	70	(28%)		
Green and Gold	44	(32%)	86	(28%)	82	(32%)	48.9	0.001
Green	64	(47%)	68	(23%)	101	(40%)		
Wildlife Sanctuary								
Gold	68	(50%)	208	(68%)	133	(52%)		
Green and Gold	35	(25%)	57	(19%)	53	(21%)	27.4	0.001
Green	34	(25%)	37	(12%)	68	(27%)		
Tourist Shopping Rezoning								
Gold	16	(12%)	58	(19%)	20	(8%)		
Green and Gold	49	(36%)	113	(37%)	93	(37%)	17.2	0.002
Green	71	(52%)	131	(43%)	138	(55%)		

Proportional reduction of error scores (Goodman and Kruskal Tau scenarios are dependent): Wetlands Scenario, 0.03; Tourist Resort Variety, 0.02; Integrated Resort, 0.04; Wildlife Sanctuary, 0.02; Tourist Shopping Rezoning, 0.01.

tions often couple together parties with apparently different lifestyles and world views who have reached the same conclusions about a development but for different reasons. The Moderate group appears in Table 5.12 as the most Gold or pro-development in their responses to tourism futures. This group is consistently 10–15% more pro-development in its responses to the scenarios and equally less likely to favor a green or cautionary developmental stance. A second important feature of Table 5.12 rests in the power of each scenario. The kind of tourism situation being appraised counts a good deal; for the moderates a pro-development perspective may be as high as 68% or as low as 13% depending on the scenario. Similarly, the support for development in the negative economic group may be as high as 50% or as low as 6%, while for the negative environmental group the support for development ranged from 52% to 3%.

Summary

Using almost any statistical computation—airport arrivals, hotel growth, industry employees—Cairns has been a major focus in the blossoming of Australian tourism in the last decade. In studying resident reaction to tourism in Cairns the researchers were seeking to conduct a major study relating Australian community attitudes to recent and rapid tourism growth. The findings of the study were envisaged as being more likely to be connected to research results from global tourism market-places than those from other domestic locations. The social representations approach and the attendant methodology that were used to sort out the existence of groups of residents sharing tourism views proved to be manageable both empirically and conceptually. Three subtly different groups of residents were identified. The largest group of respondents held what was termed a moderate but very clear social representation of tourism. For this group tourism has brought some negative environmental and economic costs but the benefits are clear too. Many in this group feel they have benefitted from tourism but the organization of their tourism views is most apparent when the future of tourism is discussed. The moderate social representation casts tourism as a desirable growth activity for Cairns, with its preferred future importance being judged as equal to or greater than the present role by 85% of the group. This support for tourism in general was also manifested as a consistently higher positive response to the specific tourism development scenarios.

A second social representation also prevailed. This view, which was entitled the negative economic perspective, was held by slightly younger residents (half of whom were under 30) and over half of whom considered that tourism had not benefitted them at all economically. This group, which had traveled somewhat less than the other two groups, again provided a clear pattern of responses to the future of tourism for Cairns as they would like to see it unfold. In this social representation tourism is viewed as a disenfranchising agent bringing higher costs and fewer job opportunities and is accompanied by the view that there should be a considerable decrease in the future role of tourism in Cairns. Of all the industries available in the area tourism ranks second last for this group.

The third social representation is held by slightly older, better traveled, and more environmentally conscious citizens. This social representation was labeled the negative environmental view but it is to be noted it contains some negative economic items and some positive economic benefits of the industry. The future of tourism in the Cairns region as perceived by this network of views is to limit growth and be cautious about tourism's future role in the community. The view is not, however,

quite as negative or as forceful as that obtained from the negative economic group. Nevertheless, the total pattern of responding, albeit arising from a different pattern of environmental, social and economic forces than is the case for the negative economic group, results in the same limited enthusiasm for development in the specific tourism development scenarios.

These social representations of tourism in what has been and remains a rapidly growing nerve center of Australian tourism are comparable in many ways to the Hawaiian material discussed in the previous chapter. The present study does not include a specific sample of the business personnel and powers of the region but the moderate group, which is moderate in terms of its view of impacts and pro-development in its future orientation, has much in common with the growth machine social representation described earlier. It is this large and relatively positive community support group which enables the powerbrokers to recreate and hasten the development of Cairns both by providing political support for the industry and by broad enthusiasm for its growth. The social representations labeled negative economic and negative environmental are paralleled in the Hawaiian example by dissatisfied industry workers and those who feel that Hawaiian culture and environments are being swept aside. Cultural change and destruction was not examined in this Australian setting, the sample size being too small to study Aboriginal Australians specifically, but the loss of the native flora and fauna and the beauty of the rainforest and bush being threatened are significant items organizing one less positive network of beliefs about tourism.

As a significant postscript to this study, it can be noted that in combination the negative environmental and negative economic social representations together account for 56% of the total sample. It is a significant measure of the force of community feeling over the future of tourism in Cairns that shortly after the present study was concluded nearly 40% of the Cairns population protested in the streets over a major wetlands development scenario which would relocate the tourist center of the city. Since that dramatic event tourism developments have been more positively received and sometimes have been avowedly environmentally conscious in their presentation and management.

Port Douglas

As in the previous case study the respondents were asked to contemplate "a list of features that have been positively or negatively affected by tourism in some places" and were asked "if this has also occurred here and, if so, by how much". Table 5.13 contains the list of features given

Table 5.14. Frequency Distributions of Ratings for Features Listed as Important by at Least 25% of the Sample (Port Douglas)

Feature	Very Good Effect	Good Effect	No Effect	Bad Effect	Very Bad Effect
Native fauna and flora	4.0	7.7	19.3	43.3	19.3
Scenic beauty of the area	12.0	26.0	18.0	31.7	11.3
Cost of living	0.3	2.3	6.7	38.3	51.7
Cost of buying a house	0.7	0.3	0.7	23.7	72.3
Job opportunities	29.0	53.0	5.0	8.3	2.7
Bush/natural environment	2.7	11.7	21.0	41.7	16.7
Traffic congestion	0.7	3.7	37.0	43.0	14.7

and the mean for the sample on a five-point scale from very good effect (1) to very bad effect (5). This table also includes the percentage of respondents who replied "don't know" or "have no opinion" about the effect of tourism on a feature, and the percentage who listed the feature as one of the five most important to them personally. Traditional survey approaches to tourism impacts have assumed that respondents know or care about all features equally and that all impacts are of equal importance. A social representations approach leads one to question and investigate such assumptions.

An examination of the table indicates that for fire-fighting services, drugs, crime levels, emergency health services, and burglary, more than 10% of the respondents do not know or have no opinion about the effect tourism that has had on these features. If attention is focused on those features deemed important by at least a quarter of the sample (native fauna and flora, scenic beauty of the area, cost of living, cost of buying a house, job opportunities, traffic congestion, and bush/natural environment), it can be seen firstly that most respondents do have an opinion about these features and, secondly, that it appears that for all items except job and business opportunities tourism has been a negative force.

Further investigation of these items, however, suggests that the mean ratings can be misleading. Table 5.14 lists the full frequency distributions for those six features perceived as important by more than 25% of the sample. There is clearly considerable variation between the features, and for four of the seven features there is variation within the sample. For example, in the case of scenic beauty nearly as many respondents believe tourism has had a positive effect (38%) as believe it has had a negative effect (43%). An investigation of the mean ratings alone cannot reveal some important aspects of the perceptions which respondents have of tourism impacts. It should be noted here that the study did not pursue detailed or technical assessments of reef coral or World Heritage rainforest fauna and flora. Rather, the environmental questions were broadly

based and should be interpreted as specifically relating to the local setting of the town and its environs.

It was decided to investigate further the responses to the four features which exhibited variation—native fauna and flora, scenic beauty of the area, traffic congestion, and the natural environment—using cluster analysis.

In the Port Douglas study analysis revealed three clusters sharing consistent responses to the four features. These responses are given in Table 5.15. The sample appeared to consist of a small Positive Impact group who saw tourism as having a positive impact on the four features used in the cluster analysis, and two larger groups, one of which saw tourism as having a bad to very bad effect on these four features (the High Negative Impact group), and one which saw tourism generally as neutral or only slightly negative in its impacts on the four features (the Low Negative Impact group). The responses of these three groups to the other three features seen as important by at least one quarter of the sample are also interesting (see Table 5.15). In the cases of cost of living and cost of buying a house all three groups believe tourism has had a bad to very bad effect, with the High Negative Impact group being the most negative. In the case of job opportunities, the Low Negative Impact group was the most positive about tourism, with the other two groups giving a similar and less positive response.

An examination of the ten features considered to be important by the three groups revealed some distinctive patterns (see Table 5.16). The Positive group was very different from the other two, placing a much

Table 5.15. **Mean Responses of the Three Clusters on Features Deemed Important by at Least 25% of the Sample (Port Douglas)**

Feature Affected by Tourism	Clusters		
	Low Negative Impact	High Negative Impact	Positive Impact
Native fauna and flora[a]	3.7 (0.7)	4.3 (0.6)	1.4 (1.2)
Scenic beauty of the area[a]	2.2 (0.7)	4.2 (0.5)	2.1 (1.1)
Traffic congestion[a]	3.6 (0.8)	3.9 (0.7)	3.1 (1.1)
Bush/natural environment[a]	3.5 (0.8)	4.1 (0.8)	1.6 (1.3)
Cost of living	4.2 (0.9)	4.6 (0.7)	4.2 (1.0)
Cost of buying a house	4.4 (1.1)	4.8 (0.6)	4.5 (0.9)
Job opportunities	1.8 (0.8)	2.2 (1.0)	2.1 (1.0)
n	114	124	62

[a]These features were used in the cluster analysis.
The range of scores in the table is from 1 to 5, with 1 representing low impacts and 5 high impacts.

Table 5.16. Ten Most Important Features (That Could be Affected by Tourism) for Three Groups (Port Douglas)

Low Negative Feature	%	High Negative Feature	%	Positive Feature	%
Cost of living	50.0	Native fauna and flora	51.6	Cost of living	54.8
Native fauna and flora	32.5	Cost of living	50.0	Cost of buying a house	32.3
Job opportunities	31.6	Bush/natural environment	45.2	Job opportunities	30.6
Scenic beauty	29.8	Scenic beauty	41.9	Sporting facilities	29.0
Bush/natural environment	28.1	Job opportunities	30.6	Scenic beauty	25.8
Cost of buying a house	24.6	Cost of buying a house	21.8	Shopping facilities	24.2
Sporting facilities	21.9	Roads and highways	21.0	Cost of renting a house	24.2
Business opportunities	21.1	Cost of renting a house	18.5	Safety in streets	22.6
Entertainment facilities	20.2	Friendliness of local residents	17.7	Medical services	22.6
Safety in the streets	20.2	Cost of buying land	16.2	Native fauna and flora	17.7
Cost of renting a house	20.2			Cost of buying land	17.7

higher emphasis on economic features and services and facilities. The High Negative group placed the greatest emphasis on environmental features, while the Low Negative group had broad concerns about the environment and the economy. There were clearly three groups which had not only different perceptions of tourism effects but also different perceptions of the importance of these features. This evidence strongly suggests the existence of three social representations of tourism.

In investigating further these three social representations it was decided to examine the responses of the groups on demographic variables, exchange variables, other measures of perceptions of tourism impacts, and attitudes towards the future development of tourism. In the first instance there were no significant differences among the groups in terms of age, level of education, and place of residence in relation to the focus of tourist activity. There was a significant difference for length of residence (F = 3.7, df = 2,299, P = 0.02), with the High Negative group having a mean of 9 years and the other two groups both having a mean of 6 years. There were also no substantial differences between the groups for contact with tourists, numbers of friends or relatives working in tourism, or personal economic benefits of tourism. Table 5.17 shows the patterns of responses for the three groups on the exchange indicator of personal economic benefits from tourism. As would be expected from an exchange approach, the High Negative group was the least likely to state that tourism benefitted them a great deal and the most likely to say that tourism cost them money. These differences, however, between the High Negative group and the other groups were not large and, as pre-

Table 5.17. Responses to Social Exchange Indicators by the Three Groups (Port Douglas)

		Group	
Variable	Low Negative	High Negative	Positive
1. How much tourism benefits me economically			
A great deal	54	45	28
	47.4%	36.3%	45.2%
A little	10	6	4
	8.8%	4.8%	6.5%
Not at all	15	18	10
	13.2%	14.5%	16.1%
Costs me money	14	35	13
-	12.3%	28.2%	21.0%

viously stated, not significant. Further, the responses of the Positive group were not consistent with an exchange perspective. This group was less likely than the low negative group to say that tourism had benefitted them a great deal, and 37% said that it had either not benefitted them at all or had cost them money.

In addition to the structured questions on tourism impacts and the question of importance of the impacts, the study asked respondents to state whether they believed that tourism had negative and positive impacts on both a personal and community level. Respondents who replied yes to any of these questions were asked in an open-ended question to list what they thought the impacts were. Table 5.18 lists the responses of the three groups for the first question of whether they believed that tourism had had various impacts. On three of the four areas, there were significant differences between the groups. The High Negative group was the most likely to say that tourism had had negative personal and community impacts and the most likely to say that tourism had had no positive community impacts. While these results might suggest some equity function, the overall pattern of the results was not consistent. In the case of positive personal results the Low Negative group was the least likely to reply positively. Further, a substantial portion of the High Negative group reported no negative personal impacts from tourism and half of them reported positive personal impacts.

Table 5.18. Responses of the Three Groups on Whether Tourism has had Negative and Positive Impacts on a Personal and Community Level (Port Douglas)

Variable		Low Negative		Group High Negative		Positive	
1. Positive Personal	Yes	54	(47%)	62	(50%)	33	(53%)
Impacts	No	57	(50%)	58	(47%)	26	(42%)
$(\chi^2 = 1.4, P = 0.8)$							
2. Negative Personal	Yes	35	(31%)	68	(55%)	22	(35%)
Impacts	No	75	(66%)	53	(43%)	38	(61%)
$(\chi^2 = 15.5, P = 0.004)$							
3. Positive Community	Yes	87	(76%)	84	(68%)	39	(63%)
Impacts	No	21	(18%)	37	(30%)	14	(23%)
$(\chi^2 = 14.7, P = 0.005)$							
4. Negative Community	Yes	82	(72%)	111	(89%)	33	(53%)
Impacts	No	22	(19%)	12	(10%)	25	(40%)
$(\chi^2 = 35.1, P = 0.0001)$							

Those respondents who believed that tourism had had impacts were asked to list what the impacts were. Their responses were collapsed into the categories of economic (e.g., improved property values, increased cost of living), services (e.g., better roads, better schools, more sporting facilities), lifestyle (more opportunities to meet people, privacy invasion), and environmental (e.g., increased landscaping, loss of heritage buildings). In the cases of positive personal and community impacts there were no differences between the patterns of responses given by the three groups. For negative impacts there were no significant differences between the groups, but the cross-tabulations (given in Table 5.19) demonstrated that the High Negative group was more sensitive to environmental impacts.

The final question analyzed was an open-ended one concerned with the future of the region which asked respondents to list what they would like to see changed about tourism in the region in the next 5 years. The responses of the three groups are given in Table 5.20. There were four categories of responses: Pro-Development responses (e.g., there should be more tourists, there should be more promotion), Anti-Development responses (e.g., it should go back to what it was, tourists should leave), Controlled Development responses (e.g., no buildings on the waterfront, there should be more Australian ownership), and Services for Locals (e.g., there should be more sporting facilities for locals). There were

Table 5.19. Types of Negative Tourism Impacts Perceived by the Three Groups (Port Douglas)

	Low Negative	Group High Negative	Positive
1. Negative Personal Impacts			
Economic	17	29	6
	(50%)	(45%)	(46%)
Environmental	9	21	0
	(27%)	(32%)	(0%)
Lifestyle	8	15	7
	(23%)	(23%)	(54%)
$(\chi^2 = 8.4, P = 0.08)$			
2. Negative Community Impacts			
Economic	32	35	11
	(42%)	(33%)	(48%)
Environmental	2	12	2
	(3%)	(11%)	(9%)
Lifestyle	43	59	10
	(56%)	(56%)	(44%)
$(\chi^2 = 6.5, P = 0.2)$			

Table 5.20. **Perceptions of What Should be Changed about Tourism in the Next 5 Years for the Three Groups (Port Douglas)**

Changes	Group Low Negative	Group High Negative	Positive
Pro-Development	22 (22%)	24 (21%)	11 (27%)
Anti-Development	22 (22%)	33 (28%)	7 (17%)
Controlled Development	33 (34%)	48 (41%)	11 (27%)
Services for Locals	21 (21%)	11 (9%)	12 (29%)

$(\chi^2 = 12.9, P = 0.015)$

significant differences between the responses of the three groups, with the High Negative group the most likely to be opposed to further development or to call for controls on development.

Summary

The complex and detailed results charting resident reaction to tourism in Port Douglas are usefully summarized by identifying three social representations of tourism in the community. It is valuable to recall that the tourism development in this community has been dramatic and rapid. In the early 1980s there was little activity but by the middle of the decade a large resort, numerous apartment-style condominiums and some substantial touring operations emerged. In terms of visitor numbers a 500% increase has taken place from 1980 to 1985 and a further 100% to the time of the study. One view of tourism, labeled in this discussion the highly negative perspective, is held by people who have been in Port Douglas for the longest mean period (9 years). It is this group who see tourism as having had the maximum local environmental impact, the strongest effect on traffic congestion, and they are the only group to mention tourism's effect on the friendliness of the residents. It can be argued that this group is anchoring their view of tourism's impact on a well-remembered and now vanished "old Port Douglas"; a place with a quiet sleepy character, rich environmental qualities, and an easy pace of life.

Residents who hold either the low negative impact social representation or the positive social representation have lived in Port Douglas for shorter periods of time. In fact, the mean for both groups is 6 years, with

undoubtedly many of these people being a part of the new wave of arrivals to the area. For them there is less nostalgia about an old Port Douglas and the anchoring process is to other Australian coastal towns and communities. One group shares a little of the concern of the longer term residents over the broad economic and natural environment issues but the job opportunities are appreciated and there is a high level of support for controlled development and local services. The positive social representation, again comprising a part of the newer arrivals, show little environmental concern and favor more development and more services. They appear to be more concerned with the future of the community than the qualities that it had in the past, and although they report they have not always personally benefitted from tourism they are a small and enthusiastic tourism supporter group.

The Port Douglas study demonstrates that coherent views of tourism can be accessed by grouping residents on their perceived and important impacts of tourism. In effect, it is an argument that the network of tourism beliefs which constitute a social representation about tourism can be accessed successfully from the content of their tourism remarks rather than by pursuing demographic differences in the resident population and attempting to determine how these groups differ from one another. As demonstrated throughout this chapter it is also possible to access the network of beliefs by focusing on other tourism attitudes and then pursuing the links to related tourism judgments.

Hinchinbrook Shire

This study used an open-ended approach to examine perceptions of tourism's impact. Table 5.21 summarizes the responses given to open-ended questions seeking positive and negative, personal and community–tourism impacts. Overall, the respondents did not appear to have detailed perceptions of tourism impacts. When given the opportunity to list as many advantages or disadvantages as they wished, most gave only one answer to each question. Respondents were most likely to see tourism as having the positive community impact of creating jobs and economic opportunities. Few respondents listed any disadvantages of tourism, with increased crime being the most common response. In this question, however, 22% of respondents took the opportunity to express the opinion that too much development would be a negative force in the community.

This pattern of results was consistent with responses to two other questions about tourism. Respondents were asked to rate their support for increasing tourism in the region, using a scale which ranged from not at all supportive (0) to very supportive (10). The mean score for the

Table 5.21. Perceived Impacts of Tourism (Hinchinbrook) ($N = 329$)

		Positive[a]		Negative[b]	
Personal	None	55%	None	83%	
	Meeting new people	10%	Loss of recreation	3%	
	Economic — jobs/business	33%	Crowding	6%	
	Provide for children's future	5%	Increased costs	7%	
	Increased recreation	6%	Increased work	1%	
	Better services and facilities	6%	Loss of atmosphere	2%	
		Positive[a]		Negative[d]	
Community	None	6%	None	56%	
	Economic — jobs/business	89%	Crowding	5%	
	Increased awareness of area	7%	Increased costs	7%	
	Increased population	6%	Increased crime	19%	
	Secure future for young people	8%	Damage to environment	4%	
	Increased cultural activities	2%	Community conflict	2%	
	Better services and facilities	10%			

[a]84% gave only one answer.
[b]82% gave only one answer.
[c]70% gave only one answer.
[d]94% gave only one answer.

sample was 7.8 (SD = 2.4), with 39% giving a score of 10 and 93% giving a score of 5 or more. Another question asked the respondents to rank several forms of economic activity in terms of their potential for the region. In this instance the existing sugar industry was given the greatest support (45% of respondents), with tourism the next most listed industry (29% of respondents). Overall, it seems that respondents are supportive of tourism, but it is not seen by the majority as a primary economic activity for the region.

In order to explore in further detail the social representations of tourism held by the sample the survey contained questions about support for 12 specific tourism development proposals. Table 5.22 summarizes the preferences expressed for these different developments.

The mean ratings suggest that the sample was positive about all of the proposals. The distribution of responses shows that while the majority of the respondents was supportive for all proposals there was much variation in the levels of support for many of the proposed developments. It was argued that this variation in support was likely to reflect different social representations of tourism and therefore these data were explored further.

A cluster analysis of responses to the 12 proposed developments revealed the existence of two groups (see Table 5.23) These two groups were labeled Pro-Tourism Development ($n = 159$) and Concerned About

Table 5.22. Support for Specific Tourism Development Proposals (Hinchinbrook)

Proposal	Mean Rating	(SD)	Percent of Sample				
			0	1–4	5	6–9	10
1. Sealing the road to scenic waterfalls	8.96	(2.2)	3	3	2	20	72
2. Expanding leisure boat charters	7.80	(2.4)	2	8	8	46	37
3. Wilderness lodge near scenic waterfalls	7.64	(2.8)	5	9	10	37	40
4. Man made attraction in town (e.g. animal/bird display)	7.47	(2.4)	2	6	15	48	29
5. Using cane train tracks for scenic tours	7.30	(2.8)	4	11	11	41	33
6. Farm tourism and B&B developments	7.13	(2.8)	4	10	12	45	28
7. Using Aboriginal heritage as an attraction (e.g. museum)	7.02	(2.7)	4	11	15	45	25
8. An Italian food and lifestyle festival	6.90	(3.0)	6	11	16	39	29
9. Developing a major wilderness walk	6.71	(3.0)	5	14	16	40	26
10. Preservation of a small village as an historic precinct	6.00	(3.3)	11	19	12	35	23
11. Development of a coastal marina and resort	5.77	(3.8)	21	14	11	26	29
12. Development of freshwater canoe trips	5.65	(3.3)	11	23	12	36	18

Table 5.23. Mean Support of the Two Clusters for the Tourism Development Proposals (Hinchinbrook)

Proposal		Pro-Tourism Development ($n = 159$)		Concerned about Specific Developments ($n = 170$)	
		\bar{x}	(SD)	\bar{x}	(SD)
1.	Sealing the road to scenic waterfalls	9.3	(2.0)	8.7	(2.4)
2.	Expanding leisure boat charters	8.7	(2.2)	6.7	(2.9)
3.	Wilderness lodge near scenic waterfalls	7.9	(2.8)	3.8	(3.6)
4.	Man made attraction in town	8.7	(1–9)	7.0	(2.6)
5.	Using cane train tracks for scenic tours	8.2	(2–2)	5.7	(3.1)
6.	Farm tourism and B&B developments	8.3	(2.3)	6.3	(2.8)
7.	Using Aboriginal heritage	8.2	(2.1)	5.9	(2.8)
8.	Italian food and lifestyle festival	7.5	(2.6)	4.0	(3.0)
9.	Major wilderness walk	8.3	(2.1)	5.2	(2.9)
10.	Preservation of small village as an historic precinct	8.5	(1.9)	6.5	(2.4)
11.	Coastal marina and resort	7.8	(2.7)	4.3	(3.0)
12.	Freshwater canoe trips	8.5	(2.0)	5.8	(2.8)

Specific Developments ($n = 170$). The second group was generally less supportive of the proposed tourist developments but expressed particular concern with the development of a wilderness lodge and a coastal resort and marina, and the Italian food and lifestyle festival. It is important to note that these three developments were the only ones which had been presented in the local media as specific or concrete proposals. All the other developments had been constructed by the researchers after consulting with members of a local tourism committee and the resultant proposals embodied in the items had not previously been discussed in the public arena.

Further investigations into the patterns of responses of the two clusters found no significant differences between them for age, length of residence in the area, the types of visitors they would prefer, their willingness to work in tourism, and their perceptions of tourism's costs and benefits for the community. As might be expected, the two groups did differ significantly in terms of their support for the development of tourism, with the concerned group being less supportive. This pattern of less support for tourism from the concerned group was also found

for responses to questions seeking support for different tourism marketing themes for the region (see Table 5.24). As might be expected from the responses to the specific development, the concerned cluster were least supportive of slogans emphasizing wilderness or ethnicity.

There were also significant differences between the clusters in their perceptions of tourism's personal benefits and costs. In terms of the personal costs of tourism only 11% of the Pro-Tourism cluster listed any personal costs, while 27% of the Concerned cluster did. A Chi-square analysis indicated that this was a significant difference (Chi-square = 120, $P = 0.0005$). Table 5.25 contains the responses of the two clusters for

Table 5.24. Differences Between the Pro-Tourism and Concerned Clusters on Support for Tourism and Marketing Themes (Hinchinbrook)

Scale	Pro-Tourism Development \bar{x} (SD)	Concerned about Specific Development \bar{x} (SD)	Test	Significance Value ($P=$)
Overall support for tourism (0–10)	8.3 (2.2)	7.3 (2.4)	$t =$ −3.95	0.0001
Support for marketing themes[a] (1–5)			$Z =$	
1. Waterfall Country	4.0 (1.1)	3.7 (1.0)	−2.8	0.0001
2. Wet Tropics Wilderness	3.8 (1.1)	3.3 (1.2)	−3.8	0.0001
3. Sugar Sand Sea	4.1 (1.0)	3.8 (1.3)	−2.1	0.035
4. Queensland with a Mediterranean Flavour	3.1 (1.4)	2.7 (1.3)	−2.7	0.006
5. Country Town Hospitality	4.0 (1.2)	3.6 (1.2)	−3.6	0.0003

[a]Results obtained using Mann–Whitney U-tests corrected for ties.

Table 5.25. Cross-Tabulation of Clusters by Perceived Personal Benefits of Tourism (Hinchinbrook)

	Benefits		
	None	Economic	Improved Facilities
Concerned about Specific Developments	103 64.8%	9 5.7%	47 29.6%
Pro-Tourism Development	69 47.9%	19 13.2%	56 38.9%

$c^2 = 10.36, P = 0.006.$

Table 5.26. Cross-tabulation of Places to be Protected from Tourism by the Two Clusters (Hinchinbrook)

	Places to Protect			
	None	**Environment in General**	**Coastal Areas**	**National Parks**
Concerned about Specific Developments	63 39.9%	13 8.2%	65 41.1%	17 10.8%
Pro-Tourism Development	77 52.08%	8 5.4%	41 27.7%	22 14.9%

$c^2 = 8.62, P = 0.035.$

personal advantages. The concerned cluster was more likely to give no perceived benefits and less likely to see tourism as providing them with personal economic benefits.

Finally, there was a significant difference between the two clusters for the places that they would like to see protected from tourism development (see Table 5.26). The concerned group was more likely to suggest places for protection, particularly coastal areas.

Summary

In this study a community with little existing tourism development was questioned on its attitudes to tourism impacts and future tourism growth. Two consistent views of tourism were accessed by focusing on residents' reactions to specific proposed tourism developments in the low tourism profile community. Respondents who were somewhat less supportive of three specific developments were also shown to be less favorable to tourism overall and less likely to perceive personal benefits arising from tourism.

This study enables the incipient growth of social representations within a community to be seen. The resident response to tourism in this study did not consist of two distinctive patterns with different webs of items connected together. Instead, the same trends and orientations exist, with one group being consistently less positive on a range of proposals and items than the other group. A striking feature of this study was the general lack of tourism knowledge and impact concerns, with few respondents listing any disadvantages of tourism. The dependence of this community on the sugar industry has been profound: 45% of respondents still believed that it was also the industry with the best future for the region. This view was revealed to the researchers in the expression that "if we look after sugar, sugar will look after us". When the community

was asked for its views on the tourism industry there was little direct local knowledge for it to use. The information available was media based and or dependent on the travel experiences of residents.

Brown (1992) explored the role of the media in influencing this community's attitudes to tourism in a 5 month longitudinal study. Her analysis revealed that there were month-to-month fluctuations in people's attitudes to specific tourism developments according to local newspaper reports in the preceding weeks. Brown's study, conducted in the same area and at the same time as the major survey, was based on a sample of only 30 residents. Nevertheless, it strengthens the case that in a community with a low information base, an impoverished consensual universe on tourism, the views on tourism are flexible, and are strongly influenced by media information as they are being developed.

Townsville

This final study added an emphasis on the types of visitors or tourists to be attracted to the town and focused in more detail on resident reactions to specific aspects of tourism development. The analysis began with a consideration of the types of visitors that residents believed should be attracted to the area (see Table 5.27). Generally, there was a high level of support for all kinds of proposed visitors, with a slightly lower level of support for backpackers and resort visitors. Questions seeking support for tourism in general also elicited mainly positive responses (see Table 5.28). Over 70% of the respondents reported that they would like to see

Table 5.27. Support for Increase in Different Types of Visitors to the Region (Townsville)

	Strongly Support %	Weakly Support %	No Support %
1. Backpackers using local hostels	57.0	30.8	12.1
2. Australian and overseas visitors using resort-style accommodation	65.5	25.7	8.7
3. Visitors who stay with friends and relatives	78.9	18.4	2.7
4. Family groups from other parts of Australia who stay in motels, budget accommodation	82.5	15.0	2.4
5. Visitors to conferences, conventions and special events	78.2	17.5	4.4
6. Caravan park travellers journeying "around the country"	69.9	21.8	8.3

Table 5.28. Support for Tourism in General (Townsville)

A. Ranking of Desirability of Industries for the Region (Townsville)
(Scale: 1 = most desirable to 8 = least desirable)

	\bar{x} rank	(SD)
Education	2.8	(1.8)
Tourism	3.2	(2.1)
Manufacturing	3.7	(2.1)
Marine industries	3.7	(1.9)
Rural industries	4.7	(1.9)
Government	5.6	(2.1)
Armed services	5.8	(2.0)
Mining	6.1	(1.7)

B. Which Industry has the Best Prospect for Future Growth?

Industry	N	%
Tourism	182	44.2
Manufacturing	88	21.4
Education	45	10.9
Marine industries	41	10.0
Rural industries	16	3.9
Armed services	14	3.4
Mining	8	1.9
Government	6	1.5

C. Preferred Role of Tourism in the Community in the Future

	N	%
Significant increase	125	30.3
Moderate increase	165	40.0
Slight increase	60	14.6
Same as at present	45	10.9
Slight decrease	4	1.0
Moderate decrease	4	1.0
Significant decrease	9	2.2

a moderate or significant increase in tourism over present levels. Tourism was also seen as the second most desirable industry for the region after education, with 44% of residents stating that it was the industry with the best prospects for future growth.

A series of cluster and cross-tabulation analyses was conducted to identify different patterns of responses to these questions which might indicate the existence of different social representations. Systematic attempts were conducted to identify clusters within the total sample based on attitudes to tourism, attitudes to types of visitors, and tourism preferences. Unlike the three studies previously reported in this chapter these analyses did not provide evidence for the existence of clear, well-

defined clusters. This prompted the view that there may be one domin-
ant social representation of tourism in the Townsville study. The
existence of a single major social representation of tourism was sup-
ported by the consistency of responses to other questions.

Table 5.29 shows the resident sample's ratings of the importance of
various negative and positive impacts of tourism. Respondents were
asked to choose the five most important negative impacts to be controlled
and the five most important positive impacts to be encouraged. In the
case of both negative and positive impacts the five most important
impacts were given by a majority of respondents. The homogeneity of
responses displayed in this community survey lend force to the
argument that the Townsville community has a shared world view on
tourism. This is not to imply that everyone thinks in exactly the same way,
but rather that there is a pattern of responding, albeit with slightly
different strengths or emphases, which organizes the topic of tourism in
the same way. A marked contrast can be made here with the Port Douglas
survey where mean scores were shown to mask different patterns of
dispersed response styles. For the Townsville study the mean scores are
aligned to the means and modes with small standard deviations, all
evidence favoring a common world view or social representation.

Specifically, residents were concerned about damage to the environ-
ment, particularly the reef, crime, rising prices, and privacy invasion
which might result from tourism development in the area. The concern
for the environment was also accompanied by the belief that tourism had
the potential to assist in the conservation of the natural environment.

**Table 5.29. The Five Most Important Positive and Negative Impacts of
Tourism (Townsville)**

A. Negative Impacts[a]		
	n	*%*
Pollution on the reef	253	61.4
Damage to the natural environment	236	57.3
Increased crime	234	56.8
Increased cost of living	220	53.4
Privacy of residents	211	51.2
B. Positive Impacts[a]		
Local exposure to foreign tourists	394	95.6
Increased job opportunities	304	73.8
Better transport access	269	65.3
Conserving the natural environment	257	62.4
Aiding conservation of the reef	242	58.7

[a]The lists of impacts given to respondents were generated from focus group
discussions.

Residents were also strongly supportive of the opportunities that tourism would bring for meeting foreign visitors, increasing jobs, and improving transport.

The sample was asked a series of both open-ended and structured questions seeking their views on various features of tourism development for the region. Table 5.30 reports support for various types of tourism development and Table 5.31 reports suggestions for stimulating tourism to the region. Consistent with their responses about potential benefits of tourism, residents were supportive of improved transport and increased access to the environment. Both questions elicited resident support for an increase in general recreational facilities including parks and shops. It is interesting to note that in both tables support for more accommodation, particularly resort accommodation, was less enthusiastic. It is possible to speculate that an anchoring process is at work in the genesis of this aspect of the Townsville social representation. As the major settlements in north-eastern Australia, Townsville and Cairns have a long history of civic competition. Cairns is a clear leader in total tourism development and has a strong resort component. For Townsville, unable to match Cairns in this area, there is possibly a community dynamic which anchors Cairns as resort-style tourism and prefers to see Townsville grow in other ways in the alternative accommodation styles.

The resident sample was also asked to list suggested improvements for the area. An examination of Table 5.32 reveals some interesting parallels with the responses given in Tables 5.30 and 5.31. Residents are particularly concerned with improving transport and increasing general recreation facilities. It appears that what the residents want for themselves is what they would hope to find provided by tourism development.

This pattern of matching tourism to their own preferences or perceived needs also emerges in the questions about the respondents' travel

Table 5.30. Preferred Types of Tourism Development for the Area (Townsville)

	n	%
More/better public transportation	310	75.2
More entertainment/recreation facilities	257	62.4
More access to the environment	208	50.5
More convention/exhibition facilities	138	33.5
More public parks	123	29.9
More budget/motel accommodation	123	29.9
More man-made attractions	99	24.0
More retail shops	73	17.7
More interpretive centres	66	16.0
More hotel/resort accommodation	63	15.3

Note: Multiple responses were allowed.

Table 5.31. Suggestions for Stimulating Tourism to the Area (Townsville)

	n	$\%$
1. Increased promotion/information for visitors and locals	182	44.2
2. Improve general facilities (e.g., parks, gardens, shops)	122	29.6
3. Improve access/transport	78	18.9
4. Themes for promotion (environment, sunshine, beaches and relaxation)	63	15.3
5. Improve tourist facilities (e.g., money-changing and conference facilities)	57	13.8
6. Increase accommodation	24	5.8

Table 5.32. Suggested Improvements for the Townsville Area (Up to Two Options Permissible)

Transport	**40.3% of Total Response** **Number of Responses**
Improve public transport	94
Better roads	63
Other	17
General Recreation Facilities	**33.3% of Total Responses** **Number of Responses**
Increase entertainment	49
Increased parks and gardens	34
Increase facilities	29
Better shops/cultural activities	18
Increased sports facilities	14
Other Services	**21.5% of Total Responses** **Number of Responses**
Decrease rubbish/litter	24
Increase tourism infrastructure	23
Increase industry	17
Other	29

experiences. The majority of the Townsville respondents had taken between one and five holidays in the last 2 years, and most had stayed within the state and most had stayed with friends and relatives or in motels. Very few used hotels and resorts.

The travel experience of the residents seems to be reflected in the kinds of tourism development they prefer; effectively tourism which

Table 5.33. Experience With and Perceived Benefits of Tourism (Townsville)

	n	%
Extent of Daily Contact with Tourists		
Almost no tourists	191	46.4
Just a few tourists	153	37.1
Quite a lot of tourists	47	11.4
Deal with tourists all the time	20	4.9
Number of Relatives/Close Friends Working in Tourism		
>10 people	19	4.6
5–10 people	24	5.8
1–4 people	139	33.7
No one	230	55.9
Perceptions of Personal Economic Benefits of Tourism		
A great deal	56	13.6
Somewhat	62	15.0
A little	111	26.9
Not at all	160	38.8
Negatively affects me	22	5.3

serves travelers like themselves. Finally, Table 5.33 shows the sample's experience with, and their perceptions of the benefits of tourism. Generally, the sample had little direct experience of tourism and few perceived any personal economic benefits.

Summary

A cursory examination of the tourism statistics comparing Townsville and Cairns at the times of the studies showed that the former received 1 million visitors, and the latter 2 million. This might lead to the view that Townsville citizens should share many of the tourism views of their northern neighbors. The statistics, however, fail to record that a large percentage of the visitors to Townsville are local visitors involved in shopping visits, health trips, sports events, and other commuting associated with a dominant regional center. The visiting friends and relatives market has always been stronger to Townsville than to Cairns, which further adds to the perspective that tourism is a very visible, commercially focused and international industry in Cairns and a more muted but emerging sector in Townsville.

The present study has revealed that only one social representation of tourism could be clearly distinguished in Townsville at the time of the research. Broadly portrayed, this social representation could be characterized as "tourism for the community" since a dominant emphasis on

the developments and facilities which were seen as desirable for tourism also served local citizen needs. The Townsville response to tourism is in the technical phrase described in *chapters 2* and *3* an emancipated representation. The views discussed show support for meeting other Australian and foreign visitors, increasing jobs, and improving transport. Indeed, there is an optimism about tourism's future in the city, with 70% reporting that they would like to see a moderate or significant increase in tourism over present levels. Importantly, support for large resort-style accommodation is less enthusiastic and the orientation of community opinion is directed towards a continued growth of the low key forms of tourism which have limited environmental impact. As has been argued in earlier sectors the social representations approach emphasizes the web and network of ideas connecting tourism thinking by residents. In the Townsville study the uniformity and consistency of this web of ideas was accessed by focusing initially on what kinds of visitors or tourists should be attracted to the area. It is a useful and flexible aspect of the social representations approach that the underlying community views about tourism may be approached from a number of pathways.

The Australian Studies—An Overview

The four Australian studies contained in this chapter provide an important bridge in the construction of this monograph. They represent a highly empirical approach to understanding how communities think about tourism but they also illustrate the use of an extensive theoretical framework to guide the numerical analysis. It is the argument of this chapter, and following in the footsteps of other social representations researchers (cf. Canter and Breakwell 1993), that the rich sociological roots of social representation thinking are not inimical to sound contemporary empirical analysis. The international case studies reviewed in *chapter 4* were effectively conceptualized as secondary data analyses for use in our social representations approach. In the present chapter more explicit and powerful demonstrations of the differences among community views of tourism have been demonstrated or such views have at least been shown to be in a state of development.

Additionally, this chapter provides another important bridge in the present work. It directs attention away from the dominant concern with the impacts of tourism and how these are seen by the community to how hosts understand, define, and evaluate the future of tourism. This concern with providing planning-relevant information, rather than assuming that a study of impacts *per se* provides planning-relevant material, is an important evolutionary step which the study of community attitudes to tourism needs to take. As has been shown in this chapter and in

reviews of previous studies there is not always a neat correspondence between perceived impacts and the preferred role of tourism in a community. It will be to the benefit of tourism planners and researchers to participate more directly in the assessment of community attitudes to the future than has been done in the past. The emphasis on planning studies raises questions such as what are the current states of practice and what kinds of research exist in this area which may be linked to better tourism planning. An examination of community participation in planning area is the next step in our understanding and management of the tourism–community relationship.

Chapter 6

Community Participation in Tourism Planning: Social Representations Perspectives

Introduction

Winston Churchill is reputed to have said that the Soviet Union was a riddle wrapped in a mystery inside an enigma. This comment could well be applied to community participation in planning inside tourism. In this chapter, the puzzle-like qualities of community participation in tourism planning will be considered and the social representations framework will be used to inform this discussion.

Murphy (1985) has made the point that there is a wide variety of interpretations associated with the notion of community participation in the tourism planning process. It would therefore seem useful to provide an operational definition of such a term. Community participation in the tourism planning process may be generally understood as the involvement of individuals within a tourism-oriented community in the decision-making and implementation process with regard to major manifestations of political and socioeconomic activities.

Simonds (1978) has observed that every highway is a political statement. So too every tourism resort and major development has a political, community, and business history. The final form of the tourism product is a statement of the powers and degree of cooperation among these interacting parties. It is the community "history" of tourism projects which is central to this chapter.

Smith (1984) notes that there are four prerequisites for public participation. These include the legal right and opportunity to participate, access to information, provision of enough resources for people or

181

groups to get involved, and genuinely public, that is broad rather than select involvement, from these communities. Importantly, Smith warns that public participation should not be confined to operational issues but should include strategic and normative (or value-based) planning as well.

The dilemmas and puzzle-like qualities of public participation alluded to above refer to questions such as what are the goals of public participation, what are the obstacles to public participation, how is it best carried out, and what sort of outcomes can be expected from the process? As an organizing framework for this chapter these issues will be presented in diagrammatic form and then discussed in more detail in the accompanying text.

One further question pertaining to public participation is central to the present volume. How does the social representations framework inform this discussion? It has already been argued in *chapters 4* and *5* that social representations can be used to understand how different community groups think about tourism. One possibility therefore of linking social representations work to public participation exercises lies at a technical level: by examining survey data on how people think about tourism, dominant social representations may be unearthed and used as the basis for planning discussions, workshops, and negotiations, as evidenced in Murphy's work. There is, however, a more conceptual contribution emanating from the social representations framework.

Moscovici's original formulation of social representations makes important connections between people's knowledge and the power of the community group (Moscovici 1984). This kind of power–knowledge link is also explicitly made in the community participation in planning literature. For example, Amy (1987) observes:

> Knowledge is power. People ... who can credibly claim to be in accord with current scientific thinking or those who know what is practically achievable in some real world situation are usually more convincing and thus more powerful in negotiations (1987:143).

This kind of analysis is identical to the distinction made by Moscovici between the consensual and reified universe, the former being the language and knowledge base of everyday conversation and the latter being the scientific technical world of expertise and education. It is an important part of unscrambling the riddles of public participation to consider how non-experts can contribute to technical planning discussion. Moscovici's distinction between the consensual and reified universe and his recognition, parallel to that expressed by Amy, that power is related to the reified world of discourse, will be an important reference point in this chapter.

One particular insight from Moscovici's analysis which is worth pursuing is that both worlds influence each other—the reified universe

is influenced by everyday concerns and agendas. In turn, the consensual universe, that is people's everyday knowledge, which is seen as separate and not inferior to scientific knowledge, is influenced by the publication of technical and scientific reports. A confirmation that these social representations perspectives are important in the community participation world comes from the work of Keogh (1990). Working in New Brunswick, Keogh observed that citizens in these areas were more favorable towards tourism as more information was available to them. Generally, however, Keogh noted that in the consensual universe there was a low level of information about tourism and with limited information people were inclined to anchor their views with inappropriate analogies to other areas of the province. The provision of information to residents is one of several goals of community or public participation programs. In short, one potential benefit of community participation is to modify the social representations on which poorly informed residents are depending to guide their responses to new developments. Social representations of tourism and the amount of community participation may be seen as linked factors in influencing how citizens respond to tourism.

The key material to be discussed on public participation is presented in Table 6.1.

The Goals and Needs for Community Participation

In any discussion on community involvement in tourism development decision making, the question of power and influence becomes a dominant consideration. For many individual citizens, the sole purpose of participation is to exercise power, or at least some influence, over the outcomes of tourism development in their residential area. Painter (1992) has distinguished between "pseudo", "partial" and "full" participation. The first, pseudo participation, is said to be restricted to such processes as informing and endorsement and offers a feeling of participation without its substance. Partial participation is said to give the participants some opportunities for exercising influence, but reserves the final power to make decisions with an authority holder. Full participation is defined as a process where each individual member of a decision-making body has equal power to determine the outcome of decisions (Pateman 1970, cited in Painter 1992). These distinctions between various types of participation are founded on assessments of the potency displayed by participants. Another and more elaborate typology of distinctions based on a similar approach is to be found in Arnstein's (1971) "ladder of participation" with its seven rungs, ascending from manipulation through therapy, information,

Table 6.1. Key Components of Public Participation

Goals and Forms of Public Participation	Factors Affecting Outcome of Public Participation	Methods and Sequences of Involving the Public	Key Outputs From Public Participation Programs
Information exchange	Type of argument	Community panels/boards	Submissions
Negotiation	Level of energy of	Surveys	Technical reports
Protest	participants	Nominal groups	Community
Education	Preparedness to negotiate	Focus groups	consultation plans
Support building for	Ongoing relationships	Mediation	CODINVOLVE or
project	between the organizations	Simulations	similar summary of
Supplementary decision	in discussion	Drop-in centres	outputs
making	Effect of physical	Agency displays	Contributions to an
Representational input	environmental/type of	Delphi process	"objective tree"; "goal
Encouraging future	location context	Social representations,	programming model"
orientation		mapping of community	or other decision models
Assisting in management		perspectives	

consultation, placation, partnership, and delegated power to control.

These distinctions, according to Painter (1992) rest on what has been described as a crude conception of power. There is said to be a tendency to confuse "power" with "powers". Pateman's category of "partial participation" is said to be based on a situation where influence may be exerted, but final "power" rests with an authority holder. It is also pointed out that if that exercise of influence is effective, then this formal "power"of the authority holder is an empty shell. In the analysis of power, a basic distinction is seen to lie between potential and actual power; one cannot always prejudge the latter from the former. Painter holds that while formal powers and political rights are an important part of the framework within which participation and consultation occur, an assessment of power needs to look at outcomes as well.

Furthermore, Painter (1992) has argued that there are at least three major forms of community participation:

1. Information Exchange

This is said to be a straightforward exercise in communication and involves such activities as making submissions in a consultative process. It is presumed that information will shape outcomes on its own. Painter points out that it is not unknown for authority structures to revise their proposals in the light of previously unavailable information provided by community groups. Such information is said to include data on public opinion, often collected by agencies themselves through their own surveys, and usually accompanied by efforts to "inform the public" about the agency's plans. Further details linking information exchange to the use of social surveys are contained in Issue Box 6.1.

2. Negotiation

Painter regards negotiation as a process of exchange aimed at reaching a settlement. The participants in such an exchange are said to be sharing in a phase of the process of policy formulation. Negotiating involves face-to-face contact and discussion between a small number of individuals with the authority to speak for others. Initiating discussions involves a conditional commitment to reaching an agreement. The process involves the use of information, the presentation of arguments in a rational format (or persuasion), and the use of threats and inducements to try to achieve a resolution. The latter are said to often remain implicit, and their use sometimes signals an end or temporary halt to

Issues Box 6.1
Improving the Community Survey

The value of a community survey as an information device for tourism parties is considerable. For the tourism change agent, much valuable local knowledge about features and resources in the area can be obtained, as well as a systematic appraisal of community preferences for types of tourism and types of tourists. This request for community information comes with some consequences. It raises an expectation that the opinions expressed may not only be recorded, but also have an influence. Additionally, the image of tourism and of the tourism change agent is affected by how the survey is conducted and how the questions are asked. As Roiser (1987) noted (see Case Study 2.5), the very presentation of survey results can change public opinion.

The methodological advice suggested by the social representations framework, for surveying communities on tourism, includes:

1. pretest the survey content (impacts, futures of tourism, preferred scenarios) and language so that the emic (community) perspective is maintained in the questions;
2. include material which links tourism to other changes in the community and to group identity and values;
3. examine the commonalities in the responses to the questions and see how the people responding in the same way are linked in terms of group identity and membership;
4. consider the power of the groups who hold any different social representations or views of tourism;
5. assess the sources of people's information about tourism and their preferred methods of future contact and knowledge about potential tourism changes; and
6. consider the advantage of longitudinal or repeated survey work so that the influences and developments relating to change can be monitored.

negotiations. Effective negotiation for Painter relies on a range of skills and ploys which are essential in producing favorable outcomes: debating and advocacy skills, committee tactics, the withholding of information or its selective release, and so on. A necessary prerequisite of effective negotiation is that people are sharing the same social representation or, at least, are understanding the respective social representations of the other party. Without such a shared view, the perceptions and responses of both parties are inevitably going to be distorted and misread. A first step in negotiation is to adopt the social representations emphasis on finding consensus—what do the parties all believe; subsequent differences can then be more effectively negotiated.

Painter points out that as a form of bargaining negotiation is distinguished by its direct, face-to-face character. He suggests that many conventional pressure-group activities, such as holding public meetings, campaigning to form public opinion, and making promises about support or opposition during elections, can be regarded as one side's

strategies in a bargaining process with government agencies and developers. These threats and inducements attempt to get concessions, and may take place as a prelude to or even during actual negotiations. On occasion, direct negotiation may not be embarked upon at all. Instead gains are said to be achieved and victories attained by default or without much effort. The direct, face-to-face character of negotiation, and the presumption of a shared interest in reaching an agreed outcome, has, according to Painter, a particular appeal to many advocates of participation, but other participatory strategies can also be used.

3. Protest

Information exchange and, in particular, negotiation, entail direct involvement in a cooperative and positive framework with decision makers, whereas protest or direct action, such as demonstrations, sitting in front of traffic, and rent strikes, are basically oppositional, rather than cooperative, forms of participation. According to Painter, protest aims to change the climate of political sanctions and rewards within which governments and developers act. Protest is said to have its own immediate impact through disruption and media exposure. It can also be aimed at building community support and demonstrating to governmental bodies the reality of opposition. As with negotiation, protest is seen as part of a wider bargaining process between community groups and the change agents that they oppose. Protests, as was argued in *chapter 3*, may be seen in terms of increasing the strength of the ingroup's polemical representations as well as an attempt to persuade outsiders of the value of the point of view.

Community groups have at their disposal a choice of strategies for opposition to change. Each strategy is said to have its pros and cons as an instrument of power, and is appropriate for particular circumstances.

Glass (1979) has articulated other goals of public participation by observing that information exchange, education, support building for the project, supplementary decision making, and representational input are all potential considerations. He further argues that these goals should be matched to techniques for eliciting public participation, as illustrated in Table 6.2. Further discussion of the variety of techniques proposed by Glass will take place later in this chapter.

The goals and values involving citizens in the planning process are specifically supported in a tourism context by Haywood (1988). Five points are highlighted in Haywood's analysis: the value of encouraging a future orientation in the community, of benefitting from innovation, of learning, of facilitating the influence of the community, and of assisting in managing tourism.

Table 6.2. The Links Between the Goals and Some Techniques of Public Participation (after Glass 1979)

Goals

Information Exchange	Education and Support Building	Supplementary Decision Making	Representational Input
1. Drop-in centers	1. Citizen advisory committees	1. Nominal group process	1. Citizen survey
2. Neighborhood meetings	2. Citizen review boards	2. Analysis of judgment	2. Delphi process
3. Agency meetings	3. Citizen task forces	3. Value analysis	
4. Public hearings			
Administrative perspective dominant		Citizen perspective dominant	

Techniques

It is valuable to observe here that, as Simmons (1994) notes, tourism–community planning is proceeding very much along the same pathway as that traversed by other public interest areas, such as housing, transport, and health. These areas of community change have had active community input since the 1950s (Glass 1979). It is perhaps useful here to restate a clear premise on which this whole book is based. Tourism as a service industry plays host to the consumer and the need for community support in the tourism arena is just as vital as the need for community consultation in the other areas of community growth (cf. Murphy 1985; Ritchie 1985, 1988).

Factors Affecting Participation Outcomes

Syme (1992) has outlined a number of fundamental elements which are said to determine outcomes in public participation. Whilst Syme addresses the general context of environmental planning, such a model would seem to be applicable to tourism development. Syme basically regards this process as ongoing negotiation between multiple competing interests. He has argued that the model is composed of five major elements: type of argument, level of energy among participants, preparedness to negotiate by the most powerful party, ongoing relationships for environmental negotiation, and the effect of environmental context.

1. Type of Argument

Syme quotes Eccles (1983) as classifying the types of argument that can occur during environmental planning, both within participating groups and between them. Specifically, he distinguishes between ideological arguments and allocative ones. Ideological issues are said to be those expressive of values in some domain. They are said to offer little room for compromise. They are embodied in statements such as "no freeways on foreshores", "no high-rise on the coast", and "no mining in national parks". They are said to be the sorts of issues that invite zero-sum negotiations. If one side achieves a victory, the other feels that it has lost.

Allocative issues may take the form of questions such as: How many resorts should be allowed on particular wetland areas? On which coral reefs should commercial activity be allowed? Questions of this type are said to allow for the possibility in which there is a potential for two or more sides to perceive the outcome as somewhat equitable (Pruitt 1981). Syme holds that these two types of argument may well call for different forms of public involvement. In the first, it may be appropriate to involve

community groups in longer term discussions, focusing on general policy issues, early in the process. Ideological negotiations are, however, liable to end in an impasse. If no genuine negotiation about policy or outcome is going to occur at this point (because there is no intention among the more powerful players of meeting the ideology of the less powerful ones) then a formal public-involvement program may not be the answer.

Syme has also argued that planning officials have an important role to play in the settlement of such disputes. The planning professional is able to act as an advocate for the weaker parties. His/her roles could in this case encompass the provision of lobbying skills, for example, in media use, in targeting decision makers, and in maintaining group cohesion. Such a role is seen as legitimate in the community psychology literature (e.g., Rappaport 1977) and also in planning theory (e.g., Hudson 1979). In this situation the argument may not get as far as the problem-solving stage unless exceptional truculence is shown by the less powerful party (Pruitt 1981). It may prove difficult for a planner to adopt such a radical role, whether employed directly or acting as a consultant. Notwithstanding, Syme maintains that it is important that such an advocacy on behalf of the weaker party become a recognized function of public-involvement planners. Without it, he argues, the public-involvement process may well fail to have a continuing and productive role. Gormley (1981), as cited by Syme (1992), suggests that government agencies should provide funding support for continued public involvement for both shorter and longer term decisions. He argues that in the long run this could make an important contribution to the effectiveness of public input. It is worth exploring whether such a funded role would prove acceptable to state and local governments as well as private developers, especially in matters involving tourist development conflict.

2. Level of energy among participants

There is said by Syme to be a tendency for the organizers of community participation programs to aim for a very high level of public input for the kind of problem they have in hand. As environmental and urban planning are becoming more institutionalized and visible, the call to devote time and energy to prepare submissions or get involved on a variety of community issues is increasing. The perceived need for public involvement will vary within the community (Syme 1992). Many are obviously not interested in public participation. Some may even actively oppose it. Among potential participants there are said to be some who wish to be kept informed at certain key stages (or at some particular key

stage). Any further demand for participation may even be seen as an attempt to coerce individuals who feel fully committed to other activities. Syme believes that community participation movements which require too much energy or time can be seen as an attempt to burn out local opposition. There may also be people, for example, those in the NIMBY (not in my back yard) category (Marks and von Winterfeldt 1984), for whom each stage in the process is of great importance and who are likely to look for close consultation at all stages.

Syme believes that the extent of involvement, the methods used and the way in which participation is incorporated into the planning process may need to vary for the differing client groups. Additionally, one can suggest that the variability from project to project is also likely to be considerable. The planner here, it is suggested, must be aware of the expectations of the community in general and of particular interest groups. The participants, however, should be aware of the limits to their power and the expectations that the planners have of them. Syme suggested that early in the planning process there needs to be some negotiation about the format and strategy of the program, and some estimation and agreement as to what can realistically be achieved, given the time and energy constraints affecting various constituent groups in the community.

3. Preparedness to Negotiate by the Most Powerful Party

In many countries, the most powerful party is usually the state or regional government. Sometimes it is in the position of being both the planner and developer, as well as the supposed mentor of the community participation program. In such a situation a conflict of interest or at least a hidden agenda may be perceived to exist. On some occasions the government may be unwilling to negotiate on particular problems for political reasons or because of other interests. It may be party policy that a particular tourist development takes place upon some public wetlands. Or, in the case of major events such as the Indy Grand Prix on Australia's Gold Coast, the timetabling and nature of the event is seen as fixed, and perceived as dictating the timetable for implementation of the plan. In the first type of circumstance, an ethically minded government may announce its intention to go ahead with a wetlands development project and so decline to involve itself in a community participation program. The decision to go ahead may, however, not be announced, and a community involvement program is undertaken in the hope that the chosen option will be preferred by the community. Syme points out that a government may try to guide this choice either by presenting only one option, or by proposing a set of choices in which the only one that is even

vaguely tenable is the one already chosen. Participation can take the guise of a public-opinion poll. Such a survey can be structured in such a way as to produce results that seem to justify the decision. Syme sums this up as being performed under the mantle of the community voice.

4. Ongoing Relationships for Environmental Negotiation

Syme's fourth major contextual factor is the history of previous relations between the parties involved in the community participation program (Bazerman 1983). This history is a part of the identity and mythology of the groups involved and, as discussed in *chapter 2*, the group offers its individuals a shared consensual social representation of how to see the world. There is, therefore, often a mistaken tendency to see the particular development project or environmental issue as a unique, stand-alone event. Bazerman points out that this is seldom the case. Even in local issues where participants are deciding for the first time to become active and protect their local environment, there are likely to be individuals from various community groups who have already had some experience with the developer or government department involved, or even some acquaintance with the relevant public servants. The community's willingness to negotiate or participate in any particular program may depend on the outcome of earlier interactions with the developer or government agency over planning issues. Thus, the history of potential participants' experiences with the major players sponsoring a public-involvement program will, it is argued, strongly influence its chances of attracting future participation. Syme also suggests that both the techniques employed and the timing of involvement may need to vary to suit different sections of a community.

5. Effect of Environmental Context

Syme's final factor said to be important in deciding when and how to implement public participation is that of the environmental context of the problem (Syme et al 1987). Syme et al pose critical questions here: Is the object of discussion a building of heritage significance for a major city? Is it the provision of a community hall for an outer suburb? Are community members struggling to find sites for noxious industry in some region? Are some people trying to develop a national conservation strategy? In this particular context is it a debate between tourism development and the preservation of some social or natural pheno-menon regarded as being of considerable or inestimable value to many members of the local community?

The physical context of the problem is said by Syme to be very important. Syme gives the example of the provision of a multipurpose community hall which may require citizen input into the evaluation of alternative designs and final selection. It is important that the design be able to accommodate the appropriate mix of demands for activities within the building. If there is conflict during the public-involvement process, this should not be regarded as necessarily abnormal. Conflict will surface anyway, perhaps in more devastating form once the building comes to be used. Widespread involvement then, should be ensured throughout the process. Syme maintains that community needs ought to be established, and the implementation of the final plan should be widely acceptable to the community.

In contrast, when a design issue encompasses problems that are said to be more ideological in nature such continuous involvement is said to be counterproductive. Syme (1992) uses the example of a team from the University of Western Australia which was asked to investigate the possibility of improving the design of the center of a historic Western Australian wheatbelt town. It was hoped that redesigning the town center would enable a clearer image of the town to emerge for both residents and visitors. Syme reports that while general public involvement would seem to be highly necessary in the early stages of developing such a plan, it was evident from the competing viewpoints that surfaced that strong opinions were held about the different alternatives, and compromise became difficult. Comment on a variety of alternative plans was found to escalate community conflict and confusion, and lessened commitment to proceed with redesign. The designer's task was to incorporate the public input so that the final design presented for comment reflected, as far as was possible, the values and aspirations of all in the town. Syme does, however, point out that this may not always be possible to achieve in a form that satisfies all or most. Techniques of community conflict management may be important in such a context.

Methods and Sequences of Involving The Public

As reported earlier, Glass (1979) outlined the need to match one's technique for gaining public participation with the goals of the exercise. For detailed representational input, systematic community survey work is likely to be an appealing option, whereas for information exchange, public hearings and media presentations may be appropriate.

Several authors have recognized the value of seeing the various methods of eliciting community participation as part of a sequence which together form a cumulative approach. Delbecq and Van de Ven (1971), writing about the general area of public participation, suggest that

specific techniques can be applied for different interest groups at different phases in the process. In their model of public participation, which they term the Program Planning Model, they distinguish five stages of involvement: problem exploration, knowledge exploration, priority development, program development, and program evaluation. They see client or consumer groups as being particularly involved in problem exploration and program evaluation, with technical and administrative personnel being the relevant audiences for other program phases. This approach represents an implicit manifestation of the assumed power and superiority of technical knowledge and effectively reduces the comments participation exercise to initial and commentary stages of the process.

Delbecq and Van de Ven's work, however, remains important despite this limitation because they advocate and define the nominal group technique, one of the methods explicitly reported and used in the tourism literature as being of value in community–tourism planning (Ritchie 1985). The technique involves bringing people from different backgrounds into groups of eight to ten people. Individuals in the groups are then charged with the task of generating lists of key concerns and issues about a specific project without consultation with other group members. The facilitation effects of this task are claimed to be powerful, with individuals generating long lists of issues. The group then functions as a communication and voting unit as individuals in a round-robin procedure itemize their listed concerns, and finally, a vote on the priorities for the whole group is taken. The procedure has several advantages, consistent with psychological research findings on human thinking and group dynamics research. In particular, the time to itemize concerns individually encourages mindful behavior on the part of group members and avoids the dominance of verbally fluent individuals which is common in focus group approaches. It also benefits from the role of audience effects in enhancing productivity (Langer 1989a; Zimbardo 1985).

Simmons (1994) reports the use of a nominal group technique in a three-stage sequence to involve the community in tourism planning. The sequence was cumulative in the sense that the results from the first stage guided the second stage and respondents in the final phase knew of the results of the second phase. The approach adopted was to conduct select interviews with key community leaders, to follow these issues in a simple random survey of the whole community, and then to use the nominal group technique combined with a focus group phase to obtain tourism preferences for a Southern Ontario community. Simmons provides a subjective rather than an empirical appraisal of this tiered approval (refer to Table 6.3).

Having considered a range of community participation techniques, it is now appropriate to introduce the value of the social representations

Table 6.3. Education of Citizen Participation Methods' in Tourism (after Simmons 1994)

Method	Type of Communication	No. of Participants	Represen- tativeness of Participants	Efficiency		Perceived personal Usefulness	
				Cost	Time	For Public	For Planners
Interviews with key stakeholders	Two way	Low	High	High	Medium	Medium	Low
Community survey	One way	High	High	High	High	Low	Medium
Focus groups (including a nominal group technique session)	Two way	Low	Medium	Medium	Medium	High	High

[a]In interpreting this table the methods need to be read as having been conducted in the sequence—interviews, surveys, focus groups. Thus, the value for planners of the focus group is greater when it has been used after the other two approaches. The table is an assessment of these approaches in their sequential use—not an assessment of them in a direct comparative sense.

framework to this topic. The social representations framework has important implications for the analysis of survey data, as illustrated in *chapters 4* and *5* of this book. In the community participation literature the social representations approach can be seen as emphasizing five features for survey design and interpretation. In particular, it stresses: recording the importance of attitudes and impacts of tourism to respondents; connecting attitudes to tourism with other attitudes to development and change; seeking consensus in community responses to tourism; providing a segmentation on community reactions to tourism, not on obvious demographic variables but using the attitudes themselves as the defining variable and then sectioning the sociodemographic differences in these representations; and, finally, suggesting that planners and business interests pay attention to the source of the community's tourism information. Careful execution of these steps in tourism planning studies, as evidenced in the previous chapter, will provide planners and developers with an organized and integrated view of what kind of tourism knowledge exists, what its direction is, and who holds it. Other processes such as mediation, negotiation, education, and citizen representativeness may then be carefully crafted to take advantage of how the community understands tourism.

It has already been suggested that various combinations of techniques and methods for community participation in tourism can be used in conjunction or in sequence. The technique of mediation, in particular, offers prospects for use with the social representations approach. Mediation, effectively the intervention by an individual not directly involved in the dispute who assists the parties to negotiate an agreement, is used in the more serious, conflict-bound public participation cases. It requires investment of resources and effort. Providing a social representations framework of how individuals and communities think about tourism also requires resources and effort, particularly in the collection, coding, and analysis of survey data. The two techniques are thus linked to the more demanding and problematic kinds of public participation exercises. However, the links are stronger than merely the issue of the resources required and the seriousness of the dispute. Mediators need to be able to communicate how the stakeholders view the world, and social representations can provide both the description of this context and the links between tourism attitudes and other development agendas.

Additionally, the mediation process, particularly the transformative mediation, which involves enhancing the abilities of groups to participate in decisions, recognizes the power of groups (Ozawa 1991, 1993). Although there is some debate on this matter (cf. Amy 1987; Folberg and Taylor 1984), a strong view in the literature on mediation is that the best solutions to conflict occur when the non-technically fluent, and often

relatively less powerful groups, can be guided through the technical information. Ozawa (1983) notes that many environmental management debates, and tourism environment debates are a worthy case in point, are confused by stakeholders bringing forth technical arguments to bolster their preferred policy option. He suggests a re-ordering of this adversarial process. He argues that the mediator's role is to get the parties to agree to deal with technical issues prior to committing to policy options. There is a great deal of value in raising several policy alternatives on the basis of agreed technical data rather than defending a prejudged option. These goals can be achieved by conducting mixed sessions of participants, that is, some technical people and some without that training, and these mixed sessions should be led by the mediator, who can usefully control the technical language and seek clarification on behalf of all participants.

It is argued that this mixed session approach promotes scientific peer review (experts from several groups are involved) rather than the more common hired-gun advocacy in much environmental debate. Further, by making the non-experts pay attention to the environmental, social, or community details they do not ignore the information or resort to existing social representations and stereotypes in making their judgments. In Moscovici's terms the efforts of transformative mediation involve keeping the reified universe as a meaningful influence on the consensual universe of the decision makers.

The social representations framework can, thus, provide both content, in terms of who is thinking what, and conceptual support for what mediation attempts to achieve in the more conflict-oriented tourism decisions. While it is arguably the case that many tourism decisions affecting communities are treated lightly by the host population—Simmons (1994), for example, remarks that over 50% of his southern Ontario residents did not fill in the surveys because they were not concerned about the tourism issue—some dramatic and controversial tourism conflicts have occurred. It can be argued that several of these costly conflicts could have been avoided if clear outputs from the community consultation process had been achieved.

Key Outputs from Public Participation Programs

Several kinds of outputs from community participation programs are possible. Summaries of community issues by consultants, planners and community groups themselves are a common input into the legal and political decision-making framework. Occasionally, a planned, strategic pattern of further community consultation is involved and a "social contract" is drawn up. (Pearce et al 1993). Such a social contract can be

a legally, but usually is only a morally binding, document which suggests ways in which the community can be involved, compensated, or rewarded for supporting the tourism venture. In this spirit, Australian casinos have legal responsibilities to provide a percentage of their income to community services and organizations.

One technique for summarizing the results of community participation exercises has been labeled CODINVOLVE (Clark and Stankey 1976). Effectively, this approach produces a matrix recording the forms of input by the community with the attitude expressed in that input. Additionally, the CODINVOLVE system lists the reasons given in support of the opinions expressed. The authors suggest that a neat summary of the community participation process in this form is critical for decision makers. An example of the CODINVOLVE system is presented in Table 6.4. One limitation of this form of presentation is that decision makers might give equal emphasis to all of the columns in the table, an emphasis which would not be consistent with the representativeness of these community inputs.

The mere provision of information, in whatever form, from a community consultation process does not guarantee that the information will be well used by decision makers. The best use of community inputs into the planning process is likely to take place when an organized system of orchestrating a range of inputs has been put in place. Such techniques include ideas such as the objective tree (Baker 1990), which is effectively a hierarchically organized system of integrating different levels of tourism planning information.

Some tourism researchers have attempted to borrow and apply concepts such as carrying capacity and limits of acceptable change to tourism planning discussions (cf. Getz 1983; Graefe 1991). These concepts, together with cost–benefit analysis and resource accounting in its various forms, all have some important limitations as summarizing devices for community input. In effect, they require *a priori* specification of the limits of growth or change by a manager or business interest. A more varied and flexible decision role model is Cocklin's (1989) goal programming model, a multiobjective optimization technique which recognizes the irreducibility of different aspects of the biophysical and socioeconomic worlds. The goal programming model attempts to set community-based and separate acceptable ranges for the different socioeconomic and biophysical factors. Attention to the matter of how community perspectives are used in the tourism planning process as well as further attention to issues of how to collect and present the community participation input is likely to be an important new topic in future tourism–community studies.

A social representation approach may be usefully employed with any of the above decision or planning models since there is a common and

Table 6.4. The CODINVOLVE system. A hypothetical matrix relating form of input to attitude (after Clark and Stankey 1976)

Tourism Development	Form of Input				
	Letters	Petitions	Reports	Form Letters	Total
Support	82 (90)[a]	(83)	(3)	82 (86)	169 (262)
Oppose	31 (35)	18 (645)	4 (5)	21 (21)	74 (706)

Reasons given in support of the opinion expressed

Reasons for:
Good for economy	(151)
Provides jobs	(111)
More recreation	(61)
Better than alternative	(43)
Stops intensive recreation	(26)
Restricts roads	(19)

Reasons against:
Already too many roads	(72)
Need for wilderness	(65)
Wildlife protection	(50)
Preserve for future	(47)
Need timber areas	(22)

[a]The top figure refers to the number of inputs. The figure in parentheses refers to the number of signatures.

core need to understand and utilize community perspectives in all these approaches. Social representations may validly be seen as the desirable precursor to the application of goal programming models, Limits to Acceptance Change (LAC) approaches and decision-free initiatives.

Techniques of Community Conflict Management

Despite the best goals, methods and clear outcome of the consultation process, conflict over tourism issues may persist.

Minnery (1985) has proposed an underlying set of techniques for community conflict management which may be applied to enduring tourism conflict situations. These techniques are summarized in Table 6.5 together with material pertaining to the final outcomes of the conflict process. Detailed explanations of these factors are discussed below.

1. Ignoring Conflict

This is included by Minnery for the sake of completeness, though it is not an active or effective technique. The definition of conflict used includes awareness and action by at least one of the parties. The unaware party may suspect a conflict but not have information about its existence. Ignoring a conflict may, in some circumstances, resolve it as the conflict may decay through lack of action.

Table 6.5. Key Techniques for Conflict Management and Major End States of Conflict Management

Key Techniques	Major End States
Conciliation	
Mediation	Compromise
Bargaining	Cooperation
Persuasion	Consensus
Advocacy	Award
Arbitration	Passive Settlement
Special-Purpose Mechanisms	

While there is no neat relationship between the techniques and the outcomes, there is some tendency reported by Minnery for the shaded techniques to relate to the shaded outcomes; and the non-shaded techniques to lead to the non-shaded outcomes (Minnery 1985).

2. Agreement to Continue

Here both parties are said, typically, to see more benefits to continuing the conflict than they see in trying to resolve it. Minnery points out that there are situations where the ending of a conflict is either not desired or is given a lower priority than the spending of resources on other matters. The continued conflict may, however, be regulated. The mechanisms discussed by Minnery apply to perceived conflict, but consciousness raising, or the making of a party aware of a conflict that it had not previously perceived, by one of the other parties, is said to imply a commitment to continuing the conflict.

3. Avoidance and Evasion

Minnery's third technique involves one or both of the parties leaving the conflict situation. Community planning is said to be future oriented and aims at avoiding possible future conflicts. Avoidance can be seen as overlapping with arbitration, when a third party (the planner) decides on the possible outcome of the action and attempts to impose his/her solution on the conflicted parties, such as community groups and developers/government bodies.

4. Conquest

This is said by Minnery to be the mechanism by which many zero-sum conflicts are ended. One party may remove or defeat the other. The conflict is thus ended, as only one party is seen to prevail. This mechanism signifies a victory/defeat ending.

5. Suppression

Here one or both of the parties, or a third party, is said by Minnery to suppress conflict behavior. He makes the point that this is not a mechanism for ending conflict, as latent or covert dissatisfaction is likely still to exist and perhaps re-emerge again at a later time.

6. Conciliation

Minnery argues that conciliation implies "... adjustment of the dispute by the parties themselves" (see Stern 1976:372). Its meaning is said to

be wider than some of the other strategies and may incorporate persuasion. Conciliation for Minnery approximates a desired end state, but is also a conflict management mechanism. Minnery points out that a variant of this approach is that proposed by Etzioni (1966) as "self-encapsulating conflicts". Encapsulation refers to the process by which conflicts are modified in such a way that they become limited by rules (the capsule) in Etzioni's terminology. The rules are said to exclude some models of conflict that may have been practiced earlier while they legitimize other strategies. Etzioni argues that the encapsulation of a conflict provides a more lasting solution than does pacification, as the parties lose some of their operating freedom and become tied to and limited by the strategy that has evolved. He specifically refers to conflicts where the capsule of rules (i.e., strategy) is developed from within the conflict structure itself. For Minnery, this is a condition of conciliation.

7. Mediation

This topic, which was also considered under the heading of a method for organizing community participation, is a key conflict management technique. Mediation here is said to be a process whereby a third party attempts to secure settlement of a dispute by persuading the parties either to continue their negotiations or to consider procedural or substantive recommendations that the mediator may make (e.g., Stern 1976:373). The decision on acceptance or rejection is left to the parties in conflict. Raymond (1980) also advances such notions, noting that mediated agreements, unlike arbitrated settlements, may not be binding.

8. Bargaining

This technique is said to be the "making of commitments, offering of rewards, or threatening of punishments or deprivation" (Stern 1976: 384). Bargaining is, by Stern, applied to interactions where both parties retain their original objectives as desirable value positions, but recognize that there are constraints which prevent these being reached and so accept that a value position must be sought which, although not always optimal, is still satisfactory. Bargaining is usually, though not always, applied to interactions between parties of approximately equal power (Komorita 1977). The equality of power is assumed by many advocates of the adversary system implicit in bargaining. Communication is seen by Minnery as a vital element necessary to bargaining.

9. Persuasion

Minnery makes the point that persuasion is a mechanism where each party attempts to alter the other party's perceptions and objectives, so that conflict is resolved by one party agreeing with the other party's objectives (and so abandoning its own original position), or agreeing to leave the arena. Coercive power in such a situation is said to be problematic: generally, persuasion assumes that power is evenly distributed or else constrained by environmental factors, but power may include control of information or the means of communication, or governmental authority (see Lukes 1974). A third party or interest stake-holder may also be involved in persuasion.

10. Coercion

This strategy is said by Minnery to focus on situations in which power is not evenly balanced, and the more powerful party attempts to impose a solution beneficial to itself on the other party. A very wide concept of power is applied by Minnery here, including force or threats, legitimacy, authority, moral authority, and control of resources. Persuasion and coercion are said to be closely related, although the coerced party will probably not change its original objectives, even if it feels forced to act outside them. There is said to be some similarity with bargaining in that strategies, such as careful use of timing, can reduce inequalities between parties. Coercion does not include actions by third parties: only those directly concerned in the conflict are involved.

11. Advocacy

The mechanism of advocacy also involves a situation of unbalanced power, but concerns a third party which has both the power and desire to redress the imbalance by acting for or with the less powerful party. As applied currently in urban planning, advocacy also assumes that this action is combined with arbitration. Minnery makes the point that it is assumed by those who support this mechanism that it is possible through advocacy to move from coercion or conquest to bargaining, persuasion, mediation, or arbitration (see also Davidoff 1973).

12. Arbitration

Minnery believes that this strategy is a means of settling disputes where

a binding decision is made on the conflicting claims of the parties in the dispute by a third party. He cites Raymond (1980), who has distinguished arbitration, where the third party is selected by the contestants as a person or agent with special knowledge or occupying a special role, from adjudication, where "... the dispute is ... submitted to a standing court" (p. 10). In community planning, both adjudication through a court and arbitration in Raymond's sense can occur. The determination in arbitration may involve judgment on priorities rather than resources in many urban planning situations. There is said by Minnery to be a form of arbitration which overlaps with coercion, in that the third party may be the most powerful of the parties. This is possibly the case where the state or regional government has much greater political and legislative power than any local authority and can force a solution to a conflict. This form of conflict management is probably more prominent in community planning in such contexts than in more general conflict situations without such governmental structures.

13. Special-Purpose Mechanisms

Minnery makes the point that these mechanisms are usually concerned with specific but limited parts of the conflict management process, such as gathering objective information, or developing goals to be agreed upon by both the parties, or in helping to allocate preferences to competing goals. These are said to include methods such as cost–benefit investigations, the related planning balance sheet (from Lichfield 1986), and the analysis of interconnected decision areas (from Roberts 1974).

14. Exacerbation

Finally, Minnery would hold that the exacerbation of conflict is said to be not widely discussed in the literature, except in terms of consciousness raising. Mechanisms available for exacerbation are seen as often the reverse of those advocated by Minnery above (such as argument instead of conciliation).

In conclusion, Minnery advises that it is important to note that many of the mechanisms for managing conflict (avoiding it, suppressing it, bargaining, persuasion, coercion, and advocacy) may be as effective in deepening conflict as in resolving it.

End States of Conflict Management Techniques

Minnery (1985) has also suggested a set of major end states or products of the exercise of these disparate yet important strategies of dispute resolution. These disparate conflict managing techniques are said to change a community conflict process to some end state. The idea that conflicts are eventually only won or lost is widespread (see Mitchell 1981). A great deal of effort is commonly expended in finding who has really won or lost a particular struggle: in industrial disputes, or in elections, or in court cases. The only other widely recognized end state is compromise. Much more sophisticated versions of this basic "win, lose, or compromise" formula are available, however, as Minnery has pointed out.

Minnery's is, however, not the only adumbration of this end state of conflict. Boulding (1962) lists, in addition to avoidance and conquest, the outcomes of reconciliation, compromise, and awareness. Mitchell (1981) suggests victory, defeat, destruction, mutual disintegration, isolation, and compromise. Mitchell quotes Holsti's six-part taxonomy: avoidance or unilateral withdrawal, conquest by force, submission to or deterrence by means of threats, compromise, award according to some structure of rules, and passive settlement, where conflicts become deadlocked and finally obsolete (Mitchell 1981, quoting Holsti 1977). These distinctions are all said to refer to manifest conflict and also to defined conflict episodes. Whatever the end of one conflict episode may be, further conflicts may arise and may be finalized differently.

The end results of conflict management which Minnery regards as of importance to community planners are listed below.

1. Victory/Defeat

For Minnery, this category includes three of Mitchell's concepts: victory, where one party is said to achieve its goals at the expense of a rival; defeat, where one party ceases its pursuit of disputed goals and acknowledges the other's command and control of resources and roles; and destruction, where one party disintegrates or is wholly annihilated as a result of the actions of the other party. Minnery takes the view that some clarification of the differences and similarities of the three ideas is necessary. Firstly, although victory is a product of the successful party, defeat is realized by the loser, in that it must be acknowledged by the loser (see Coser 1967). Victory and defeat are thus not regarded as completely opposite. Moreover, defeat may be acknowledged, but only as a temporary state of transitory reversal of fortunes.

2. Isolation

This outcome is said by Minnery to appear where one or more party abandons its struggle and withdraws from the contest, so that interaction between the parties ceases, and with it the conflict. This condition overlaps with victory/defeat, in so far as the withdrawal of one party can be seen as a victory for the other.

3. Compromise

Minnery cites Mitchell (1981) as cogently summarizing compromise: "The conflict ends with both parties abandoning some of their goals in the interests of (a) certainly achieving others, and (b) avoiding the continued costs of attempting to coerce the adversary and being the target of the adversary's own coercive attempts" (Mitchell 1981:6). As the more powerful of the parties typically makes the fewest concessions, the final goal or destination will usually be closer to its original position than that of the adversary. Many, or all, of the original goals are said to be maintained.

4. Cooperation

This end state is said by Minnery to encapsulate a situation in which the parties both completely retain their original goals, yet agree for some other reason to work together, as a temporary measure. The additional reason may involve the achievement of a meta-goal, such as protecting their joint interests from a new or more serious threat. It is also suggested here that the original conflict may have been over the means of achieving an objective now seen to be held in common.

5. Consensus

By consensus Minnery refers to an outcome wherein both parties agree on a new common goal. This may result from one party being totally persuaded by the arguments of the other, or both finding a new common goal. It may lead to both parties merging into a single new entity. Minnery quotes Etzioni (1966), who draws attention to a major problem with consensus formation: "The larger the number of participants in the unit, the greater the differences of belief and interest among them, the more difficult such a consensus becomes, to form or keep" (p. 136). In a group which decides to work by consensus there is said to

be the danger that if the majority of members have only a moderately strong opinion, or are undecided on a particular issue, but one member has a strong opinion, then the consensus reached may be at the value position espoused by that member.

6. Award

This end state is said to result from a prior agreement to accept the verdict of an outside authority. In community planning situations the outside authority is likely to have its powers defined by government legislation. There may be no specific agreement to accept the verdict but instead an obligation in law to do so. Determinations may favor one party or the other, but a compromise which achieves only part of each party's goals is, in community planning at least, by far the most common, and is more likely to lead to an acceptable solution, in the eyes of many community members.

7. Passive Settlement

Finally, Minnery argues that this outcome occurs where the conflict is shelved and eventually becomes obsolete. In addition to these end results, overt conflict can be turned into covert conflict by suppression, a type of end state in itself as well as an ongoing process.

Summary

Much of the literature and ideas presented in this chapter have developed independently from any consideration of tourism and community relationships. The dominant influences on the community participation in planning literature have come from legal, administrative, political science, and environmental studies fields. As discussed in this chapter, however, this body of work is highly relevant to tourism planning and, as evidenced by the specific case study presented at the end of the chapter, the field of tourism planning can benefit from the insights gained in other community participation fields.

For the reader who requires a quick summary of the main content of this chapter, Tables 6.1 and 6.4, which, respectively, note the goals and methods of community participation and the technique and outcomes of conflict management in community participation, serve as an efficient overview. In addition, it is important to note the multiple roles that the social representations framework can play in informing this

Case Studies and Specific Examples 6.1
Community Participation in Practice—A Specific Case Study

Koloff (1991) has recorded a specific example of conflict in tourism development pertaining to a proposed integrated tourism resort at Caves Beach, approximately 140 km north of Sydney on the east coast of Australia (see also Stanton and Aislabie 1992). Koloff notes that when the proposal was first announced to the public, many residents attending the resident action meetings, convened to express opposition to the project, were looking for more information about it. At this early stage of the interaction between the change agents and the community groups, emancipated (information-seeking) social representations and hegemonic ones (operating within existing organizations) can be seen as co-existing.

A dominant resident concern was the speed at which the Council acted to recommend the required zoning and approvals for the development to proceed. Again, for the undecided community member, the image of how tourism works, of how community consultation is undertaken, was critical since a network of negative images about the industry can elicit other unfavorable attitudes.

The public meetings called for the development to have an environmental impact statement conducted. The concern here is, perhaps, less for the technical information which such a process generates and more for the resident to be respected, to be more directly involved in the development decisions relating to the proposed project. The goals of information exchange had been ignored and the community's opportunity to negotiate was limited, thus leading to the further option of protest (cf. Painter 1992).

The power bases of this conflict were apparent in the residents' view that deals were being done out of the public gaze. A call for a public hearing was, effectively, an act to establish and affirm the identity of the residents as a group of significance and power.

In the Australian political system, where there are three levels of government— federal, state, and local—a further perception by the residents that their views were being ignored was created by the State government officials executively approving key aspects of the project.

The particular content of the resort over which the residents and developers disagreed can be seen as reflecting the different values and social representations of what tourism can do for an area. The developers, with a view akin to Molotch's growth-machine perspective, saw their integrated resort as facilitating public access to the beach, rehabilitating badly degraded areas of vegetation, providing some elite residential opportunities within the site, fostering employment growth, and raising land values. For some residents these benefits were interpreted differently: beach access was seen as restructured, vegetation changed, the elite community living seen as at odds with the current housing in the area, the extra numbers in employment of little concern to those who had retired, and the rise in land values, and consequent rates, as undesirable for those on fixed incomes.

After the initial pressure, the Council and developer agreed to meet with 30–50 residents for more detailed information and explanation. Concessions and compromises resulted, with the developer agreeing to maintain broadly based beach access, public access to all facilities, public landscaped areas, with some land being transferred to the Council, and zoned open space. Koloff concludes that the conflict was inevitable and ultimately beneficial. A more important considera-tion, however, is whether or not the arrangement of residents in this case was efficient and effective in time, quality of interaction, and mutual benefits. A much more open initial involvement of the community in the planning of this resort could, undoubtedly, have saved time and money and added valued perspective to the final tourism product.

planning literature. As evidenced in Issues Box 6.1, a social representations framework can generate detailed technical advice on how and what to look for in surveying community responses to tourism. Importantly, the social representations framework can also provide a conceptual commentary and organizer of what is happening during a conflict or ongoing tourism–community debate. The commentary is achieved by paying attention to what kinds of social representations are being made by what kinds of community groups backed by specific levels of power and identity. In effect, the diagram produced as Figure 3.4 can be referred to as a summary of the social representation appraisal of the conflict situation. Further, the interaction between the consensual universe (everyday knowledge) and reified (technical, scientific) universe in the tourism–community debate also warrants emphasis. An important feature of moving efficiently from the points of conflict to points of resolution in Figure 3.4 is to recognize, as argued earlier in this chapter, that no universe of discourse can be dominant in resolving tourism conflicts. In particular, the need to provide mediation and explanation between the reified universe and the consensual universe is critical, otherwise the decision-making parties are likely to ignore the scientific evidence in favor of existing, but not well-informed, views of the world.

Chapter 7

The Future of the Tourism–Community Relationship

This book has set out to address the question of how those working in and researching tourism could improve their understanding of resident perceptions, values, and priorities regarding tourism's role in communities. The argument for the importance of this question was that tourism must be a sustainable business. There is an imperative here for those involved in tourism development and community change. Most international and global forecasters predict that tourism will continue to grow and grow handsomely in some areas of the world. Communities can, however, halt this growth and call an end to business prosperity in tourism. A backlash against tourism may take several forms. It may be manifested in reduced support for the politicians and advocates of tourism, it may result in a decreased willingness to work in the tourism industry, it may be manifested in a reduced desire to market tourism products by word of mouth, it may be a less than welcoming response to visitors and, finally, it may result in disruptive legal and physical activities which slow new developments or make them financially impossible (Pearce, P. 1989). These negative responses by an alienated community can understandably create a climate of fear in the minds of the would-be tourism developer. The problem with a fear-based approach to managing the community is one of seeing the process as inevitably troubled, a hurdle to overcome, a cross to be worn, rather than a necessary and productive process of change.

If the initial motivation for tourism business interests to consult the local community is one of fear alone, then the consultation may well be a troubled process as the predisposition to negotiate will be low. Instead, it is likely to be more productive to view community involvement as good business. The process of effective community involvement in tourism can

generate ideas from extensive local knowledge, it can develop partnerships in the purchasing and production of tourism related goods, and it can be a first plank in the total marketing plan for the business.

The need for such community involvement has been espoused by many in the tourism literature and Murphy's (1985) work is often quoted in this context. Indeed, many of those who have conducted research into resident perceptions of tourism have argued that one of the goals of their research is to contribute to a stronger role for communities in tourism development. Despite these sentiments there is little evidence to suggest that such research has contributed to the planning and management of tourism. There has been little development of theory or method in understanding resident reactions to tourism.

The central aim of the present monograph is to make a contribution to both methods and ideas. The intent of this volume has been to advance a new theoretical framework for understanding community reaction to tourism. In presenting this framework, it has been necessary to deal with some complex sociological and social psychological history and to examine critically the methods and outcomes of previous tourism–community research. Further, examples from Hawaii and New Zealand and from a range of case studies in Australia were described to illustrate the power of the social representations framework. Finally, a review of the community participation in tourism literature was also undertaken and a number of links to social representations theory were observed.

Throughout this monograph an attempt has been made to pursue Cohen's (1979) requirements for quality tourism research: an emic or participant emphasis has been taken, a process-based approach is abundantly clear with an emphasis on the concept of social representations, and the need for longitudinal studies has been emphasized. Cohen's further emphasis that contextual factors be taken into account is also recognized in this work. Effectively, the importance of taking the context into account is a major reason why this monograph has not produced a recipe-like approach to conducting community participation work. As explained in *chapter 6*, there are a large number of predisposing conditions which influence the outcome of community involvement and which require judgment as to what sort of program to recommend to achieve set goals within a specific time frame.

The social representations framework presented in this monograph challenges would-be tourism developers and existing managers to think of community issues as representing a system of knowledge, effectively a system which links how tourism is perceived and understood with other community attitudes held by local residents. These empirical studies show that this knowledge consists of a very specific local content driven by a larger view of what tourism is and means. Often significant other locations are used as anchor points to define how residents think about

tourism. The identity of individuals and groups counts when tourism attitudes are being formed and maintained. In situations where conflict emerges the different social representations and knowledge systems are focused and highlighted. The power residing in community groups will affect how likely it is that their social representation prevails. The tourism developments which ultimately take place depend both on these power relationships and on the content and structure of the social representations of tourism.

More specifically, twelve research directives can be identified from a social representations framework. The challenge is for tourism researchers to advance this field by incorporating these directives into their studies.

1. Community Knowledge about Tourism is a Complex System of Everyday Knowledge and Includes Values, Beliefs, Attitudes, and Explanations

There is evidence that many communities know little about the system and business of tourism and, importantly, in times of a crisis concerning a tourism development, the community often has very little knowledge of the development. Further attitudes towards tourism are part of a web of attitudes towards development, change and politics.

2. The Content and Structure of Tourism Knowledge are Important

Tourism knowledge, when conceived of as a social representation, is often organized as powerful negative or positive images of tourism impacts, with the causal chain from the world view of tourism to the impacts of tourism often being dominant. In future work, at both the academic and the planning level, it will be beneficial not just to assess how residents view impacts but how residents view tourism as a whole and in context. This wider view will assist in accounting for the different responses to tourism proposals. An examination of both consensus and conflict will be critical here.

3. Tourism Knowledge Defines and Organizes Community Reality

A number of studies discussed in this volume confirm the view that greater knowledge about tourism is related to a greater complexity in the community view, but in both positive and negative terms. For tourism entrepreneurs keen to act in community-sensitive ways, there will

be important differences between working with tourism-aware and tourism-naive communities. In particular, the goals of the public participation programs can be seen to vary as discussed in *chapter 6* (refer to Figure 6.1). For example, information exchange will be a dominant goal in tourism-naive communities, while power sharing and facilitated design are likely to be more important in tourism-aware destinations.

4. The Tourism Knowledge System that we have Defines and Organizes our Communication and Interaction

An emphasis in this chapter has been placed on the need for tourism business leaders to understand the perspective of the residents. In return, residents too need to see the organizing world view of the other parties. This point leads to the important finding that the arguments in tourism conflicts are often not over the facts of the case but rather how the different knowledge systems interpret those facts.

5. Tourism Knowledge Systems make the Unfamiliar Familiar

One of the enduring clichés of the tourism–community response identified both in studies by the present authors and in other cases is that often communities do not want to be like another negatively defined location. Such an emphasis on retaining local identity and regional distinctiveness (cf. Lynch 1976) is a powerful organizer of people's attitudes when there is little information on a proposed tourism future. For sustainable business, the challenge is to create a tourism product which reflects the region's idiosyncratic features. The development of tourism businesses which suit or fit the environmental and sociocultural style of a region was well illustrated in the Townsville case study in *chapter 5*. This feature of social representations, the need for communities to build on what is familiar to them, is highly consistent with previous writing on community-based and ecological models of tourism development (Murphy 1985).

6. The Community's Knowledge of Tourism Expands and Deals with New Information using Analysis, Metaphors, and Comparisons; New and Abstract Concepts are Fitted into Existing Frameworks

The emphasis here is on how new developments are processed in the community. The media and information outlets may describe a

new development as being for the affluent visitor, thus creating the "rich resort" description which residents then label as not appropriate for their community. The power of language to summarize information on new tourism is a dominant feature in understanding how communities respond to proposals. There is a clear need here for research which examines how tourism knowledge circulates through communities.

7. Images are Central to the Community Knowledge of Tourism

The power of a clever caption or a brief television snapshot can label the type of tourism and tourism development succinctly for residents. The role of the media in developing images of tourism and providing the metaphors and comparisons for social representations has yet to be examined.

8. The System of Knowledge that Community Members have about Tourism is Linked to their Group and Individual Identity

For some time a view has been expressed that people do not hold precisely defined attitudes. Rather, a considerable body of evidence reveals that attitudes are influenced by social contacts and the groups in which we mix (Argyle et al 1981; Eiser 1986). An important contribution of the present volume has been to emphasize that we should understand what systems of knowledge there are about tourism in the community and then identify what the holders of these beliefs share in terms of group membership and sociodemographic characteristics. This idea is closely akin to market segmentation studies which seek to understand how people view the product and then ascertain who they are in order to conduct appropriate target marketing. Instead of focusing on how age, gender, suburb of residence, and occupational differences produce marginal differences in people's tourism responses, researchers can first explore the commonality of individual attitudes and then, when there are differences, what kinds of social groupings and patterns explain these different views. Forceful recommendations on how to assess community attitudes through survey techniques were presented in *chapter 6* of this book (refer to Issues Box 6.1). Conducting studies of community attitudes according to these guidelines has the power to convert the social dimensions of the planning process into a forceful and effective contributor to quality tourism, rather than a burden for all concerned.

9. A Social Representations Approach Considers the Power of Community Groups to be Critical but also Malleable in the Tourism Development Process

Community consultation can be a rich and expansive process. Several interacting parties can benefit from the process. Nevertheless, there are some voices that will not be heard in the final tourism decision because they simply lack power to influence the decision process. A failure to recognize the importance of who has the power in tourism decision making will make for ineffective community participation. The approach adopted in this monograph is that power is a social contract that can be negotiated and redefined and conflict itself can, in limited forms, be a positive process. This perspective is consistent with the emphasis of social representations theory on power as an important arbiter of change, and follows Burr's (1991) view that communities are interacting dynamic cells, not neatly organized or necessarily harmonious, social systems.

10. The System of Tourism Knowledge is Prescriptive; it will Direct Action and People's Thoughts; Nevertheless, Individuals can and do Change Systems of Tourism Knowledge

A telling example of this process is the political reaction to the environmental movement. Once dismissed as a marginal activity by conservative political forces, the international agenda on this topic, culminating in the Rio summit, has witnessed some spectacular individual re-alignments in attitude. Powerful individuals, including prime ministers and board chairpersons, can individually influence how a whole group sees a tourism issue by their altered stance on a topic. In the future of the tourism–community relationship, there will undoubtedly be opportunities for leading tourism political figures to influence how residents view tourism. The power of the individual and the extent to which group members accept and identify with the individual will in turn affect how broadly the new views are incorporated into people's social representations. For example, Australia's Prime Minister Paul Keating, reflecting on Australia's economic difficulties in a key Budget speech in the early 1990s, referred to tourism as "the shining star in Australia's economic performance". This kind of imagery and pro-tourism statement has the potential to influence how many communities view tourism by changing the web of knowledge surrounding the value of the industry.

11. The System of Tourism Knowledge is both Influenced by and Influences Science

Science here may be thought of in two ways. The kind of research conducted in the biological and engineering spheres concerning tourism's impacts plays a role in how communities think about tourism. Examples of tourist damage to monuments and fragile ecosystems, and littering of pristine environments may all create a social representation of tourism as an environmental threat (cf. Buckley and Parnell 1990).

But science may also be thought of as the more generic social science; in particular, the systematic, logical and empirical study of tourism. Thus, tourism scientists may influence public thinking if their findings are popularized in the media and can be easily assimilated by the community. Thus, a research announcement that prostitution has expanded as tourism in the community has grown may have considerable impact. A well-publicized research finding of this type quickly moves from the reified scientific universe to the public domain and may change resident understanding of tourism's local influence.

Science, too, is shaped by what the community believes it is acceptable to study and what it further considers are important topics. This is manifested in the actions of funding agencies, who are often not technical or scientific experts in the field of influence. Such funding panels respond to topics which are judged as important from media and personal social influences. In this way the prevailing social representations of topics, including tourism topics, influence scientific research.

12. The Social Representations Approach has Applicability across Countries and Cultures

In the first chapter of this book diverse examples of the impacts of tourism from English-speaking countries and studies were cited. In the case study chapters of this volume detailed empirical work from Hawaii, New Zealand, and Australia was considered. The focus on English-based material is acknowledged: this was partly due to the greater volume of data-based published material available to the authors, but should not be taken as indicating that the approach taken here applies only to Westernized English-speaking cultures. In fact, the different content of social representations when dealing with other cultures is easily demonstrated (cf. Triandis 1972). While the details of how people develop and acquire their tourism knowledge may be different from place to place, the fundamental processes of conceiving of tourism as a part of an individual's and a group's system of knowledge is a globally

applicable framework. Clearly, the power of community views in influencing tourism development varies enormously from country to country and within cultures, but the explicit recognition of identity processes and the power bases of those holding different social representational perspectives offers a flexibility in researching resident perceptions in all continents. Importantly, the rapid growth of tourism in many developing countries, including Asian, South American, and African countries, has often taken place without extensive community consultation. In those communities where there is a growing affluence and increased understanding of global issues in sustainable growth, voices emphasizing community input into shaping tourism development are likely to emerge. It is anticipated that the social representations work advocated here can be used to understand the emerging social views and subjective cultures of these developing tourism communities.

This monograph opened with an account of the inquiring style adopted by Lord Florey. In the last year of his life, Florey wrote several lines which may usefully serve as a conclusion to this volume:

> We should not conceive of applied scientists as being those associated particularly with the physical sciences. Perhaps it is the biologists and those dealing with human characteristics who have to obtain and apply new knowledge if we are to have lives which will be really satisfactory and not an unendurable succession of frustrations (Bickel 1983:280).

The date of Florey's address was 1964; the year in which Moscovici published his first major volume on social representations.

References

'Akau'ola, L., L. 'Ilaiu, and A. Samate
 1980 The Social and Cultural Impact of Tourism in Tonga. *In* Pacific Tourism as Islanders See It, pp. 17–23. Fiji: Institute of Pacific Studies of the University of the South Pacific and the South Pacific Social Sciences Association.
Allen, A. R., H. R. Hafer, P. T. Long, and R. R. Perdue
 1993 Rural Residents' Attitudes Toward Recreation and Tourism Development. Journal of Travel Research 31(4):27–33.
Allen, L. R., P. T. Long, R. R. Perdue, and S. Kieselbach
 1988 The Impact of Tourism Development on Residents' Perceptions of Community Life. Journal of Travel Research 27(1):16–21.
Amy, D.
 1987 The Politics of Environmental Mediation. New York: Columbia University Press.
Andressen, B., and P. E. Murphy
 1986 Tourism Development in Canadian Travel Corridors: Two Surveys of Resident Attitudes. World Leisure and Recreation 28(5):17–22.
Andronicou, A.
 1979 Tourism in Cyprus. *In* Tourism. Passport to Development? Perspectives on the Social and Cultural Effects of Tourism in Developing Countries, E. de Kadt, ed., pp. 237–264. New York: Oxford University Press.
Ap, J.
 1990 Residents' Perceptions Research on the Social Impacts of Tourism. Annals of Tourism Research 17:610–616.
Ap, J.
 1992 Residents' Perceptions on Tourism Impacts. Annals of Tourism Research 19:655–690.
Ap, J., and J. L. Crompton
 1993 Residents' Strategies for Responding to Tourism Impacts. Journal of Travel Research 31(3):47–50.
Ap, J., T. Var, and K. Din
 1991 Malaysian Perceptions of Tourism. Annals of Tourism Research 18:321–323.
Argyle, M., A. Furnham, and J. A. Graham
 1981 Social Situations. Cambridge: Cambridge University Press.
Arnstein, S. R.
 1971 A Ladder of Citizen Participation in the USA. Journal of the Town Planning Institute 57:176–182.
Augoustinos, M., and J. M. Innes
 1990 Towards an Integration of Social Representations and Social Schema Theory. British Journal of Social Psychology 29:213–231.
Awekotuku, N. T.
 1977 A Century of Tourism. *In* The Social and Economic Impact of Tourism

on Pacific Communities, Farrell, B. H., ed., pp. 104–105. Santa Cruz: Centre for South Pacific Studies, University of California.

Baker, I.
1990 The Objective Tree in Tourism Planning. Journal of Travel Research 28(4):33–36.

Bandura, M. M., E. J. Langer, and B. Chanowitz
1984 Interpersonal Effectiveness from a Mindlessness/Mindfulness Perspective. *In* Radical Approaches to Social Skills Training, P. Trower, ed., pp. 182–204. London: Croom Helm.

Bazerman, M. H.
1983 Negotiator Judgement: A Critical Look at the Rationality Assumption. American Behavioural Scientist 27:211–228.

Belisle, F. J., and D. R. Hoy
1980 The Perceived Impact of Tourism by Residents: A Case Study in Santa Marta, Colombia. Annals of Tourism Research 7:83–101.

Berger, P. L., and T. Luckmann
1967 The Social Construction of Reality. New York: Anchor Books.

Berlyne, D. E.
1967 Arousal and Reinforcement. *In* Nebraska Symposium on Motivation, 1967, D. Levine, ed., pp. 1–110. Lincoln: University of Nebraska Press.

Bickel, L.
1983 Florey: The Man Who Made Penicillin. Melbourne: Sun Books.

Billig, M.
1993 Studying the Thinking Society: Social Representations, Rhetoric, and Attitudes. *In* Empirical Approaches to Social Representations, G. M. Breakwell and D. V. Canter, eds., pp. 39–62. Oxford: Clarendon Press.

Boissevain, J.
1979 The Impact of Tourism on a Dependent Island: Gozo, Malta. Annals of Tourism Research 6:76–90.

Boulding, K. E.
1962 Conflict and Defense: A General Theory. New York: Harper and Row.

Bowen, R. L., L. J. Cox, and M. Fox
1991 The Interface Between Tourism and Agriculture. Journal of Tourism Studies 2(2):43–54.

Brayley, R., and T. Var
1989 Canadian Perceptions of Tourism's Influence on Economic and Social Conditions. Annals of Tourism Research 16:578–582.

Breakwell, G. M.
1993 Integrating Paradigms, Methodological Implications. *In* Empirical Approaches to Social Representations, G. M. Breakwell and D. V. Canter, eds., pp. 180–204. Oxford: Clarendon Press.

Breakwell, G. M., and D. V. Canter
1993 Aspects of Methodology and Their Implications for the Study of Social Representations. *In* Empirical Approaches to Social Representations, G. M. Breakwell and D. V. Canter, eds., pp. 1–12. Oxford: Clarendon Press.

Brewer, J. D.
1984 Tourism and Ethnic Stereotypes: Variations in a Mexican Town. Annals of Tourism Research 11:487–501.

Broadbent, D. E.
1954 The role of auditory localization in attention and memory span. Journal of Experimental Psychology 47:191–196.

Brougham, J. E., and R. W. Butler
 1981 A Segmentation Analysis of Resident Attitudes to the Social Impact of Tourism. Annals of Tourism Research 8:569–590.
Brown, B. J. H.
 1985 Personal Perception and Community Speculation. A British Resort in the 19th Century. Annals of Tourism Research 12:355–369.
Brown, E. R., and M. L. Nolan
 1989 Western Indian Reservation Tourism Development. Annals of Tourism Research 16:360–376.
Brown, M.
 1992 A Longitudinal Study of Attitudes Towards Tourism Development in Ingham, North Queensland. B. Admin. (Tourism) unpublished Honours Thesis, Department of Tourism, James Cook University.
Brundtland, G. H.
 1987 The Brundtland Report. Our Common Future. World Commission on Environment and Development. Oxford: Oxford University Press.
Bruner, J. S.
 1960 Individual and Collective Problems in the Study of Thinking. Annals of the New York Academy of Science 71:22–37.
Buckley, R., and J. Parnell
 1990 Environmental Impacts of Tourism and Recreation in National Parks and Conservation Reserves. Journal of Tourism Studies 1(1):24–32.
Burr, S. W.
 1991 Review and Evaluation of the Theoretical Approaches to Community as Employed in Travel and Tourism Impact Research on Rural Community Organisation and Change. In Leisure and Tourism: Social and Environmental Changes, A. J. Veal, P. Jonson and G. Cushman, eds., pp. 540–553. Papers from the World Leisure and Recreation Association Congress, Sydney, Australia.
Butler, R. W.
 1980 The Concept of a Tourism Area Cycle of Evolution: Implications for Management of Resources. Canadian Geographer 24:5–12.
Butler, R. W.
 1990 Alternative Tourism: Pious Hope or Trojan Horse? Journal of Travel Research 28(3):40–45.
Butler, R. W.
 1992 Alternative Tourism: The Thin End of the Wedge. In Tourism Alternatives, V. L. Smith and W. R. Eadington, eds., pp. 31–46. Philadelphia: University of Pennsylvania Press.
Bystrzanowski, J.
 1989 Tourism as a Factor of Change: A Sociocultural Study. Vienna: Vienna Center.
Campbell, A., and S. Muncer
 1987 Models of Anger and Aggression in the Social Talk of Women and Men. Journal for the Theory of Social Behaviour 17:489–511.
Canan, P., and M. Hennessy
 1989 The Growth Machine, Tourism, and the Selling of Culture. Sociological Perspectives 32:227–243.
Caneday, L., and J. Zeiger
 1991 The Social, Economic, and Environmental Costs of Tourism to a Gaming Community as Perceived by its Residents. Journal of Travel Research 30(2):45–49.

Canter, D., and C. Monteiro
1993 The Lattice of Polemical Social Representations: A Comparison of the Social Representations of Occupations in Fauelas, Public Housing and Middle Class Neighbourhoods in Brazil. *In* Empirical Approaches to Social Representations, G. Breakwell and D. Canter, eds. Oxford: Clarendon Press.
Canter, L. W.
1977 Environmental Impact Assessment. New York: McGraw-Hill.
Carugati, F. F.
1990 From Social Cognition to Social Representations in the Study of Intelligence. *In* Social Representations and the Development of Knowledge, G. Duveen and B. Lloyd, eds., pp. 126–143. Cambridge: Cambridge University Press.
Cazes, G. H.
1989 Alternative Tourism: Reflections on an Ambiguous Concept. *In* Towards Appropriate Tourism: The Case of Developing Countries, T. V. Singh, H. L. Theuns and F. Go, eds., pp. 117–126. Frankfurt am Main: Peter Lang.
Chaiken, S., and C. Stangor
1987 Attitudes and Attitude Change. Annual Review of Psychology 38:575–630.
Cherry, E. C.
1953 Some Experiments on the Recognition of Speech, With One and With Two Ears. Journal of the Acoustical Society of America 25:975–979.
Clark, R. W., and G. H. Stankey
1976 Analyzing Public Input to Resource Decisions: Criteria, Principles and Case Examples of the CODINVOLVE System. Natural Resources Journal 16:213–136.
Cleverdon, R.
1979 The Economic and Social Impact of International Tourism on Developing Countries. London: Economist Intelligence Unit.
Cocklin, C. R.
1989 Methodological Problems in Evaluating Sustainability. Environmental Conservation 16:343–351.
Cohen, E.
1979 Rethinking the Sociology of Tourism. Annals of Tourism Research 6:18–35.
Cohen, E.
1982a Thai Girls and Farang Men. The Edge of Ambiguity. Annals of Tourism Research 9:403–428.
Cohen, E.
1982b Marginal Paradises. Bungalow Tourism on the Islands of Southern Thailand. Annals of Tourism Research 9:189–228.
Cohen, E.
1989 "Alternative Tourism"—A Critique. *In* Towards Appropriate Tourism: The Case of Developing Countries, T. V. Singh, H. L. Theuns and F. Go, eds., pp. 127–141. Frankfurt am Main: Peter Lang.
Cooke, D.
1982 Guidlines for Socially Appropriate Tourism Development in British Columbia. Journal of Travel Research 21(1):22–28.
Coser, L. A.
1967 The Termination of Conflict. *In* Continuities in the Study of Social Conflict, L. A. Coser, ed., pp. 37–52. New York: Free Press
Cowan, G.
1977 Cultural Impact of Tourism with Particular Reference to the Cook

Islands. *In* A New Kind of Sugar. Tourism in the Pacific, B. R. Finney and K. A. Watson, eds., pp. 79–86. Santa Cruz: Centre for South Pacific Studies.

Cox, L. J., and M. Fox
1991 Agriculturally Based Leisure Attractions. Journal of Tourism Studies 2(2):18–27.

Crick, M.
1989 Representations of International Tourism in the Social Sciences: Sun, Sex, Sights, Savings, and Servility. Annual Review of Anthropology 18:307–344.

Crompton, J. L., and P. K. Ankomah
1993 Choice Set Propositions in Destination Decisions. Annals of Tourism Research 20:461–476.

Crystal, E.
1978 Tourism in Toraja (Salawesi, Indonesia). *In* Hosts and Guests: The Anthropology of Tourism, V. Smith, ed., pp. 109–125. Oxford: Blackwell.

D'Alessio, M.
1990 Social Representations of Childhood: An Implicit Theory of Development. *In* Social Representations and the Development of Knowledge, G. Duveen and B. Lloyd, eds., pp. 70–90. Cambridge: Cambridge University Press.

D'Amore, L. J.
1992 Promoting Sustainable Tourism—The Canadian Approach. Tourism Management 13:258–262.

Dann, G., D. Nash, and P. L. Pearce
1988 Methodology in Tourism Research. Annals of Tourism Research 15:1–28.

Dann, G. M. S.
1984 Santa Marta Revisited: Comments on Belisle and Hoy's "The Perceived Impact of Tourism by Residents: A Case Study in Santa Marta, Colombia". Annals of Tourism Research 11:292–296.

Dann, H.
1992 Subjective Theories and Their Social Foundation in Education. *In* Social Representations and the Social Bases of Knowledge, M. von Cranach, W. Doise and G. Mugny, eds., pp. 161–168. Lewiston: Hogrefe and Huber.

Davidoff, P.
1973 Advocacy and Pluralism in Planning. *In* A Render in Planning Theory, A. Faludi, ed., pp. 277–298. Oxford: Pergamon.

Davis, D., J. Allen, and R. M. Cosenza
1988 Segmenting Local Residents by Their Attitudes, Interests, and Opinions Toward Tourism. Journal of Travel Research 27(2):2–8.

de Carsalho, R.
1982 Waar Die Andere God Woort. Amsterdam: De Arbeiderspers.

de Kadt, E., ed.
1979 Tourism: Passport to Development? New York: Oxford University Press.

Delbecq, A. L., and A. H. Van de Ven
1971 A Group Process Model for Problem Identification and Program Planning. Journal of Applied Behavioural Science 7:466–492.

De Paolis, P.
1990 Prototypes of the Psychologist and Professionalisation: Diverging Social Representations of a Developmental Process. *In* Social Representations and the Development of Knowledge, G. Duveen and B. Lloyd, eds., pp. 144–163. Cambridge: Cambridge University Press.

Department of Business and Economic Development
1989 1988 Statewide Tourism Impact Core Survey: Detailed Findings (Vol.

3) Results for Demographers and Social Researchers. Honolulu: Department of Business and Economic Development.

de Rosa, A. S.
1992 Thematic Perspectives and Epistemic Principles in Developmental Social Cognition and Social Representation. *In* Social Representations and the Social Bases of Knowledge, M. Von Cranach, W. Doise and G. Mugny, eds., pp. 120–143. Lewiston: Hogrefe and Huber.

Deutscher, I.
1984a Foreword. *In* Social Representations, R. M. Farr and S. Moscovici, eds., pp. xiii–xviii. Cambridge: Cambridge University Press.

Deutscher, I.
1984b Choosing Ancestors: Some Consequences of the Selection from Intellectual Traditions. *In* Social Representations, R. M. Farr and S. Moscovici, eds., pp. 71–100. Cambridge: Cambridge University Press.

Di Giacomo, J. P.
1980 Intergroup Alliances and Rejections Within a Protest Movement (Analysis of the Social Representations). European Journal of Social Psychology 10:329–344.

Doise, W.
1993 Debating Social Representations. *In* Empirical Approaches to Social Representations, G. M. Breakwell and D. V. Canter, eds., pp. 157–170. Oxford: Clarendon Press.

Doise, W., A. Clémence, and F. Lorenzi-Cioldi
1993 The Quantitative Analysis of Social Representations. New York: Harvester Wheatsheaf.

Dougherty, K. C., M. Eisenhart, and P. Webley
1992 The Role of Social Representations and National Identities in the Development of Territorial Knowledge: A Study of Political Socialization in Argentina and England. American Educational Research Journal 29:809–835.

Dowling, R. K.
1993 Tourism Planning, People and the Environment in Western Australia. Journal of Travel Research 31(4):52–58.

Doxey, G. V.
1975 A Causation Theory of Visitor–Resident Irritants, Methodology and Research Inferences. The Impact of Tourism. Sixth Annual Conference Proceedings of the Travel Research Association, San Diego, pp. 195–198.

Duffield, B. S., and J. Long
1981 Tourism in the Highlands and Islands of Scotland. Rewards and Conflicts. Annals of Tourism Research 8:403–431.

Duveen, G., and B. Lloyd
1990 Introduction. *In* Social Representations and the Development of Knowledge, G. Duveen and B. Lloyd, eds., pp. 1–10. Cambridge: Cambridge University Press.

Duveen, G., and B. Lloyd
1993 An Ethnographic Approach to Social Representations. *In* Empirical Approaches to Social Representations, G. M. Breakwell and D. V. Canter, eds., pp. 90–109. Oxford: Clarendon Press.

Eadington, W. R.
1986 Impact of Casino Gambling on the Community. Comment on Pizam and Pokela. Annals of Tourism Research 13:279–282.

Eadington, W. R., and V. L. Smith
1992 Introduction: The Emergence of Alternative Forms of Tourism. *In*

Tourism Alternatives, V. L. Smith and W. R. Eadington, eds., pp. 158–179. Philadelphia: University of Pennsylvania Press.

Eccles, R.
1983 Negotiations in an Organisational Environment: A Framework for Discussion. *In* Negotiating in Organisations, M. H. Bazerman and R. J. Lewicki, eds., pp. 154–166. Beverley Hills: Sage.

Echabe, A. E., E. F. Guede, C. S. Guillen, and J. F. V. Garate
1992 Social Representations of Drugs, Causal Judgement and Social Perception. European Journal of Social Psychology 22:73–84.

Echabe, A. E., and D. P. Rovira
1989 Social Representations and Memory: The Case of AIDS. European Journal of Social Psychology 19:543–551.

Ecologically Sustainable Development Working Group
1991 Final Report—Tourism. Canberra: Australian Government Publishing Service.

Eiser, J. R.
1986 Social Psychology: Attitudes, Cognition and Social Behaviour. Cambridge: Cambridge University Press.

Ellison, R.
1965 Invisible Man. Harmondsworth, Middlesex: Penguin Books.

Emler, N.
1987 Socio-Moral Development from the Perspective of Social Representations. Journal for the Theory of Social Behaviour 17:371–388.

Emler, N., and J. Ohana
1993 Studying Social Representations in Children: Just Old Wine in New Bottles? *In* Empirical Approaches to Social Representations, G. M. Breakwell and D. V. Canter, eds., pp. 63–89. Oxford: Clarendon Press.

Esman, M. R.
1984 Tourism as Ethnic Preservation: The Cajuns of Louisiana. Annals of Tourism Research 11:451–467.

Etzioni, A.
1966 Studies in Social Change. New York: Holt Rinehart and Winston.

Farr, R.
1987 Social Representations: A French Tradition of Research. Journal for the Theory of Social Behaviour 17:343–369.

Farr, R.
1990 Social Representations as Widespread Beliefs. *In* The Social Psychological Study of Widespread Beliefs, C. Fraser and G. Gaskell, eds., pp. 47–64. Oxford: Clarendon Press.

Farr, R. M.
1993a Theory and Method in the Study of Social Representations. *In* Empirical Approaches to Social Representations, G. M. Breakwell and D. V. Canter, eds., pp. 15–38. Oxford: Clarendon Press.

Farr, R. M.
1993b Common Sense, Science and Social Representations. Public Understanding of Science 2:289–304.

Farr, R. M., and S. Moscovici
1984 On the Nature and Role of Representations in Self's Understanding of Others and of Self. *In* Issues in Person Perception, M. Cook, ed., pp. 1–27. London: Methuen.

Farrell, B.
1982 Hawaii, the Legend that Sells. Honolulu: University Press of Hawaii.

Farrell, B. H., ed.
 1977 The Social and Economic Impact of Tourism on Pacific Communities. Santa Cruez: Centre for South Pacific Studies, University of California.
Farver, J. M.
 1984 Tourism and Employment in the Gambia. Annals of Tourism Research 11:249–265.
Finney, B. R., and K. A. Watson, eds.
 1975 A New Kind of Sugar. Tourism in the Pacific. Honolulu: East–West Center.
Fishbein, M., and I. Ajzen
 1975 Belief, Attitude, Intention and Behavior. Reading: Addison-Wesley.
Flick, U.
 1992 Everyday Knowledge in the History of Social Psychology: Styles and Traditions of Research in Germany, France and the United States. Canadian Psychology 33:568–573.
Folberg, J., and A. Taylor
 1984 Mediation: A Comprehensive Guide to Resolving Conflicts Without Litigation. San Francisco: Jossey-Bass.
Fong, P.
 1980 Tourism and Urbanization in Nausori. *In* Pacific Tourism as Islanders See It, pp. 87–88. Fiji: Institute of Pacific Studies of the University of the South Pacific and the South Pacific Social Sciences Association.
Forgas, J. P.
 1981a Epilogue: Everyday Understanding and Social Cognition. *In* Social Cognition: Perspectives on Everyday Understanding, J. P. Forgas, ed., pp. 259–272. London: Academic Press.
Forgas, J. P.
 1981b What is Social About Social Cognition? *In* Social Cognition: Perspectives on Everyday Understanding, J. P. Forgas, ed., pp. 1–26. London: Academic Press.
Forster, J.
 1967 The Sociological Consequences of Tourism. International Journal of Comparative Sociology 8:218–223.
Forsyth, P., and L. Dwyer
 1993 Foreign Investment in Australian Tourism. A Framework for Analysis. Journal of Tourism Studies 4(1):26–37.
Fox, M.
 1977 The Social Impact of Tourism—A Challenge to Researchers and Planners. *In* A New Kind of Sugar. Tourism in the Pacific, B. R. Finney and K. A. Watson, eds., pp. 28–35. Santa Cruz: Centre for South Pacific Studies.
Fukunaga, L.
 1977 A New Sun in North Kohala: The Socio-Economic Impact of Tourism and Resort Development on a Rural Community in Hawaii. *In* A New Kind of Sugar. Tourism in the Pacific, B. R. Finney, and K. A. Watson, eds., pp. 199–220. Santa Cruz: Centre for South Pacific Studies.
Galam, S., and S. Moscovici
 1991 Towards a Theory of Collective Phenomena: Consensus and Attitude Changes in Groups. European Journal of Social Psychology 21:49–74.
Galtung, J.
 1981 Structure, Culture, and Intellectual Style: An Essay Comparing Saxonic, Teutonic, Gallic and Nipponic Approaches. Social Science Information 6:817–856.

Gamper, J. A.
 1981 Tourism in Austria. A Case Study of the Influence of Tourism on Ethnic Relations. Annals of Tourism Research 8:432–446.
Gamson, W. A., D. Croteau, W. Hoynes, and T. Sasson
 1992 Media Images and the Social Construction of Reality. Annual Review of Sociology 18:373–393.
Gardner, H.
 1987 The Mind's New Science: A History of the Cognitive Revolution. New York: Basic Books.
Gaskell, G., and C. Fraser
 1990 The Social Psychological Study of Widespread Beliefs. *In* The Social Psychological Study of Widespread Beliefs, C. Fraser and G. Gaskell, eds., pp. 3–24. Oxford: Clarendon Press.
Gergen, K.
 1983 Toward Transformation in Social Psychology. New York: Springer.
Getz, D.
 1983 Capacity to Absorb Tourism Concepts and Implications for Strategic Planning. Annals of Tourism Research 10:239–263.
Getz, D.
 1989 Special Events: Defining the Product. Tourism Management, 10(2): 125–137.
Glass, J. J.
 1979 Citizen Participation in Planning: The Relationship Between Objectives and Techniques. Journal of the American Planning Association 45:180–189.
Glasson, J.
 1994 Oxford: A Heritage City Under Pressure. Tourism Management 15:137–144.
Good, D.
 1993 The Problems of Investigating Social Representations: Linguistic Parallels. *In* Empirical Approaches to Social Representations, G. M. Breakwell and D. V. Canter, eds., pp. 171–179. Oxford: Clarendon Press.
Gormley, W. T.
 1981 Public Advocacy in Public Utility Commission Proceedings. Journal of Applied Behavioral Science 17:446–462.
Graefe, A. R.
 1991 Visitor Impact Management: An Integrated Approach to Assessing the Impacts of Tourism in National Parks and Natural Areas. *In* Leisure and Tourism: Social and Environmental Change, A. J. Veal, P. Jonson and C. Cushman, eds., pp. 74–83. Sydney: University of Technology.
Greenwood, D. J.
 1978 Culture by the Pound: An Anthropological Perspective on Tourism as Cultural Commoditization. *In* Hosts and Guests, V. L. Smith, ed., pp. 129–138. Oxford: Blackwell.
Gunn, C.
 1993 Tourism Planning (3rd ed.). New York: Taylor and Francis.
Gunn, C.
 1994 A perspective on the purpose and nature of tourism research methods. *In* Travel, Tourism, and Hospitality Research (2nd ed.), J. R. B. Ritchie and C. R. Goeldner, eds., pp. 3–11. New York: John Wiley & Sons.
Halfacree, K. H.
 1993 Locality and Social Representation: Space, Discourse and the Alternative Definitions of the Rural. Journal of Rural Studies 9:23–37.

Hall, C. M.
1994 Tourism in the Pacific Rim: Development, Impacts and Markets. Melbourne: Longman Cheshire.

Hall, S. S. J., ed.
1992 Ethics in Hospitality Management. East Lansing: Educational Institute of the American Hotel and Motel Association.

Harré, R.
1981 Rituals, Rhetoric and Social Cognitions. *In* Social Cognition: Perspectives on Everyday Understanding, J. P. Forgas, ed., pp. 211–224. London: Academic Press.

Harré, R., and P. Secord
1972 The Explanation of Social Behaviour. Oxford: Blackwell.

Haukeland, J. V.
1984 Sociocultural Impacts of Tourism in Scandinavia. Tourism Management 5:207–214.

Hawkins, D. E.
1993 Global Assessment of Tourism Policy. *In* Tourism Research. Critiques and Challenges, D. G. Pearce and R. W. Butler, eds., pp. 175–200. London: Routledge.

Haxton, P.
1993 A Post-Event Evaluation of the Social Impacts and Community Perceptions of Mega-Events. Unpublished Honours Thesis, Department of Tourism, James Cook University.

Haywood, K. M.
1988 Responsible and Responsive Tourism Planning in the Community. Tourism Management 9:105–118.

Hewstone, M., J. Jaspars, and M. Lalljee
1982 Social Representations, Social Attribution Theory and Social Identity: The Intergroup Images of 'Public' and 'Comprehensive' Schoolboys. European Journal of Social Psychology 12:241–269.

Himmelweit, H. T.
1990 The Dynamics of Public Opinion. *In* The Social Psychological Study of Widespread Beliefs, C. Fraser and G. Gaskell, eds., pp. 79–98. Oxford: Clarendon Press.

Holsti, K. J.
1977 International Politics: A Framework for Analysis. Englewood Cliffs: Prentice-Hall.

Horoi, S. R.
1980 Tourism and Solomon Handicrafts. *In* Pacific Tourism as Islanders See It, pp. 111–114. Fiji: Institute of Pacific Studies of the University of the South Pacific and the South Pacific Social Sciences Association.

Hudson, B. M.
1979 Comparison of Current Planning Theories: Counterparts and Contradictions. Journal of the American Planning Association 45:387–406.

Hughes, R.
1987 The Fatal Shore. London: Collins Harvill.

Husbands, W.
1989 Social Status and Perception of Tourism in Zambia. Annals of Tourism Research 16:237–253.

Hyma, B., A. Ojo, and G. Wall
1980 Tourism in Tropical Africa. A Review of Literature in England and Research Agenda. Annals of Tourism Research 7:525–553.

Isard, W.
1975 Introduction to Regional Science. Englewood Cliffs: Prentice-Hall.

Jafari, J.
1989 Sociocultural Dimensions of Tourism. An English Language Literature Review. *In* Tourism as a Factor of Change. A Sociocultural Study, J. Bystrzanowski, ed., pp. 17–60. Vienna: European Coordination Centre for Research and Documentation in Social Sciences.

Jafari, J.
1990 Research and Scholarship: The Basis of Tourism Education. Journal of Tourism Studies 1(1):33–41.

Jahoda, G.
1988 Critical Notes and Reflections on 'Social Representations'. European Journal of Social Psychology 18:195–209.

Jaspars, J., and C. Fraser
1984 Attitudes and Social Representations. *In* Social Representations, R. M. Farr and S. Moscovici, eds., pp. 101–123. Cambridge: Cambridge University Press.

Johnson, J. D., and D. J. Snepenger
1993 Application of the Tourism Life Cycle Concept in the Greater Yellowstone Region. Society and Natural Resources 6:127–148.

Johnson, J. D., D. J. Snepenger, and S. Akis
1994 Residents' Perceptions of Tourism Development, Annals of Tourism Research 21:629–642.

Jones, A.
1992 Is There a Real 'Alternative' Tourism? Tourism Management 13:102–103.

Jordan, J. W.
1980 The Summer People and the Natives. Some Effects of Tourism in a Vermont Vacation Village. Annals of Tourism Research 7:34–55.

Jud, G. D., and W. Krause
1976 Evaluating Tourism in Developing Areas: An Exploratory Inquiry. Journal of Travel Research 15(2):1–9.

Kariel, H. G.
1989 Tourism and Development: Perplexity or Panacea? Journal of Travel Research 28(1):2–6.

Kariel, H. G., and P. E. Kariel
1982 Socio-Cultural Impacts of Tourism: An Example From the Austrian Alps. Geografiska Annaler B64:1–16.

Katz, E., and P. F. Lazarsfeld
1955 Personal Influence. Glencoe: Free Press.

Kent, N.
1975 A New Kind of Sugar. *In* A New Kind of Sugar, B. R. Finney and K. A. Watson, eds., pp. 169–198. Honolulu: East–West Center.

Keogh, B.
1990 Public Participation in Community Tourism Planning. Annals of Tourism Research 17:449–465.

King, B., A. Pizam, and A. Milman
1993 Social Impacts of Tourism: Host Perceptions. Annals of Tourism Research 20:650–655.

Knox, J. M.
1978 Classification of Hawaii Residents' Attitudes Toward Tourists and Tourism. Tourism Research Project: Occasional Paper No. 1. Honolulu: University of Hawaii.

Koch, S.
1959 Epilogue. *In* Psychology: A Study of a Science, Vol. III, S. Koch, ed., pp. 729–788. New York: McGraw-Hill.

Koloff, M. L.
1991 Conflict Surrounding Tourism Development. *In* Leisure and Tourism: Social and Environmental Change, A. J. Veal, P. Jonson and G. Cushman, eds., pp. 603–608. Sydney: University of Technology.

Komorita, S. S.
1977 Negotiation from Strength and the Concept of Bargaining Strength. Journal of the Theory of Social Behaviour 7:65–79.

Kousis, M.
1989 Tourism and the Family in a Rural Cretan Community. Annals of Tourism Research 16:318–322.

Krippendorf, J.
1987 The Holiday Makers: Understanding the Impact of Leisure and Travel. London: William Heinemann.

Kruse, L. and S. Schwarz
1992 Who Pays the Bill? The Language of Social Representation. *In* Social Representations and the Social Bases of Knowledge, M. von Cranach, W. Doise and G. Mugny, eds., pp. 23–29. Lewiston: Hogrefe and Huber.

La Piere, R. T.
1934 Attitudes Versus Actions. Social Forces 13:230–237.

Landis, J. R.
1986 Sociology: Concepts and Characteristics (6th ed.). California: Wadsworth.

Lane, B.
1991 Sustainable Tourism: A New Concept for the Interpreter. Interpretation Journal 49:1–4.

Lange, F. W.
1980 The Impact of Tourism on Cultural Patrimony. A Costa Rican Example. Annals of Tourism Research 7:56–68.

Langer, E.
1978 Rethinking the Role of Thought in Social Interaction. *In* New Directions in Attribution Research (Vol. 2), J. H. Harvey, W. Ickes and R. F. Kidd, eds., pp. 35–58. Hillsdale: Lawrence Erlbaum Associates.

Langer, E., and R. Abelson
1974 A Patient by Any Other Name ...: Clinician Group Differences in Labelling Bias. Journal of Consulting and Clinical Psychology 42:4–9.

Langer, E., and H. Newman
1979 The Role of Mindlessness in a Typical Social Psychology Experiment. Personality and Social Psychology Bulletin 5:295–299.

Langer, E. J.
1989a Mindfulness. Reading: Addison-Wesley.

Langer, E. J.
1989b Minding Matters: The Consequences of Mindlessness–Mindfulness. Advances in Experimental Social Psychology 22:137–173.

Lankford, S. V.
1994 Attitudes and Perceptions Toward Tourism and Rural Regional Development. Journal of Travel Research 32(3):35–43.

Lankford, S. V., and D. R. Howard
1994 Developing a Tourism Impact Attitude Scale. Annals of Tourism Research 21:121–139.

LaTour, S., P. Houlden, L. Walker, and J. Thibault
1976 Some Determinants of Preference for Modes of Conflict Resolution. Journal of Conflict Resolution 20:319–356.

Lea, S., S. Kemp, and K. Willetts
1994 Residents' Concepts of Tourism. Annals of Tourism Research 21:406–409.

Lewis, A.
1990 Shared Economic Beliefs. *In* The Social Psychological Study of Widespread Beliefs, C. Fraser and G Gaskell, eds., pp. 192–209. Oxford: Clarendon Press.

Lichfield, N.
1986 Cost Benefit Analysis in Town Planning: A Case Study of Cambridge. Cambridge: Cambridgeshire and Isle of Ely Country Council.

Lind, E., B. Erickson, N. Friedland, and M. Dickenberger
1978 Reactions to Procedural Models for Adjudicative Conflict Resolution: A Cross-National Study. Journal of Conflict Resolution 22:318–341.

Liu, J., and T. Var
1986 Resident Attitudes Toward Tourism Impacts in Hawaii. Annals of Tourism Research 13:193–214.

Liu, J. C., P. J. Sheldon, and T. Var
1987 Resident Perception of the Environmental Impacts of Tourism. Annals of Tourism Research 14:17–37.

Lludman, L. E.
1978 Tourist Impacts: The Need for Regional Planning. Annals of Tourism Research 5:112–125.

Logan, J., and H. Molotch
1987 Urban Fortunes: The Political Economy of Place. Berkeley: University of California Press.

Long, P., R. Perdue, and L. Allen
1990 Rural Resident Tourism Perceptions and Attitudes by Community Level of Tourism. Journal of Travel Research 28(3):3–9.

Loukissas, P. J.
1982 Tourism's Regional Development Impacts. A Comparative Analysis of the Greek Islands. Annals of Tourism Research 9(4):523–542.

Loukissas, P. J.
1983 Public Participation in Community Tourism Planning: A Gaming Simulation Approach. Journal of Travel Research 22(1):18–23.

Lovel, H., and M. Feuerstein
1992 The Recent Growth of Tourism and the New Questions on Community Consequences. Community Development Journal 27:335–352.

Lukes, S.
1974 Power: A Radical View. London: Macmillan.

Lynch, K.
1976 Managing the Sense of a Region. Cambridge: MIT Press.

Lynn, W.
1992 Tourism in the Peoples' Interest. Community Development Journal 27:371–377.

Macnaught, T. J.
1982 Mass Tourism and the Dilemmas of Modernization in Pacific Island Communities. Annals of Tourism Research 9:359–381.

Madrigal, R.
1993 A Tale of Tourism in Two Cities. Annals of Tourism Research 20:336–353.

Madrigal, R.
1995 Residents' Perceptions and the Role of Government. Annals of Tourism Research 22:86–102.
Manning, F. E.
1979 Tourism and Bermuda's Black Clubs: A Case of Cultural Revitalization. In Tourism: Passport to Development?, E. de Kadt, ed., pp. 157–176. New York: Oxford University Press.
Mansfeld, Y.
1992 Group-Differentiated Perceptions of Social Impacts Related to Tourism Development. Professional Geographer 44:377–392.
Markova, I.
1992 Scientific and Public Knowledge of AIDS: The Problem of Their Integration. In Social Representations and the Social Bases of Knowledge, M. von Cronach, W. Doise and G. Mugny, eds., pp. 179–183. Lewiston: Hogrefe and Huber.
Markova, I., and P. Wilkie
1987 Representations, Concepts and Social Change: The Phenomenon of AIDS. Moral Development from the Perspective of Social Representations. Journal for the Theory of Social Behaviour 17:389–409.
Marks, G., and D. Von Winterfeldt
1984 Not in My Backyard: Influence of Motivational Concerns on Judgements About Risky Technology. Journal of Applied Psychology 69:408–415.
Mathieson, A., and G. Wall
1982 Tourism: Economic, Physical and Social Impacts. London: Longman.
May, R. J.
1977 Tourism and the Artefact Industry in Papua New Guinea. In A New Kind of Sugar. Tourism in the Pacific, B. R. Finney, and K. A. Watson. Santa Cruz: Centre for South Pacific Studies.
McCool, S. F., and S. R. Martin
1994 Community Attachment and Attitudes Toward Tourism Development. Journal of Travel Research 32(3):29–34.
McElroy, J. L., and K. De Albuquerque
1986 The Tourism Demonstration Effect in the Caribbean. Journal of Travel Research 25(2):31–34.
McGuire, W. J.
1985 Attitudes and Attitude Change. In Handbook of Social Psychology (Vol. 2, 3rd ed.), G. Lindzey and E. Aronson, eds., pp. 233–247. New York: Random House.
McGuire, W. J.
1986 The Vicissitudes of Attitudes and Similar Representational Constructs in Twentieth Century Psychology. European Journal of Social Psychology 16:89–130.
McIntosh, R.
1992 Early Tourism Education in the United States. Journal of Tourism Studies 3(1):2–7.
McKean, P. F.
1978 Towards a Theoretical Analysis of Tourism: Economic Dualism and Cultural Involution in Bali. In Hosts and Guests, V. L. Smith, ed. Oxford: Blackwell.
McKinlay, A., and J. Potter
1987 Social Representations: A Conceptual Critique. Journal for the Theory of Social Behaviour 17:471–487.

McKinlay, A., J. Potter, and M. Wetherell
1993 Discourse Analysis and Social Representations. *In* Empirical Approaches to Social Representations, G. M. Breakwell and D. V. Canter, eds., pp. 134–156. Oxford: Clarendon Press.

Mead, G. H.
1934 Mind Self and Society: From the Standpoint of a Social Behaviorist. Chicago: University of Chicago Press.

Meleisea, M., and P. S. Meleisea
1980 "The Best Kept Secret": Tourism in Western Samoa. *In* Pacific Tourism as Islanders See It, pp. 35–46. Fiji: Institute of Pacific Studies of the University of the South Pacific and the South Pacific Social Sciences Association.

Merton, R. K.
1949 Discrimination and the American Creed. *In* Discrimination and National Welfare, R. M. MacIver, ed., pp. 99–126. New York: Harper & Brothers.

Milgram, S.
1984 Cities as Social Representations. *In* Social Representations, R. M. Farr and S. Moscovici, eds., pp. 289–309. Cambridge: Cambridge University Press.

Milman, A., and A. Pizam
1988 Social Impacts of Tourism on Central Florida. Annals of Tourism Research 15:191–204.

Mings, R. C.
1980 A Review of Public Suipport for International Tourism in New Zealand. New Zealand Geographer 36:20–29.

Minnery, J. R.
1985 Conflict Management in Urban Planning. Aldershot: Gower.

Mitchell, C. R.
1981 Peacemaking and the Consultant's Role. Westmead: Gower.

Mok, C., B. Slater, and V. Cheung
1991 Residents' Attitudes Towards Tourism in Hong Kong. International Journal of Hospitality Management 10:289–293.

Molinari, L., and F. Emiliani
1990 What Is In An Image? The Structure of Mothers' Images of the Child and Their Influence on Conversational Styles. *In* Social Representations and the Development of Knowledge, G. Duveen and B. Lloyd, eds., pp. 91–106. Cambridge: Cambridge University Press.

Molotch, H.
1976 The City as a Growth Machine: Toward a Political Economy of Place. American Journal of Sociology 82:309–322.

Molotch, H., and J. Logan
1984 Tension in the Growth Machine: Overcoming Resistance to Value-Free Development. Social Problems 31:483–499.

Monk, J., and C. S. Alexander
1986 Free Port Fallout. Gender, Employment and Migration on Margarita Island. Annals of Tourism Research 13:393–413.

Morrison, A. M.
1989 Hospitality and Travel Marketing. Albany: Delmar.

Moscardo, G., and K. Hughes, eds.
1991 Visitor Centres: Exploring New Territory. Proceedings of the National Conference on Visitor Centres, Townsville, April 28th–May 1st, 1991. Townsville: Department of Tourism, James Cook University of North Queensland.

Moscovici, S.
1963 Attitudes and Opinions. Annual Review of Psychology 14:231–260.
Moscovici, S.
1972 Society and Theory in Social Psychology. *In* The Context of Social Psychology, J. Israel and H. Tajfel, eds., pp. 17–68. London: Academic Press.
Moscovici, S.
1973 Foreword. *In* Health and Illness, C. Herzlich (D. Graham, trans.), pp. ix–xiv. London: Academic Press.
Moscovici, S.
1981 On Social Representations. *In* Social Cognition: Perspectives on Everyday Understanding, J. P. Forgas, ed., pp. 181–209. London: Academic Press.
Moscovici, S.
1984 The Phenomenon of Social Representations. *In* Social Representations, R. M. Farr and S. Moscovici, eds., pp. 3–69. Cambridge: Cambridge University Press.
Moscovici, S.
1985 Comment on Potter and Litton. British Journal of Social Psychology 24:91–92.
Moscovici, S.
1987 Answers and Questions (G. Heinz, trans.). Journal for the Theory of Social Behaviour 17:513–529.
Moscovici, S.
1988 Notes Towards a Description of Social Representations. European Journal of Social Psychology 18:211–250.
Moscovici, S.
1990 Social Psychology and Developmental Psychology: Extending the Conversation. *In* Social Representations and the Development of Knowledge, G. Duveen and B. Lloyd, eds., pp. 164–185. Cambridge: Cambridge University Press.
Moscovici, S.
1992 The Psychology of Scientific Myths. *In* Social Representations and the Social Bases of Knowledge, M. von Cranach, W. Doise and G. Mugny, eds., pp. 3–9. Lewiston: Hogrefe and Huber.
Mugny, G., and F. Carugati
1989 Social Representations of Intelligence. Cambridge: Cambridge University Press.
Munro-Clark, M., ed.
1992a Citizen Participation on Government. Sydney: Hale & Iremonger.
Munro-Clark, M.
1992b Introduction: Citizen Participation—An Overview. *In* Citizen Participation on Government, M. Munro-Clark, ed., pp. 13–21. Sydney: Hale & Iremonger.
Munro-Clark, M.
1992c Participation in Practice: Conclusions and Reflections. *In* Citizen Participation on Government, M. Munro-Clark, ed., pp. 197–205. Sydney: Hale & Iremonger.
Murphy, P. E.
1978 Preferences and Perceptions of Urban Decision-Making Groups: Congruence or Conflict? Regional Studies 12:749–759. New York: Methuen.
Murphy, P. E.
1981 Community Attitudes to Tourism: A Comparative Analysis. Tourism Management 2:189–195.

Murphy, P. E.
1983 Perceptions and Attitudes of Decision-Making Groups in Tourism Centers. Journal of Travel Research 21(3):8–12.

Murphy, P. E.
1985 Tourism: A Community Approach. New York: Methuen.

Murphy, P. E.
1988 Community Driven Tourism Planning. Tourism Management 9:96–104.

Mutunayagam, N.
1981 Cooperative Management: An Alternative Approach to Multi-jurisdictional Management of Environmental Resources. Unpublished Manuscript, Department of Environmental Design and Planning. Blacksburg: Virginia Polytechnic Institute and State University.

National Centre for Studies in Travel and Tourism (NCSTT)
1991 Tourism Trends in the Cairns Region. Report Prepared for The Douglas Shire Tourism Study. Brisbane: National Centre for Studies in Travel and Tourism.

Neuman, W. R.
1990 The Threshold of Public Attention. Public Opinion Quarterly 54:159–176.

New Zealand Ministry of Tourism
1992 Residents' Perceptions and Acceptance of Tourism in Selected New Zealand Communities. Wellington: Ministry of Tourism.

Nisbett, R. E., and T. D. Wilson
1977 Telling More Than We Can Know: Verbal Reports on Mental Processes. Psychological Review 84:231–259.

Niukula, P.
1980 The Impact of Tourism on a Suvavou Village. In Pacific Tourism as Islanders See It, pp. 83–85. Fiji: Institute of Pacific Studies of the University of the South Pacific and the South Pacific Social Sciences Association.

Norusis, M. J.
1990 SPSS Base System Users' Guide. Chicago: SPSS.

OECD
1980 The Impact of Tourism on the Environment. Paris: OECD.

Ozawa, C. P.
1991 Recasting Science: Consensual Procedures in Public Policy Making. Boulder: Westview Press.

Ozawa, C. P.
1993 Improving Citizen Participation in Environmental Decision Making: The Use of Transformative Mediator Techniques. Environment and Planning II: 103–117.

Painter, M.
1992 Participation in Power. In Participation on Government, M. Munro-Clark, ed., pp. 21–37. Sydney: Hale & Iremonger.

Palmerino, M., E. Langer, and D. McGillis
1984 Attitudes and Attitude Change: Mindlessness–Mindfulness Perspective. In Attitudinal Judgement, J. R. Eiser, ed., pp. 179–196. New York: Springer.

Parker, I.
1987 'Social Representations': Social Psychology's (Mis)use of Sociology. Journal for the Theory of Social Behaviour 17:447–469.

Pateman, C.
1970 Participation and Democratic Theory. Cambridge: Cambridge University Press.

Pearce, D.
1989 Tourism Development (2nd ed.). Harlow: Longman.
Pearce, D. G.
1990 Tourism, the Regions and Restructuring in New Zealand. Journal of Tourism Studies 1(1):33–42.
Pearce, P. L.
1982 The Social Psychology of Tourist Behaviour. Oxford: Pergamon Press.
Pearce, P. L.
1983 Fun, Sun and Behaviour: Social Psychologists and the Tourist Industry. Australian Psychologist 18:89–95.
Pearce, P. L.
1989 Social Impacts of Tourism. *In* The Social, Cultural and Environmental Impacts of Tourism, pp. 1–39. Sydney: NSW Tourism Commission.
Pearce, P. L.
1991 Travel Stories: An Analysis of Self-Disclosure in Terms of Story Structure, Valence, and Audience Characteristics. Australian Psychologist 26:172–174.
Pearce, P. L.
1993 From Culture Shock to Culture Exchange: The Agenda for Human Resource Development in Cross-Cultural Interaction. Paper presented at the Global Action to Global Change: A PATA/WTO Human Resources for Tourism Conference, October 1993, Bali, Indonesia.
Pearce, P. L., S. Briggs, and P. Phibbs
1993 Social and Economic Assessment of Proposed Club Mediterranee Village. Report Prepared for Byron Shire Council.
Pearce, P. L., G. Moscardo, and G. F. Ross
1991 Tourism Impact and Community Perception: An Equity-Social Representational Perspective. Australian Psychologist 26:147–152.
Peck, J. G., and A. S. Lepie
1978 Tourism and Development in Three North Carolina Coastal Towns. *In* Hosts and Guests, V. L. Smith, ed., pp. 159–172. Oxford: Blackwell.
Peiyi Ding, and J Pigram
1995 Environmental Audits: An Emerging Concept in Sustainable Tourism Development. Journal of Tourism Studies 6(2):2–10.
Perdue, R. R., P. T. Long, and L. Allen
1987 Rural Resident Tourism Perceptions and Attitudes. Annals of Tourism Research 14:420–429.
Perdue, R. R., P. T. Long, and L. Allen
1990 Resident Support for Tourism Development. Annals of Tourism Research 17:586–599.
Petty, R. E., and J. T. Cacioppo
1986 The Elaboration Likelihood Model of Persuasion. Advances in Experimental Social Psychology 19:123–205.
Piaget, J.
1928 Judgement and Reasoning in the Child. New York: Harcourt Brace.
Pigram, J.
1980 Environmental Implications of Tourism Development. Annals of Tourism Research 7:554–583.
Pigram, J. J.
1990 Sustainable Tourism: Policy Considerations. Journal of Tourism Studies 1(2):2–9.

Pi-Sunyer, O.
1978 Through Native Eyes: Tourists and Tourism in a Catalan Maritime Community. *In* Hosts and Guests: The Anthropology of Tourism, V. L. Smith, ed., pp. 149–155. Oxford: Blackwell.

Pizam, A.
1978 Tourist Impacts: The Social Costs to the Destination Community as Perceived by its Residents. Journal of Travel Research 16(1):8–12.

Pizam, A., and A. Milman
1986 The Social Impacts of Tourism. Tourism Recreation Research 11:29–33.

Pizam, A., and J. Pokela
1985 The Perceived Impact of Casino Gambling on a Community. Annals of Tourism Research 12:147–166.

Poon, A.
1992 Tourism, Technology and Competitive Strategies. Wallingford: C.A.B. International.

Preglav, M.
1994 Is TIAS a Valid Tourism Impact Measurement Tool? Annals of Tourism Research 21:828–829.

Prentice, R.
1993 Community-Driven Tourism Planning and Residents' Preferences. Tourism Management 14:218–227.

Price, V.
1989 Social Identification and Public Opinion: Effects of Communicating Group Conflict. Public Opinion Quarterly 53:197–224.

Pruitt, D. G.
1981 Negotiation Behavior. New York: Academic Press.

Rajotte, F.
1980 Tourism Impact in the Pacific. *In* Pacific Tourism as Islanders See It, pp. 1–14. Fiji: Institute of Pacific Studies of the University of the South Pacific and the South Pacific Social Sciences Association.

Rappaport, J.
1977 Community Psychology: Values, Research, Action. New York: Holt, Rhinehart & Winston.

Raymond, A.
1980 Conflict Resolution and the Structure of the State System: An Analysis of Arbitrative Settlement. New Jersey: Allanheld Osun Monclair.

Ritchie, J. R. B.
1985 The Nominal Group Technique. Tourism Management 6:82–94.

Ritchie, J. R. B.
1988 Consensus Policy Formulation in Tourism: Measuring Resident Views via Survey Research. Tourism Management 9:199–212.

Ritchie, J. R. B.
1993 Tourism Research: Policy and Managerial Priorities for the 1990s and Beyond. *In* Tourism Research. Critiques and Challenges, D. G. Pearce and R. W. Butler, eds., pp. 201–216. London: Routledge.

Ritchie, J. R. B., and C. E. Aitken
1984 Assessing the Impact of the 1988 Olympic Winter Games—The Research Program and Initial Results. Journal of Travel Research 22(3):17–25.

Ritchie, J. R. B., and C. E. Aitken
1985 Olympulse II—Evolving Resident Attitudes Towards the 1988 Olympic Winter Games. Journal of Travel Research 23(3):28–33.

Ritchie, J. R. B., and M. Lyons
 1987 Olympulse III/Olympus IV: A Mid-Term Report on Resident Attitudes Concerning the XV Olympic Winter Games. Journal of Travel Research 26(1):18–26.
Roberts, M.
 1974 An Introduction to Town Planning Techniques. London: Hutchinson Educational.
Robertson, C., and J. C. Crotts
 1992 Information Effects on Residents' Perception of Tourism Development. Visions of Leisure and Business 11:32–39.
Roekaerts, M., and K. Savat
 1989 Mass Tourism in South and Southeast Asia. A Challenge to Christians and the Churches. *In* Towards Appropriate Tourism: The Cast of Developing Countries, T. V. Singh, H. L. Theuns and F. M. Go, eds., pp. 35–69. New York: Peter Lang.
Roiser, M.
 1987 Commonsense, Science and Public Opinion. Journal for the Theory of Social Behaviour 17:411–432.
Rosenow, J., and G. Pulsipher
 1978 Tourism. The Good, the Bad, and the Ugly. Lincoln: Century Three Press.
Ross, G. F.
 1991 Community Impacts of Tourism Among Older and Long-Term Residents. Australian Journal of Aging 10:17–24.
Ross, G. F.
 1992 Resident Perceptions of the Impact of Tourism on an Australian City. Journal of Travel Research 30(3):13–17.
Rothman, R. A.
 1978 Residents and Transients: Community Reactions to Seasonal Visitors. Journal of Travel Research 16(3):8–13.
Runyan, D., and C. T. Wu
 1979 Assessing Tourism's More Complex Consequences. Annals of Tourism Research 6:448–463.
Sampson, E. E.
 1978 Scientific Paradigms and Social Values: Wanted—A Scientific Revolution. Journal of Personality and Social Psychology 36:1332–1343.
Samy, J.
 1980 Crumbs from the Table? The Workers Share in Tourism. *In* Pacific Tourism as Islanders See It, pp. 67–83. Fiji: Institute of Pacific Studies of the University of the South Pacific and the South Pacific Social Sciences Association.
Scarbrough, E.
 1990 Attitudes, Social Representations and Ideology. *In* The Social Psychological Study of Widespread Beliefs, C. Fraser and G. Gasket, eds., pp. 99–117. Oxford: Clarendon Press.
Schlüter, R., and T. Var
 1988 Resident Attitudes Toward Tourism in Argentina. Annals of Tourism Research 15:442–445.
Sheldon, P.
 1990 Journals in Tourism and Hospitality. The Perceptions of Publishing Faculty. Journal of Tourism Studies 1(1):42–48.
Sheldon, P. J., and T. Var
 1984 Resident Attitudes to Tourism in North Wales. Tourism Management 5:40–47.

Sherer, M., and D. W. Rogers
 1984 The Role of Vivid Information in Fear Appeals and Attitude Change. Journal of Research in Personality 18:321–334.
Simmel, G.
 1950 The Sociology of Georg Simmel (H. Woolf, transl.). New York: Free Press of Glencoe.
Simmons, D. G.
 1994 Community Participation in Tourism Planning. Tourism Management 15:98–108.
Simonds, J. O.
 1978 Earthscape. A Manual of Environmental Planning. New York: McGraw-Hill.
Skinner, R. J.
 1980 The Impact of Tourism on Niue. *In* Pacific Tourism as Islanders See It, pp. 61–64. Fiji: Institute of Pacific Studies of the University of the South Pacific and the South Pacific Social Sciences Association.
Smith, L. G.
 1984 Public Participation in Policy Making: The State-of-the-Art in Canada. Geoforum 15:253–259.
Smith, V.
 1978a Eskimo Tourism: Micro-Models and Marginal Men. *In* Hosts and Guests, V. Smith, ed., pp. 51–70. Oxford: Blackwell.
Smith, V. L., ed.
 1978b Hosts and Guests: The Anthropology of Tourism. Oxford: Blackwell.
Snepenger, D. J., and J. D. Johnson
 1991 Political Self-Identification and Perceptions on Tourism. Annals of Tourism Research 18:511–515.
Snow, R.
 1983 Creating Media Culture. Beverley Hills: Sage.
Sofield, T.
 1991 Sustainable Ethnic Tourism in the South Pacific: Some Principles. Journal of Tourism Studies 2(1):56–72.
Sofield, T.
 1994 Tourism in the South Pacific. Annals of Tourism Research 21:207–214.
Stanton, J., and C. Aislabie
 1992 Local Government Regulation and the Economics of Tourist Resort Development. An Australian Case Study. Journal of Tourism Studies 3(2):20–31.
Stern, L. W.
 1976 Managing Conflicts in Distributional Channels. *In* Interorganizational Relations: Selected Readings, W. M. Evan, ed., pp. 369–389. Harmondsworth: Penguin.
Swain, M. B.
 1978 Cuna Women and Ethnic Tourism: A Way to Persist and Avenue to Change. *In* Hosts and Guests, V. Smith, ed., pp. 71–81. Oxford: Blackwell.
Sweet, J. D.
 1989 Burlesquing "The Other" in Pueblo Performance. Annals of Tourism Research 16:62–75.
Syme, F.
 1980 Thoughts on the Consequences of Tourism. *In* Pacific Tourism. as Islanders See It, pp. 57–59. Fiji: Institute of Pacific Studies of the University of the South Pacific and the South Pacific Social Sciences Association.

Syme, G. J.
 1992 When and Where Does Participation Count. *In* Citizen Participation on Government, M. Munro-Clark, ed., pp. 78–99. Sydney: Hale & Iremonger.
Syme, G. J., D. K. Macpherson, and P. Fry
 1987 Public Involvement and Environmental Planning in Western Australia. Journal of Architectural and Planning Research 4:18–27.
Taylor, S.
 1981 The Interface of Cognitive and Social Psychology. *In* Cognition, Social Behaviour and the Environment, J. H. Harvey, ed., pp. 189–211. Hillsdale: Laurence Erlbaum.
Thibodeau, R.
 1989 From Racism to Tokenism: The Changing Face of Blacks in New Yorker Cartoons. Public Opinion Quarterly 53:482–494.
Thomas, W. I.
 1928 The Unadjusted Girl. Boston: Little, Brown.
Thomason, P., J. L. Crompton, and B. D. Kamp
 1979 A Study of the Attitudes of Impacted Groups Within a Host Community Toward Prolonged Stay Tourist Visitors. Journal of Travel Research 17(3):2–6.
Timmerman, G. F.
 1992 Media Analysis: The Image of Tourism as Portrayed by the Print News Media. B. Admin. (Tourism) Hons Thesis (unpublished), Department of Tourism, James Cook University.
Toffler, A.
 1970 Future Shock. New York: Random House.
Triandis, H.
 1972 The Analysis of Subjective Culture. New York: Wiley.
Tsartas, P.
 1992 Socioeconomic Impacts of Tourism on Two Greek Isles. Annals of Tourism Research 19:516–533.
Turner, L., and J. Ash
 1975 The Golden Hordes. London: Constable.
Tversky, A., and D. Kahneman
 1983 Extensional vs. Intuitive Reasoning: The Conjunction Fallacy in Probability Judgement. Psychological Review 90:293–315.
United Nations Educational, Scientific and Cultural Organization
 1977 The Effects of Tourism on Socio-Cultural Values. Annals of Tourism Research 4:75–105.
Urbanowicz, C.
 1978 Tourism in Tonga: Troubled Times. *In* Hosts and Guests, V. Smith, ed., pp. 129–138. Oxford: Blackwell.
Urry, J.
 1990 The Tourist Gaze. London: Sage.
van Doorn, J., ed.
 1985 Tourism in Its Socio-Cultural Context: A Factor of Change; Occasional Paper on the Tourproject. Vienna Centre Newsletter Nos. 23 & 24:1–55.
van Doorn, J.
 1989a A Critical Assessment of Socio-Cultural Impact Studies of Tourism in the Third World. *In* Towards Appropriate Tourism: The Case of Developing Countries, T. V. Singh, L. Theuns and F. Go, eds., pp. 71–91. Frankfurt am Main: Peter Lang.

van Doorn, J. W. M.
 1989b A Critical Assessment of Socio-Cultural Impact Studies of Tourism in the Third World. *In* Towards Appropriate Tourism: The Case of Developing Countries, T. V. Singh, H. L. Theuns and F. M. Go, eds., Chap. 3, pp. 71–91. Frankfurt am Main: Peter Lang.
Var, T., K. W. Kendall, and E. Tarakcioglu
 1985 Resident Attitudes Towards Tourists in a Turkish Resort Town. Annals of Tourism Research 12:652–658.
von Cranach, M.
 1992 The Multi-Level Organisation of Knowledge and Action—An Integration of Complexity. *In* Social Representations and the Social Bases of Knowledge, M. Von Cranach, W. Doise and G. Mugny, eds., pp. 10–22. Lewiston: Hogrefe and Huber.
Walter, J.
 1982 Social Limits to Tourism. Leisure Studies 1:295–305.
Wandersman, A. H., and W. K. Hallman
 1993 Are People Acting Irrationally? Understanding Public Concerns About Environmental Threats. American Psychologist 48:681–686.
Warren, R. L.
 1978 The Community in America (3rd ed.). Chicago: Rand McNally.
Wason, P. C., and P. N. Johnson-Laird
 1972 Psychology of Reasoning. Cambridge: Harvard University Press.
Weimann, G.
 1991 The Influentials: Back to the Concept of Opinion Leaders? Public Opinion Quarterly 55:267–279.
Wells, A.
 1987 Social Representations and the World of Science. Journal for the Theory of Social Behaviour 17:433–445.
Wheeller, B.
 1992 Alternative Tourism—A Deceptive Ploy. Progress in Tourism, Recreation and Hospitality Management 4:140–145.
Wilkinson, P. F.
 1989 Strategies for Tourism in Island Microstates. Annals of Tourism Research 16:153–177.
Wolpert, L.
 1992 The Unnatural Nature of Science. London: Faber.
Wu, C.
 1982 Issues of Tourism and Socioeconomic Development. Annals of Tourism Research 9:317–330.
Young, G.
 1973 Tourism, Blessing or Blight? Harmondsworth: Penguin.
Zajonc, R. B.
 1989 Styles of Explanation in Social Psychology. European Journal of Social Psychology 19:345–368.
Zimbardo, P.
 1985 Psychology and Life. Glenview: Scott, Foresman and Company.

Appendix: Tourism Impact Literature Reviewed

This appendix consists of three lists of references; one of reviews of tourism impacts, one of case studies, ethnographic and other qualitative approaches to tourism impacts, and one of survey studies of perceived tourism impacts. These references were used to generate Tables 3.6 and 3.7 and in the writing of the section on the social representations of tourism which accompanies these tables.

A: Reviews of tourism impacts

Forster, J.
 1967 The Sociological Consequences of Tourism. International Journal of Comparative Sociology 8:218–223.
Fox, M.
 1977 The Social Impact of Tourism—A Challenge to Researchers and Planners. *In* A New Kind of Sugar. Tourism in the Pacific, B. R. Finney and K. A. Watson, eds., pp. 28–35. Santa Cruz: Centre for South Pacific Studies.
Hyma, B., A. Ojo, and G. Wall
 1980 Tourism in Tropical Africa. A Review of Literature in England and Research Agenda. Annals of Tourism Research 7:525–553.
Jafari, J.
 1989 Sociocultural Dimensions of Tourism. An English Language Literature Review. *In* Tourism as a Factor of Change. A Sociocultural Study, J. Bystrzanowski, ed. Vienna: European Coordination Centre for Research and Documentation in Social Sciences.
Lovel, H., and M. Feuerstein
 1992 The Recent Growth of Tourism and the New Questions on Community Consequences. Community Development Journal 27:335–352.
Macnaught, T. J.
 1982 Mass Tourism and the Dilemmas of Modernization in Pacific Island Communities. Annals of Tourism Research 9:359–381.
Pizam, A., and A. Milman
 1986 The Social Impacts of Tourism. Tourism Recreation Research 11:29–33.
Rajotte, F.
 1980 Tourism Impact in the Pacific. *In* Pacific Tourism as Islanders See It,

Fiji: Institute of Pacific Studies of the University of the South Pacific and the South Pacific Social Sciences Association.

Roekaerts, M., and K. Savat
1989 Mass Tourism in South and Southeast Asia. A Challenge to Christians and the Churches. *In* Towards Appropriate Tourism: The Cast of Developing Countries, T. V. Singh, H. L. Theuns and F. M. Go, eds. New York: Peter Lang.

Runyan, D., and C. T. Wu
1979 Assessing Tourism's More Complex Consequences. Annals of Tourism Research 6:448–463.

United Nations Educational, Scientific and Cultural Organization
The Effects of Tourism on Socio-Cultural Values. Annals of Tourism Research 4:75–105.

Wilkinson, P. F.
1989 Strategies for Tourism in Island Microstates. Annals of Tourism Research 16:153–177.

Wu, C.
1982 Issues of Tourism and Socioeconomic Development. Annals of Tourism Research 9:317–330.

Young, G.
1973 Tourism, Blessing or Blight? Harmondsworth: Penguin.

B. Case studies, ethnographic and qualitative approaches to tourism impacts

'Akau'ola, L., L. 'Ilaiu, and A. Samate
1980 The Social and Cultural Impact of Tourism in Tonga. *In* Pacific Tourism as Islanders See It Fiji: Institute of Pacific Studies of the University of the South Pacific and the South Pacific Social Sciences Association.

Andronicou, A.
1979 Tourism in Cyprus. *In* Tourism. Passport to Development? Perspectives on the Social and Cultural Effects of Tourism in Developing Countries, E. de Kadt, ed. New York: Oxford University Press.

Awekotuku, N. T.
1977 A Century of Tourism. *In* The Social and Economic Impact of Tourism on Pacific Communities, Farrell, B. H., ed. Santa Cruz: Centre for South Pacific Studies, University of California.

Boissevain, J.
1979 The Impact of Tourism on a Dependent Island. Gozo, Malta. Annals of Tourism Research 6:76–90.

Cohen, E.
1982a Thai Girls and Farang Men. The Edge of Ambiguity. Annals of Tourism Research 9:403–428.

Cohen, E.
1982b Marginal Paradises. Bungalow Tourism on the Islands of Southern Thailand. Annals of Tourism Research 9:189–228.

Cowan, G.
1977 Cultural Impact of Tourism with Particular Reference to the Cook Islands. *In* A New Kind of Sugar. Tourism in the Pacific, B. R. Finney and K. A. Watson. Santa Cruz: Centre for South Pacific Studies.

Crystal, E.
1978 Tourism in Toraja (Salawesi, Indonesia). *In* Hosts and Guests: The Anthropology of Tourism, V. Smith, ed. Oxford: Blackwell.

Duffield, B. S., and J. Long
1981 Tourism in the Highlands and Islands of Scotland. Rewards and Conflicts. Annals of Tourism Research 8:403–431.

Esman, M. R.
1984 Tourism as Ethnic Preservation: The Cajuns of Louisiana. Annals of Tourism Research 11:451–467.

Farver, J. M.
1984 Tourism and Employment in the Gambia. Annals of Tourism Research 11:249–265.

Fong, P.
1980 Tourism and Urbanization in Nausori. *In* Pacific Tourism as Islanders See It, pp. 87–88. Fiji: Institute of Pacific Studies of the University of the South Pacific and the South Pacific Social Sciences Association.

Fukunaga, L.
1977 A New Sun in North Kohala: The Socio-Economic Impact of Tourism and Resort Development on a Rural Community in Hawaii. *In* A New Kind of Sugar. Tourism in the Pacific, B. R. Finney and K. A. Watson. Santa Cruz: Centre for South Pacific Studies.

Gamper, J. A.
1981 Tourism in Austria. A Case Study of the Influence of Tourism on Ethnic Relations. Annals of Tourism Research 8:432–446.

Greenwood, D. J.
1978 Culture by the Pound: An Anthropological Perspective on Tourism as Cultural Commoditization. *In* Hosts and Guests, V. L. Smith, ed. Oxford: Blackwell.

Horoi, S. R.
1980 Tourism and Solomon Handicrafts. *In* Pacific Tourism as Islanders See It, pp. 111–114. Fiji: Institute of Pacific Studies of the University of the South Pacific and the South Pacific Social Sciences Association.

Jordan, J. W.
1980 The Summer People and the Natives. Some Effects of Tourism in a Vermont Vacation Village. Annals of Tourism Research 7:34–55.

Jud, G. D., and W. Krause
Evaluating Tourism in Developing Areas: An Exploratory Inquiry. Journal of Travel Research 15(2):1–9.

Kariel, H. G.
1989 Tourism and Development: Perplexity or Panacea? Journal of Travel Research 28(1):2–6.

Kariel, H. G., and P. E. Kariel
1982 Socio-Cultural Impacts of Tourism: An Example From the Austrian Alps. Geografiska Annaler B64:1–16.

Kousis, M.
1989 Tourism and the Family in a Rural Cretan Community. Annals of Tourism Research 16:318–322.

Lange, F. W.
1980 The Impact of Tourism on Cultural Patrimony. A Costa Rican Example. Annals of Tourism Research 7:56–68.

Lludman, L. E.
1978 Tourist Impacts: The Need for Regional Planning. Annals of Tourism Research 5:112–125.

Loukissas, P. J.
 1982 Tourism's Regional Development Impacts. A Comparative Analysis of the Greek Islands. Annals of Tourism Research.
May, R. J.
 1977 Tourism and the Artefact Industry in Papua New Guinea. *In* A New Kind of Sugar. Tourism in the Pacific, B. R. Finney and K. A. Watson. Santa Cruz: Centre for South Pacific Studies.
McElroy, J. L., and De Albuquerque
 1986 The Tourism Demonstration Effect in the Caribbean. Journal of Travel Research 25(2):31–34.
McKean, P. F.
 1978 Towards a Theoretical Analysis of Tourism: Economic Dualism and Cultural Involution in Bali. *In* Hosts and Guests, V. L. Smith, ed. Oxford: Blackwell.
Meleisea, M., and P. S. Meleisea
 1980 "The Best Kept Secret": Tourism in Western Samoa. *In* Pacific Tourism as Islanders See It, Fiji: Institute of Pacific Studies of the University of the South Pacific and the South Pacific Social Sciences Association.
Monk, J., and C. S. Alexander
 1986 Free Port Fallout. Gender, Employment and Migration on Margarita Island. Annals of Tourism Research 13:393–413.
Niukula, P.
 1980 The Impact of Tourism on a Suvavou Village. *In* Pacific Tourism as Islanders See It, pp. 83–85. Fiji: Institute of Pacific Studies of the University of the South Pacific and the South Pacific Social Sciences Association.
Peck, J. G., and A. S. Lepie
 1978 Tourism and Development in Three North Carolina Coastal Towns. *In* Hosts and Guests, V. L. Smith, ed. Oxford: Blackwell.
Samy, J.
 1980 Crumbs from the Table? The Workers Share in Tourism. *In* Pacific Tourism as Islanders See It, pp. 67–83. Fiji: Institute of Pacific Studies of the University of the South Pacific and the South Pacific Social Sciences Association.
Skinner, R. J.
 1980 The Impact of Tourism on Niue. *In* Pacific Tourism as Islanders See It, pp. 61–64. Fiji: Institute of Pacific Studies of the University of the South Pacific and the South Pacific Social Sciences Association.
Smith, V.
 1978a Eskimo Tourism: Micro-Models and Marginal Men. *In* Hosts and Guests, V. Smith, ed., pp. 51–70. Oxford: Blackwell.
Swain, M. B.
 1978 Cuna Women and Ethnic Tourism: A Way to Persist and Avenue to Change. *In* Hosts and Guests, V. Smith, ed. Oxford: Blackwell.

C: Survey studies of perceived tourism impacts

Ap, J., T. Var, and K. Din
 1991 Malaysian Perceptions of Tourism. Annals of Tourism Research 18:321–323.
Belisle, F. J., and D. R. Hoy
 1980 The Perceived Impact of Tourism by Residents: A Case Study in Santa Marta, Colombia. Annals of Tourism Research 7:83–101.

Brayley, R., and T. Var
1989 Canadian Perceptions of Tourism's Influence on Economic and Social Conditions. Annals of Tourism Research 16:578–582.

Bystrzanowski, J.
1989 Tourism as a Factor of Change: A Sociocultural Study. Vienna: Vienna Center.

Caneday, L., and J. Zeiger
1991 The Social, Economic, and Environmental Costs of Tourism to a Gaming Community as Perceived by its Residents. Journal of Travel Research 30(2):45–49.

Davis, D., J. Allen, and R. M. Cosenza
1988 Segmenting Local Residents by Their Attitudes, Interests, and Opinions Toward Tourism. Journal of Travel Research 27(2):2–8.

Dowling, R. K.
1993 Tourism Planning, People and the Environment in Western Australia. Journal of Travel Research 31(4):52–58.

Haukeland, J. V.
1984 Sociocultural Impacts of Tourism in Scandinavia. Tourism Management 5:207–214.

Johnson, J. D., and D. J. Snepenger
1993 Application of the Tourism Life Cycle Concept in the Greater Yellowstone Region. Society and Natural Resources 6:127–148.

Johnson, J. D., D. J. Snepenger, and S. Akis
1994 Residents' Perceptions of Tourism Development. Annals of Tourism Research 21:629–642.

King, B., A. Pizam, and A. Milman
1993 Social Impacts of Tourism: Host Perceptions. Annals of Tourism Research 20:650–655.

Lankford, S. V.
1994 Attitudes and Perceptions Toward Tourism and Rural Regional Development. Journal of Travel Research 32(3):35–43.

Lankford, S. V., and D. R. Howard
1994 Developing a Tourism Impact Attitude Scale. Annals of Tourism Research 21:121–139.

Liu, J. C., P. J. Sheldon, and T. Var
1987 Resident Perception of the Environmental Impacts of Tourism. Annals of Tourism Research 14:17–37.

Liu, J., and T. Var
1986 Resident Attitudes Toward Tourism Impacts in Hawaii. Annals of Tourism Research 13:193–214.

Long, P., R. Perdue, and L. Allen
1990 Rural Resident Tourism Perceptions and Attitudes by Community Level of Tourism. Journal of Travel Research 28(3):3–9.

Madrigal, R.
1993 A Tale of Tourism in Two Cities. Annals of Tourism Research 20:336–353.

Madrigal, R.
1995 Residents' Perceptions and the Role of Government. Annals of Tourism Research 22:86–102.

McCool, S. F., and S. R. Martin
1994 Community Attachment and Attitudes Toward Tourism Development. Journal of Travel Research 32(3):29–34.

Milman, A., and A. Pizam
 1988 Social Impacts of Tourism on Central Florida. Annals of Tourism Research 15:191–204.
Mok, C., B. Slater, and V. Cheung
 1991 Residents' Attitudes Towards Tourism in Hong Kong. International Journal of Hospitality Management 10:289–293.
Murphy, P. E.
 1981 Community Attitudes to Tourism: A Comparative Analysis. Tourism Management 2:189–195.
Perdue, R. R., P. T. Long, and L. Allen
 1987 Rural Resident Tourism Perceptions and Attitudes. Annals of Tourism Research 14:420–429.
Perdue, R. R., P. T. Long, and L. Allen
 1990 Resident Support for Tourism Development. Annals of Tourism Research 17:586–599.
Pizam, A.
 1978 Tourist Impacts: The Social Costs to the Destination Community as Perceived by its Residents. Journal of Travel Research 16(1):8–12.
Pizam, A., and J. Pokela
 1985 The Perceived Impacts of Casino Gambling on a Community. Annals of Tourism Research 12:147–165.
Prentice, R.
 1993 Community-Driven Tourism Planning and Residents' Preferences. Tourism Management 14:218–227.
Ritchie, J. R. B.
 1988 Consensus Policy Formulation in Tourism: Measuring Resident Views via Survey Research. Tourism Management 9:199–212.
Schlüter, R., and T. Var
 1988 Resident Attitudes Toward Tourism in Argentina. Annals of Tourism Research 15:442–445.
Sheldon, P. J., and T. Var
 1984 Resident Attitudes to Tourism in North Wales. Tourism Management 5:40–47.
Tsartas, P.
 1992 Socioeconomic Impacts of Tourism on Two Greek Isles. Annals of Tourism Research 19:516–533.

Author Index

Subject Index